My Soul's Been Psychedelicized

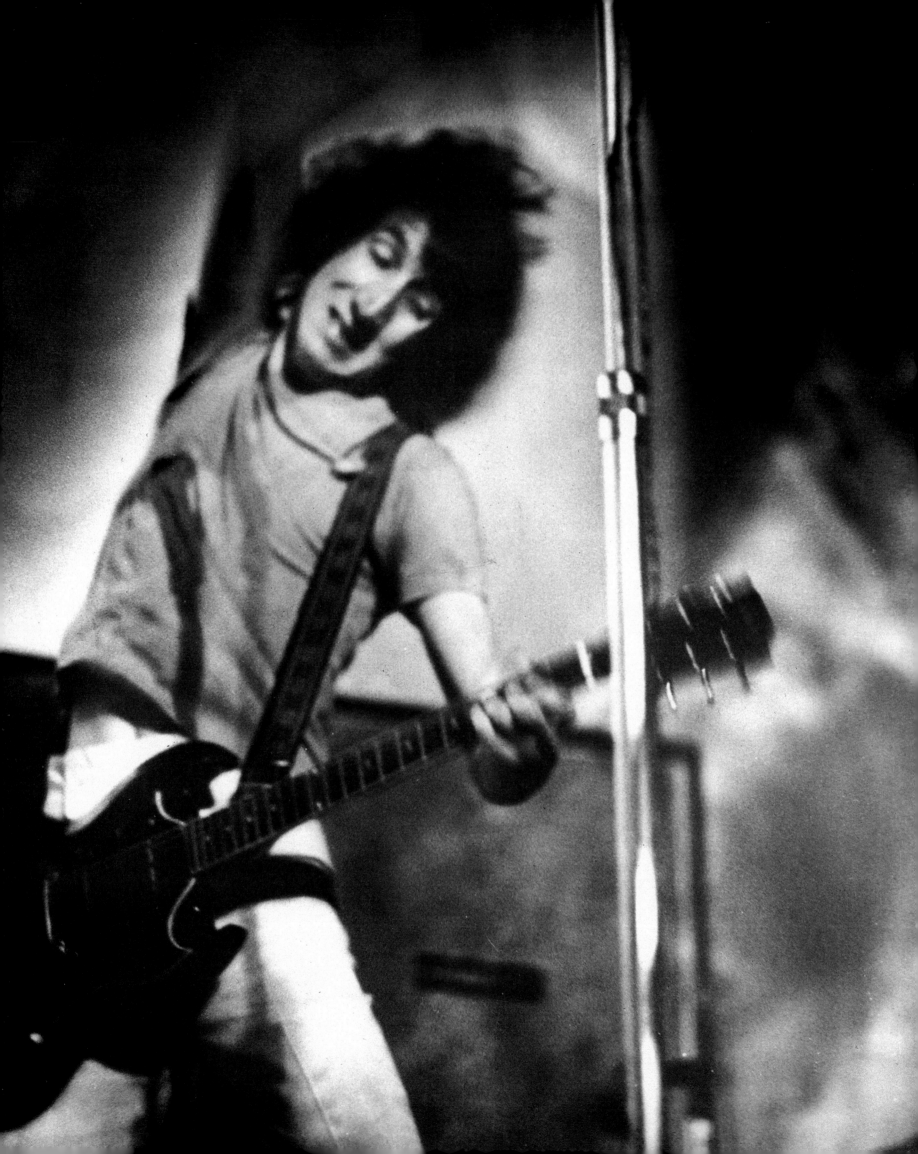

My Soul's Been Psychedelicized

Electric Factory

FOUR DECADES IN POSTERS AND PHOTOGRAPHS

LARRY MAGID WITH ROBERT HUBER

Temple University Press Philadelphia

Temple University Press
Philadelphia, Pennsylvania 19122
www.temple.edu/tempress

Copyright © 2011 by Larry Magid
All rights reserved

Published 2011

Frontispiece: Pete Townshend with the Who at Electric Factory, May 3, 1969. Photo © Eric Bazilian.
Book design by Phillip Unetic, UneticDesign.com

This book is printed on acid-free paper.

Printed in China

2 4 6 8 9 7 5 3 1

Library of Congress Cataloging-in-Publication Data

Magid, Lawrence J.
 My soul's been psychedelicized : Electric Factory : four decades in posters and photographs / Larry Magid, with Bob Huber.
 p. cm.
Includes index.
ISBN 978-1-4399-0180-9 (cloth : alk. paper)
1. Rock music—Pennsylvania—Philadelphia—Pictorial works.
2. Electric Factory (Philadelphia, Pa.)—Pictorial works. 3. Music-halls (Variety-theaters, cabarets, etc.)—Pennsylvania—Philadelphia—Pictorial works. I. Huber, Robert Louis. II. Title. III. Title: Electric Factory : four decades in posters and photographs.
ML3534.3.M34 2011
792.709748'11--dc22

 2010051799

Dedicated to Allen Spivak
a partner in a work of dreams
and
Herb and Jerry Spivak and Shelley Kaplan
for sharing a vision of possibilities

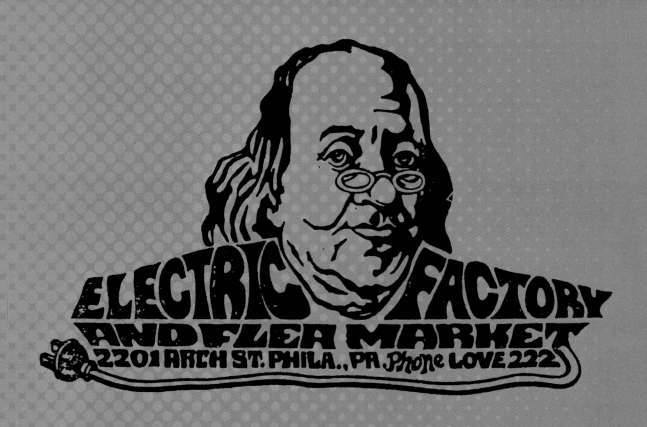

CONTENTS

Electric Factory

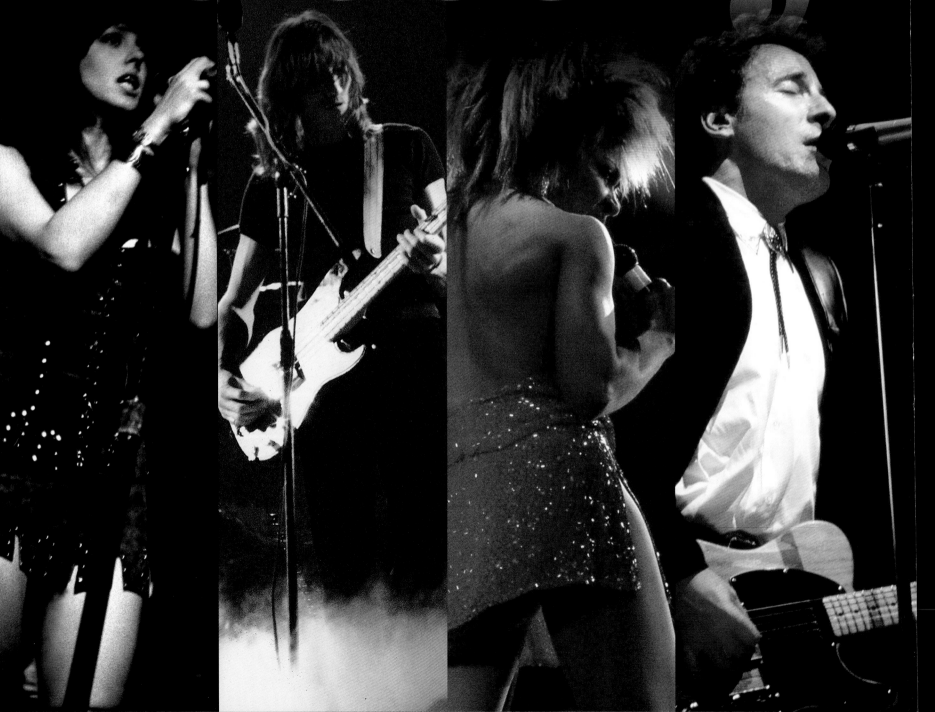

The Day-Glo colors shimmered under a nearly full moon as psychedelic painted shapes and forms danced along the outside walls. A klieg light searched the sky. All at once the big blue doors burst open. Swirling lights and driving, potent sounds pierced the darkness and announced the new dawn. Colors swam on a sea of endless possibilities. **Electric Factory had landed.**

The warmth that fell over us broke the coldness of that evening, Friday, February 2, 1968. The world as I knew it changed that night. Expectations would meet the unexpected, as I stood before it . . . a dweller on the threshold, just like the spiritual wanderer waiting to be purified by the light in the Van Morrison song.

The evening electric summoned a new gathering of the tribes. Frank Zappa would call the new clubs "psychedelic dungeons," but our club, Electric Factory, became a shelter for hippies, an oasis for the descendants of bohemians and beatniks, and a haven for anyone searching for a better system of values—Jack Kerouacs in bellbottoms and beads—and rockin'.

None of this was our intent, yet our building—which started out as Vernelson's Bakery and was later converted to a tire warehouse—became a rallying place for Philadelphia's disenchanted and disenfranchised. As art imitates life and life imitates art, we had music. Lots of it!

The small music scene that bubbled and buzzed around the country and fueled the Summer of Love in 1967 gave way to something new, born out of discontent and a little magic. Music would reshape how we examined and reacted to our lives. This was true even in Philadelphia, the home of *American Bandstand* and a rhythm and blues underground, a city whose musical culture was defined by a neighborhood mentality. Two things often misunderstood about Philadelphians are how curious and discerning we are in general and how sophisticated we are about the arts. A small Philadelphia scene visible only to insiders waited for and finally gave way to the future. Brash new troubadours threw themselves against the walls of conformity until the old Quaker facade began to crumble.

The five of us who started the Electric Factory had a different vision and a creativity that we probably didn't know existed before. Our views were not political at first, yet when we were backed into a wall by an archaic and bullying leadership, we found that you could fight City Hall and win. We weren't there for the "peace and love"! We were there for the music, and the rewards that came with it, and the success that we all needed.

Left to right, Grace Slick of Jefferson Airplane, Electric Factory, April 14, 1970. Photo © Jeff Hurwitz. Roger Waters of Pink Floyd, Electric Factory, September 26, 1970. Photo © Bobby Startup. Tina Turner, Spectrum, May 30, 1984. Photo © Zohrab Kazanjian. Bruce Springsteen, March 8–9, 1988.

As we progressed, persevered, and learned, this new lifestyle washed over us and changed us. As we stood up and fought the city, our bonds with this new community grew. In the springs and summers of 1969 and 1970, we did something so radical that most lucid businessmen would never even consider it. We put on a series of shows called be-ins on Belmont Plateau in Fairmount Park. These free Sunday events featured the acts we had played the night before at the Factory, plus local bands and whatever national groups were in the area. It wasn't the smartest thing we ever did . . . and yet it was probably as smart as anything we did.

How did this happen? Who were we anyway, and how did we penetrate and expand Philadelphia's musical underground? Who was there before us, ready to welcome us when we made our move?

The five men who started down this path together were not the likeliest people to venture into this world, but our backgrounds had prepared us well for the moment. We had the right blend of hope, dreams, needs, perseverance, luck, desire, and work ethic.

> **How did this happen? Who were we anyway, and how did we penetrate and expand Philadelphia's musical underground? Who was there before us, ready to welcome us when we made our move?**

The Spivak brothers—Allen, Herby, and Jerry—were comfortable, regular guys who were looking to break out of their past careers running bars in black neighborhoods. All three were vital and resourceful, strong and fun-loving. Herb ran the Showboat, a top jazz nightspot at Broad and Lombard. Seeing that the big names were pricing themselves out of clubs, the Spivaks started working in larger venues and presenting concerts with headliners like Lou Rawls, Ramsey Lewis, Mongo Santamaria, and Hugh Masekela. They built jazz packages, yet they knew that real success lay elsewhere.

When the jazz scene started to wane, they took in a partner, Shelley Kaplan. I knew Shelley from college. He was an unsung hero of this new-world project, helping to shape it with his creativity and curiosity. Allen, the youngest of the Spivaks, was the most grounded

of the group. His commonsense approach kept the engine running smoothly. We would have a close partnership for 34 years.

e all used to meet at the Showboat. I was a young talent agent in New York. As a student at Temple University, I had spent three years booking bands and acts for college venues and clubs. During this incubation period, I tried to put together a couple of concerts. When the local company I worked for declined to take advantage of opportunities to promote concerts with the Beatles and Frank Sinatra, I knew I was facing a dead end. I left school and sold both my car and my share of a management contract with Len Barry, a promising blue-eyed soul singer who had a string of hits, first with the Dovells and then on his own. I headed for New York.

An agency I worked for in New York, General Artists Corporation, was the largest talent agency in the world at the time. Our roster included the major headliners of the day: the Beatles, Bob Dylan, Joan Baez, Herb Alpert and the Tijuana Brass, Woody Allen, Simon and Garfunkel, the Supremes, the Temptations, and Tom Jones. The young guys worked with newer acts until those performers got hot. I was the youngest and got to book Jimi Hendrix, Big Brother and the Holding Company with lead singer Janis Joplin, Cream, the Moody Blues, Van Morrison, and Vanilla Fudge.

Herb Spivak wanted to get into the pop and rock business but didn't have an entrée. Most of the people he knew were jazz or R&B agents. There had never been a concert scene in Philly, and acts that came into town generally played a club or, occasionally, the Academy of Music or Convention Hall, or lip-synched at a record hop. The Spivaks managed to do a couple of pop shows at Town Hall, a 1,900-seat venue that stood at Broad and Race streets until it was demolished in 1983. Herb landed a couple of pop groups—the Association and Spanky and Our Gang—for separate shows, but he wanted to blend jazz acts into those shows. That wasn't going to be easy—you had to be careful. Lines were drawn, and audiences tended to be rigid. We both liked Gabor Szabo, a jazz guitarist with a gypsy flair who was trying to cross over to a bigger audience. I thought he would go over. He was added to the Association's show and was enthusiastically received.

In the summer of '67, I started to come back to Philadelphia more often. When the Spivaks and Shelley and I caught up at the Showboat, the conversation always drifted to the rock scene. Concerts were "the thing"—occasional and happening on college campuses and in theaters—I thought, but a club might be a good

vehicle to develop acts. The Trauma was another stop on those visits. It was a small rock room owned by Manny Rubin, who was quite a character. To me, he was the prototypical club owner, tough on the outside and difficult to read, but a softy on the inside. He was an idol of mine, and a very good guy. Earlier, he had owned a coffeehouse called the Proscenium at 20th and Walnut. Later, he had a folk club called the Second Fret at 19th and Sansom. My favorite of his venues, the Market Street Opera House at 20th and Market, was a very hip club playing contemporary acts in the mid-sixties. I watched Manny build it with his own hands. It lasted only a couple of years, but it was ahead of its time. It was the kind of place I had in mind when we opened the Bijou Cafe several years later.

Below left: 2nd Quaker City Jazz Festival poster from the Spectrum's opening weekend, 1967. The Spectrum opening was an incredibly bright moment in Philadelphia history, starting a new era and spurring a much-needed revitalization of our city.

Below right: The poster for the Electric Factory's opening shows, 1968.

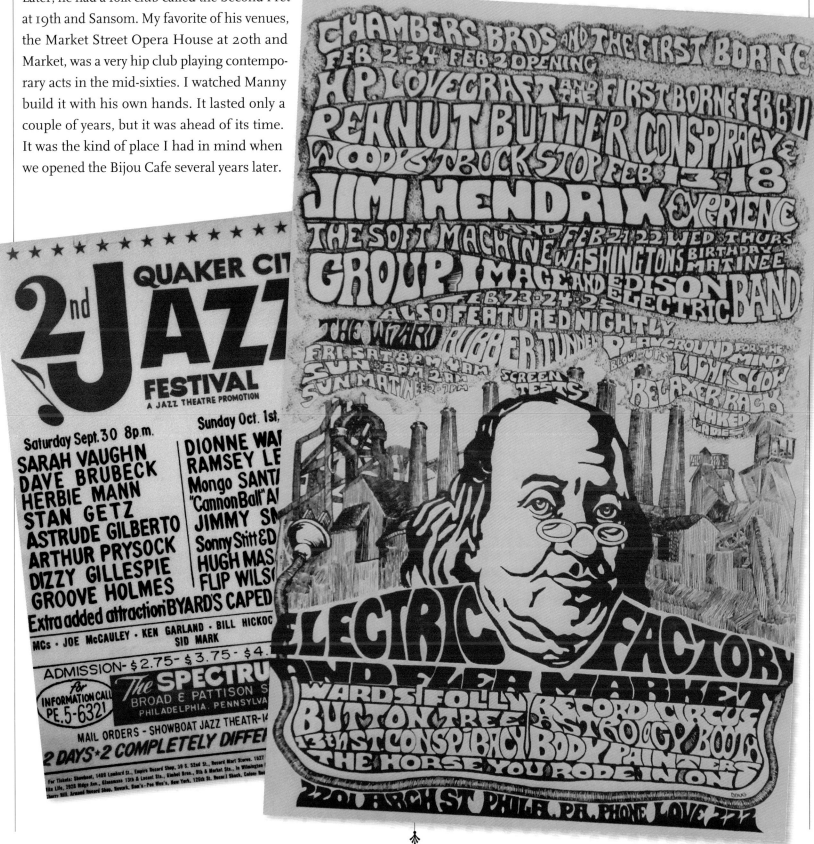

Manny's clubs were on the small side and couldn't handle the rising costs of entertainment. Standing outside the Trauma with Manny one night, I tried to persuade him to open a larger club so he could afford the newer, hotter acts, especially the ones coming from England. If he didn't, someone else would come along and build a bigger mousetrap. (I never thought at the time that I would have a part in building it.) Manny was stubborn. He never saw the change that was coming, and he wasn't interested in concerts. Still, he made a valuable contribution to the city's pop culture.

New York was fun for a while. For a young guy, the city can be heaven or hell. Working for a large agency had its moments. Greenwich Village was thriving, and I spent a lot of time at clubs there, looking after the company's acts. That was the good part. The bad part grew out of the office politics and petty jealousies. One day I wore a sport jacket and a striped dress shirt and tie to work and was sent home at lunchtime to put on a suit and a white shirt.

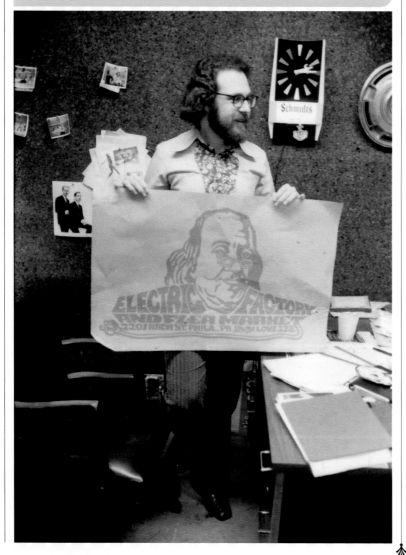

Larry Magid with the artwork for the Factory's logo, circa 1970.

My roommates in New York were folksingers from Villanova. In New York they tried their hands as session singers backing vocalists on records. A couple of them did a Sinatra session. That was big. Jim Croce frequently crashed at our apartment. Tom Picardo, one of the roommates, used the name Tommy West professionally. He wrote or co-wrote and produced many of Jim's records. His girlfriend was a part of the original Manhattan Transfer. Many nights they practiced in our living room.

Although I had a promising career in New York, with several offers to work for other agencies and management companies, I was becoming disenchanted and losing interest in the business. Acts were outgrowing the New York club scene. Concerts were held at the Anderson Theatre, in the Village Theater (soon to become the Fillmore East), and in the Singer Bowl in Queens. Young guys my age were promoting these shows. I found that I missed Philadelphia. Why couldn't this happen there? In August 1967 I started thinking about returning to Philadelphia and introducing my hometown to what was beginning to happen in New York and around the country.

Herb was planning to open the Spectrum, the city's brand-new, circular, state-of-the-art sports facility, with a two-day jazz festival. The Spectrum started a new era and launched a much-needed revitalization of the city. The thought of doing shows there was intriguing—not many acts could play an arena at the time, but it didn't hurt to dream. I wanted in!

After much discussion at the Showboat during my visits home, we decided to open a rock club—but not just *a* club. It would be an *environment* where rock acts were featured. My job would be to book the acts and manage the club. Herby and Allen would handle the business. Jerry would help construct it, and Shelley would add creative touches. We debated about the name for a long time. We didn't think much of the one we came up with, but we simply could not come up with anything better than "Electric Factory," with a logo incorporating Ben Franklin. My argument was that the name would become generic in six months, anyway: whatever we called the place, fans would just ask, "Who's playing at the club?" As it turned out, the name has lasted, and the logo—Ben Franklin with long hair and granny glasses—was perfect. It just fit.

Herby had a location in mind: a vacant warehouse at 22nd and Arch that had previously housed a bakery, the Reliable Pontiac dealership, and then tires. Herb knew the daughter of the owner and went to see her. He had trouble telling her exactly what he wanted to rent the building *for*, mostly because he wasn't

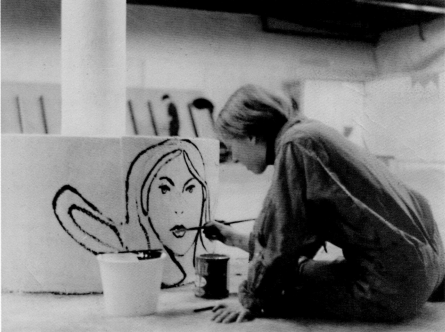

Our design was carried out, lovingly, by students from the Museum School (now the University of the Arts) —Doug Aldefer, Ichabod, Snake, Lisa Patch (above), and many willing helpers who painted the warehouse inside and out and added their own touches, working hard to build an environment of their own. The whole process was enhanced by a creative force that embraced a new music and a new lifestyle.

sure himself. He called the new venture "an entertainment thing"; rent would be $1,500 a month. He would have to get a dance license from the city. In those days, three people grooving to a jukebox constituted a dance club, which required licensing, showing how dangerous the city protectors believed such activity could be. Luckily, the club, as a former car dealership, had huge pull-up doors, so the exits would be large enough to meet city guidelines. The plan was that Herb would negotiate with the owner while I stayed in New York, working at the agency until everything was ready.

Things were moving slowly. I prodded Herby often. The Showboat was fading, as were all the jazz clubs. On Thanksgiving weekend in 1967, unwilling to wait any longer, I returned home. Herb had said everything was set. It wasn't.

"I'm here."

"What do you mean? You're where?"

"I'm back in Philly."

"What're you doing in Philly?" Herb had neglected to sign the lease and seemed to be stalling on the whole idea of opening a club.

"Herb, we talked last month," I told him. "We talked two weeks ago. I told you I was putting my notice in."

I embarrassed him into finally signing the lease, I guess. I came home on a dream. Then the magic began.

The Spivaks, Shelley Kaplan, and I worked around the clock for two months to transform the old tire warehouse into a rock club that offered hope and fun as well as entertainment. We brainstormed late into the night before deciding to build pine coffins along one wall, set up monkey bars, space big footprints on the ceiling, and serve food out of a long rolling tongue. The light show was projected from a house on stilts. Every day we had a new idea. We wanted to establish the right tone, a sense of enjoyment and goofiness and underground edginess in a place where American and British rock 'n' roll could be introduced to scores of young people for the first time.

Our design was carried out, lovingly, by students from the Museum School (now the University of the Arts)—Ichabod, Snake, Lisa Patch, and many willing helpers who painted the warehouse inside and out and added their own touches, working hard to build an environment of their own. The whole process was enhanced by a creative force that embraced a new music and a new lifestyle.

The headliners for the first show were the Chambers Brothers, the best act ever to open a rock club. Their neo-soul and gospel sounds were fresh, and they had that Philadelphia feel. They created a sense that you were in another universe. Four African American brothers with a white drummer, the right juxtaposition for the times, blurted out the first rock anthem: "Time! Time has come today. Time!" It surely had. The chorus echoed the mood, piercing through that mystical night: *"And my soul has been psychedelicized!"* Oh, yeah! The Chambers Brothers played the entire weekend.

That first night—February 2, 1968—the new world was welcoming. The environment, totally different from that of any venue before or since, was warm and inviting, and the music was very, very hip.

Suddenly we were the shamans of a new generation. The music was our message, and the possibilities were dreams that hadn't manifested themselves but were getting closer day by day.

Electric Factory was an immediate hit. It had character and honesty. There was a lot of room to move about, except when the biggest acts came in. We did two shows a night on the weekends, at eight and eleven (seven and ten on Sundays). At the beginning, sometimes there were matinees, and we occasionally did shows on weekdays. We had three acts a night: a headliner, an intriguing up-and-coming act, and a local band.

Getting the acts on and off and minimizing the setup time between acts was important. We had to stay on top of the crew. My days were spent on the phone talking to managers and agents, learning about new bands, figuring out who we could get to come to Philly. Because it was all so new, we all figured it out as we went along and I could shape the club's artistic ethos in any number of ways. I could (and did) bill jazz guitarist B.B. King and rocker Eric Clapton to play the same night, or the Grateful Dead and jazz saxophonist Cannonball Adderley. We could book new acts and mix genres and performers because people were open to new experiences.

A group called Pink Floyd, not very well known at the time, got stranded in the United States and needed $1,750 to get back to England, so they contacted me. They had played the club months before and had a ball. We added them to a bill with Savoy Brown, and they put on a brilliant hour-and-a-half set and made enough money to go home.

e booked Jeff Beck, who was a guitar hero in England even then. His manager was Peter Grant (who helped create Led Zeppelin), a 300-pound former wrestler who carried a hand-carved cane. The band's singer—Rod Stewart—had to sing standing off to the side in front of the drums so that the audience could watch Jeff Beck.

There was a new group named Ten Years After, which also had a good guitar player, Alvin Lee, and I booked them to go on right before the Jeff Beck Group. They were hot; the audience loved them. Grant wasn't happy about this arrangement and wanted me to take them off the bill. I said there was no way we could do that—not contractually, not any other way. The two bands played the next show, and again Ten Years After were real crowd-pleasers. Grant repeated his complaint, and I suggested that if his band was unhappy following Ten Years After, maybe they could go on *before* them. The confrontation spilled out of the club, and the ex-wrestler followed me all the way back to my car. We laugh about it now, but neither of us thought it was funny at the time.

In 1970 I heard about a group from down South that hadn't released a record. Phil Walden, who had discovered Otis Redding

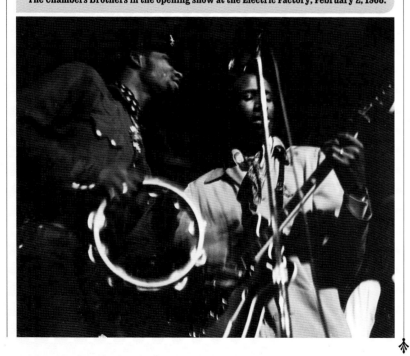

The Chambers Brothers in the opening show at the Electric Factory, February 2, 1968.

Pink Floyd

A group called Pink Floyd, not very well known at the time, got stranded in the United States and needed $1,750 to get back to England, so they contacted me. They had played the club months before and had a ball. We added them to a bill with Savoy Brown, and they put on a brilliant hour-and-a-half set and made enough money to go home. Roger Waters of Pink Floyd, on the bill with Savoy Brown at Electric Factory, September 26, 1970.

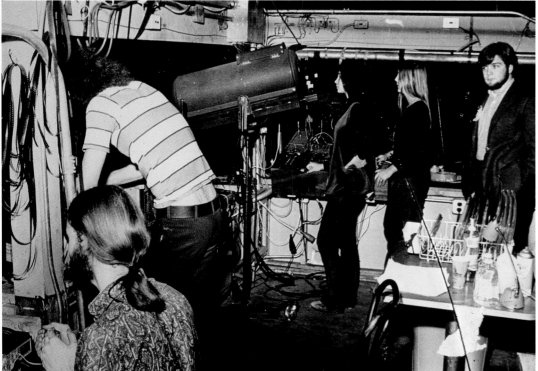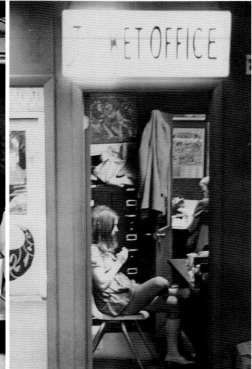

Above left: The Factory's light booth, a room on stilts, with Jims Nelson, John Musall, two lighting assistants, and Hoag Levins, an *Inquirer* reporter.
Above right: The Factory's office, which also handled advance tickets. Carole "Chico" Palermo, who answered phones, at her desk, circa 1970.

and Sam and Dave and founded Capricorn Records, got in my ear over the phone, telling me I had to play this band—it was great music, I had to take a shot.

I knew Walden from my New York days and respected his opinion. His endorsement of a white band counted for a lot, since he usually worked with black artists. Putting on a band without an album was not the norm, but word of mouth—buzz—counted too. I said okay—the Allman Brothers Band could play for three nights, for a grand total of $600. They drove up in a motor home and parked in the alley behind the Electric Factory. The club ran a line out to give them electricity. What a band! There were two drummers—not one drummer playing the front and the other the back; they were playing the same thing, creating a rhythm line that probably shook the sidewalk from 22nd and Arch to City Hall. Gregg Allman played brilliantly on a Hammond B3 organ and sang with the voice of somebody who was carrying the weight of the world. Duane Allman was as good a guitar player as I've ever heard. He went on to record with many other people, but he had a sound that was uniquely his own.

The Allmans were the perfect band for the time, more musical and melodic than the psychedelic bands, and with a fuller sound. They introduced blues-based music to a lot of white kids. This was one way the club helped older blues musicians find the audience they deserved—an audience outside the folk clubs and festivals where they normally played. Because they were electric, rock clubs were where they showed off their talents best. In these cases we weren't "discoverers" but were more like catalysts. We put different performers and new audiences together and made things happen. More conventional promoters thought everything revolved around the act, but we thought that Electric Factory itself was the rallying point. Time after time, we took risks, experimented, and made it work.

For major acts we turned the house over between shows to let a new audience come in. But we often let people stay for both shows. Initially, patrons had to be eighteen to get in, but after a while we softened up on that. The new rules were that we had no rules. Just no drugs, no fights! Enjoy the show and don't infringe on anyone else's fun. It worked! The city had a curfew, so we had to watch closely for possible violators. That's why we had the eighteen-year-old rule in the first place. The trouble was that everyone wanted to come—not just kids, but adults, society people, politicians, music fans, and curiosity seekers. Most of them had a really good time.

In addition to the acts, we had a whole array of constantly changing elements designed to trip the senses. Back then, fog machines, strobe lights, Day-Glo paint, mirrored balls, and black lights were relatively new. Put them all together with a hot band, a light show, and multicolored oil pulsating through an overhead projector, and you had a wild night ahead of you. Other shift-

ing sensory elements included mirrored and floating tunnels, a flea market, a repertory company, a guy in a gorilla costume who would entertain the lines of people waiting to get in, and a collection of the city's finest and coolest trendsetters.

We worked constantly to promote the club. We hired David Kasanow, a recent Penn grad, to help at the Factory a few months after it opened. Some days we went all over the city with tack hammers, nailing up posters. Within an hour of hanging, most of the posters would be gone, already gracing bedroom walls—which was, in fact, exactly what we thought would happen. Posters brought the Factory directly to the public, generating the buzz that sold out shows.

For all of that, it was the music and the bands that brought people in and brought them back. Everyone played there. You saw Jimi Hendrix burn his guitar, Pete Townshend smash his. Frank Zappa and the Mothers of Invention also played that first spring. The band was aptly named: they were of the times *and* ahead of the times. Zappa was one part Baltimore doo-wopper and one part impresario, with a little taskmaster thrown in. He was tough on his band—but that made his band tight. He was also a very cool, intimidating guy, with his exaggerated, droopy Fu Manchu mustache and a cigarette hanging out of his mouth. When he first walked into the Electric Factory, on the Friday afternoon before his first show, Zappa looked around cautiously.

Frank Zappa, leader of the Mothers of Invention, and they truly were inventive— of the times and ahead of the times.

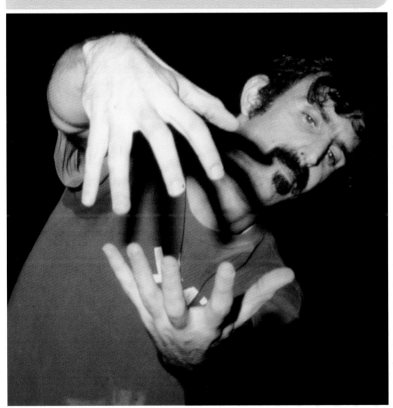

"Let me show you how we think about you," I told him. I took Zappa to a bathroom in the little area where we'd built a flea market. Into the stall we went, and I lifted the lid of the toilet seat. On the inside of the lid was a painting of Zappa's face; the seat itself was his arms.

He burst out laughing. He thought everyone was full of it, including himself. Zappa played several times at Electric Factory, and his shows were as much theater as music. He appeared for the third time right after Lyndon Johnson announced that

For all of that, it was the music and the bands that brought people in and brought them back. Everyone played there. You saw Jimi Hendrix burn his guitar, Pete Townshend smash his. Frank Zappa and the Mothers of Invention also played that first spring. The band was aptly named: they were of the times and ahead of the times.

he wasn't seeking the nomination for reelection in '68. It was a rainy Sunday night. Before the show I told Zappa, "We've got to do something special."

Zappa knew immediately what he wanted to do: "Can you get me a casket?"

That night "the Mothers" completely wrapped an Electric Factory employee in toilet paper, while Zappa ad-libbed a 30-minute eulogy for Lyndon Johnson as the band played behind him. Then they put the mummy into the casket. Zappa's sharp satirical edge set the tone we were looking for.

Another night—there was Janis Joplin swigging Jack Daniels between songs. Jefferson Airplane played two shows at the Factory. They were the top band of that era, and the first to travel with their own sound system. The Grateful Dead, Steve Miller with Boz Scaggs, and Van Morrison debuting *Astral Weeks* also appeared. Eric Clapton was featured in three different configurations: Cream, Delaney & Bonnie, and Derek and the Dominos. A few weeks after the opening, Jimi Hendrix performed, on the

THE SPIVAK BROTHERS

The Electric Factory was the brainchild of five men: the Spivak brothers—Jerry, Herb, and Allen—Shelley Kaplan, and Larry Magid. The Spivaks were children of the 1940s and 1950s who came of age in a city colored by World War II, lower-middle-class ethnic neighborhoods, and the belief that their generation would do better than their parents had. They grew up in Wynnefield when it was a Jewish neighborhood; their father, Harry "Speedie" Spivak, owned three Philadelphia bars with predominantly black clienteles. In the mid-fifties the brothers were already working in their father's business. Above the bar at 22nd and South were three-dollar rooms frequented by prostitutes. This was Captain Frank Rizzo's district; Jerry, the oldest brother, knew him well.

Harry Spivak died in 1955, leaving the bars to his sons. Allen was running Speedie's Red Brick Inn in the 1800 block of Market when he was 18—still too young to drink in his own bar. He was married at 20 and soon had three children.

Herb owned the Showboat, a club at Broad and Lombard that featured whatever jazz acts came through the city: Lou Rawls, Mongo Santamaria, Miles Davis. Upstairs was the Douglass Hotel. Herb was a jazz buff who went to New York to pick the brains of jazz agents and managers and drove his family all over the country in a borrowed Cadillac, hitting jazz haunts down South and on the West Coast, getting a feel for the business.

Something new started building in 1966 and '67—a kind of music that Herb didn't understand, played by young West Coast groups with names like the Grateful Dead and Jefferson Airplane. Herb was 35, past, as he says, "the cusp of being trusted" by

the new musicians and their fans. He and his brothers would need someone younger who could connect with the emerging underground.

For a while after the Factory opened, Allen Spivak still spent much of his time running his bar in the 1800 block of Market Street. Speedie's Red Brick Inn was a top-notch beef and ale place open seven days a week. Allen had no special affinity for rock, but he liked Elton John and the Grateful Dead. He even liked Pink Floyd's music, if not the theatrics. "I used to like bands that weren't show bands," he says. "In other words, that weren't a big production. Someone would say, 'How'd you like the show last night?' I'd say, 'Ah, man, they just pulled their pants down and played. It was a pull-down-your-pants-and-play band.' That's what I used to call them. Because they would just come on, just do it."

For Herb Spivak, entering the big time created a sort of cognitive dissonance. He was trying to live a normal life as a family man with four kids and help run a business that was not normal. "That first Stones concert at the Spectrum, we had to give Mick Jagger $75,000 in cash. The next morning, when I woke up at home, my daughter asked me for her allowance—it was three dollars. I asked her how she was going to spend it. We had an argument about it. It was hard to live in those two worlds."

cusp of becoming a star. He had painted his hands with Day-Glo colors. With the rest of the stage darkened, a spotlight caught them. For a few moments all you could see were his hands, flying up and down the neck of the guitar, flying over the strings. At the end of his performance, Hendrix set fire to the guitar.

The Band ran out of songs and repeated some on encores. Zappa played there with Captain Beefheart. Wes Montgomery, Cannonball Adderley, Hugh Masekela, Buddy Rich, and other jazz greats appeared. The Who played their rock opera *Tommy* for the first time in America in October 1969.

Tommy is the story of a deaf, dumb, and blind kid, a Pinball Wizard. The opera is a narrative of teenage angst and frustration, building to an explosive crescendo. It was absolutely mesmerizing. Keith Moon drummed so fast that his sticks kept flying out of his hands into the audience. He grabbed another set, pulsing to a violent end until he knocked over his drums, and Pete Townshend, in his white jumpsuit, smashed his guitar onstage.

The city's afternoon newspaper, the *Bulletin,* didn't get it: "The antics of Pete Townshend and Roger Daltrey, the lead singer, are original and vital, if perhaps overdone. The light show by Illumi-

nations, the regular Factory group, was pertinent and effective. The tempo was rushed at the beginning, but evened out before too long."

The show built to an explosion to make a point. It had to be emphatic—literally an explosion. The Who may have been the best band ever—they truly embodied the spirit of the music and the times.

We were among the first to book jazz trumpeter Miles Davis in a rock setting. I got to know him while working for the New York City agency that represented him. At the Factory he was playing for a largely white audience of city and suburban kids. He seemed to enjoy the acceptance by a new, freer audience as he began his evolution into rock star status.

Miles wouldn't play his older hits or his older songs but performed whatever he was recording at that time. And he interpreted his songs differently every night—something I thought he had in common with Bob Dylan. This was a great and critical period of reflection and growth for many performers, and it was

Jimi Hendrix at the Spectrum, April 12, 1969. Photo © Eric Bazilian.

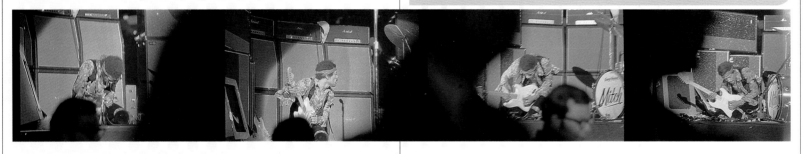

A few weeks after the opening, Jimi Hendrix performed, on the cusp of becoming a star. He had painted his hands with Day-Glo colors. With the rest of the stage darkened, a spotlight caught them. For a few moments all you could see were his hands, flying up and down the neck of the guitar, flying over the strings. At the end of his performance, Hendrix set fire to the guitar.

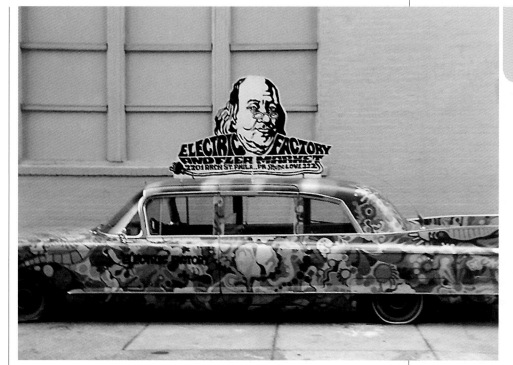

embodied in these two. They were among the most credible artists out there—they had already made it, and yet they chose to be still part of the counterculture. They had dared to be different before, and now they dared to continue to evolve. Miles fused jazz with rock and other forms; Dylan went on to record a country album.

Phil Ochs played at the Factory twice. The first time he appeared as an outstanding folk and protest singer. For his second appearance, in 1970, he wore a gold lamé suit that he had commissioned from Elvis's costumer. The show ended badly. His new persona seemed to me like a protest of a protest. The rock scene was taking over from the folk scene. When Ochs tried to make it as a rock performer, more out of desperation than anything else, the transformation didn't come off, and you could see the beginning of his demise right in front of the audience.

Janis Joplin appeared at the Factory for the first time right after Hendrix. When she showed up Friday afternoon, posters advertising his Thursday performance were still up all over the place. I went over to greet her.

"*Why the fuck* are all these Jimi Hendrix posters up?" Janis yelled. "Where are *my* posters?"

I had a soft spot for Joplin, despite her gruffness. The minute you saw her, you felt how she embodied the whole scene. She could be tender and sweet, and then equally rough. The next time I booked her band—Big Brother and the Holding Company—at the Factory, it was for seven shows in three days; she showed up with a 101-degree fever, slugged Southern Comfort for two days, and

somehow played all her shows . . . brilliantly!

The Dead performed several times at the Factory in '68. They weren't great musicians, apart from Jerry Garcia, and they didn't yet have a popular song that readily identified them. Their initial appeal was in the way they lived—as a commune. The sweet sense of a new rolling movement defined them. One weekend the club loaned them the Electric Factory car, a '59 Cadillac limo with big fins and a psychedelic paint job. The Dead loved tooling around the city in the limo, although they were less enthused about the accommodations offered at the Douglass Hotel above the Showboat at Broad and Lombard, the Spivaks' three-dollar-a-room joint, where a lot of the guests stayed maybe an hour. Garcia and his bandmates found the Douglass way too funky. For years, they would tease Allen Spivak and me about it: "You put us up at that place."

We had children's concerts and classical concerts. One featured pianist Susan Starr. A symphony orchestra played Mahler, with narration by Councilman Jack Kelly (Grace Kelly's brother) and Philadelphia political icon Thacher Longstreth. We did a Howdy Doody revival with Buffalo Bob Smith. Dave Rabe staged his first play, *Sticks and Bones,* at the Factory; Sally Kirkland starred. We even had Henry Crow Dog, a Sioux medicine man. All for $3.00 or $3.50 a ticket.

Somebody had to be the adult, booking the acts and orchestrating the scene in a clear-eyed manner, yet at 26 I was young enough to feel an affinity for a world opening up right before my eyes. I could look out on it from the Electric Factory office, whose window was a one-way mirror incorporated into Ben Franklin's eyeglasses. Or I would drive around in the company's psychedelic Caddy. Every once in a while I'd take the car over to my mother's house. My hair was longer; I had a beard. My mother would say, "Can you park that car a block away?"

The police and the city establishment had reservations too. Police Commissioner Frank Rizzo had made his name in the fifties and sixties raiding coffeehouses and gay bars. Electric Factory had a higher profile than any of those establishments, and not just because the exterior was covered with wild Day-Glo shapes and figures. We didn't open the doors until half an hour before showtime. Fans would line up on 22nd Street starting at five o'clock or even

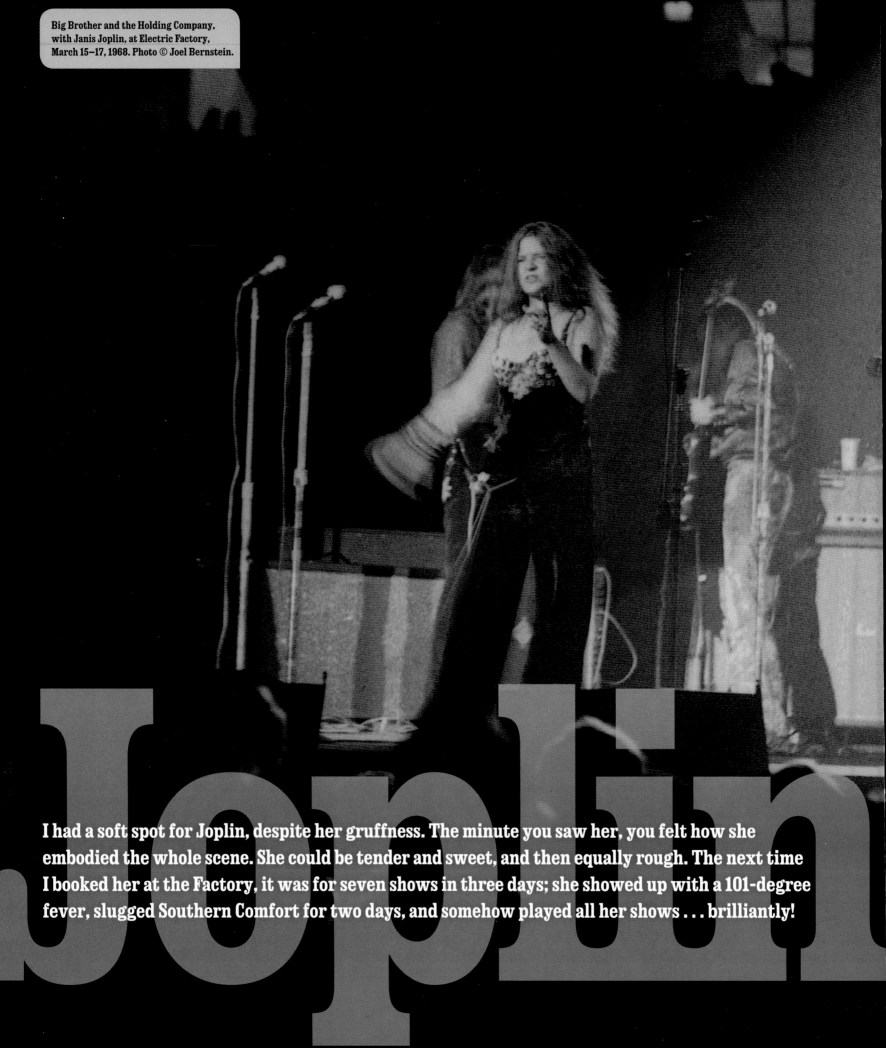

Joplin

I had a soft spot for Joplin, despite her gruffness. The minute you saw her, you felt how she embodied the whole scene. She could be tender and sweet, and then equally rough. The next time I booked her at the Factory, it was for seven shows in three days; she showed up with a 101-degree fever, slugged Southern Comfort for two days, and somehow played all her shows . . . brilliantly!

four. This was a form of marketing. In those days, before I-95 cut through the city, anyone who wanted to go west on the Schuylkill had to drive right up 22nd Street, past this psychedelic warehouse with all the kids outside. Rizzo and Mayor James H. J. Tate felt that they had to check us out. Rizzo came in one Friday night during a show and watched for a while. Reluctantly I approached him.

"Commissioner, can I help you?" I asked.

"This your place?" Rizzo boomed.

"I work here."

"So who's the owner? I want to speak to the owner."

I found Allen and Jerry Spivak. Rizzo told them that he was going to put us out of business. The next Friday he showed up with Mayor Tate. They looked around, waited for the show to start, checked out what was going on. Later, we heard that what really upset the mayor and the commissioner was black boys dancing with white girls.

We did a couple of concerts in other venues: Jimi Hendrix at the old Arena and Judy Collins at the Academy of Music. Our first rock show at the Spectrum was the First Quaker City Rock Festival on October 19, 1968: Vanilla Fudge, the Chambers Brothers, Big Brother with Janis Joplin, Moby Grape, and the Buddy Guy–Junior Wells Blues Band. They performed on a rather small 20- by 20-foot rotating stage. Two months later we were promoting the 2nd Annual Quaker City Rock Festival, with Iron Butterfly, Steppenwolf, the Grateful Dead, Sly and the Family Stone, and Creedence Clearwater Revival.

In my opinion Electric Factory Concerts never got the credit we deserved for helping to save and rebuild the Spectrum. The original owner went bankrupt, and the Spectrum was placed in receivership. When the legal smoke had cleared and the arena came out of bankruptcy, Electric Factory Concerts laid the groundwork for recovery by making a deal to present shows there at a reasonable rate. Judge Harvey Schmidt, who was overseeing the case, had asked us to guarantee ten shows at the Spectrum. We exceeded that requirement in a few months. We put on 30 that year and made more money for the building than any other entity, including the sports teams, and we continued to do that for many years. Soon we were up to 55 or 60 shows a year. Those shows helped bring the building out of receivership and made it much more attractive to new management. Personally, I'm happy that we at EFC were among the architects of the Spectrum's success but surprised that we never got full recognition for that.

Early on, we saw the possibility of presenting music in bigger venues, creating rock concerts before tens of thousands. Big rock concerts were still a novel idea in the late sixties when we started the Factory, but from the club's inception I thought about how we might use it not only to introduce new music to the city, but also to build performers for something bigger down the road. We also built bigger audiences: arena rock shows were our intention and invention. At the Spectrum we pioneered in general admission tickets, also known as festival seating. EFC called these events dance concerts—a term that signaled our sense of the difference between an orchestral concert in the Academy of Music and the freedom and audience involvement of a rock show.

Sometimes we shrank the venue and called it the Spectrum Theater. For acts that drew smaller crowds, EFC curtained off parts of the 20,000-seat arena to create a space for 5,000, 7,000, or 10,000 fans. This flexibility made the Spectrum attractive to groups that couldn't sell 20,000 tickets, and it also gave audiences a more intimate experience. As part of our ongoing plan to build acts for the next stage of their careers, introduce up-and-coming artists to Philadelphia, and match performers with the audiences they were ready for, we were the first to experiment with both the cut-down arena and festival seating.

We cut the arena down for the Beach Boys' first show after their tour with the Maharishi, a period when nobody would

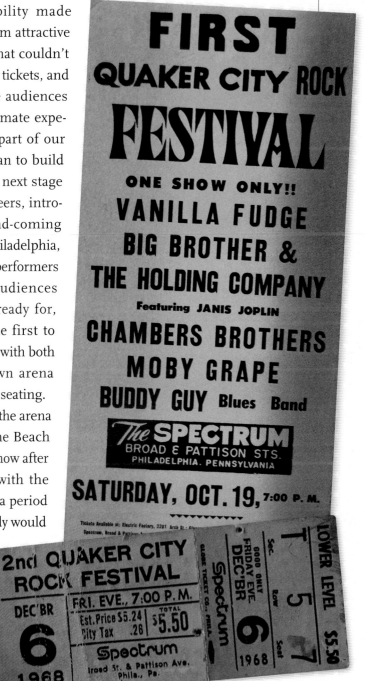

GENERATIONAL GAP

Philadelphia's historic conservatism is an important part of the Electric Factory story. At the midpoint of the 20th century, Philadelphia was losing manufacturing jobs and residents. No clubs catered to teenagers. Jazz and R&B acts coming into town were still handled like vaudeville performers—with half a dozen different acts billed together over one long night at places like the Uptown on Broad Street or the Tower and State theaters in West Philly. Folk acts in basement cafes downtown drew small audiences of beatniks and intellectuals. Meanwhile, Dick Clark's *American Bandstand*, debuting in August 1957 out of West Philly, presented a squeaky-clean TV version of popular music, featuring neat attire and no racial mixing. The collective energy and desire for large-scale change that would make the sixties a transformative decade had not yet materialized.

"What we were doing, it was difficult," Paul Fishkin says of his generation. Fishkin grew up near the Spivaks in Overbrook and, like Larry Magid, whom he also knew, was a hip Jewish kid taken by R&B and jazz. Fishkin would later manage the local bands Woody's Truck Stop (featuring Todd Rundgren) and American Dream. For a few months, he and Magid—as "Paul Fiction and Larry Magic"—had a show on WDAS. "We were trying to twist our way out from our parents' belief system." White doo-wop groups sang on the corner. Fishkin was briefly in the first incarnation of the Dovells. "We knew it was cool and hip. And it was risky. When you went to the Uptown to see James Brown or others, you had to be careful. But no matter how scared you might be, the passion for the music came first."

The Spivaks did a couple of pop music shows at the old Town Hall at Broad and Race. In 1966 the city's underground consisted of about 100 hippies who congregated in

Rittenhouse Square or on Sansom Street. By early 1968 the Spivaks and Magid had thousands of young seekers of the underground lining up around the block at 22nd and Arch.

From the night it opened, the Electric Factory was a testing ground. Music had become the wedge between old and new ways of thinking and behaving. Some of the city's authorities—notably Police Commissioner Frank Rizzo—represented the conservatism of the ethnically defined blue-collar neighborhoods, the very neighborhoods that had bred restless kids now ravenous for change.

The driving emotion and protest lyrics of rock 'n' roll were fueled by a stance of confrontation and expectation. Bringing the new music to a town roiling with generational conflict, the Factory quickly became both a gathering spot and a creative force for change. It immediately drew in Philadelphia's underground fringe, but its gravitational pull reached far beyond that. "There were many levels of opportunity at the Factory," Fishkin remembers. "It started with the underground hippies, the cool ones, then other kids came in to find out about the club. Kids from the suburbs intimidated by the underground found out it was okay to come in." That edgy but open-hearted inclusiveness gave the Factory much of its energy and charm.

Local students, most from the University of Pennsylvania, organized Earth Week, a series of activities focused on the environment and leading up to a gathering in Fairmount Park on April 22, 1970. Electric Factory produced the event on Belmont Plateau, which featured local bands and such notables as Senator Edmund Muskie, consumer advocate Ralph Nader, futurist Buckminster Fuller, and poet Allen Ginsberg (left column of contact sheet).

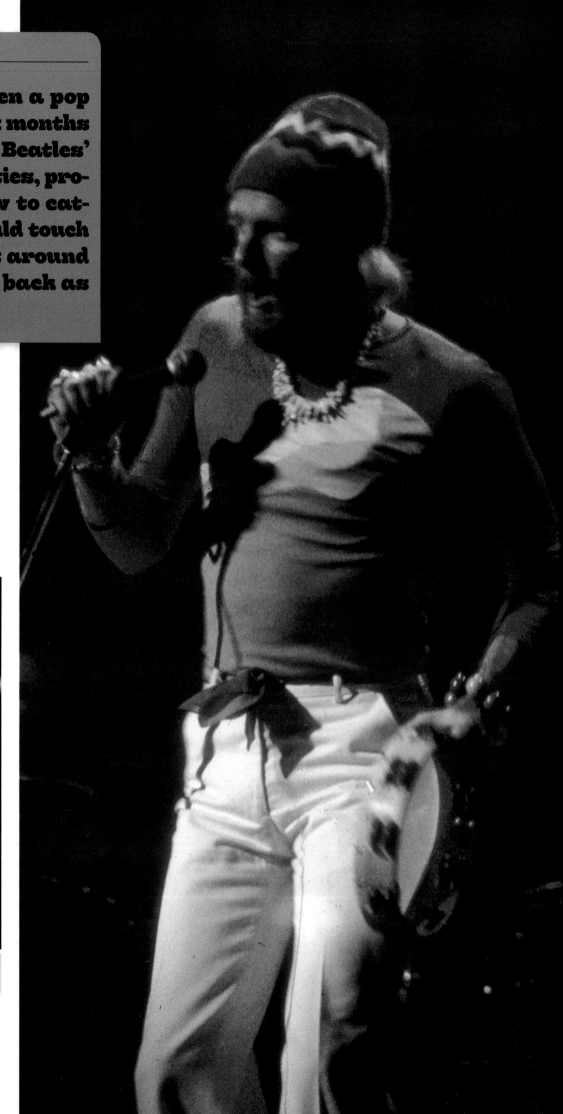

The Beach Boys had been a pop act. After they spent six months with the Maharishi (the Beatles' guru) in the early seventies, promoters didn't know how to categorize them. No one would touch them. We put a rock act around them and brought them back as a concert act.

touch them. They weren't like the Beatles: they were blue-eyed blonds who sang pop songs, and the audience didn't readily accept their association with the guru.

Electric Factory Concerts reached out to them and surrounded them with more credible acts: Boz Scaggs and Taj Mahal. It was May 7, 1971. We cut the Spectrum in half and sold 10,000 tickets. This event was a turning point

Above: Boz Scaggs played guitar in the Steve Miller Band. Electric Factory, circa 1969 or 1970. Right: Mike Love, April 6, 1973. Photo courtesy of the Spectrum.

for the Beach Boys, who had never been an arena band and were not that popular on the East Coast. It brought them back as a concert act. In this case and others, EFC took a chance critically and culturally, not just financially. Our name gave a band credibility and an association with a community of music.

James Taylor had played the Electric Factory, and I sensed that he could project to a larger audience; after having him play the Academy of Music a couple of times, I booked him into the Spectrum. John Denver successfully played a second Spectrum show that started at midnight. When we booked it, we weren't sure how many John Denver fans would want to leave a concert at 2:30 a.m. We booked David Bowie for four Spectrum shows and Rod Stewart played for the same number over several months when neither was doing as well anywhere else. For Elton John, it might be four performances over four days.

The Spectrum's management was forward-thinking and good to work with. In those days a lot of arenas were municipal buildings, staffed by city workers who didn't want problems. But the Spectrum made it comfortable for us to take chances, and we took a lot of them. A form called a yellow sheet used to circulate among venue operators throughout the country, telling them what to expect and what problems to anticipate when they booked various acts. It would say things like "Alice Cooper bit the head off a chicken"—so venues wouldn't book him. That never happened to us at the Spectrum. Nothing deterred us from taking a risk if we thought we could entertain enough people.

The vision got bigger because the stakes were bigger. Concerts were the thing now. Just like jazz acts, rock acts were starting to price themselves out of clubs. The audience was growing quickly. The demographics were spreading—this was no longer only a cultish situation. We were there to broaden the appeal and broaden the audience.

By this time we knew how to put on a concert—and the opportunities started to come. Concerts did not come prepackaged, as most do today. Agents, managers, and record companies expected promoters to put the shows together. We did it better than most because of our club experience and my eclectic musical tastes.

The city was changing. The same city agencies that had tried to close down the Electric Factory permitted us to put on free Sunday afternoon concerts at Belmont Plateau in Fairmount Park. They were called be-ins, and they began at noon. Sunday was a lazy day in Philadelphia, especially in the summer, when the Factory was closed. The first be-in drew maybe 300 people. The stage was set up on the back of a beer truck. Vendors supplied free food.

Then the be-ins grew. A July 1969 be-in featuring the Buddy Guy Blues Band, Jerry Jeff Walker, the Times Square, and a half dozen other acts drew some 7,500 folks; apart from creating traffic headaches and disrupting a few softball games, the event allowed the gentle spirit of the underground movement to be on mass outdoor display. Some revelers formed a huge circle to dance; others showered them with handfuls of the park's long grass.

The be-ins were a relaxing interlude for us too, a way for us to simply hear music. The Spivak kids would come. The Dead and Jefferson Airplane each played at one. There were also local favorites like American Dream and Mandrake Memorial, Woody's Truck Stop, Edison Electric Band, and Elizabeth. For tough businessmen like the Spivaks and a competitive neighborhood guy like me, the slow pace of free concerts where collections were taken up for Children's Hospital, plus the sense of just letting it happen, was something of a revelation. We all took in what was happening. It was a free, trusting openness that most of us hadn't experienced, and most of us *still* don't experience.

The counterculture was offering us new ideas, new values, new concepts, not based on the profitability of anything. The first nine years I worked in the music business, I made very little money. We hoped that we could make it a stable business, never thinking it was going to grow into what it did.

The be-ins kept getting bigger, until one drew some 75,000 fans and tied up traffic in the city for a whole day. The city decided,

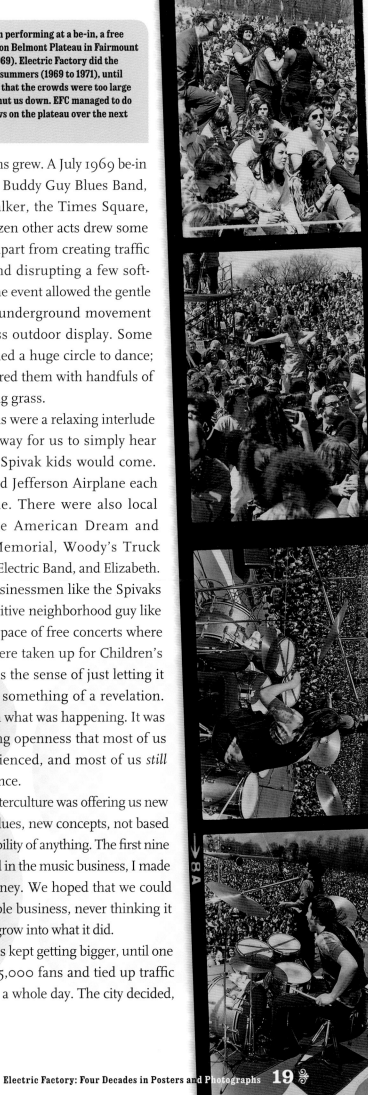

that's it—no more be-ins. But the music scene, and the city itself, had opened up. We had made our point, showing how much we cared about bringing this new music to our city.

Sometime in 1969 we decided that the Factory had generated enough energy to make a three-day festival work. It had to be in the summer. The Factory wasn't air-conditioned, and not a lot went on in the summers at that time—either in the club or in Philadelphia. Allen and Herby contacted Bob Levy, owner of the Atlantic City Race Course. It was an ideal location outside of the city. Atlantic City itself was experiencing a downturn, but it was an accessible spot near the ocean—a natural drawing card in the summer. And everybody knew the way to A.C.

Festivals were beginning to spring up in cities like Denver and Atlanta, but we felt that a three-day show in a controlled environment with camping nearby was going to be bigger and better. A two-day festival in upstate New York had been announced: a folk show one day and a rock show the next. The hours seemed limited to me, but the location was interesting. It was in Woodstock, where Bob Dylan lived at the time, recuperating after a bad motorcycle accident. No doubt the promoters were going to take full advantage of Dylan's ever-growing mystique and Woodstock's seeming hipness as an artists' retreat.

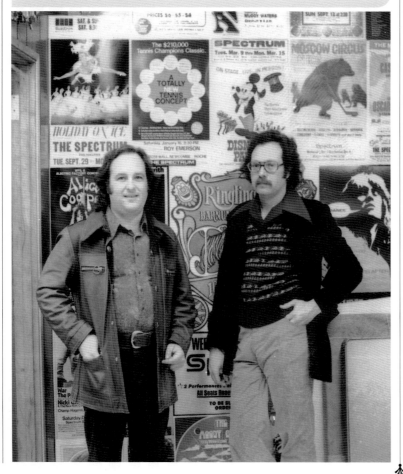

Allen Spivak and Larry Magid in the foyer of Electric Factory's offices at 1231 Vine Street, circa mid-seventies.

Meanwhile, we went about our business, booking and promoting our own festival, which would take place August 1, 2, and 3, two weeks before the Woodstock event. We had 29 acts, including Janis Joplin, Jefferson Airplane, the Byrds, Joe Cocker, Zappa, and Creedence Clearwater Revival. It was stacked. The Santana Blues Band would make their debut (I had booked them as a favor for my friend Bill Graham, who managed them). A couple of months before the festival, I had picked up Joni Mitchell and her manager, Elliot Roberts, at the airport. She was in town for a concert at the Academy of Music. Also at the airport was Graham Nash, who went on and on about his new group featuring David Crosby from the Byrds and Stephen Stills from Buffalo Springfield. The new band, aptly known as Crosby, Stills and Nash, was surrounded by a buzz even before they released their first album. Nash convinced me, and I called David Geffen, a friend and their agent at the time. The Atlantic City Pop Festival would be their debut. However, they pulled out a few weeks before the show because they weren't ready yet, so it wasn't a big deal.

We started to sell tickets immediately—a lot of them. About two or three weeks after our tickets went on sale, the Woodstock organizers changed their festival to a three-day rock show. Ticket sales for Woodstock had been slow, but the decision altered history. Over the years, people connected to Woodstock have said our festival pushed them into that change. I think it did too!

We started at four in the afternoon on Friday with the futuristic sound of Lothar and the Hand People. "Lothar" was a Theremin, an electronic device that made strange melodic sounds as you waved your hands across it. We closed at 10 p.m. on Sunday with the guy who started rock 'n' roll, Little Richard. He played in a steady rain, following the best Janis Joplin performance I had ever seen, and he froze everyone in the place.

Festival-goers got their money's worth. Tickets were $6 a day, or $15 for three days. The racetrack held 40,000 people, and we sold out each day. Outside the track was a makeshift camping area. We called it Ripple Hill. On the last day of the festival, about a hundred of the Ripple Boys broke through a secured fence and ran a couple of hundred yards toward the backstage compound. It was a pretty warm day, so a good many of them jumped into the lake on the track's infield. The crowd cheered. Everyone backstage had a huge laugh, including me.

I had to emcee the event, along with Glenn McKay, who provided the light show for the Airplane. We stepped in because our guest host, Biff Rose, a singer-songwriter, had partaken of too many substances and was horizontal for much of the weekend. Glenn had a booming baritone voice and looked every inch the San Francisco hippie artist that he was. Being the stage manager

Record companies looking for the hot acts and bands paid close attention to what radio stations played for two reasons: the audience in Philadelphia was very discerning, and the disc jockeys, whether practicing the new free-form style of FM or the hit format of AM radio, chose and played a lot of music before the rest of the country picked up on it. Ask Bowie, Springsteen, Elton, Billy Joel, Yes, Genesis, and a host of other acts. If you could make it in Philly, the reasoning was, you could make it anywhere.

and booker of the show, I was onstage throughout the entire three days anyway. I make note of my role because my future wife was in the audience. We lived in the same apartment building, and I had been trying to capture her attention. I'm not sure that my stage announcing attracted her, but I thank God for all the small miracles that brought us together.

The finale was tricky. We had to finish by ten on Sunday because of a local curfew, and we built to that moment. Janis Joplin—performing now as a solo artist, no longer as part of Big Brother and the Holding Company—was one of the big final acts.

Everybody wanted to see Joplin. Another hot act booked for that last day was blues guitarist Johnny Winter, but there was a problem. Winter wanted to go on after dark, because he's an albino and the sun bothers him. But time was winding down. He was slated to go on at 3 p.m. but didn't show until much later. With that 10 p.m. curfew looming, there were three acts left to play, but time for only two.

Allen Spivak had to send somebody to get Joplin a bottle of Southern Comfort—she wouldn't perform without it. The crowd was clamoring for her. She made it on, and it started to rain—just a light rain at first. Her new band was led by a kick-ass sax player, Snooky

Young. It was a terrific end. Janis had the crowd of 40,000 dancing and screaming.

Time for one more performer. Would it be Johnny Winter or my boyhood hero, Little Richard, who was making a comeback? When Little Richard had retired from rock 'n' roll in 1956 to become a minister, I was devastated. And there was no way Johnny Winter could follow *Joplin*. I gave Little Richard the nod.

The rain had picked up, and people were starting to leave. Little Richard, in a classic mirrored vest, jumped onstage as the piano was being tuned, itching to go: "All right, give me an A!" But it was taking too long, and the rain started coming down even harder. Little Richard leaped up on the piano and said, "That's close enough!" Then he hit it: "*A-wop-bop-a-loo-bop-a-wop-bam-boom*"—just like when I first heard it in the fifties. The people on their way out stopped dead in their tracks. Little Richard held them there, a perfect finale in the rain. What an amazing way to close a show!

ELECTRIC FACTORY
SEPT 25
SAVOY BROWN · CHICKEN SHACK
- $3.50 -
SEPT 26
SAVOY BROWN ☆ PINK FLOYD
- $3.50 IN ADVANCE ∘ $4.00 AT DOOR -
OCT 2+3
MUNGO JERRY ☆ HUMBLE PIE
- $3.50 -
OCT 16+17
DEREK & THE DOMINOS with ERIC CLAPTON
$4 IN ADVANCE ∘ $4.50 AT DOOR
— SPECTRUM —
SEPT 27
MOODY BLUES
VAN MORRISON ☆ DION
- $4.. $5.. $6.∘ -
OCT 23-24
QUAKER CITY ROCK FESTIVAL
GRAND FUNK RAILROAD
SMALL FACES with ROD STEWART
ERIC BURDON AND WAR
- OTHERS TO BE ANNOUNCED -

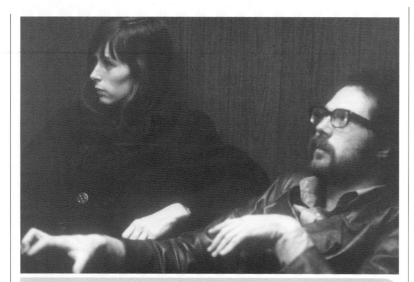

Barbara Moran, who came to be known as Mickey, and Larry Magid at the Electric Factory shortly before they were married, circa 1969.

It was just one of those wonderful moments. I had chosen right. Johnny Winter was a newer, hotter act, but Little Richard deserved the turn.

For the first time ever, I made a little money. Two weeks later, Woodstock was the big news. Wanting to see what it was all about, I hopped into my '67 Mercury Cougar with a couple of friends and headed north. The night before, my friends and I had drunk a considerable number of tequila shooters, the late sixties' drink of choice. The New York Thruway was closing just as we neared the festival. The crowds seemed to be coming from everywhere. The promoters had violated rule number one for putting on a festival: they didn't get the turnstiles and fencing up on time. We headed over to our motel.

Friday night started out at the bar, where I bumped into Janis Joplin, along with Arma Andon, Jock McLean, and two young Apple record company execs. As they say, the eagle flies on Friday, and we emptied a lot of glasses that night. Saturday afternoon I went backstage, grabbed a sandwich, and then walked up to a table with coffee and tea urns. I asked a guy there—who turned out to be Wavy Gravy, a disciple of the Dead and one of Ken Kesey's Merry Pranksters—what was in one container. "Oh, this is electric," Wavy Gravy said.

Not knowing what he meant, I drank some. It was electric, all right—LSD. I felt as if I was in a cartoon. Walking along and talking to someone, I came to an old car—and instead of walking around the car, I walked *up* it. Then I stood on the roof, still carrying on our conversation, and then I walked down the hood and kept walking and talking. Sometime after that I bumped headfirst into the Airplane's brand of magical potions. By nightfall I was totally gone. When I awoke on Sunday morning, I knew I had to escape back to Philadelphia.

On Monday I walked into the Factory office and told the Spivak brothers that I was leaving and going out on my own.

By this time I had established a good reputation as a promoter and had quite a few industry friends supporting me. Shelley Kaplan left as well. We did several shows with The Band, Joplin, and Jefferson Airplane. Then Shelley drifted into other things. Three months later, I underwent another dosing on my 27th birthday. A few things happened to me. First, I realized that although all the shows I promoted were successful and industry giants like Albert Grossman, Bert Block, Frank Barsalona, Herb Spar, and Bill Thompson were very kind to me, I felt strange. A chance meeting with Herby Spivak on the street revealed to me that I missed the daily interaction with the Spivaks and the team I had helped to build. Allen called me a couple of days later, and I agreed to come back, this time as a partner. Then the girl in my apartment building, Barbara Moran, finally decided to go out on a date with me. We've been together ever since. If you're counting, it's been 41 years with only one change: she now responds to the nickname "Mickey," a term of endearment everyone at the Factory started calling her. By the end of our first year together, I began to make a little money. After nine years of struggling, I found not only the financial success I had sought, but also the stability and happiness that had eluded me since my father passed away twelve years earlier.

The concerts came quicker. The music was bursting out. Careers were built step by step by several strong and caring managers and agents. Promoters were popping up and branching out. Philadelphia was once again a music center.

The year after the A.C. Pop Festival success, late in the fall of 1970, Electric Factory closed. There were many reasons. We had successfully fought City Hall for the right to exist, but the club we built wasn't the same club in the end. Police Commissioner Frank Rizzo had promised to turn it back into a tire warehouse, and it had started to look like one again. The roof leaked, the paint was chipped, and the landlord, seeing some long lines, had decided to double the rent. The place couldn't be cooled in the summer. And the music scene had gotten so much larger. With top bands beginning to charge as much as $20,000, the laws of economics were starting to catch up with the 2,500-seat club—which had never made any money in the first place.

Van Morrison played on the final weekend and came out for an encore with the bizarre but low-key announcement that this

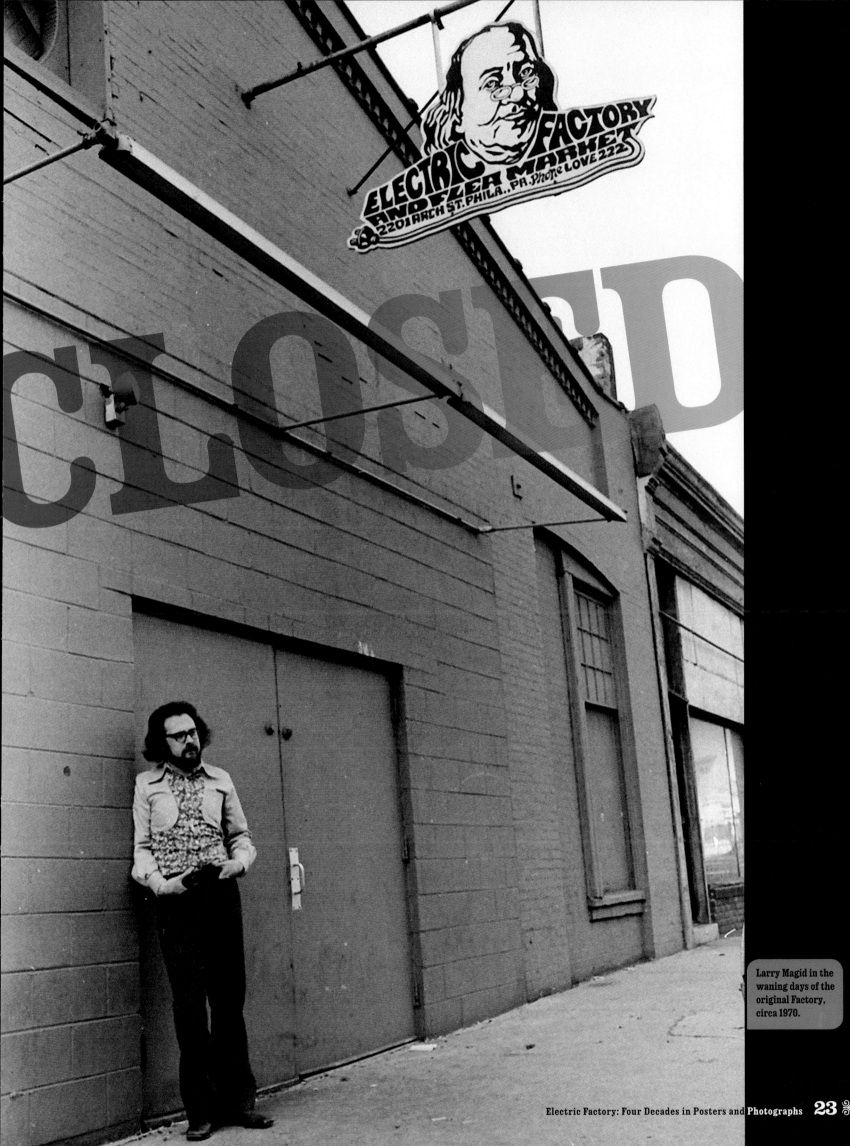

ELECTRIC FACTORY
AND FLEA MARKET
2201 ARCH ST. PHILA., PA. Phone LOVE 222

CLOSED

The Bijou opened in October 1972, lasted ten years, and helped launch the careers of Bette Midler, Billy Joel, Linda Ronstadt, Weather Report, David Letterman, Tom Waits, Steely Dan, Peter Allen, Bonnie Raitt, George Thorogood, Grover Washington Jr., Richard Belzer, Jay Leno, Al Jarreau, Hall and Oates, and many others. Billy Crystal and Jerry Seinfeld started there as opening acts. U2, Richard Pryor, and Warren Zevon appeared. Leno and Letterman did stand-up comedy there the same year. Herbie Mann, Mary Travers, and the Manhattan Transfer were Bijou mainstays.

WANTED

$1.75
BILLY THE KID
served in 12oz.
frosted tumblers

The Bijou had a drink special for every act. We'd make a new table tent, but it was always the same drink. Billy Joel played the Bijou September 25–28, 1974, before he released his first album.

would be the last night for Electric Factory. The club had won the right to stay open, and it was closing down. There was a stirring in the audience, but no uproar. That was in November 1970. We vowed to find another location quickly.

Herby had closed the Showboat too, turning it into a singles bar called Chances Are. It did very well for a while, but faded after a couple of years. The Showboat was a mythical place for me and many, many others. I had an idea that intrigued Allen and Herby— to turn it into a small, hip night-club for music lovers of all kinds. We could play rock, pop, jazz, comedy—anything!—improv-

ing its chances for success and endurance. We would run shows Wednesday through Saturday, allowing us to work with the press and radio disc jockeys to build the acts. It would be an intimate club along the lines of the hungry i in San Francisco and clubs like it, places that had nurtured young talent in the sixties and turned Lenny Bruce, Mort Sahl, and the Kingston Trio, among others, into cultural icons. At the Bijou I would shape the booking along those lines.

My argument was that the audience we started with in 1968 had grown up and was looking for other entertainment challenges and venues. We needed a new showcase to build future concert acts, as we had done with the Factory. It's not hard to develop a hot act. It's another thing to develop an unknown act—when somebody puts their career in your hands. And so the Bijou Cafe was born. A lot of promoters didn't see the logic of running a small club, but everyone in the business watched what we did. This was not

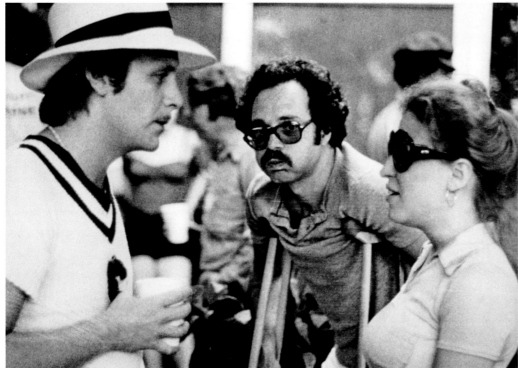

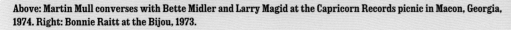
Above: Martin Mull converses with Bette Midler and Larry Magid at the Capricorn Records picnic in Macon, Georgia, 1974. Right: Bonnie Raitt at the Bijou, 1973.

a casual decision for us, but we took risks at every level.

Back when he designed the Showboat, Herb had come up with the idea of putting a stage behind the bar, and cutting through the upper floor to create a balcony. On the first floor we put rows of chairs and tables with checkered tablecloths. (At the Bijou we would name drinks after the performers and print drink cards for the tables.) Upstairs we built tiered banquettes. The intimacy we created was great for both artists and audience. Much of the audience was looking down on the performers—almost like looking at surgery. As at the Factory, performers walked through the audience when they made their way from the dressing room to the stage.

In 1972 Herby and Jerry left the business for a family-owned restaurant venture, H. A. Winston, which eventually became a chain of deluxe burger spots—the first in the country. It was Allen and me from that point on. We worked well together and complemented each other. This business was moving much too quickly for one person to handle it all, but together we built a strong foundation for the acts and our business.

At the Bijou, we gave audiences an opening act. Comedians were desirable because they could open the show without any equipment to set up and they put the audience in a good mood for the rest of the evening. I'd say 95 percent of the comedians we booked were funny, and many became headliners.

Billy Joel played at the Bijou before he'd ever cut an album. Joel had performed "Captain Jack," his coming-of-age song, live

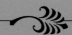

on WMMR, creating enough of a local sensation that I thought he was ready for takeoff. Before his performances Steve Martin went out onto Broad Street with an arrow through his head to work the waiting crowd and direct traffic.

Bonnie Raitt was a friend before I knew she was a singer. She had come to Philadelphia to work for Dick Waterman, a famous blues artist manager. One night I walked into the Second Fret, a folk club, and discovered that she was the opening act.

I started looking for musicians and comics who were going to appear on *The Tonight Show*. At one point, Johnny Carson cited the Bijou so many times when he was listing his guests' upcoming performance schedules that he noticed the trend: "Boy, that's becoming a common name for a club," he said.

Live at the Bijou

Grover Washington Jr. loved the club and wanted to record a live album there. His *Live at the Bijou*, recorded in May 1977, was a giant hit. Widely imitated, paving the way for many "smooth jazz" musicians, Grover could really play—and he could play anything.

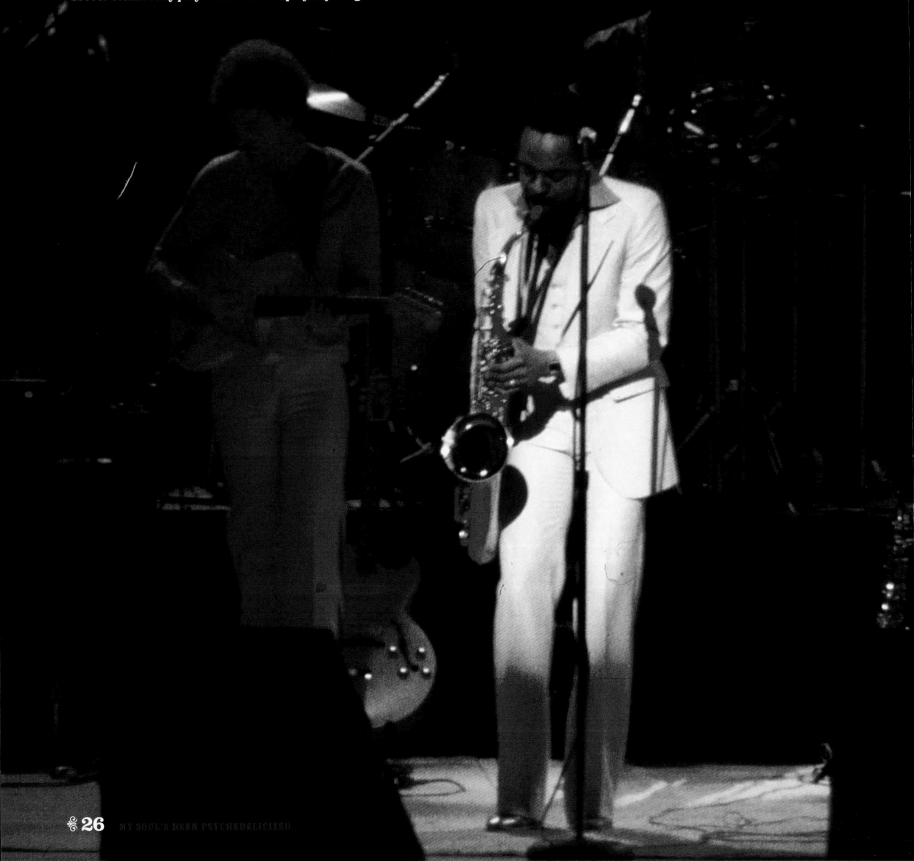

One of the ideas behind opening the Bijou was to help build acts and get them into the more lucrative concert halls. Building those acts involved a series of relationships. Booking a new act for four consecutive nights gave me the chance to sit down with performers, get to know them, and help lay the groundwork of a career. It was all about reading the possibility for a new act—and creating possibility too, through advertising and stirring up talk on radio stations. Part of my job was to create a buzz. With local DJs, press, and record executives popping into the club, a strong band could take off a lot faster. The ability of the record companies to get the local radio stations and disc jockeys to play them was key—disc jockeys could pick out their own songs in those days. The quickest way to get noticed was to get your record played. We incorporated music critics and DJs from WMMR and other stations into the scene. Whenever they mentioned, on the air or in print, where they had been the night before, they would automatically be talking up the Bijou. It was the hip place to be.

In addition, we started looking for musicians and comics who were going to appear on *The Tonight Show*. At one point, Johnny Carson cited the Bijou so many times when he was listing his guests' upcoming performance schedules that he noticed the trend: "Boy, that's becoming a common name for a club," he said.

What we learned at the Bijou helped us at theaters and arenas. When an act was booked for five days, ticket sales for the first and second shows would be about the music, but the third, fourth, and fifth shows were about the event itself—people inspired by word of mouth or advertising to take a look and be part of something. We tried to convey to the public that there was something interesting going on, and the resulting atmosphere made Philadelphia an important market for a lot of acts.

Only one act that I wanted eluded me. Bruce Springsteen had played for us at the Spectrum, opening for Chicago. The record company had put him on the show, but it wasn't a good fit. Chicago had become a pop band, while Springsteen was new and edgier. After his performance, I told him that it just wasn't the right show. You could see something special there: with the proper showcasing and career building, he could become an important act. His manager called and said that they wanted to play the Bijou. But we couldn't seem to find the right week. Finally, they pressed for a specific Wednesday to Friday, since Springsteen already had a show booked on Saturday that paid a decent amount. We needed the Saturday: that was the day we made money. We started on a Wednesday with media presence, and if we had a strong performance, by the weekend we would sell out. For us, I reasoned, giving up a Saturday night would set a bad precedent and send the wrong signal to other acts. We passed. He played the

Main Point, a coffeehouse in Bryn Mawr, and it turned out to be a historic engagement.

Springsteen's first arena show as a headliner was at the Spectrum, and he did his first multi-night arena shows there. He had become very big in our area; as a headliner at the Spectrum, he had sold out several multi-date performances, involving fewer than 20,000 seats for each show. However, he wasn't selling out in large venues elsewhere. The next leap would be a local stadium with four times as many seats, a step that would broaden his popularity and develop his career. However, he seemed reluctant to make the transition, even though I thought that the success of his Spectrum shows proved he was ready to do that in Philadelphia. Sometime in the late seventies, I invited Springsteen to a concert at JFK so he could get a feel for stadium concerts. When I took him to JFK, he sat on the metal ledge of the upper press box, with his feet dangling over the edge, taking in the huge expanse of people, trying to wrap his mind around playing for an audience of 90,000. The mental aspect of big concerts is huge. Performers have to visualize it.

In the late seventies, I invited Springsteen to a concert at JFK so he could get a feel for stadium concerts. He seemed reluctant to make the leap to stadiums, though I thought he was ready to do that in Philadelphia, given the success of his Spectrum shows. Springsteen sat on the metal ledge of the upper press box, with his feet dangling over the edge, taking in the huge expanse of people, trying to wrap his mind around playing before an audience of 90,000. The mental aspect of big concerts is huge. Performers have to visualize doing it.

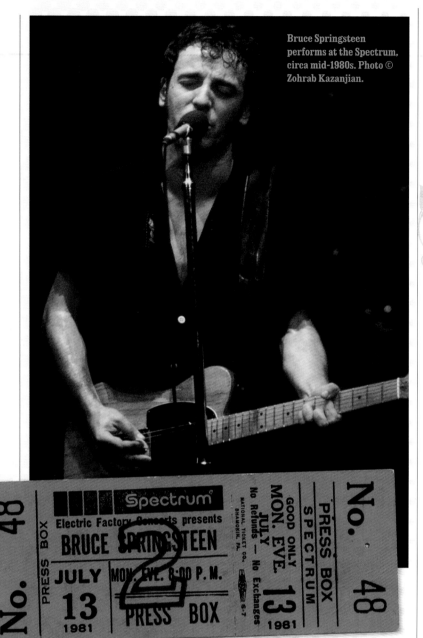

Bruce Springsteen performs at the Spectrum, circa mid-1980s. Photo © Zohrab Kazanjian.

ence. We knew what they liked and how to reach them. Our ability to pick talent and grow it was equally well developed. U2 started at the Bijou in 1981 with an audience of 100 people. Dire Straits' American debut was there. Boston, Richard Pryor, Freddie Prinze, Ry Cooder, and Return to Forever played the Bijou, as did Andy Kaufman. All were considered cutting-edge at that time. Barry Manilow, who was not cutting-edge, played his first show there.

Kaufman opened for Manilow. Part of Kaufman's act was reading *War and Peace* to the audience: sitting on stage, taking his time, reading Tolstoy out loud. The audience became a little restless. Who knew which acts, which pairings, would work? Sometimes you'd play an act because somebody would ask: "Can you give my act a chance?" And you'd try it. It was experimental.

Some of the acts at the Bijou carried a social or political charge. Before he performed there, Dick Gregory told me that a certain Philadelphia group had warned him that they were coming to see him. That night John Africa arrived at the club with some other MOVE members. MOVE was a back-to-nature cult that would have a deadly standoff with police in 1978. Later, following a second confrontation in 1985, the police, under Mayor Wilson Goode, would drop a bomb from a helicopter onto a MOVE stronghold, killing eleven people and burning an entire block of row houses on Osage Avenue in West Philadelphia.

Before Gregory went on, I talked to John Africa outside the club and gave him the ground rules. He was a gentleman. I told him that the MOVE members were welcome. If Gregory was willing to talk to them after the show, fine, but they couldn't heckle his act. If they did, they would have to leave. Africa and his companions listened politely and then took their seats in the balcony.

The Pointer Sisters opened. Then Dick Gregory started his act. Within the first few minutes, MOVE members began talking to him—not heckling per se, but trying to engage him politically. It got a little confrontational. After the third interruption, I made my way to the balcony and asked them to leave, which they did, calmly.

We had booked Richard Pryor for a week at the Bijou. His first show coincided with Richard Nixon's resignation, August 8, 1974. I was worried that everybody would stay home to watch Nixon's speech on TV, and then I had a brainstorm. Why not put a TV on stage, let the speech play live, and have Pryor riff on it as it happened? Pryor, who had a Tricky Dick routine in his act, loved the idea. We promoted this historic Pryor-Nixon collaboration through the local DJs, and Richard Pryor gave our 37th president an inimitable sendoff.

Springsteen had grown up as a rocker playing bars on the Jersey shore, and Philadelphia became his seat of power. This was where he should risk the next step, but if he wasn't strong enough to pull it off, he would lose that seat of power. It took Springsteen a year or so, from that day sitting in the press box, to start playing stadiums. His appearance at JFK was his first headline stadium concert.

One of the challenges is to figure out who can make that leap. A lot of good promoters are risk-averse, but my thinking wasn't so much about risk as projecting the possibilities. That's what Allen Spivak and I were about—risk and possibilities.

The Bijou proved to be a happening place for acts, the audience, and us. It became just as important to us as the Electric Factory. When we started doing concerts, we used our own names as presenters, but that was becoming uncomfortable. In the end, we just expanded our old name and used "Electric Factory Concerts."

We knew how to sell tickets. We were in tune with the audi-

Electric Factory Concerts

Spectrum
(215) FU 9-5001 PHILADELPHIA 19148

SHUBERT THEATRE

SUNDAY, DEC. 9

THE
EARL SCRUGGS
REVIEW

Special Guest
LINDA
RONSTADT
1 SHOW ONLY—7PM
$5,6

SATURDAY, DEC.15

ELECTRIC
LIGHT
ORCHESTRA
8&11 PM $5, $6

SOLD OUT

Tues. Dec. 4
THE WHO

Tues. Dec. 11
Dance Concert
EMERSON,
LAKE,
&
PALMER
SPOOKY TOOTH
STRAY DOGS
$5.50 in advance
$6 at the door

Fri. Dec. 14
Dance Concert
THE
BEACHBOYS
Special guest
JO JO GUNNE
$6.00 in advance
$6.50 at the door

Thurs. Dec. 27 - Fri. Dec. 28
3rd Annual
ALLMAN
BROTHERS
BAND
XMAS
"Eat a Peach"
BOOGIE
$5.50 in advance
$6 at the door

BIJOU CAFE

Dec. 5-10
MOSE ALLISON

Dec. 12-15
BRUCE
SPRINGSTEEN
HENRY GROSS

Dec. 19-22
CHIC COREA
with
RETURN FOREVER

Jan. 3-5
TEX RITTER

Jan. 9-12
GARY BURTON

Jan. 16-19
BOBBY
"BLUE"
BLAND

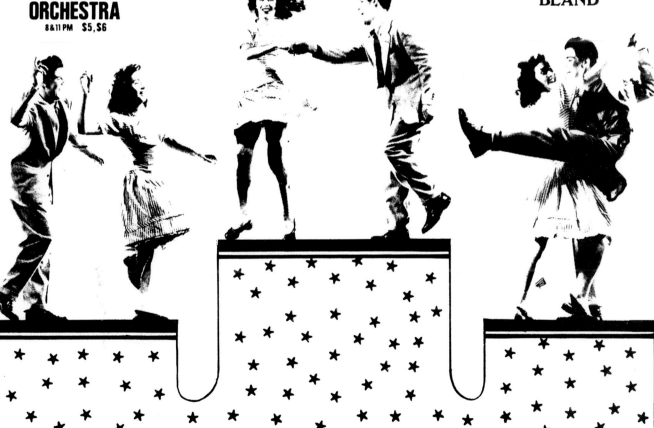

The ad for the Springsteen show at the Bijou that didn't go on in 1973.

We mixed it up pretty good, even booking Tex Ritter, the original singing cowboy, Soupy Sales, the Dixie Hummingbirds, and Barry White.

The first time we brought Bob Marley to play in Philadelphia, we booked him for two nights—a Monday and a Tuesday—because we thought Marley could sell those nights, especially at $3.00 a ticket. Before his first performance, I got a call from the manager of the Bijou. Marley's band were in their dressing rooms above the club—in what used to be the three-dollar-a-night rooms of the Douglass Hotel—and they were cooking. They'd brought their own pots and pans and goat meat.

I rushed over to the club from my office. The smell of broiling meat was overwhelming. Then, as I walked up the steps, the scent of marijuana rolled down to meet me.

Marley's manager explained that the utensils, cooking, and smoking were all part of their spiritual rituals. I listened. Police Commissioner Frank Rizzo was now Mayor Frank Rizzo, and I had to make a choice between art and caution. "*Fine,*" I told the manager, "but please tone it down. And try not to walk through the club toking on a big spliff."

It was the right choice: Marley and his band played spectacularly for two nights. Whatever anyone has heard about them isn't enough to describe how good they were. They later headlined at the Spectrum.

For a decade, that was the Bijou: a training ground, a comfortable place for performers to grow, and a venue for Philadelphians to hear and see just about anything. Many of the acts we played at the club became concert headliners faster in Philadelphia than in any other city. The average attendance at concerts, especially arena shows, was higher than in any other city, and there were more major concerts in Philadelphia than anywhere. Again, this was especially true at the Spectrum.

What a great place the Spectrum was for a big concert! The band's proximity to the audience and the steepness of the seating area let the applause roll down onto the stage. Acts thrived on the great—often deafening—reactions Philadelphia audiences showered on them. The venue was intimate for a large arena.

The Doors were the one big touring act that never played at

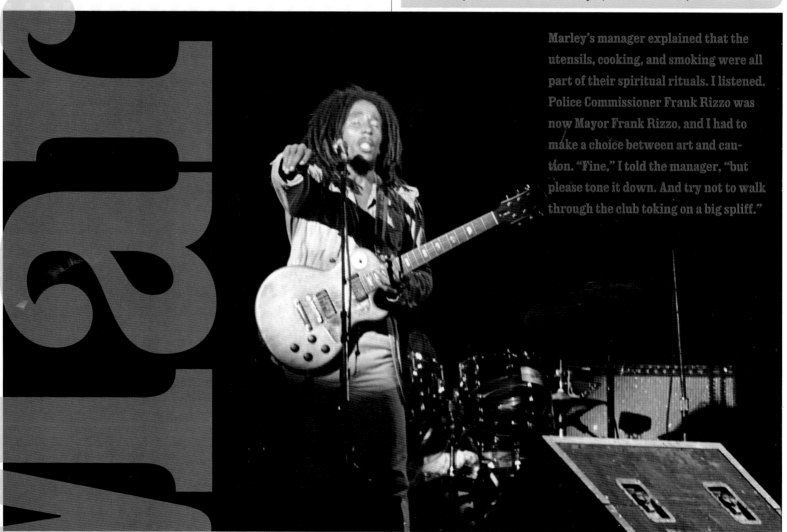

Bob Marley and the Wailers at the Bijou, November 10–11, 1975.

Marley's manager explained that the utensils, cooking, and smoking were all part of their spiritual rituals. I listened. Police Commissioner Frank Rizzo was now Mayor Frank Rizzo, and I had to make a choice between art and caution. "Fine," I told the manager, "but please tone it down. And try not to walk through the club toking on a big spliff."

the Electric Factory. Back when I was working in New York, my boss took me to Ondine's on East 59th Street one Monday night to see a new rock band. Maybe there were ten people in the place, half of them agents wearing coats and ties. A trio performed. The singer looked down at the floor for the entire set and seemed nervous. But there was something about the songs and the singer, a good-looking guy with an edge—you could feel it even without eye contact. His name was Jim Morrison.

I urged my boss to sign the Doors, but we lost out to another agency. Now Electric Factory Concerts wanted to bring them to the Spectrum, but Rizzo (still police commissioner at that point) didn't want them in Philadelphia. "You're not bringing the Doors in," he kept telling us.

We went ahead and booked them at the Spectrum for May 1, 1970. The timing could not have been trickier: Morrison had recently been arrested for exposing himself onstage in Miami.

Dance concerts—where audience members are allowed to congregate on the floor—were an Electric Factory innovation and specialty. Not that dancing was required, per se—it was simply an open floor. The audience could stand or sit. The Doors event was a dance concert. A few minutes before the group was going to hit the stage in front of a sold-out crowd of 20,000, a fire marshal appeared and announced that we couldn't do the show because all those people pushed up against the stage constituted a fire hazard. Roped-off aisles had to be created. There was no time for that; trying to make aisles now would create chaos. The fire marshal and I went back and forth. Meanwhile, the Spectrum was filled.

I was asked to go up onstage to make an announcement just as the concert was supposed to begin. The crowd moved toward me—a natural, unconscious movement of people wanting to be close to an act and to touch the performers.

I asked the crowd several times to back away from the stage, but no one was listening. All they cared about was that Jim Morrison and the Doors were moments away. It was like yelling at deaf people. The fire marshal hovered. I threatened the crowd with a canceled show. Twenty thousand fans stayed put, as close to the stage as they could get, ready for action. The fire marshal wouldn't back down. I was as nervous as I have ever been.

Then the fire marshal relented. And the show came off just fine. Although Morrison had been drunk when David Kasanow picked him up at the airport that afternoon, he performed without exposing himself. A little over a year later, Morrison would be dead of a drug overdose.

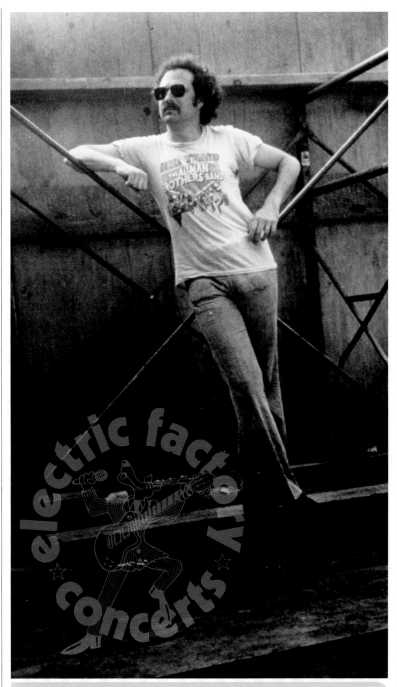

Larry Magid at JFK Stadium for "The Round Up," June 20, 1981.

During the summer of 1975, we were approached about buying the Tower, a former vaudeville house and movie theater. The owners of another, smaller concert company had rented the theater several times and had the option to continue to rent or buy it. They declined. I never knew their reason, but when we had been offered the Tower a few years back, I passed on it too. As a young kid, I had attended many movies and several rock 'n' roll shows there, but I just didn't think people would support the location. Boy, was I wrong—and not for the first time either. Earlier I had predicted that Led Zeppelin wouldn't outlive their hype.

Then I bumped into Bob Ellis, the owner of the Tower, in the airport in Baton Rouge. We talked for 30 minutes. The next week Electric Factory Concerts agreed to buy the theater. We opened with Labelle for two shows, then put on five with Bruce Springsteen and the E Street Band, including one of the best New Year's Eves I ever spent.

The Tower has seen many terrific shows. The Rolling Stones show in 2002 stands out—that was a tour in which the band chose to perform in some smaller venues like the Tower. They trusted the Philadelphia audience because of the city's feel for music as much as anything else: the band always had an affinity for rhythm and blues, which is a powerful element in our musical flavor. Philadelphia was a strong market for the Rolling Stones, and we always worked hard for them.

Electric Factory Concerts produced shows in venues around the country: Shreveport, Monroe, and New Orleans, Louisiana; Jackson, Mississippi; Little Rock, Arkansas; Jacksonville and Tampa, Florida; Norfolk, Virginia; New Haven, Connecticut; Johnstown, Lancaster, and Scranton, Pennsylvania. Not to mention Washington, D.C., Richmond, Miami, Raleigh, Baton Rouge, Memphis, Nashville, Boston, Providence, and Hartford, as well as Baltimore, College Park, and Salisbury, Maryland, and State College, Wilkes Barre, Harrisburg, Hershey, York, Allentown, Pittsburgh, and Erie, Pennsylvania. And there were plenty more in a series of endless one-nighters. That doesn't include the music and comedy tours and touring plays that we staged in North America and around the world. Doing these one-nighters was tough on Allen and me, but it strengthened our position in a difficult business.

One day I got a call from Lawrence Katz, a very successful businessman who wanted to set up a meeting at his office. There he asked if Allen and I would be interested in doing shows at the Erlanger Theatre, located at 21st and Market streets. The theater, which he owned, had been closed for several years, but it had once been an important venue for pre-Broadway tryouts. One was *Funny Girl*, starring Barbra Streisand.

It turned out that his son, Harry Jay Katz, a local playboy, had been bugging him about reopening the Erlanger, but Mr. Katz would only open it if we would do the shows there. We were wary of Harry's interference, but we agreed. It was a beautiful venue once it was restored to its earlier grandeur. Among the more memorable shows at the Erlanger were those by Supertramp and Labelle. At one, Labelle wore outrageous (for the time) silver outfits befitting space travelers. They came down Market Street in a horse-drawn open carriage wearing their stage outfits. We urged the audience to "Wear Something Silver." The house was filled with more silver than a lot of banks.

Our first foray into Broadway shows took place at the Erlanger in the spring of 1975, when we produced the pre-Broadway run of Bette Midler's *Clams on the Half Shell Revue*. What special performances in a special venue! We had a lot of fun at that 2,000-seat theater, but somehow Harry screwed it up, and his father decided to close the place. He gave us the opportunity to buy it, but we didn't have the million dollars necessary, so they sold it and it became a parking lot and eventually an office building. Being unable to buy that theater is one of my few regrets.

We did buy the TLA on South Street. The Theater of Living Arts had been a movie house and then a repertory theater and then a movie theater again. It fit our needs.

The repertory company was initially run by Andre Gregory and later by Tom Bissinger. They did off-Broadway and experimental shows and featured performers like Morgan Freeman, Judd Hirsch, and Danny DeVito.

Bette Midler in her *Clams on the Half Shell Revue* pre-Broadway tryout, Erlanger Theatre, March 31–April 5, 1975.

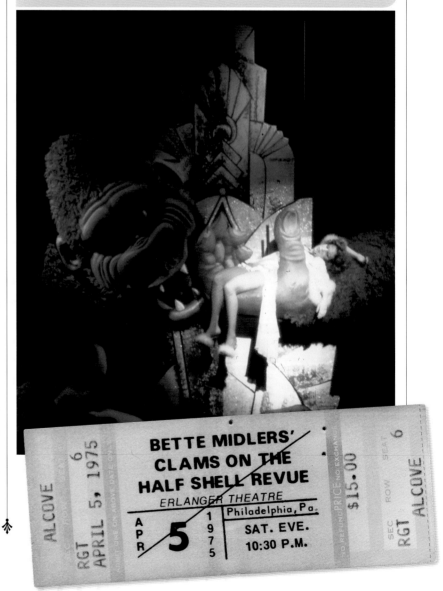

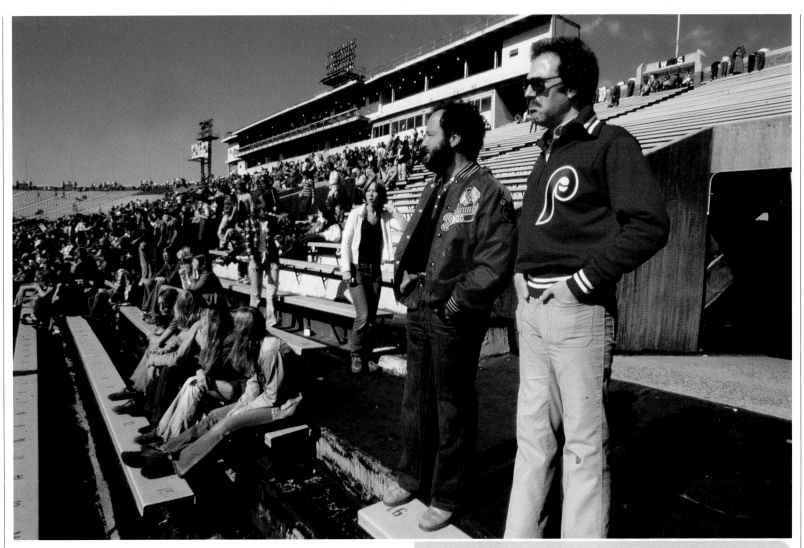

Allen Spivak and Larry Magid at the first EFC show at JFK, featuring Yes and Peter Frampton, June 12, 1976.

TLA's size allowed a lot of different types of shows to be held there. (It seated 500, but we took the seats out.) Bob Dylan chose to play there as he revitalized his career. The Rolling Stones rehearsed there. The Cowboy Junkies and Jackie Mason, the BoDeans and Ani DiFranco, Phish and Harry Connick Jr., Phyllis Hyman, Lyle Lovett, and the Disco Biscuits—they all played there. For my money, reviving TLA made South Street. We salvaged the street's artistic tradition and helped bring it back to life.

From the be-ins and the Atlantic City Pop Festival, we learned a lot about putting on stadium shows. In 1976 Allen was finally able to persuade the city to allow us to rent JFK Stadium—the largest stadium in the country—to put on a big show on Saturday, June 12. The co-headliners were Yes and Peter Frampton, with Gary Wright and the Pousette-Dart Band as support. We were allowed to sell 100,000 tickets. The acts were peaking, and we picked a time when a lot of students were getting out of school. We sold out, and another 5,000 to 10,000 people worked their way into the show. After that we were limited to 90,000 tickets.

Big stadium shows brought their own logistical problems. Road crews were overworked back then. How you handled their demands had a lot to do with surviving. EFC was the first concert-promotion company to supply backstage catering for roadies at all our concerts: we wanted to keep them in the building. Sometimes stagehands took off to eat dinner before a show and returned drunk or high, which could result in shaky lighting work or other problems during a concert. Before a Grateful Dead concert at JFK Stadium in the seventies, a roadie setting up the show demanded to be supplied with cocaine. Allen refused. The roadie and his crew stopped working, a standoff that lasted four or five hours. Finally Allen decided to give them a $5,000 down payment on their night's work, and that did the trick. One thing we never did was supply drugs or women to anyone.

The strangest band demand involved M&M's. Van Halen wanted M&M's in their dressing room, but they stipulated—in a clause buried deep in their contract—that they didn't want any *brown* M&M's. I figured it out immediately. David Lee Roth didn't have some illusion that brown M&M's tasted different from green ones. The reason was simpler and not so neurotic. In the past

ern rock bands: the Allman Brothers Band, the Marshall Tucker Band, the Outlaws, Molly Hatchet, and .38 Special. At the time the Allmans, Tucker, and Hatchet had cooled off a lot. The Outlaws and 38 Special would prop up the show, but it was the sum of the parts that would pull it through. The acts were booked. I was able to buy all the bands on a flat guarantee that was higher than usual, but they wouldn't receive any percentages. If the show did well, we could score.

Most people in the business (even the agents and managers of the acts) thought it was a weak show, especially for a stadium. And then Mayor Bill Green expressed doubts about our using JFK Stadium any longer. He held up the show. At 7 p.m. the night before tickets were scheduled to go on sale, the mayor relented and called me with the good news.

The tickets went on sale the next morning with no advance advertising, and 7,500 tickets were purchased. Amazing! Stunning! And then the show sold out—all 90,000 tickets. It was the rarest of outcomes: we made more than the combined artists' fees. When the show ended, we did what any happy promoters would do—we celebrated. Our wives drove us home. Our company was saved. New shows and concerts followed at a rapid pace.

It was a whirlwind experience. I would be in the office at 10 a.m. . . . home for dinner . . . then on to the Bijou until midnight on weekdays, 2 a.m. on the weekends. Maybe the act wanted to go out for a bite after the show. My only real outlet was going to Phillies or 76ers games. It was a crazy, fast-paced time, hard to explain to anyone who hasn't lived it. Looking back, which I can only afford to do now, I realize how much fun it was and how many good friendships were born during that period, but also how all-consuming it was.

Late in 1981 we closed the Bijou Cafe. We hadn't made a lot of money there—if any—but as with Electric Factory we were a catalyst for artists' success, creating momentum and building careers. For the week that an act played the Bijou, our focus was on that act. And the public trusted us to bring in good performers. For many years, the club was a way of getting careers from point A to point B to point C—and sometimes, for some acts, we skipped point B.

What killed the Bijou was its own success. Most clubs have a certain shelf life. And most, like the Bijou, simply aren't big enough to be sustainable. Artists' prices go up, and they can't afford to play multiple nights in a club. The more concert acts we helped build, and the faster they grew, the harder it was to replace

many riders had been ignored, and this one was a test to see if Van Halen's contract was *actually being read*. We had our staff pull out the brown M&M's.

There were a number of highly successful events at JFK, including Live Aid in 1985. We packaged the shows like festivals. Because of our success in doing outdoor shows, we started four Rolling Stones stadium tours—two in Philadelphia, one in Washington, D.C., and one in Memphis. It's important to start off a tour well. We were extremely well prepared for outdoor shows, and the band was comfortable with us. A strong launch in Philadelphia helped at a time when the band was just moving from arenas.

We hit a rough patch in 1981. The economy was not very good. Interest rates were at an all-time high, and a lot of acts weren't working for various reasons. We were having trouble making payroll. Allen and I went for an entire year without taking paychecks. We even considered selling the company, but somehow we held on. For five years, we had put on a big show in June. We needed one this year.

Out of desperation as much as anything else, we put together a stadium show we called "The Round Up." It featured five south-

them at the club level. And record companies were no longer supporting tours as before. Still, it was great fun! And I had often said that the longer an act played the club, the less well we were doing our job.

We thought about turning the Bijou into a comedy club, but there were already several of them in the area. Personally, I felt that we would be bullying those other clubs. The Bijou worked great for comics, but I was afraid of the public perception. So we passed on that idea. It was a mistake. Not long after that, the building was sold. A bigger mistake.

••••●••••

By this time our relationship with the city had come a long way since the mayor and police commissioner tried to turn the Electric Factory back into a tire warehouse.

Elton John played his first public show in America at the Factory (previously there was a benefit at the Troubadour in Los Angeles). That was September 1969, the first weekend after the summer break. He was the opening act for a Philadelphia group called American Dream.

Seven years later, I was meeting with the mayor's press secretary to prepare for Elton John Day, honoring Elton for his tribute to Billie Jean King and the Philly sound, "Philadelphia Freedom." My old adversary, Mayor Frank Rizzo, was to present him with a replica of the Liberty Bell at City Hall. I wasn't planning to attend, but then Elton's manager, John Reid, asked, "What time do we pick you up?"

The anteroom of the mayor's office was crowded, and I stood to the side, keeping my distance. But Rizzo was in a gracious mood and beckoned everyone into his office, and I was shuffled in with the group. Howard Rose, Elton John's agent, who has a dark sense of humor, remarked: "Well, Mayor Rizzo, you know our friend Larry Magid, I'm sure." Mayor Rizzo put out his enormous hand. I shook it. Then he grabbed me, pulled me closer, and said quietly, "I just want you to know, Larry, in my heart I thought I was right." A second later, he boomed to the whole gathering, "*Of course* I know Larry!"

We went on to do 40 or 50 free shows for the city, plus many of the July 4th celebrations. The biggest shows, of course, were Live Aid and Live 8.

Live Aid was a remarkable event. It was the biggest concert ever. It raised more money for a charity or cause than has ever been raised. It was a festival taking place on two continents, hooked up by television, run live throughout the world, with a

telethon attached. Clearly the people who came up with this idea were demented.

In fact, it was one man's idea. His mental disorder must have been contagious because a lot of people were infected quickly. It had to be done quickly, because otherwise someone might have woken up one morning and said, "You've got to be kidding." An event of this magnitude cannot be put on in five weeks. And yet we did it, and it was a pretty smooth operation. We had our share of hiccups, but the shortness of time became an ally rather than a hindrance.

Bob Geldof, a singer who had enjoyed moderate success with the Boomtown Rats, came up with this mad idea. The cause was Ethiopian famine relief. Geldof managed to convince Elton John, who convinced Paul McCartney, and he got Harvey Goldsmith, an English promoter, to produce the event in London. Several English acts were being approached, as well as the U.S. producer Bill Graham, who was based in San Francisco. But the West Coast wouldn't work as a concert location—it was too far from the London time zone. The U.S. part had to happen on the East Coast.

We had worked with Bill on several stadium shows. He trusted Allen and me. Collectively, he and Allen and I had promoted far more big outdoor concerts than everyone else, but we didn't have the big egos that other promoters had when it came to producing events. Rather, we were professionals used to functioning as parts

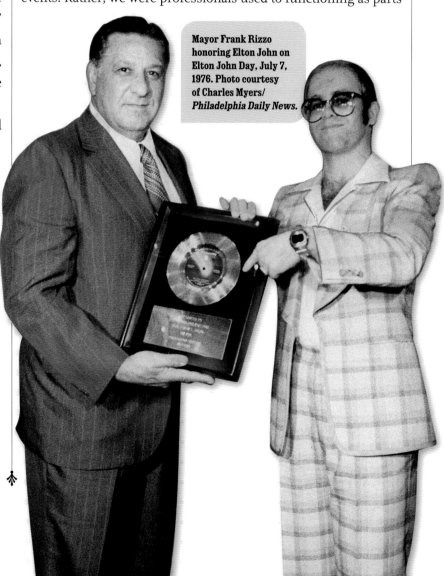

Mayor Frank Rizzo honoring Elton John on Elton John Day, July 7, 1976. Photo courtesy of Charles Myers/ *Philadelphia Daily News.*

Live Aid was a remarkable event. It was the biggest concert ever. It raised more money for a charity or cause than has ever been raised. It was a festival taking place on two continents, hooked up by television, run live throughout the world, with a telethon attached. Clearly the people who came up with this idea were demented.

of a team when it came to putting on a large show. Bill Graham Presents and Electric Factory Concerts were the two top producers and promoters in the country. Our combined stature was a selling point to the acts that we were asking to join in this noble venture.

New York was the obvious choice for the U.S. component of the festival. Persuading everyone to do it in Philadelphia was a challenge. I got on the phone with Graham and Geldof and made the case for Philly. We had a bigger stadium where we could sell more tickets and raise more money, and it was less expensive than any other large East Coast venue. We had everything at hand here in Philadelphia, along with excellent reputations and relationships to fall back on.

Working in another environment might be restricting, and time was moving quickly—plus, I was stubborn. It would work better in Philadelphia than any other place, I insisted. We were the birthplace of liberty and freedom, America's first capital. We knew JFK Stadium, and I swore that I would get the city on board.

The organizers said yes to Philadelphia. Now we had five weeks to pull it off. A remarkable collection of people joined together. The television side was run by Mike Mitchell along with Tony Verna, an ex-Philadelphian who served as director of the event. (He is the inventor of the instant replay and the brother of City Council president Anna Verna.) Also on board were Harvey Schilling, an Olympic Committee member, and Vince Scarza, a noted television director and producer and another former Philadelphian. They were exceptional and great to work with.

Everyone got along very well at first. It was like being part of an all-star team. We had five outstanding production managers who had worked on international tours in the past, plus our own outstanding personnel. It all helped.

There were three problems, however. The first was persuading the city government to allow us to do this show and to bill us for expenses only—an arrangement that I had already promised to Geldof and Graham. Mayor Wilson Goode's administration was hesitant and even resistant at first. A big meeting at the Spectrum drew at least 50 people from various city departments; Geldof flew in for it, and he would later describe me in his book as "serene"—not an adjective I or the people who know me use very often—in my confidence that we could pull off the event. I had no choice—showing any doubt at that meeting would have made it impossible to change the city's mind. I insisted that the city allow the use of JFK Stadium for free, but pointed out all the advantages that the city would gain in return: not just the obvious goodwill and publicity for Philadelphia, but serious money on concessions and for hotels and restaurants.

The unsung hero of the Philadelphia portion was Jim White, the city's managing director. He got it and helped us at every twist and turn. Without his foresight, I'm not so sure we would have been as successful.

The second problem was Bill. He could be a headache on the best of days. His well-timed outbursts were notorious in our industry, and he did not get along with the TV people at all. A furious territorial argument raged for five weeks of production over whether this was a "live event" or a "television event." Who was actually in charge? Somehow I became the go-between for two factions that seemed to speak different languages. Bill quit several times. The TV people tried to fire him; in fact, at one point they called the police to have him removed. I

Although Mayor W. Wilson Goode initially opposed bringing Live Aid to Philadelphia, the enthusiasm of his managing director, James White, persuaded him. Here, Bill Graham, Wilson Goode, and Larry Magid at the mayor's press conference announcing the event in 1985.

got on the phone with Geldof and others, pleading Graham's case. Graham and I could not have been more diametrically opposed in terms of public persona: I try to stay out of the limelight, mostly because press and notoriety will just make the job harder; Graham played the ultimate attention-grabbing showman. Yet I had deep respect for him as a producer.

Fortunately, I won this point too. Graham could stay, but only if I took charge. I decided to plant Graham onstage—to make him the stage director so that he couldn't come off that stage under any circumstances. That would give him a large role and simultaneously contain his theatrics. The unsung hero of this part of the story was Jan Simmons, Bill's invaluable assistant, who knew him better than anyone.

The third problem was that Allen Spivak and I were producing a show in Atlantic City that would become our first Broadway show. *Uptown It's Hot,* starring Maurice Hines, was opening the same night as Live Aid. Allen took the reins on the show and divided his time between the two projects.

Booking the acts for Live Aid was initially a challenge as well. We had to explain the idea. Some acts got it; some didn't. Some didn't like the political implications; others joined in for their own personal reasons. Bob and I thought we needed to put on black acts that would represent America and the cause that we were addressing.

Performers hemmed and hawed, but we prevailed. Acts that had initially turned us down later found religion and tried to get onto the program. In the end, we had to say no to a lot of pleading managers.

The Brits announced that Prince Charles would be the host, so Bill Graham brought in American royalty: Jack Nicholson. We added an array of celebrity hosts and announcers and ran film clips from other celebrities and short films between acts.

The concert lasted fourteen hours and included performances by scores of rock luminaries: Led Zeppelin (with Genesis's Phil Collins on drums), Madonna, the Pretenders, Tom Petty and the Heartbreakers, Philadelphia's Patti LaBelle, Eric Clapton, Mick Jagger and Tina Turner, and Bob Dylan accompanied by Keith Richards and Ron Wood of the Rolling Stones. Timing the acts was difficult. Normally, even in a concert with many performers, one set going longer or shorter is not particularly important. When it's for TV, however, timing is crucial—especially a TV program that is bouncing between live performances in the United States and England. We were going to need a revolving stage.

At 5 a.m. on the morning of July 13, 1985, I walked into JFK Stadium. The first person I saw was Chappy O'Shea, the stagehands' union steward. "Well, what do you think of the turntable?" I asked him, meaning the revolving stage. "Do you think it's going to work?"

"It has to," O'Shea said. "I don't know if it's going to work, but somehow it has to."

O'Shea was right about the importance of the turntable. While one act performed, another had to be simultaneously set up on another part of the stage, which would then be turned into proper position for lights and cameras. But right up to the morning of the show, there were arguments back and forth about how the turntable should be operated. It was designed to operate mechanically—press a button, it turns. But it was so heavy that a lot of us feared that it might break down. If that happened, we were doomed. So we decided to turn it by hand: seventeen stagehands would each grab an iron peg in the stage and pull it around.

Somehow, it all worked out. We nailed the timing to within 30 seconds of Dylan's last song. What happened next demonstrates just how lucky we were.

At the end of the show, everybody came out on the stage and sang "We Are the World." Harry Belafonte, Lionel Richie, and other artists who had recorded that song were invited up. So were people who had worked on the show. There was a children's choir. My wife and I were pushed onstage, and we were singing too. It was a wonderful finale. We finished the show and got everybody off the stage. And within 30 seconds of the last person's leaving the stage, the turntable crashed through it. Had it happened at any time during the show—any time—we would have lost the show. We never could have gotten that turntable working again.

When that happened, we all looked at each other, and nobody said a word. We just breathed a big, communal sigh of relief.

Bill Graham, noted producer and founder of the Fillmore, and Larry Magid planning Live Aid at JFK Stadium, June 1985.

I skipped the post-event party at the Four Seasons. For five weeks I hadn't slept more than four hours a night. The only thing I wanted to do now was go home and catch up.

I drove to my house on the Jersey shore. When I opened the door, I found that some friends had strung a giant sign over the stairs saying, "You Did It." I was touched, but Live Aid was one man's dream. Bob Geldof shared his dream with us, and we were helped along by a great number of skilled hands and willing workers. Some were paid, but a good many, like our company, worked solely for the sake of the cause—and worked hard and gladly.

Shows like that don't just serve the intended beneficiary; they arouse and wake the consciousness in all of us to do things for the common good.

Over the years we participated in more benefits and causes than I can count—the Amnesty International tour; "United We Stand," a benefit for Pentagon families after 9/11; "Rock the Vote" and "Vote for Change"; and, of course, Live 8.

After Live Aid the television producers sent me a complete set of tapes of the London and Philadelphia shows. After watching for fifteen minutes, I turned it off. I had lived it. I didn't have to see it. There would be plenty of time to look back.

Twenty years later I got a call from Bob Geldof and Harvey Goldsmith about doing another event. They called it Live 8. Somehow Bono had persuaded them to try to get world leaders at the G8 Summit to pay attention to Third World poverty and forgive those nations' debt.

Geldof had sworn that he'd never undertake another massive concert, but sometimes it's hard to say no. Live Aid had called forth a wonderful display of people's humanity. I too doubted that it could be repeated. And yet, reluctantly, I said yes. Then I proceeded to watch the Live Aid tapes for the first time.

Geldof at first wanted to do it on the Mall in D.C.; then the site was New York. Again I made the case for Philly. The U.S. end of Live 8 would be set up in front of the Art Museum, with a sea of fans extending out along the Benjamin Franklin Parkway.

There was a press conference at City Hall. This event would have five component shows in five countries. This time there would be no Bill Graham, no Allen Spivak, who had retired. Only a few of EFC's Live Aid staff remained. Most of the production staff would be new, and so would the television crew. Dave Matthews and I exchanged "We're here—now what?" looks during the press conference.

The smoothness of Live Aid was gone. There were more chiefs and fewer Indians. On the other hand, we had more time to put on this event: six weeks, another whole week longer than the Live Aid preparation! And we had some great people assisting us, and that helped. A few times I tried to quit, just as Bill Graham had in 1985. A lot of people were vying for credit. The old question of whether this was a "live event" or a "television event" was raised again.

When you do a show on this scale (or any show, for that matter), you realize that it is much larger than you. So you put away any reservations and make it as good as you can. All in all, Live 8 was a great show. The London stage had a terrific lineup of older acts and reunion bands: Led Zeppelin, Pink Floyd, Genesis. We couldn't compete with their lineup; instead, our show would feature younger, pure entertainment and would touch on all facets of American music: the Dave Matthews Band, Stevie Wonder, Sarah McLachlan, Josh Groban, Kanye West, Jay-Z, Bon Jovi, Toby Keith, Alicia Keys, and Linkin

Park. Hosting would be Will Smith, a Philly guy, who was joined by Don Cheadle, Jimmy Smits, and Richard Gere, among others. The City of Philadelphia, once again, did a great job. The show was totally free, and there may have been over one million people crowded onto the Ben Franklin Parkway. The show went off without a hitch.

Everyone came together in the final two weeks. As usual, my staff did their job. As at Live Aid, they rose to the occasion, and once again I was very proud of them. When we were finished, everyone said that we would get together in another 20 years. I don't think so.

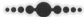

Over the years thousands and thousands of people have helped us produce and promote more than 16,000 performances. They work full and part time. EFC has been blessed with numerous outstanding employees who have gone on to careers in many areas. Working with them brings me much joy.

Our staffs have been unrivaled. It was comforting to go to work knowing that everyone was working hard to ensure that every ticket purchaser would draw the full measure of pleasure from our shows.

In 2000 Allen and I sold EFC to Robert Sillerman and SFX Entertainment, which in turn sold it to Clear Channel. After five years, Clear Channel Entertainment spun it off into a company named Live Nation.

The years with Clear Channel Entertainment were tumultuous, with frequent changes in leadership. The company was led by a series of promoters who based their ideas on their past regional success and applied those lessons dogmatically. Those years were not as enjoyable as I had hoped.

We knew it was time. Allen and I had seen a great many changes in the business through the years. We started with very little except hope for some mod-

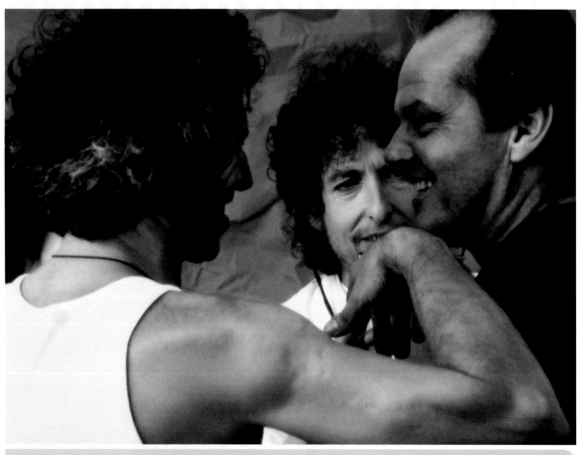

Keith Richards, Bob Dylan, and Jack Nicholson backstage at Live Aid. Photo © Ken Regan, July 13, 1985.

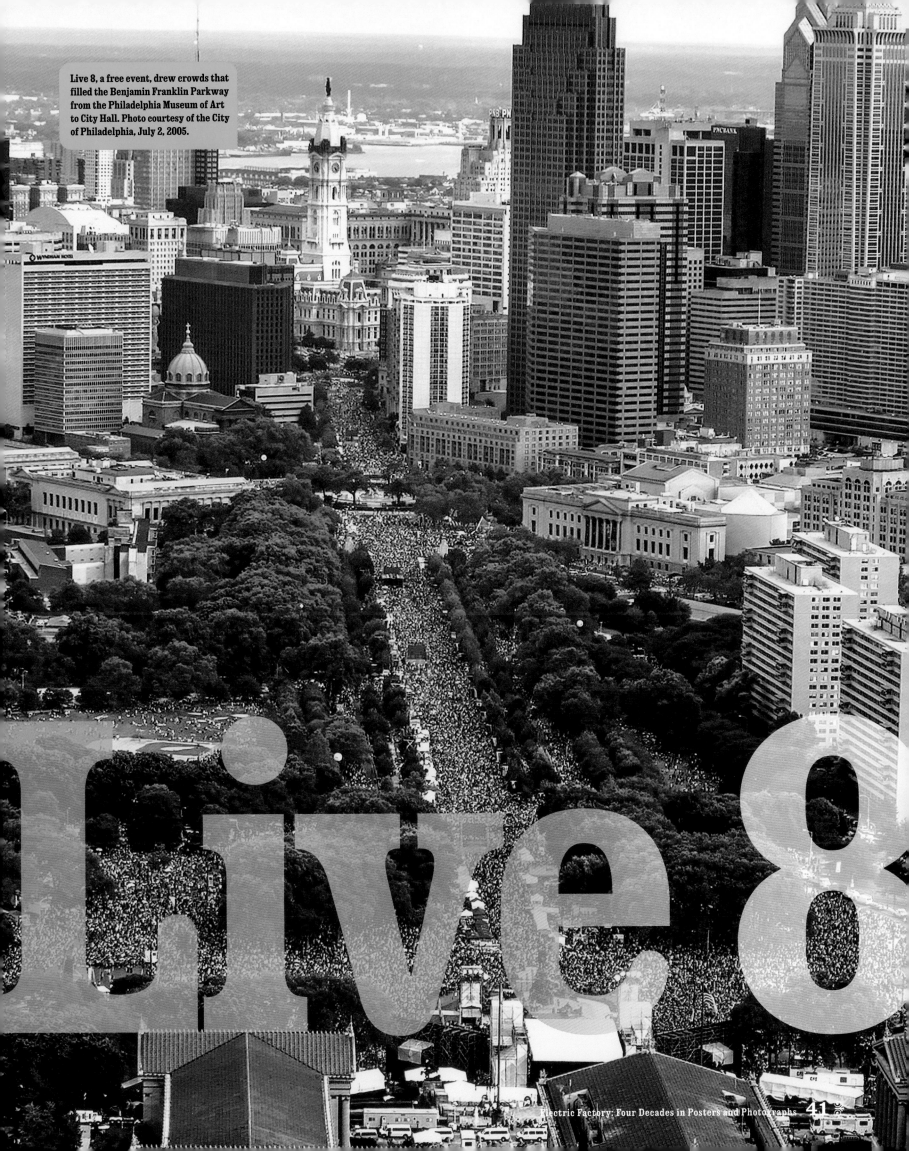

Live 8, a free event, drew crowds that filled the Benjamin Franklin Parkway from the Philadelphia Museum of Art to City Hall. Photo courtesy of the City of Philadelphia, July 2, 2005.

erate success. No one knew how big the business would become . . . and how fast it would grow. By the late nineties, we could see that not all of the current changes were good. Profits were sinking as ticket prices rose. It had become a seller's market in the mid-seventies and stayed that way for some time. The day of the independent promoter (like us) was quickly disappearing. Bill Graham had died; Frank Barsalona, architect of the rock concert business, had become ill and retired. The large amphitheater was challenging the arena as the major venue in most markets.

We turned down several offers to sell. By this time Allen was busy with Broadway, and I had produced national and international tours.

Still, the writing was on the wall, and there were no erasers nearby. Big companies like Bill Graham Presents in San Francisco, the Don Law Company in New England, Pace in Texas, and Cellar Door in Washington, D.C., had sold out to SFX Entertainment. Others followed. We resisted, but we could not fend off the inevitable. We might have held out longer, but we would have had to lay people off. Finally there came an offer that we couldn't resist. We sold our theaters, the Tower and TLA, but kept one venue. In October 1995, after many years of looking for the right location, Allen and I had finally found one at 7th and Callowhill

streets. Fittingly, it was an old General Electric warehouse. There we reopened Electric Factory.

ith EFC established in the seventies, we branched out. We were being asked to promote Sinatra, Presley, Denver, Diana Ross, and others. We did matinees and midnight shows. Nobody was doing that. In 1971 we presented a two-day Evil Knievel event at the Spectrum. He was a charismatic, impressive, and generally good guy. We also presented closed-circuit boxing, motorcycle races, and the Moscow Circus. We managed Grover Washington Jr., Patti LaBelle, and Ramsey Lewis, and we kept reinventing ourselves and our company over the years. We continue to innovate.

Three major stars played the Bijou early in their careers. Bette Midler hit like a meteor in December 1972. She broke nationally after her appearance. Three years later, her manager, Aaron Russo, asked us to help produce a Broadway show she conceived, *Clams on the Half Shell*. It opened at the Erlanger Theatre in Philadelphia on March 31, 1975, and went on to become a smash hit on Bette's way to becoming one of the greatest entertainers of our time.

Richard Pryor did commentary, as Nixon resigned, from the Bijou stage. Murry Swartz, our partner in the management company, lined up his three national tours. Pryor was brilliant, yet also the most humble and honest person imaginable.

We also became involved with many Broadway shows, with Allen at the helm. Over several years, Billy Crystal and I discussed the possibility of a one-man show on Broadway. Billy had started his career as an opening act at the Bijou. I felt his comedic talent and gift for storytelling and character development would be a natural for relating the stories about his family members that he wove into a dialogue. He called the show *700 Sundays*, a reference to the short time he had spent with his father, who died when Billy was in his teens. He asked me to come to the La Jolla Playhouse tryout in June 2004 and tell him what I thought of the show. No other industry people were invited.

Billy was brilliant and his timing impec-

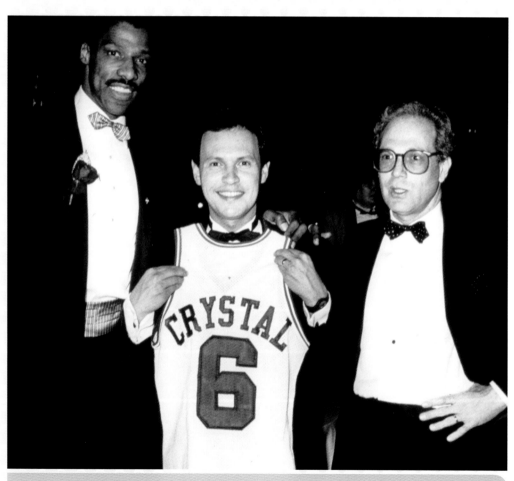

Julius "Dr. J" Erving, Billy Crystal, and Larry Magid at a 76ers Winners Ball Circle charity event, circa 1981.

The new Factory was a hit from the first day and continues to be a rallying point for music in Philadelphia. Bands get a giant boost from playing there because succeeding at the Factory gives them a certain seal of hipness. Prince, B.B. King, Bruce Springsteen, the Pretenders, Levon Helm, and the Temptations are among the greats who have hit the new stage. Newer acts like Radiohead and Lady Gaga emerged. The new Factory is in some ways much more successful than the original. But where would we be without that original magical kingdom at 22nd and Arch?

cable, as always. His performance made the audience laugh, cry, and laugh again. His story is universal, but I was especially moved because my dad passed away when I was in high school, too.

We talked about the show and he asked me to co-produce it on Broadway with his production company and his wife, Janice. I felt honored that he trusted me to be the lead producer for the story of his family relationships. *700 Sundays* became the highest-grossing nonmusical in Broadway history. We all won Tonys, my second one, with four nominations. I believe this is the finest one-man performance in Broadway history.

Over the years we've been involved with many national and international tours, including Midler, Pryor, and Crystal and Stevie Wonder and Robin Williams. They have been exhilarating experiences. The chance to work closely with these talented people and present them in America and other countries has been very gratifying and a privilege. It doesn't get much better.

In 2007 EFC put on some 700 concerts. In February 2008 we turned 40 years old. I estimate that we've produced more than 16,000 shows. In 1999 EFC had started doing shows at the E Center in Camden, now known as Susquehanna Bank Center. On the Philadelphia side, we continued our excellent relationship with the Wachovia Center and the Spectrum. Allen and I kept our relationships and our employees, but the transition to Clear Channel wasn't easy, especially for the employees, who were used to our style and independence.

Allen, my ally, my friend, my partner, retired after his second year with Clear Channel. Like me, he's not a corporate guy: we're still the same people we were when we started in the concert business. We shared so much and I owe him so much. There would be no Electric Factory Concerts if not for Allen and his contribution. We built this company together and invented the arena rock show at a time when there were no precedents for what we were trying to do. The Philadelphia Music Alliance called us "architects of the concert industry as it is known today."

The CEO of Live Nation offered me a new job as chairman of the North American Music Division. I considered it: perhaps I could have reinserted some of the passion and sense of the music that get strangled in a corporate atmosphere. But fortunately for both of us, I turned down the offer.

My Live Nation experience ended in February 2010, 42 years after the opening of the original Electric Factory and in my 48th year in the entertainment business. Live Nation and Ticketmaster merged, creating the kind of giant company in which creativity and entrepreneurship can be stifled. It was no place for someone like me to thrive. Back in my days as an agent in New York, I had learned about the pitfalls of company politics. Not being ready for the elephants' graveyard, I've moved on and am anxiously awaiting my 50th anniversary in this crazy business—that will be in 2012—with a head full of new ideas and plans.

Meanwhile, the new Factory was a hit from the first day and continues to be a rallying point for music in Philadelphia. Bands get a giant boost from playing there because succeeding at the Factory gives them a certain seal of hipness. We've sprinkled in a host of established stars. Prince, B.B. King, Bruce Springsteen, the Pretenders, Levon Helm, and the Temptations are among the greats who have hit the new stage. Bob Dylan has performed there several times. Newer acts like Radiohead and Lady Gaga emerged. The new Factory is in some ways much more successful than the original. But where would we be without that original magical kingdom at 22nd and Arch?

This is a life, not a business. It's part of the creative process

Jeff Beck, who played the old club in 1968, its first year, recently appeared at the Electric Factory. The reaction to this great guitarist was phenomenal and well deserved. After a spectacular performance, I visited Jeff backstage. We talked about the original place and its excitement. He loved the old place, and playing at the Factory again was special to him. Jeff Beck, circa 1975. Photo © Michael Lessner.

that there has to be humanity in what you're doing and what you're projecting. You're trying to give people enjoyment. A young employee came up to me at a show recently and said, "How does it feel to have made so many people happy for so long?" It was a great question. I was stunned for a moment. So I just said, "You know, it feels good." But you don't think of it like that.

When you're at a show, and you feel a magical moment, you actually get goose bumps. You train yourself to watch the audience as much as you watch the stage. Over the years I've seen how music has helped people ask big questions about themselves, and that's important. Being at a show, listening to the performers, watching the audience—those are the moments, the seminal moments, when you say: "This is what I'm here for. This is what I'm supposed to be doing. This is why I'm in the business."

•••••—●—•••••

J eff Beck, who played the old club in 1968, its first year, recently appeared at the Electric Factory. The reaction to this great guitarist was phenomenal and well deserved. After a spectacular performance, I visited Jeff backstage. We talked about the original place and its excitement. He loved the old place, and playing at the Factory again was special to him. His new manager is my old friend Harvey Goldsmith. The three of us chatted for some time.

When I got home, I found that I couldn't sleep. Memories rushed back—the stories, the people, the times!

I'm in West Philly, singing from a hits magazine with my friends on the O'Conners' steps, across the street from my parents' house at 59th and Webster. Jimmy O'Conner, Melvin Sultzburgh, and Steve Marinoff are there. Then Little Richard—"A-wop-bop-a-loo-bop-a-wop-bam-boom!" I'm seeing Frankie Lymon and the Teenagers at the Tower, James Brown at the Uptown, Jocko and the Rocket Ship Show, Hy Lit, the Cannonball: "One, two, three, four, the Cannonball is in the hall. Seven, eight, nine, ten, the Cannonball is back again."

Four of us are in the car on a Saturday night, looking for a party, girls, something to do, and ready to give up. "Let's go to Jim's Steaks and then go home." No—"Let's see if we can get into WDAS!" We're at Belmont Avenue and Edgely Road, driving down a long dirt road to a tiny cinder-block building. We go through the screen door. The engineer's booth, the controls, switches, and toggles—I'm in heaven! The great Cannonball is doing his show.

The other guys go out to buy steak sandwiches for the DJ; I stay behind and get to introduce a record, do a couple of dedica-

tions. Now I'm doing a guest slot on Saturday nights. Cannonball is saying: *"Are you ready on the right? Are you ready on the left? Are you ready, Joe Tomato?"* It changes my life—I become Joe Tomato! My father sneaks downstairs when everyone else is asleep to listen to me on the radio.

Now I'm booking shows for fraternity parties from a couch in Mitten Hall at Temple University. I move on to the Cadillac Sho-Bar, the Eric Social Club, El Rancho. College concerts with Godfrey Cambridge are up next, and the Four Seasons and Bill Cosby, Manny Rubin and Herby Spivak, Jack Goldenberg at Pep's.

I'm in a time tunnel, but I can't stop and don't want to. After driving all night with Len Barry or Lee Andrews to the next gig, we're unloading the equipment by ourselves, getting home at six in the morning only to head out a few hours later to another school or club. Then I'm in New York, the big time: Paul Butterfield at the Cafe au Go Go, Dick Cavett at the Bitter End, Bill Evans and Herbie Mann at the Village Gate, Astrud Gilberto and Joe Cuba at Basin Street East.

"I'm home, Mom—yeah, back home! We're opening a club called the Electric Factory. Yeah, it'll be very cool!" The faces are warm, and they're smiling at me. Paul Fishkin, Chico, the McDonnell sisters, Suzanne Egbert, Margo, Margie. Freebo, Kathy Kool, Dick Waterman, Mickey Brook, Woody's Truck Stop, Bonnie Raitt. David Kasanow, Jims Nelson's Light Show, the Zahn broth-

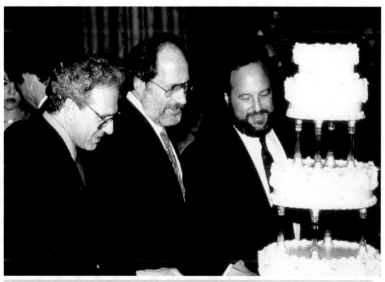

Larry Magid, Herb Spivak, and Allen Spivak at the 30th-anniversary party for Electric Factory Concerts, 1998.

ers—oh, man! The strobe lights are flashing in my eyes. Joplin, Hendrix, the Dead, Elton John, the Kinks. No! It's Rizzo and the cops. We'll fight it. Traffic's playing tonight, then it's Chicago, Pink Floyd.... That's far out, man!

Did someone slip something in my drink? I feel like I'm tripping. I'm at the Atlantic City Pop Festival joking with Zappa. The

Chambers Brothers are here. Creedence is killing them.

I'm in New York at Albert Grossman's office, and he's playing a new album for me. We listen till the end, with no one speaking. "Wow, Albert—that's great! Who are they?" . . . "The band? Yeah, I know they're *a band,* but what's their *name?*"

My head is spinning off my neck. I'm at Woodstock, drinking with Janis. I'm talking rock music and jazz backstage with Miles at Monterey, sharing a boardinghouse bathroom with Jimi Hendrix at the Isle of Wight, sitting in a car in Providence with Paul Kantner and Grace Slick, waiting ten minutes for the light to turn green. Whew. I'm flying. Rain is pouring down, and I'm back at the Atlantic City Race Course with Crosby, Stills, Nash and Young and Santana—and the show is going on anyway. Man, I hope no one slipped me any acid.

Concerts. "Let's take out the seats and we'll make it a party, one big club." We've got the Rolling Stones coming in. "Sure, B.B.—sure, Stevie. I'll help you get on their tours." Elvis is back. "Yeah, Ma—I'll get you good seats." We're going to open the Bijou Cafe with Dan Hicks & His Hot Licks, plus this good local group, Whole Oats—two kids named Daryl and John. "And wait till you see this new girl, Bette Midler; she'll be the next big thing." A couple of Miles's old guys are starting a new group. Weather Report? Okay. "Sure, Billy, you can open a show—and who's this new guy, Billy Joel?" We've got the Ace Trucking Company coming in. You can call me Ray! You can call me Jay! The Second City. "Yeah, they're booked. Sure . . . Belushi, let's go to the ball game." Steve Martin's outside the club with an arrow in his head, and he's—what?—directing traffic. "Sure, Grover, you can record live here!"

No! The city won't let us do any more be-ins. The last one drew 75,000 people. Dylan is coming back with The Band. Three shows at the Spectrum for sure. George Harrison—"That'll be great." The Stones can do another show. "How about a matinee? After all, Chicago did a show after school on a weekday, and we had to add another show for John Denver at midnight." Sinatra's coming back. That's Leo Durocher and Jack Benny hanging out backstage. "No, Mr. Benny, I don't smoke cigars, thanks anyway." Hey, Bette's going to Broadway—told you! "You know, Crystal, you can do a one-man show on Broadway. Bet you win a Tony. I'd like to produce it!"

So many shows—it's a blur. "What's that? 'Live Aid'? Bill, what are you smoking? . . . Okay, but it's got to be in Philly." Phil Collins is going to play *both* stadiums? Dylan confirmed. We're waiting to hear about Madonna. "Jack, you welcome everybody and announce the acts. It'll be cool." We get a call from a hospital: someone in the audience is waiting for a kidney transplant and they got one. "Find him—quickly!"

I'm fading. What's that? Yeah, Murry, let's do another tour with Richard Pryor. Let's get all of the Yes members and do a tour with them. "Okay, Allen, we can do that Broadway show—and the tour, no problem." "Mickey, guess what? We are gonna sell the company. I won't have to work so much. Stop laughing! I mean it!"

"Hello, Bob. Another Live Aid? Sure, it's been 20 years . . . but . . . but . . . okay, I'm in." Yep, Stevie Wonder will close. Hey, is he *crying* onstage? Well, someone always gets emotional at these things. Stephen Starr will do the backstage catering; he used to be a competitor, you know. The new guy, Kanye West, will be something. Give Dave Matthews the right time slot. "It's over, Bob. Yeah, thanks, but don't call me anymore." This Live Nation thing could work. I like the young guys. "I'm going over to the Factory tonight. Beck's playing. He played the old club in '68. He'll be great!" Sleep—yeah, just a few hours. Got a big show this weekend.

<center>••••●••••</center>

This book is dedicated to anyone who ever bought a ticket to one of our shows or snuck in. Without you, I'd be back with my corner boys, the Turbans, "looking for the heart of Saturday night." Hope that you enjoy the look back. I have!

We couldn't put everything in here. You can't relive 43 years of Electric Factory Concerts in one book. For me, it's been an unbelievable ride. This journey has taken me through 49 years and some great adventures. Sure, I've made my share of mistakes along the way. I've stumbled and fallen, but you were always there waiting for the excitement of another show. So was I! For me, helping to bring some fun and music into your lives has been a dream come true. I got to do what I wanted after failing to do much with my life for most of the first 25 years. The early struggle was well worth it.

If you are looking for the bad moments in this book, you won't find any. We've all had too much pain in our lives for that. Remember, rock 'n' roll redeems us and wraps us in its sound and soul. We've changed the world together. Baby, "let the good times roll!"

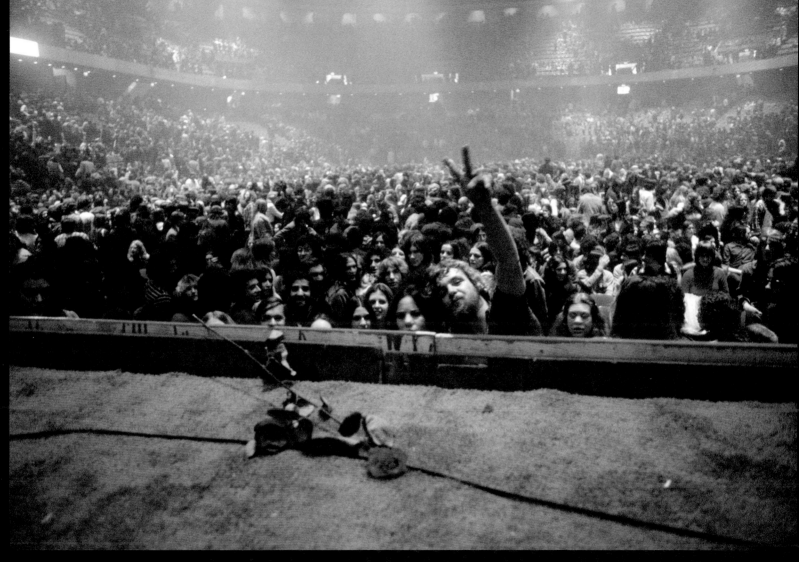

A rose left onstage at the end of a Neil Young concert at the Tower Theater. Photo © Joel Bernstein.

ELECTRIC FACTORY
1968-1970

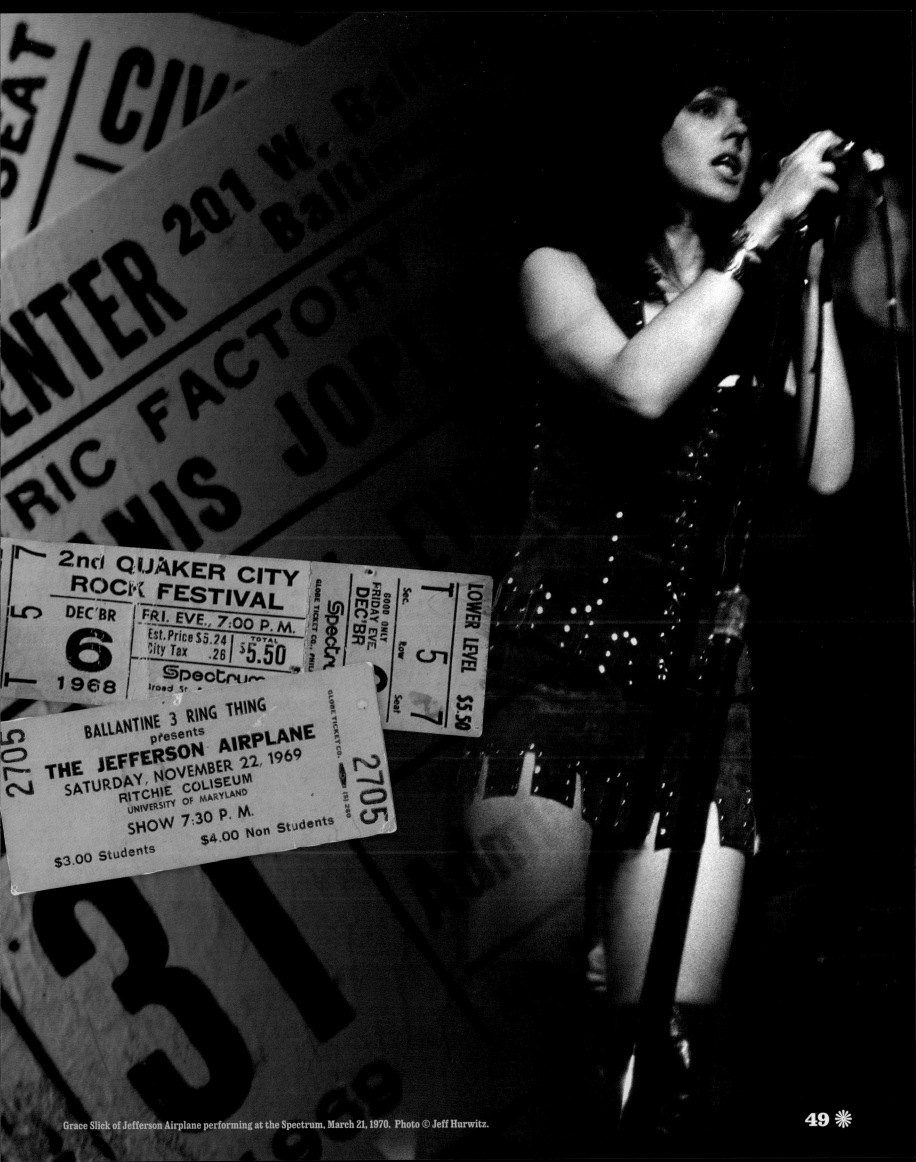

Grace Slick of Jefferson Airplane performing at the Spectrum, March 21, 1970. Photo © Jeff Hurwitz.

THE ELECTRIC FACTORY

That first night twenty-five hundred people slipped through the big blue doors of the Electric Factory and into a sensory explosion of strobe lights and fog machines, a phantasmagoria of raw energy and delirious, rollicking fun. At the box office, girls with Day-Glo flowers painted on their faces collected the three-dollar admission. Some patrons paid with handfuls of change panhandled on the street corner. When you threw the money down, your own hands changed color in the vestibule's black light.

Inside the Factory, a painted Buddha checked you out. Depending on the angle and the light, his eyes stared or glanced away or seemed closed. In the mirror-lined tunnel, timed strobe lights—fast, slow, fast—struck you as you floated or hopped on mattresses. Light bounced off a spinning silver ball. Taking a right turn out of the tunnel, through a flap, you emerged into a new reality.

Hippies in full regalia danced to loud rock 'n' roll. Tiny flea market booths sold penny candy, homemade cookies, and other wares. A Monopoly™ board was painted on the floor; giant footprints stalked across the ceiling. If you parked yourself in a barber chair, girls would paint your face and hands. Along the walls were pine coffins decorated in Day-Glo colors. You could lie back in one and take in the scene from another angle. Wherever you turned, your senses were assaulted with pulsating lights and music. There was a powerful feeling, too, that from this point there was no turning back. You had entered not a club, but an *experience*, an Alice in Wonderland confrontation with the ordinary world in which you had been standing, a few moments before, out there at 22nd and Arch.

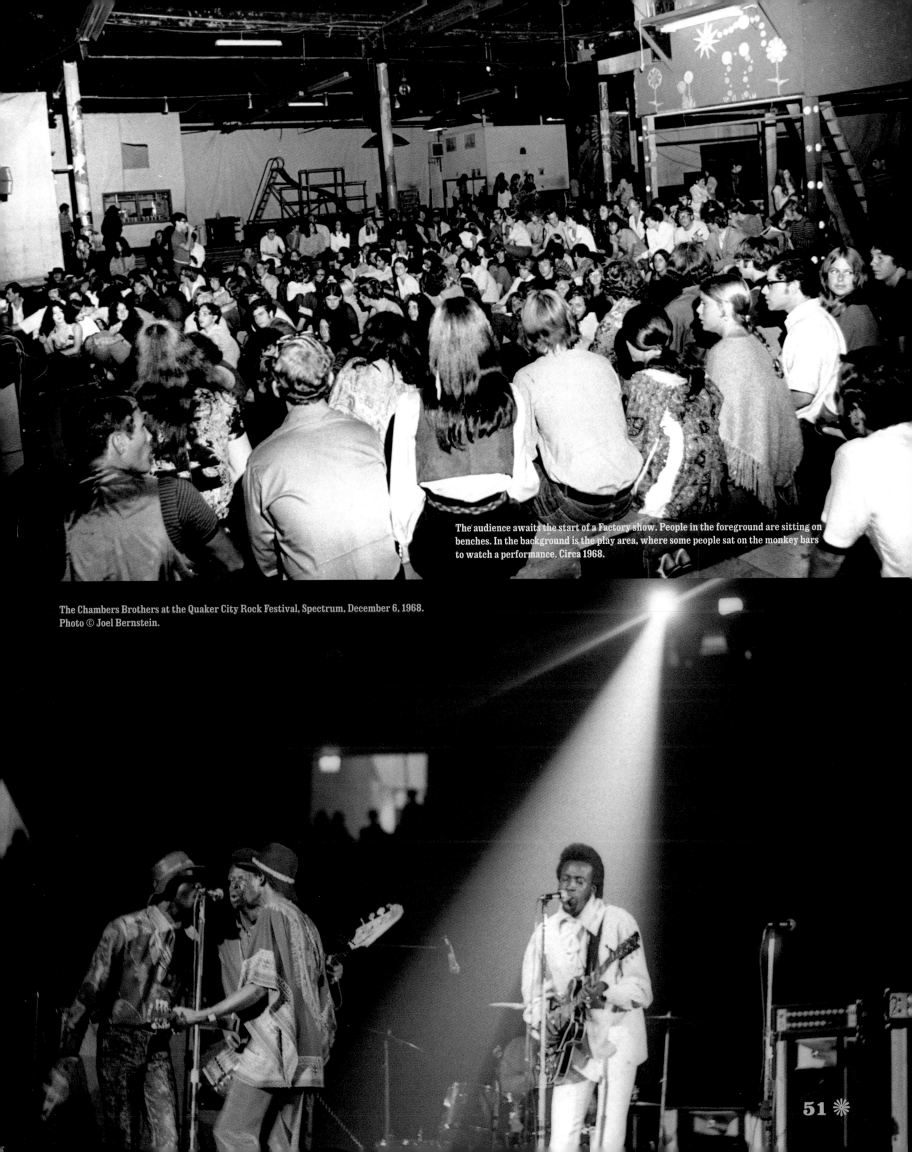

The audience awaits the start of a Factory show. People in the foreground are sitting on benches. In the background is the play area, where some people sat on the monkey bars to watch a performance. Circa 1968.

The Chambers Brothers at the Quaker City Rock Festival, Spectrum, December 6, 1968. Photo © Joel Bernstein.

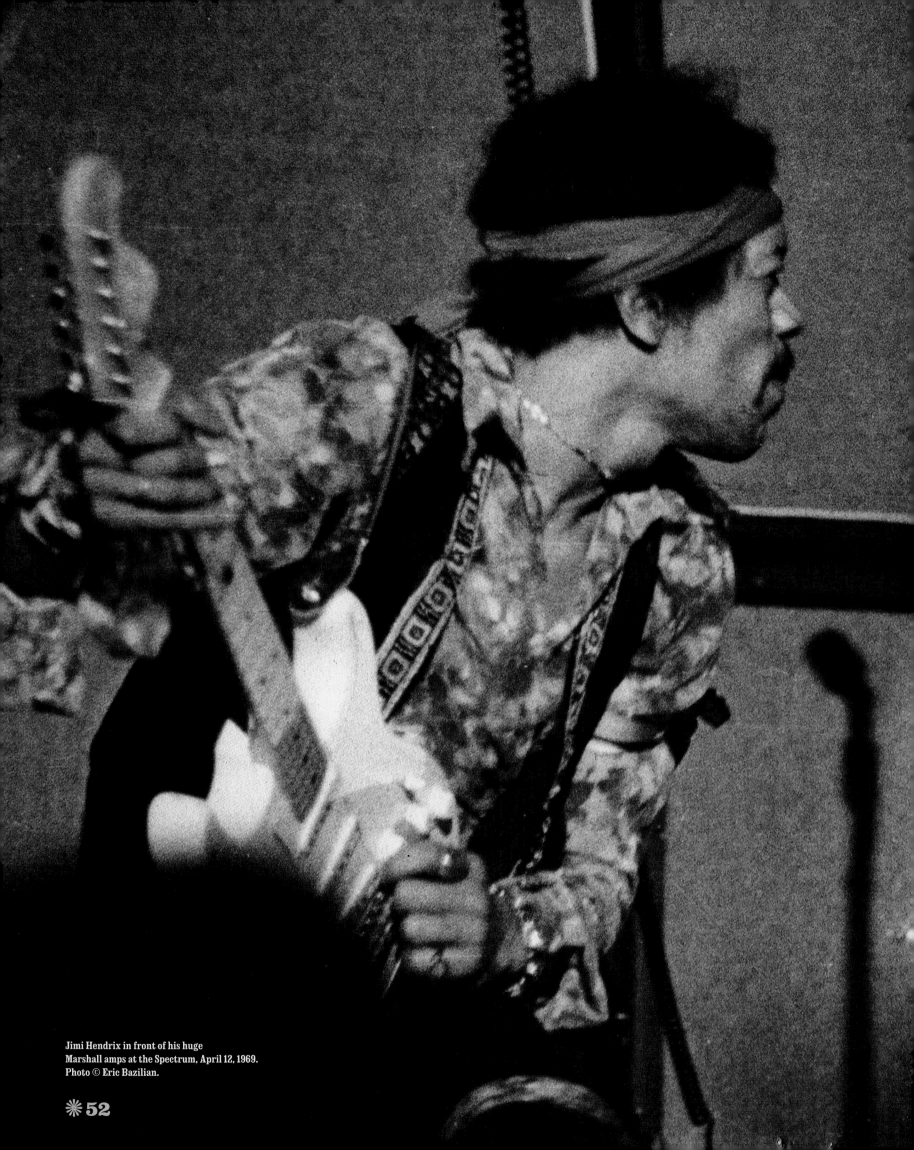

Jimi Hendrix in front of his huge
Marshall amps at the Spectrum, April 12, 1969.
Photo © Eric Bazilian.

✳ 52

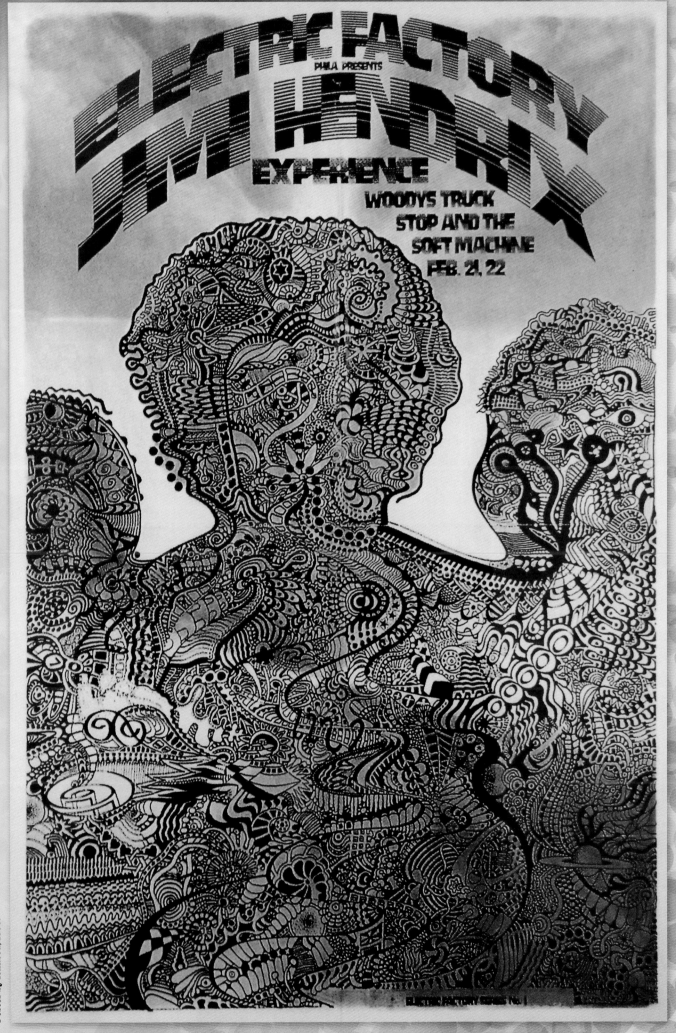

Poster by Ichabod, 1968.

 ELECTRIC FACTORY
AND FLEA MARKET
2201 ARCH ST PHILA., PA. 215 LOVE 222

MARCH 12-14 woody's truck stop·
march. 15 BIG BROTHER and the HOLDING
17 COMPANY plus EDISON ELECTRIC band
MARCH 19-
march 21 eden'schildren
NOVA LOCAL AND THE MOTHERS of INVENTION MARCH 22-24
mar 26·31 muddy waters blues band

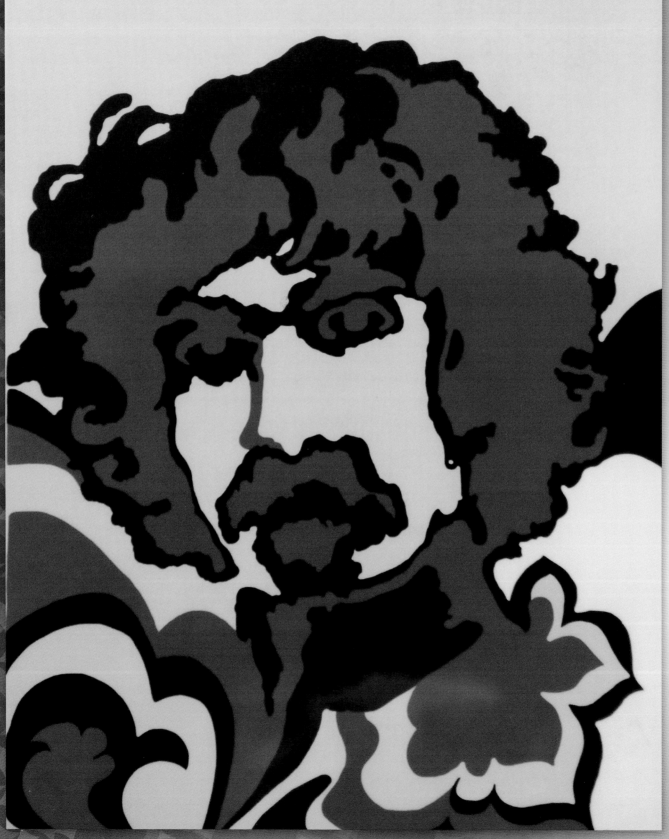

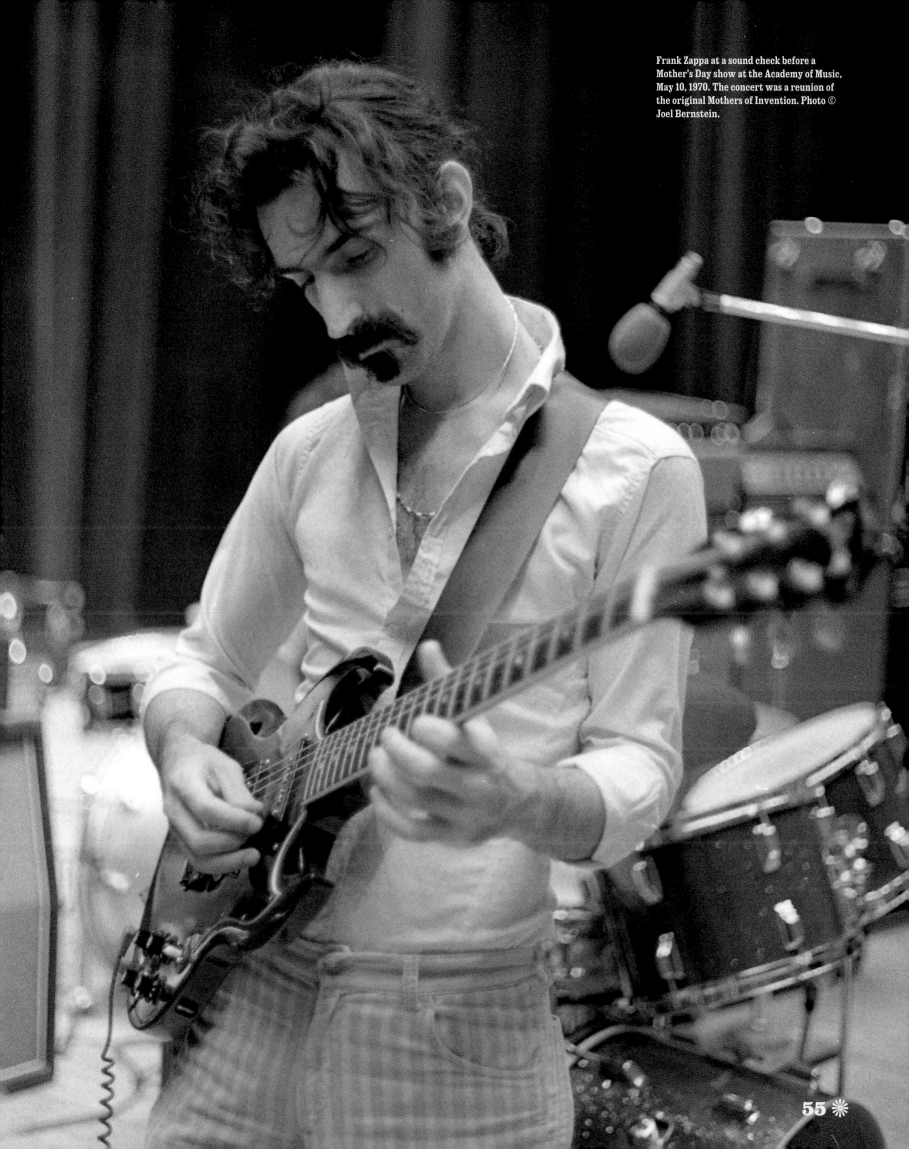

Frank Zappa at a sound check before a Mother's Day show at the Academy of Music, May 10, 1970. The concert was a reunion of the original Mothers of Invention. Photo © Joel Bernstein.

Above: Janis Joplin's name didn't appear on posters when Big Brother played the Factory in early 1968. Right: 1970.

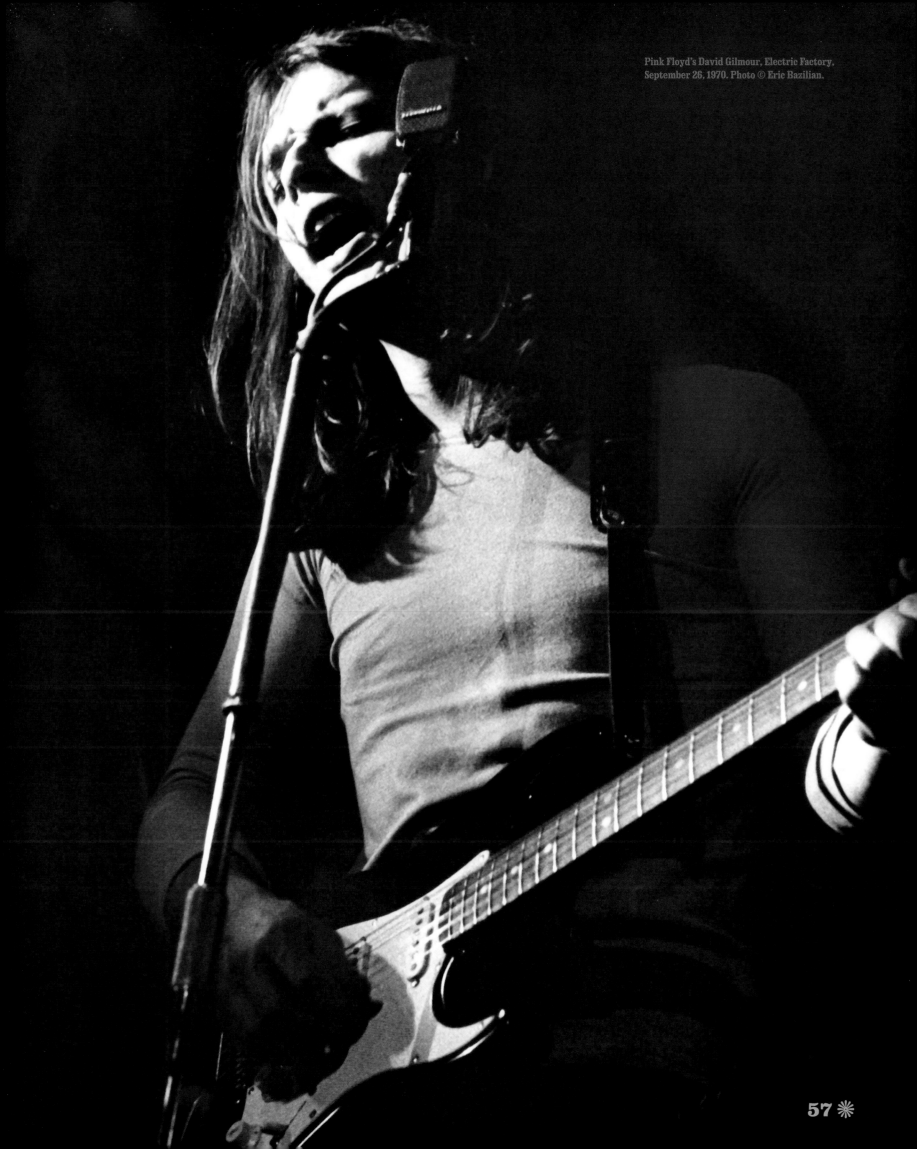

Pink Floyd's David Gilmour, Electric Factory.
September 26, 1970. Photo © Eric Bazilian.

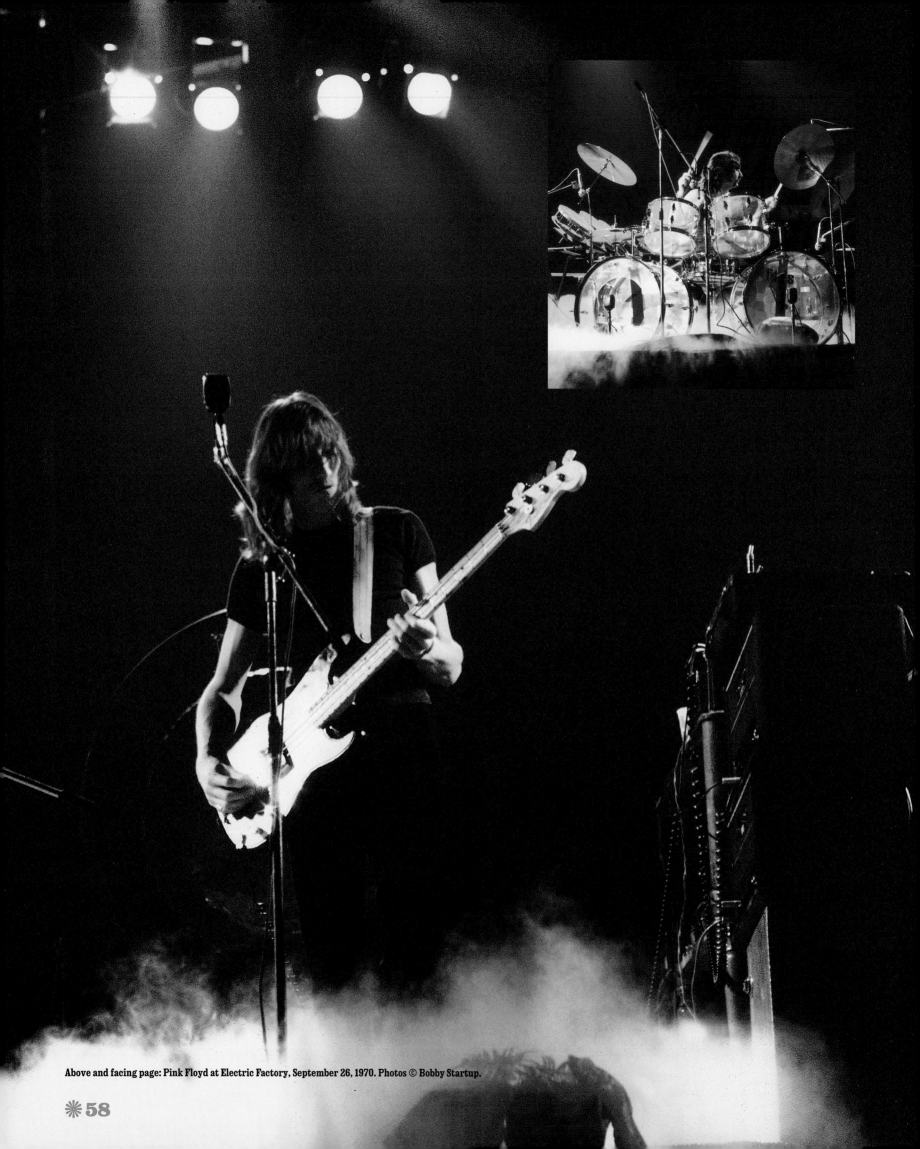

Above and facing page: Pink Floyd at Electric Factory, September 26, 1970. Photos © Bobby Startup.

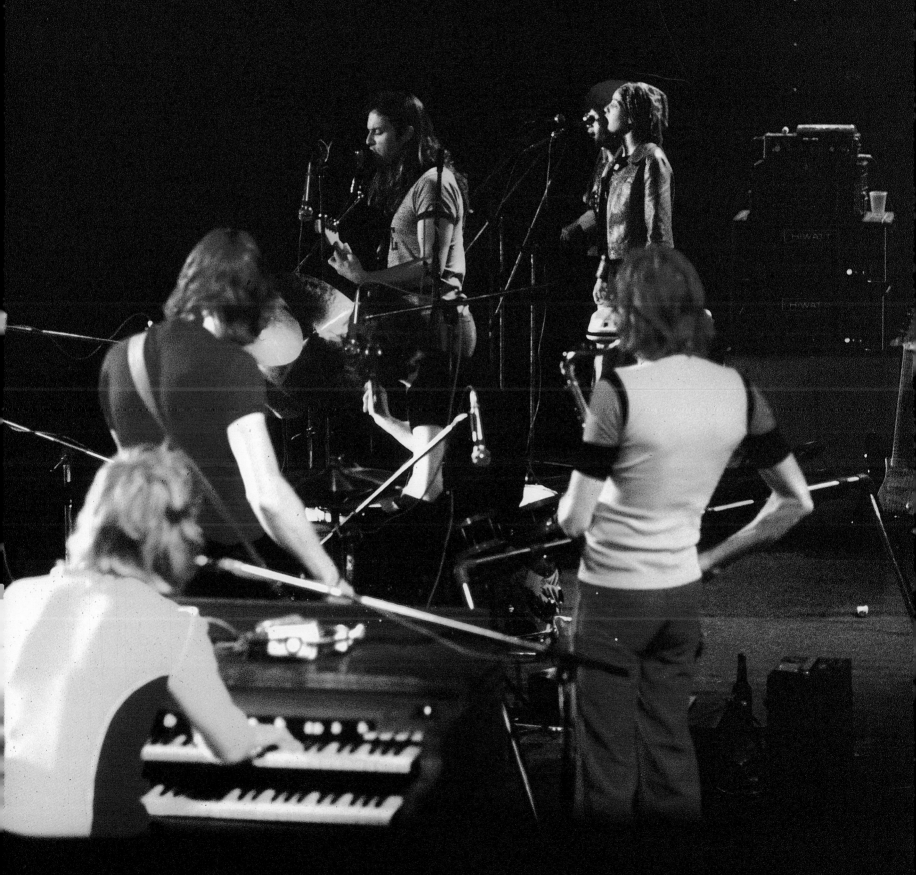

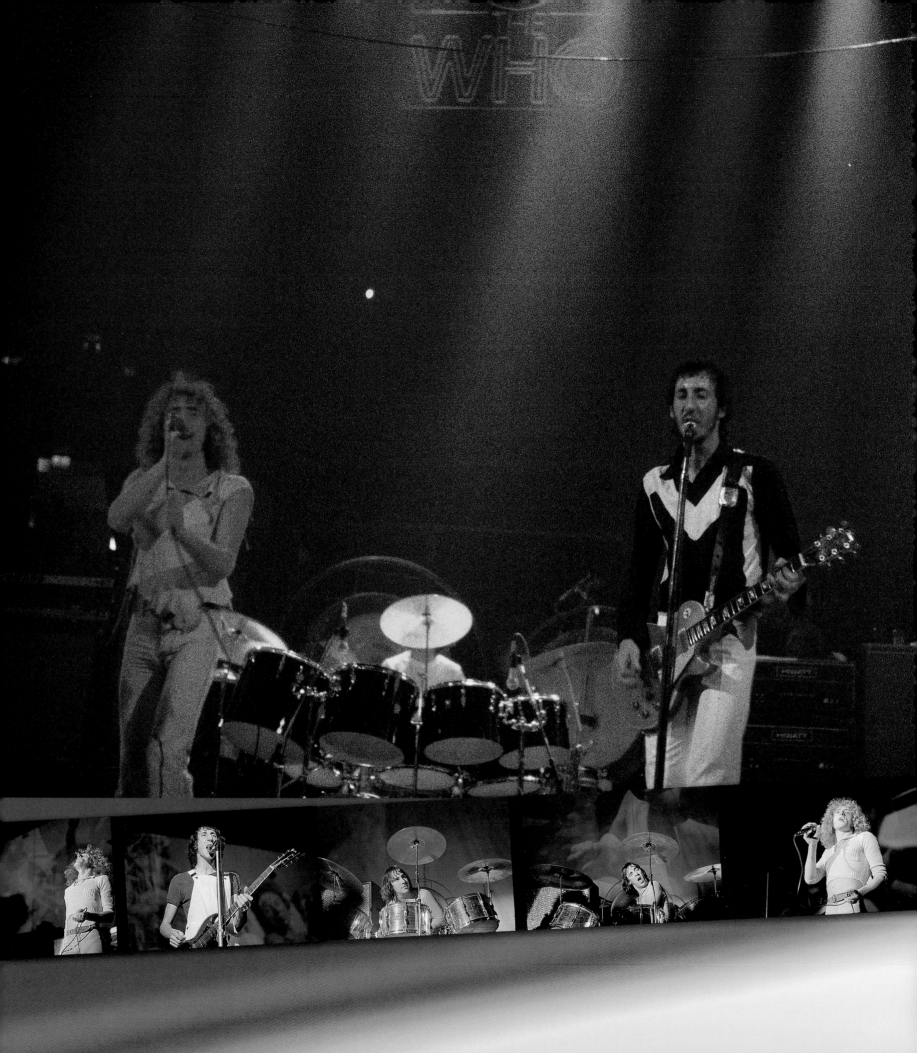

Above: The Who's Roger Daltrey, Keith Moon (behind cymbal), and Pete Townshend, circa 1970. Photo © Michael Lessner. Photo strip: The Who's American premiere of their rock opera *Tommy* was at the Factory, October 19, 1969. Photo strip © Eric Bazilian.

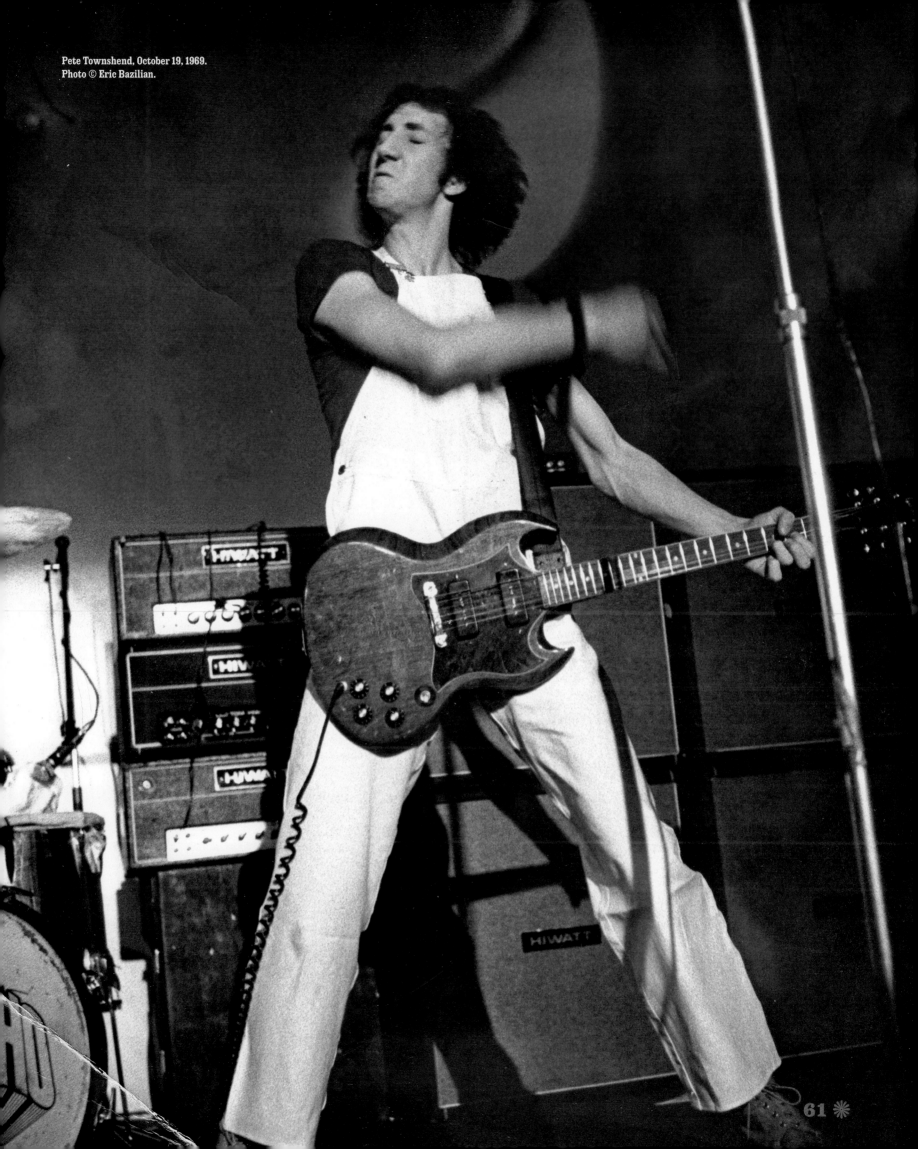

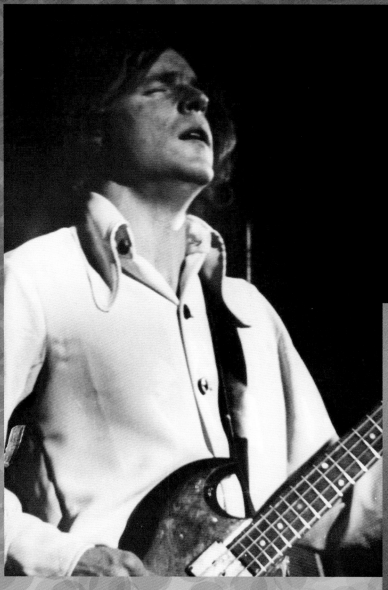

Above: Jack Bruce, Cream, Spectrum, November 1, 1968. Photo © Eric Bazilian.
Right: 1968.

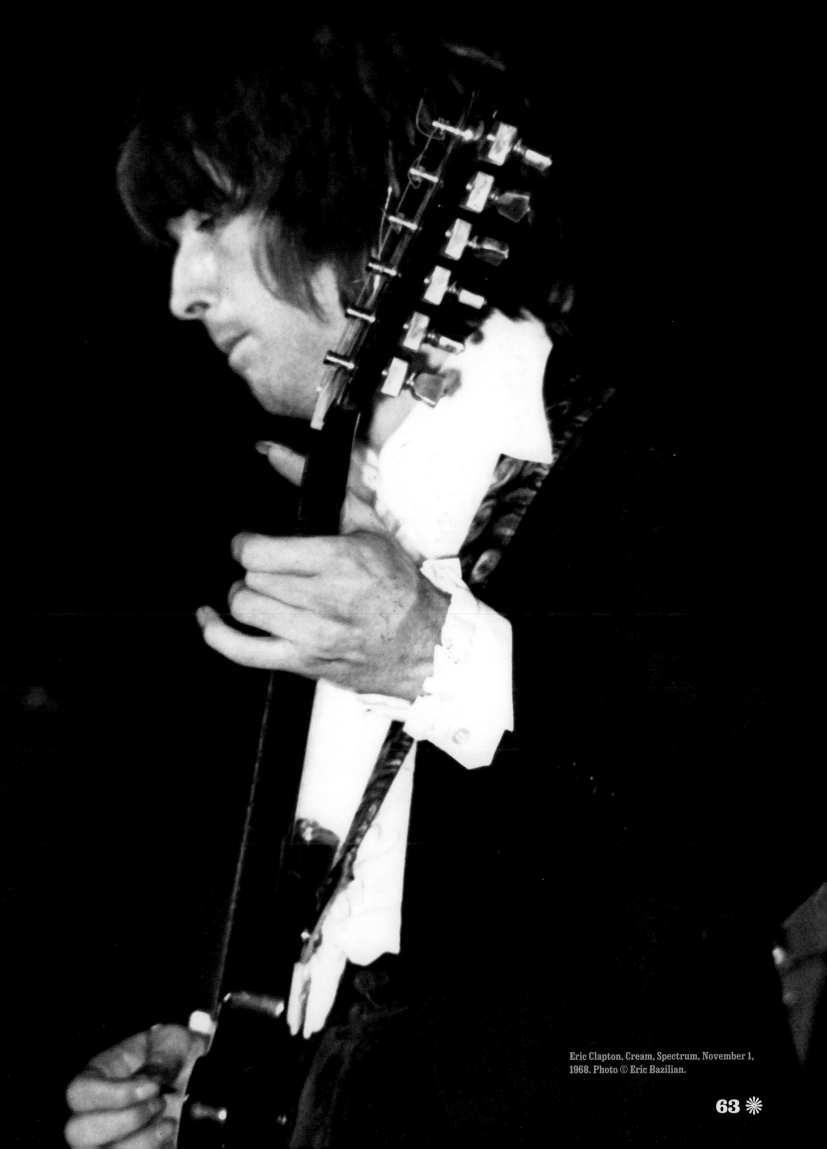

Eric Clapton, Cream, Spectrum, November 1, 1968. Photo © Eric Bazilian.

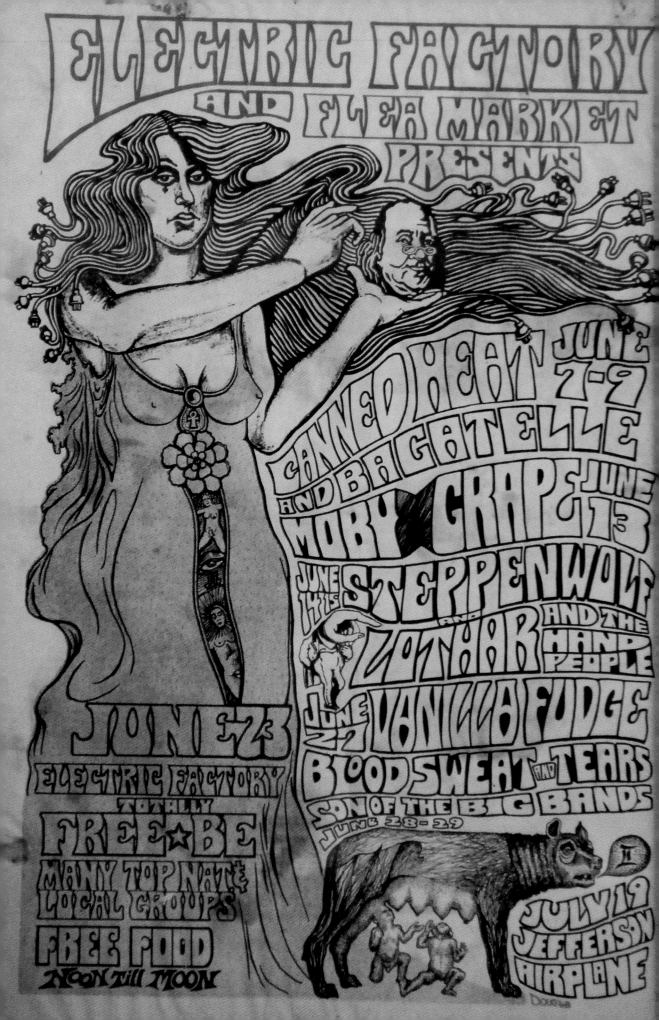

With no air-conditioning, the Factory was closed in the summer but presented free shows called be-ins on Belmont Plateau in Fairmount Park. The posters, left and below, are from a be-in and the fall reopening of the club in 1969. The Quaker City Rock Festival took place in 1970.

GRAND FUNK RAILROAD
SMALL FACES WITH ROD STEWART
ERIC BURDON AND WAR
★ ELIZABETH ★
QUAKER CITY ROCK
OCT 23 ★ SPECTRUM ★ 8PM ★ $4, $5, $6

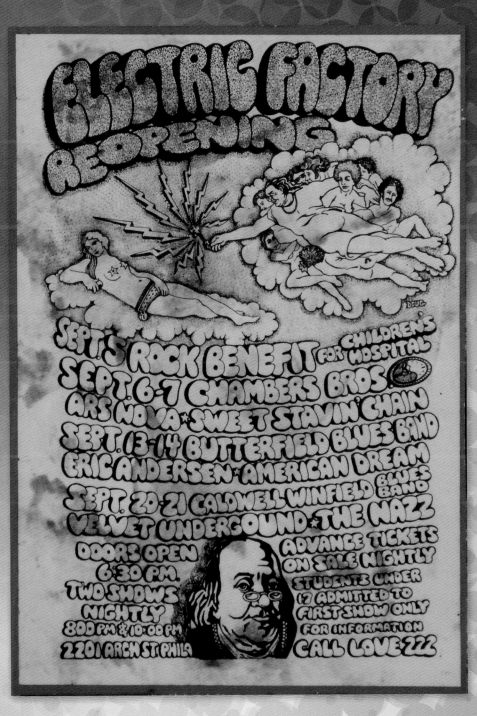

ELECTRIC FACTORY REOPENING

SEPT 5 ROCK BENEFIT FOR CHILDREN'S HOSPITAL
SEPT 6-7 CHAMBERS BROS.
ARS NOVA ★ SWEET STAVIN' CHAIN
SEPT 13-14 BUTTERFIELD BLUES BAND
ERIC ANDERSEN ★ AMERICAN DREAM
SEPT 20-21 CALDWELL WINFIELD BLUES BAND
VELVET UNDERGOUND ★ THE NAZZ

DOORS OPEN 6:30 P.M.
TWO SHOWS NIGHTLY
8:00 P.M. & 10:00 P.M.
2201 ARCH ST PHILA

ADVANCE TICKETS ON SALE NIGHTLY
STUDENTS UNDER 17 ADMITTED TO FIRST SHOW ONLY
FOR INFORMATION
CALL LOVE 222

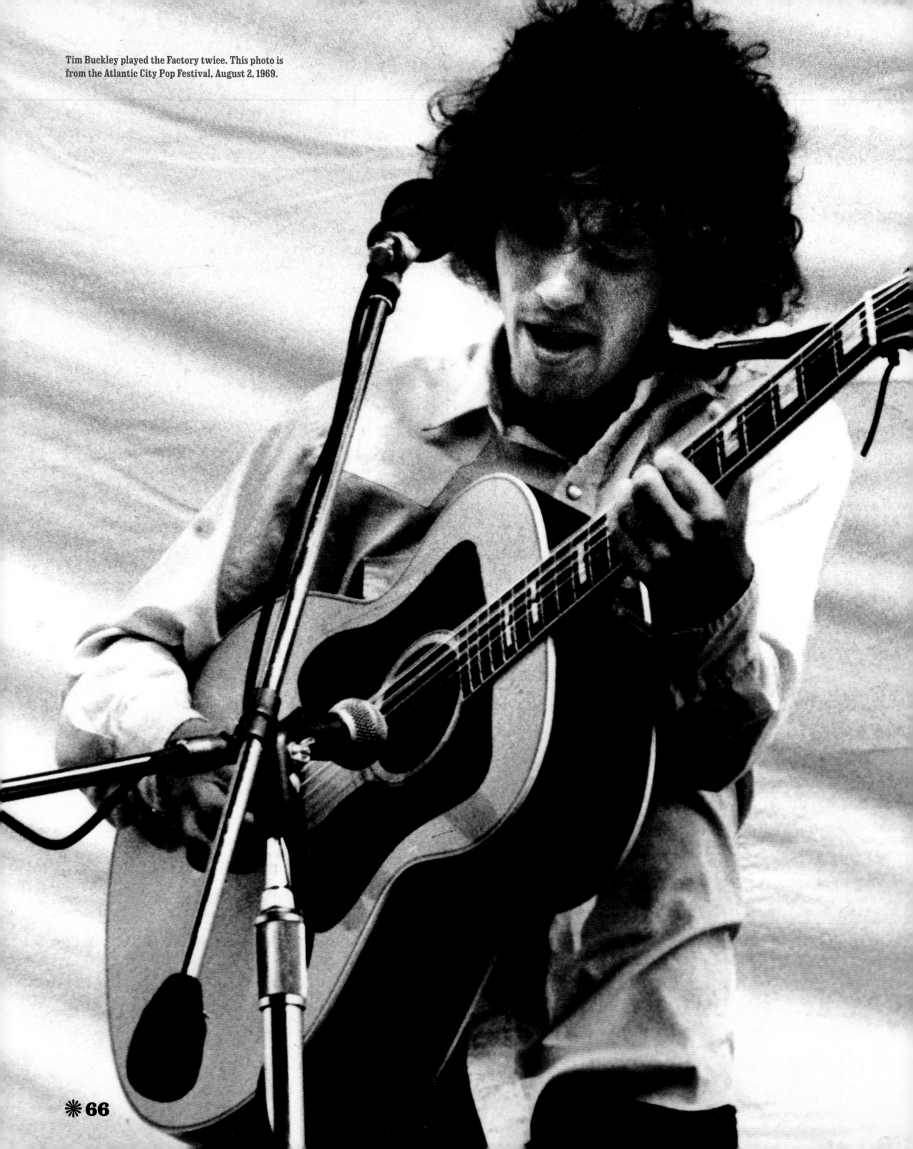

Tim Buckley played the Factory twice. This photo is from the Atlantic City Pop Festival, August 2, 1969.

✳ 66

In 1967, during the Summer of Love, the Monterey Pop Music Festival opened the era of rock festivals. Ninety thousand fans put Jimi Hendrix, the Who, Janis Joplin, and Otis Redding on the road to stardom. Two years later the Electric Factory mounted the Atlantic City Pop Festival, an outdoor rock extravaganza held at the Atlantic City Race Course two weeks before the festival at Woodstock.

Before the casinos were built, Atlantic City was a beat-up, dying resort town. Herb Spivak was driving down to the ocean that winter, thinking about Miami's recent rock festival, which had been at a racetrack. Suddenly he made a left turn into the Atlantic City Race Course. Within a couple of hours he had a handshake deal with the owner to rent the track on the first three days of August for 17 percent of the gross.

Did Philly and Jersey have enough music lovers to fill the A.C. Racetrack? Factory manager David Kasanow packed Pop Festival posters into his mother's VW bug and headed down South and up to Montreal and Toronto, hitting record stores and rock stations, handing out free tickets, passing out posters on college campuses, creating a buzz for the festival.

The racetrack setting had a structural advantage over Woodstock. The festival would be within the racetrack, and to get in you had to walk through a turnstile, restricting the concert to actual ticket-buyers. No drug- or alcohol-fueled shenanigans could seep beyond the festival's purview. Some 70 craft and food booths were set up. The stage, designed by Buckminster Fuller, the Penn professor who invented the geodesic dome, revolved on a turntable so that two acts could go on back to back.

The A.C. Pop Festival, unlike the three days in the mud on Yasgur's farm in upstate New York, made money and stayed organized. Nevertheless, it was Woodstock's immediate infamy that established the public image of the outdoor rock festival and associated it with danger and mayhem.

Allen Spivak kept trying to replicate the success of the A.C. Pop Festival, pursuing an outdoor site in Pennsylvania at Pocono Raceway or Bushkill Falls. As far as the locals near Pocono Raceway were concerned, a three-day show meant a half million people tramping in. A community meeting at a firehouse became so crazy, so threatening, that Allen's attorney told him, "We have to get the hell out of here. We're going to be lynched."

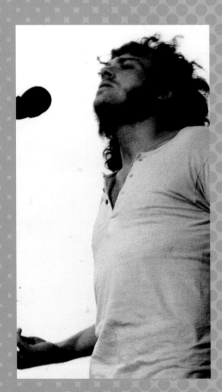

Joe Cocker, Atlantic City, August 3, 1969.

Original festival poster. The lineup changed somewhat.

A three-day festival called Harmonyville came a little closer to realization. Bushkill Falls, a beautiful farm along the Delaware, was a "scratch site," meaning that the festival promoters had to build everything. Spivak found investors. They brought in amped-up electricity, constructed access roads, erected a fence, created an entrance. Acts were booked, posters designed. Then the community organized against the festival, and a judge ruled that Electric Factory Concerts had to stop selling tickets. The concert business was shifting toward larger venues, but they weren't going to be in the form of big outdoor festivals.

Atlantic City Pop Festival
AUGUST 1·2·3
Atlantic City Race Track/Atlantic City, N.J.

Friday·Aug. 1 · Iron Butterfly·Procol Harum Crosby, Stills & Nash · Booker T & the M. G.'s Joni Mitchell·Chicago·Santana Blues Band Johnny Winter ·

Saturday·Aug. 2 · Jefferson Airplane Glen McKay's Headlights Creedence Clearwater · Lighthouse · Crazy World of Arthur Brown · B. B. King Butterfield Blues Band · Tim Buckley Byrds · Hugh Masekela · American Dream

Sunday·Aug. 3 · Janis Joplin · Canned Heat Mothers of Invention·Sir Douglass Quintet 3 Dog Night · "Dr. John" the Night Tripper · Joe Cocker · Buddy Rich Big Band · Little Richard · · Moody Blues

Music·Carnival and 3-Day Exposition

Advance tickets:
$6. per performance
$15. for all 3 performances.
Tickets at door.
$6.75 per performance.
For additional information c
The Electric Factory
LO 3-9284
Atlantic City Race Track
(609) 646-5002

TICKETS AVAILABLE · In Philadelphia · Electric Factory, 2201 Arch St. · Wax Three Record Shop, Fly. Mkel. Mall · Gleasmans, 13th & Locust Sts. · Wanamaker's Stores · All Jerrys Record Shops · Record Den, Normandy Sq. Mall · Hotsie Record Shop, Sansom Village · Univ. of Penn., Houston Hall · Gimbels, 1214 So. 7th · Vineland · Apple Boutique · Runnemeer · Silver Plum · Atlantic City · Apple Boutique, Ritz Carlton Hotel · Idle Hour Book Store · All Gimbels Stores · Albany · Area · Baltimore · All 1st Nam. Banks of Maryland · Washington · All Woodward & Lothrop Stores · All Sears Stores · Siza Stuks, 13226 Georgia Ave., Wheaton, Md. 7020 Wis. · Bethesda, Md. 3849 Riverdale Rd., Riverdale Md., 26th & Philadelphia Ave., Ocean City, Md. · Montreal · All Steinberg Miracle Mart's · New York · Gimbels & Union · All Wiz City Stores · Gertz Stores · T.W.A. · Libby Bros. · And All T.R.S. Agencies Throughout The Country

Muddy Waters, a later addition to the festival, Atlantic City, August 1969.

No. 05311

BALLANTINE Presents

THE JEFFERSON AIRPLANE IN CONCERT

for CAMPUS CHEST of
THE UNIVERSITY OF PENNSYLVANIA

At the PALESTRA
33rd & Locust Sts. Phila., Pa.

FRIDAY EVENING, NOVEMBER 21, 1969—8:00 P.M.
GENERAL ADMISSION $4.00

ATLANTIC CITY RACE COURSE

ATLANTIC CITY POP FESTIVAL

AUGUST 1, 2, 3, 1969

ATLANTIC CITY
RACE COURSE

ATLANTIC CITY
POP FESTIVAL

GOOD ONLY
SUNDAY
AUGUST 3

69 *

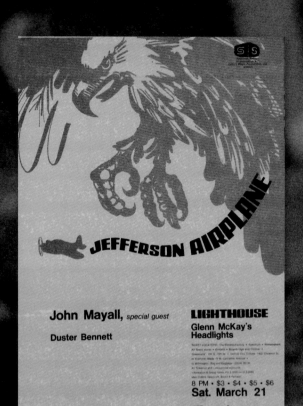

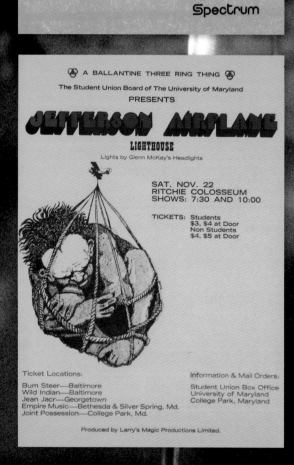

Poster top: 1970. Poster above: 1969.

Grace Slick and Jorma Kaukonen of Jefferson Airplane, the
era's top band and the first to travel with their own sound
system. They appeared frequently in Philadelphia. Spectrum,
April 14, 1970. Photo © Jeff Hurwitz.

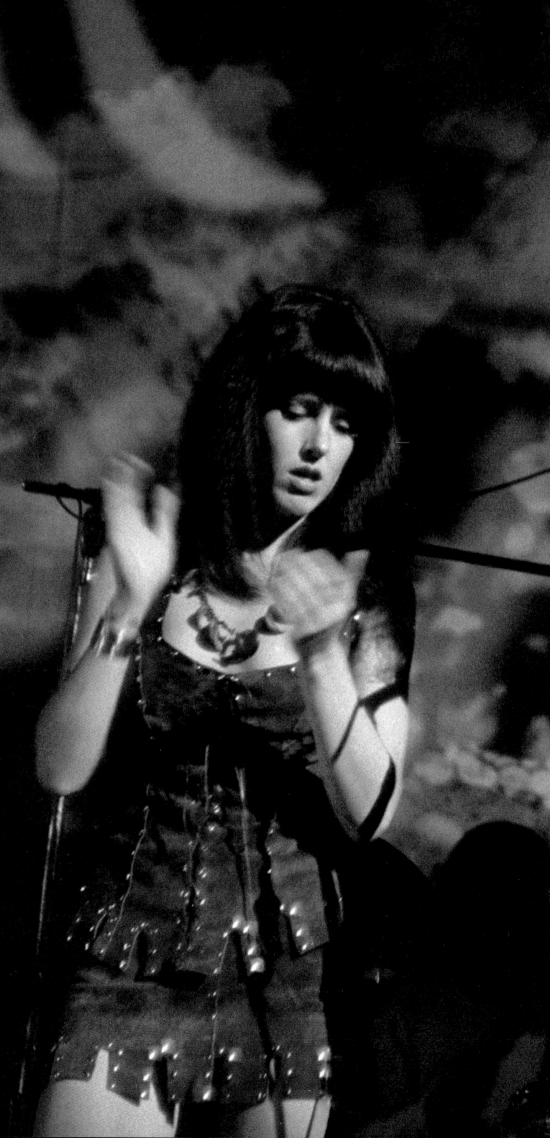

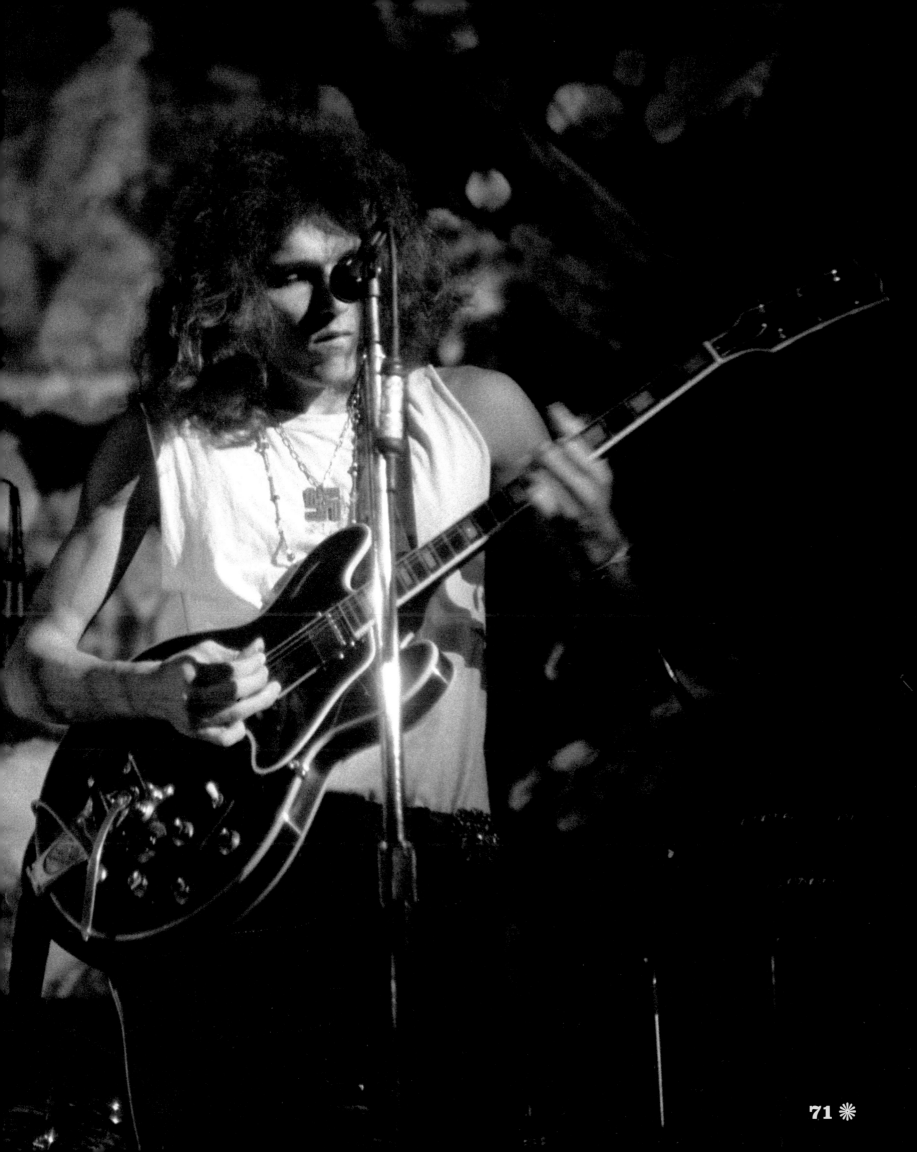

By Overwhelming Public Demand!

SPIVAK BROS. present

THE ROLLING STONES

ON LONDON RECORDS

IN PERSON! IN CONCERT!
Plus TERRY REID &
B. B. KING
TUES. NOV. 25
4:30 P.M.
SPECTRUM

THE ROLLIN
NEW A
"LET IT
Available
at your
Record

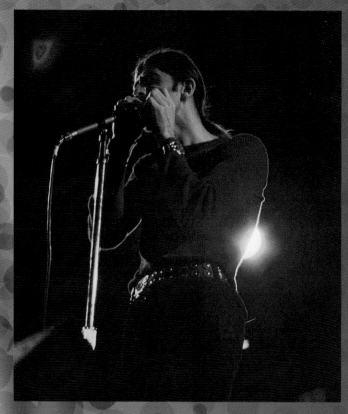

Above: John Mayall, whose Bluesbreakers at various times included Eric Clapton, Jack Bruce, Mick Taylor, and John McVie. Here, Mayall shared the bill with Jefferson Airplane at the Spectrum, March 21, 1970. Photo © Bobby Startup.

Below: Mick Jagger. The Rolling Stones played the Spectrum for the first time on November 25, 1969. Photo © Eric Bazilian.

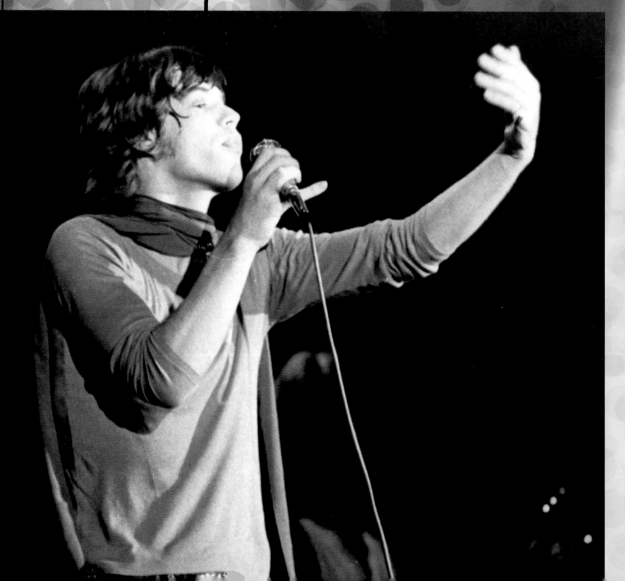

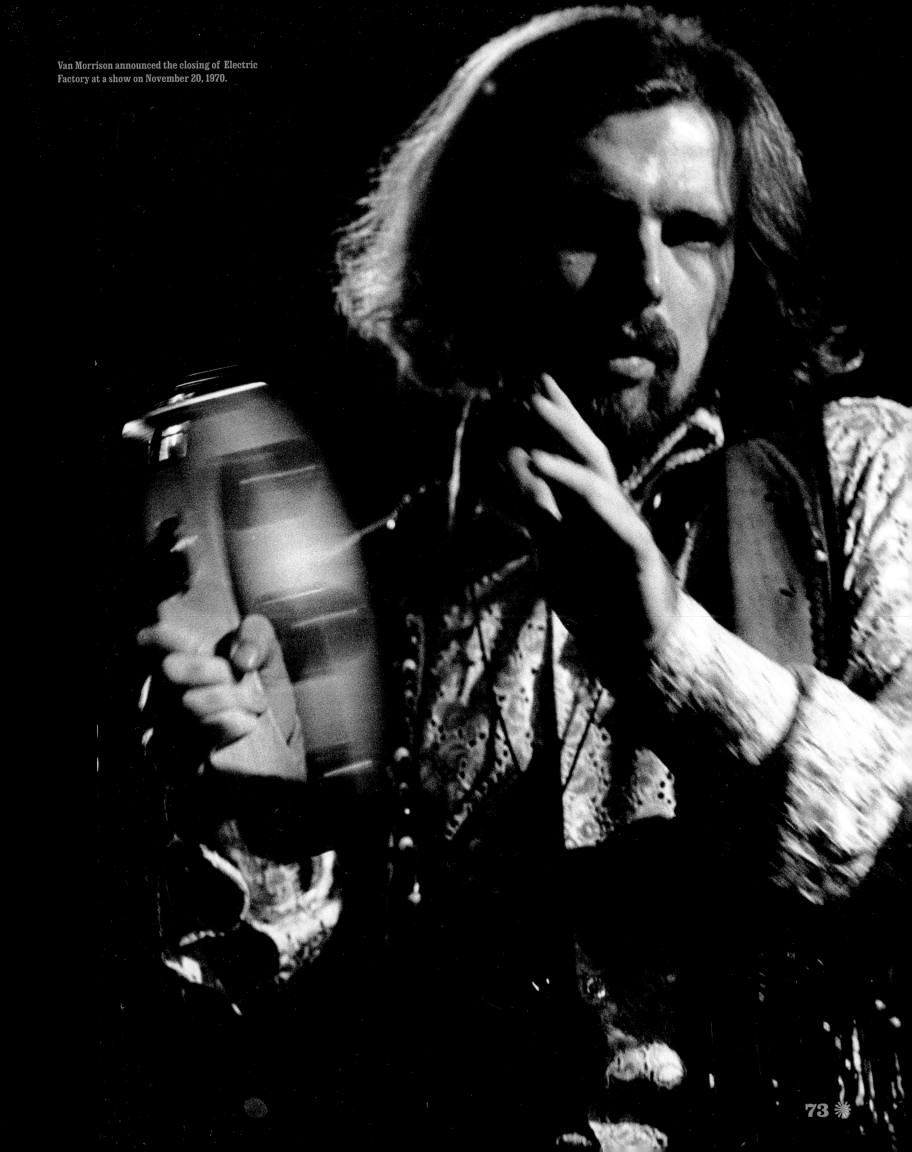

Van Morrison announced the closing of Electric
Factory at a show on November 20, 1970.

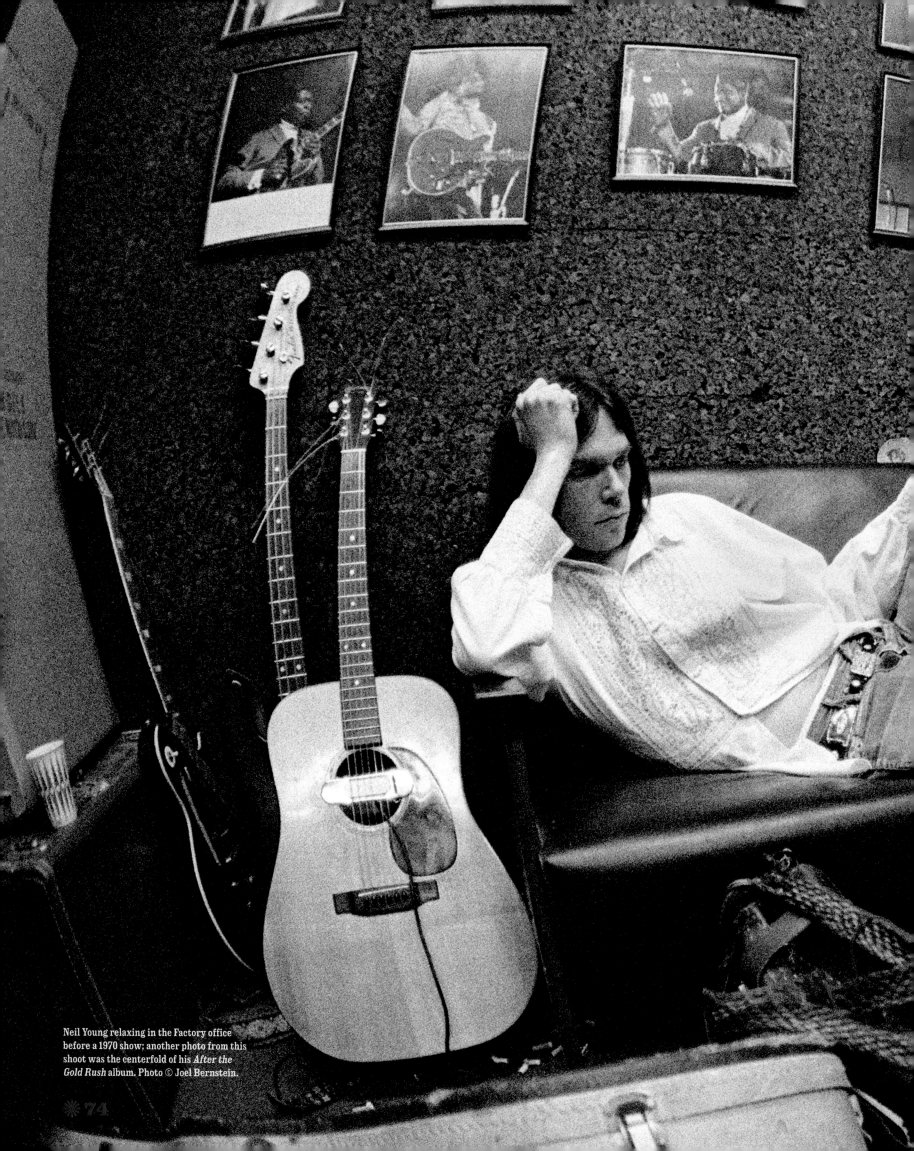

Neil Young relaxing in the Factory office before a 1970 show; another photo from this shoot was the centerfold of his *After the Gold Rush* album. Photo © Joel Bernstein.

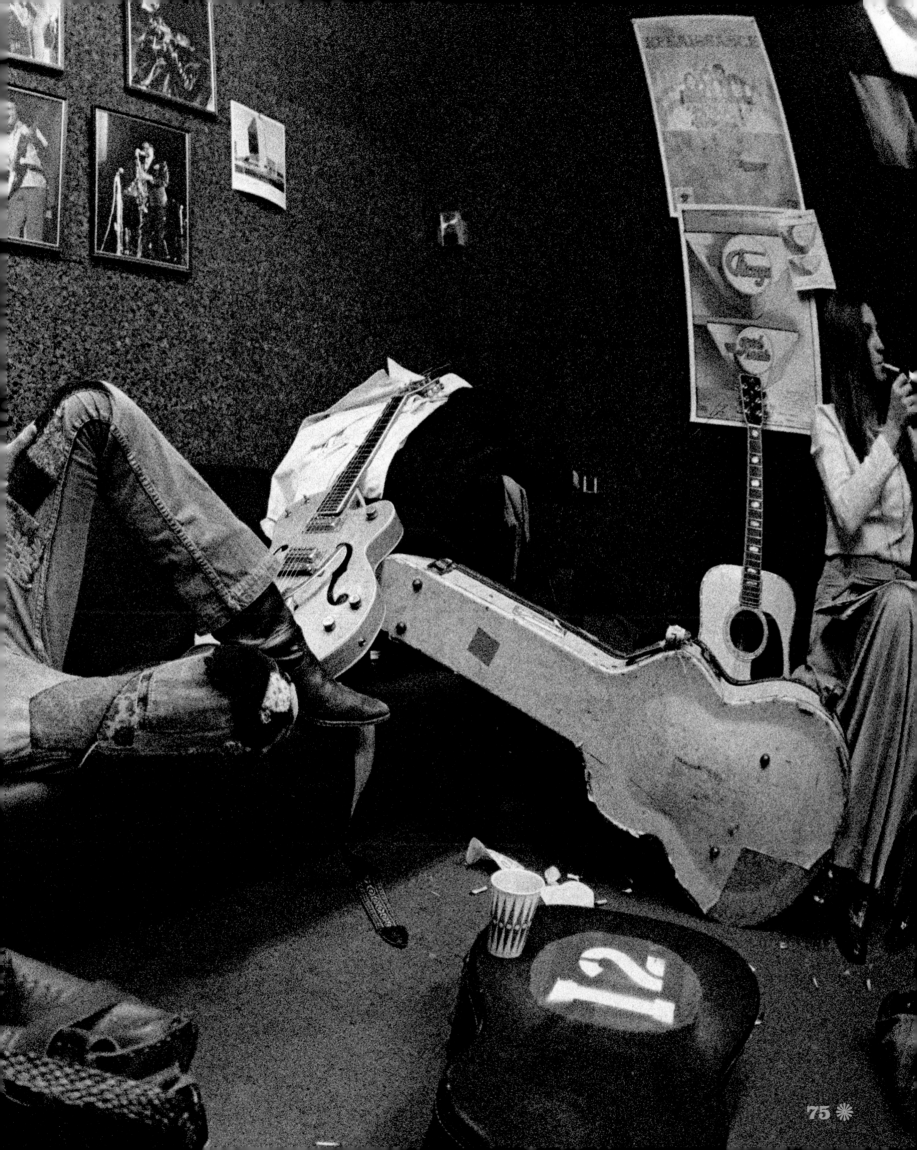

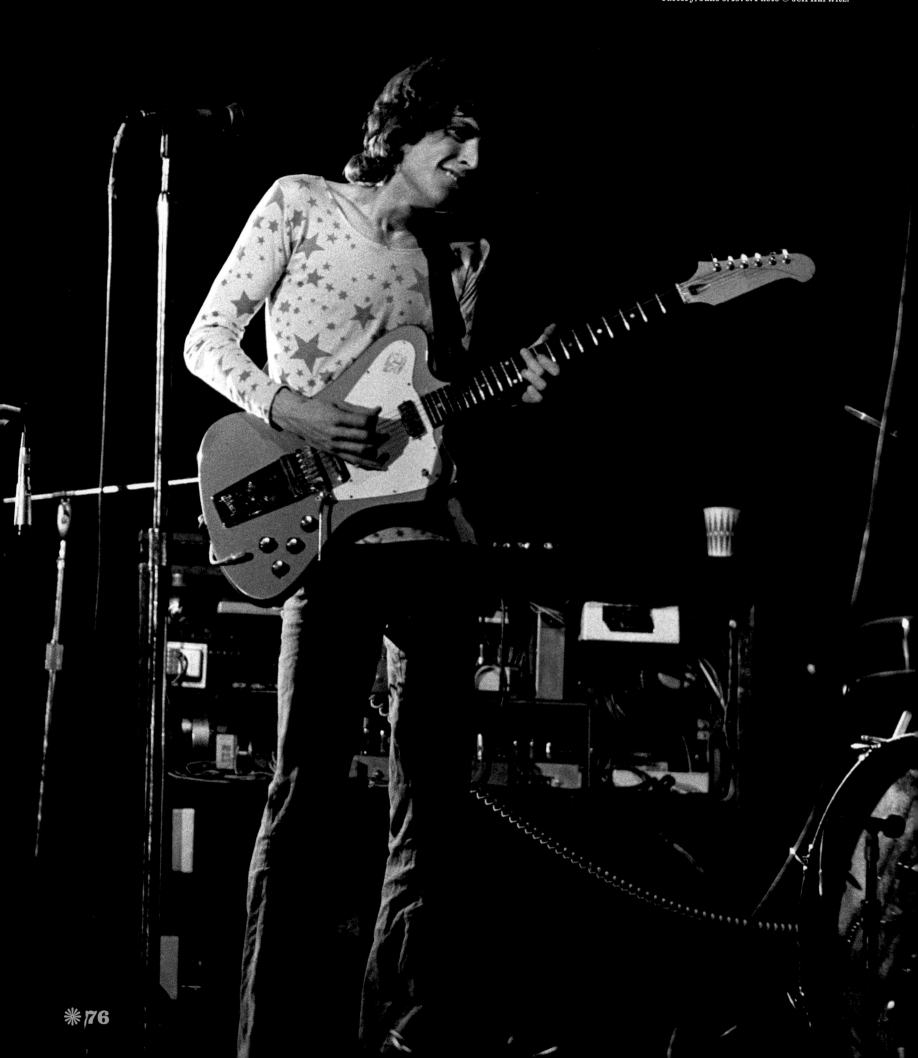

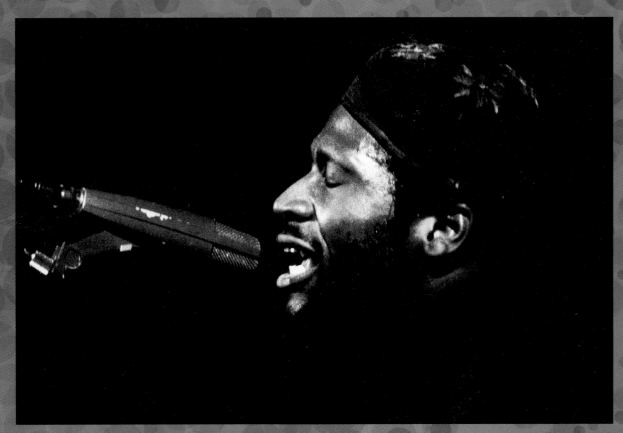

Taj Mahal at Electric Factory, circa 1969.

Phil Ochs played the Factory twice. The first time, he was in good form as an outstanding folk and protest singer-songwriter. The second time, he presented himself as a pop singer in a gold lamé suit made for him by Elvis's tailor. April 3–4, 1970. Photo © George Bilyk.

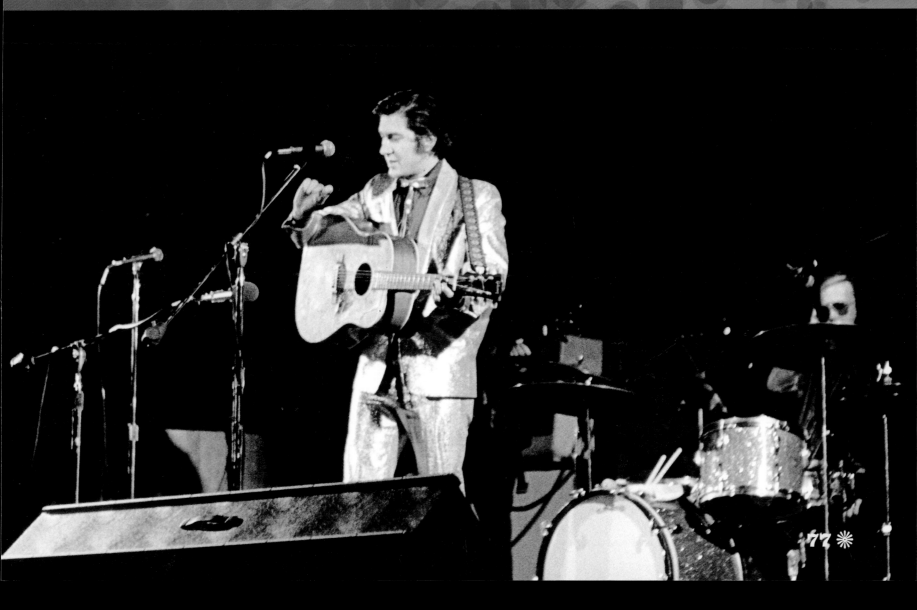

ERIC BAZILIAN: KID WITH A CAMERA

I was fourteen in 1968 when Electric Factory opened; as a musician, I couldn't stay away and repeatedly violated Philadelphia's curfew for minors. I appeared on Larry Magid's radar as an underage threat to the venue's survival, and a game evolved between us. I was determined to stay in, and Larry was just as determined to at least give the appearance of keeping me out.

The first show I saw there was Cream. I didn't bring my camera, and even if I had, it wouldn't have mattered. I was standing far enough back that I swore I'd never be anywhere but up front for a show that I cared about. I developed a system. After school on Friday I would take the train to Suburban Station and walk to 22nd and Arch, arriving by five o'clock. I'd be first in line and first in the door to claim the front and center spot in front of the stage. After the show I'd catch the train back home, develop the negatives, and dry them overnight. After printing them on Saturday, I'd take the train into town, sell my prints to the kids in line at the Factory, and give copies to the band onstage at the end of the show.

When the larger shows moved to the Spectrum, I could easily navigate to the front of the rotating stage and get good angles. Cream was my first show there, too. Jimi Hendrix was next, as I recall. When the Stones played in November, Jerry Spivak actually led me through the crowd to the front of the stage so I could "get some good pictures, kid." The Who played in '71, right after *Who's Next* was released. I preferred my Factory shots, though: skinny Pete in a T-shirt and the psychedelic light show projected on white sheets behind the band.

The Factory shows I remember best: the Jeff Beck Group (with Rod Stewart, Ron Wood, Nicky Hopkins, and Mickey Waller), with Ten Years After opening (they stole the show); Ten Years After, with Sweet Stavin Chain opening; Spirit, with Chicago Transit Authority opening; the Grateful Dead (first of many); Pink Floyd during the *Atom Heart Mother* period; Traffic with Fairport Convention; Jefferson Airplane; Moby Grape (unfairly forgotten in the sea of rock history); the Faces right after Rod and Ronnie had joined them, maybe opening for Grand Funk Railroad; Elton John, at least twice; the Who, three nights. Two in May, as *Tommy* was being released, and one in October. Revelatory.

—Eric Bazilian, *songwriter, guitarist, and sometime photographer*

Pete Townshend with the Who at Electric Factory, May 3, 1969. Photos © Eric Bazilian.

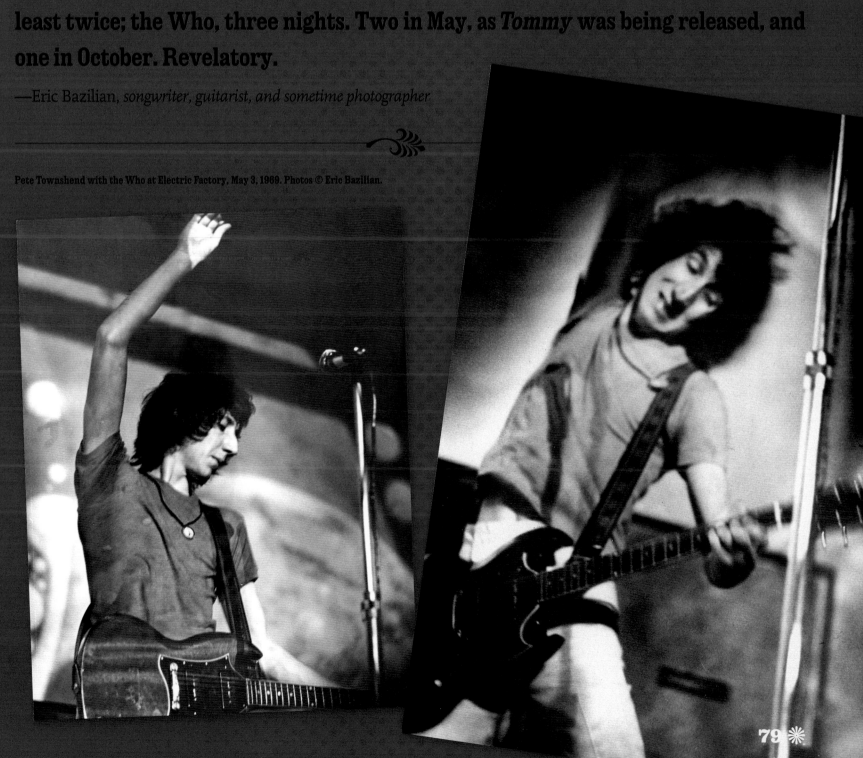

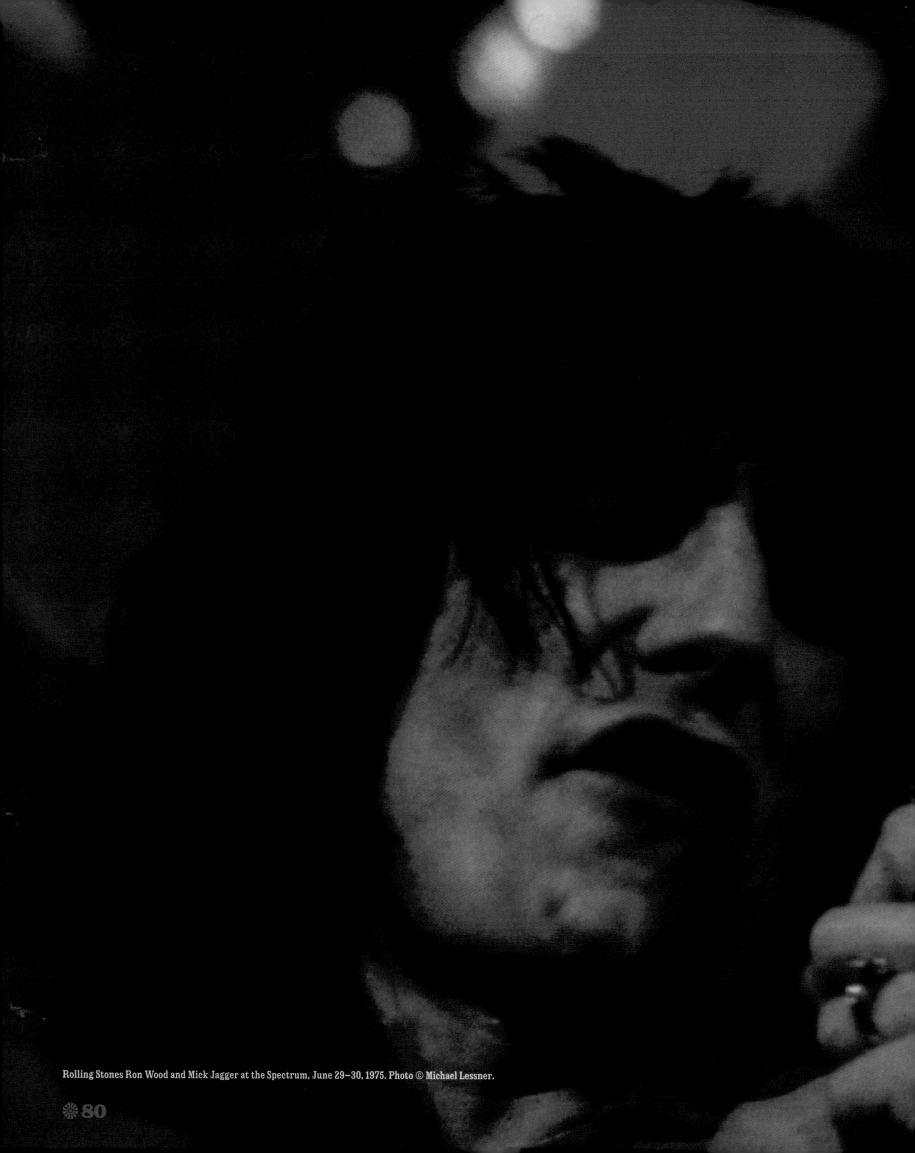

Rolling Stones Ron Wood and Mick Jagger at the Spectrum, June 29–30, 1975. Photo © Michael Lessner.

ELECTRIC FACTORY
1970s

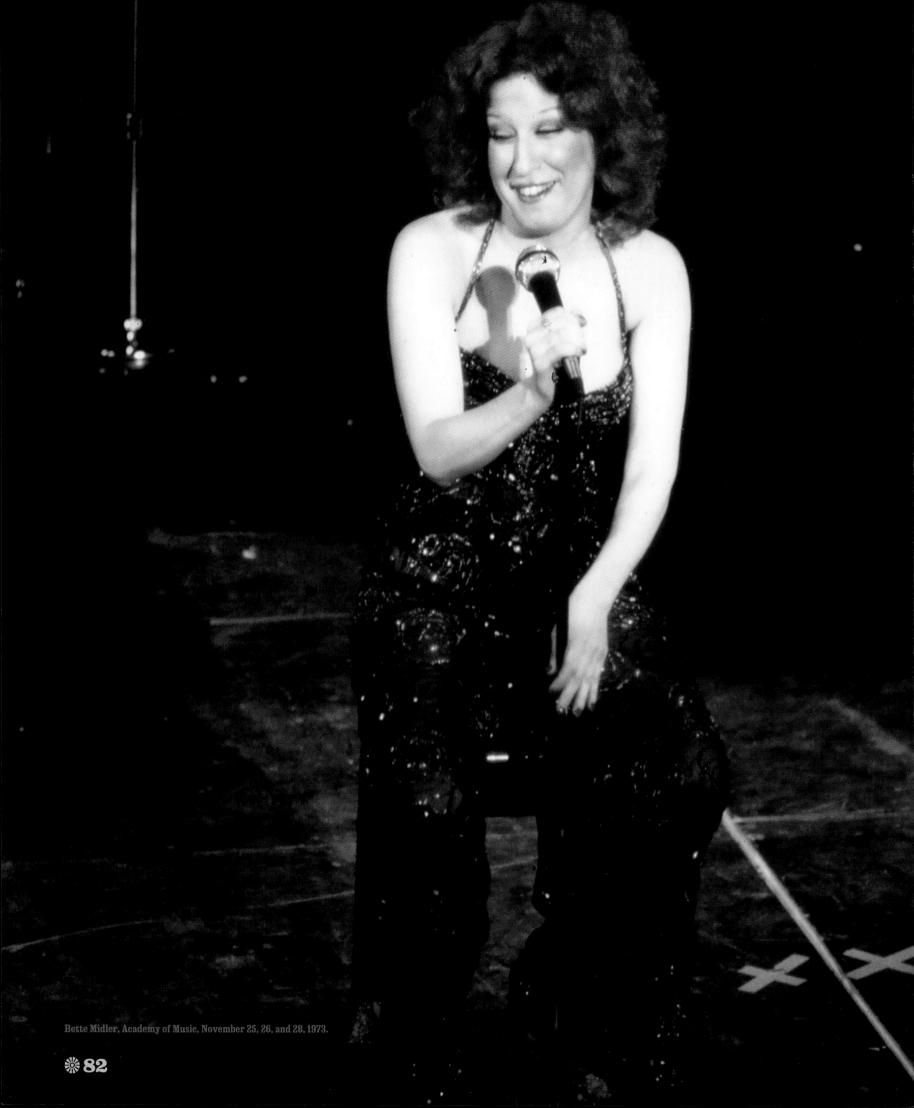

Bette Midler, Academy of Music, November 25, 26, and 28, 1973.

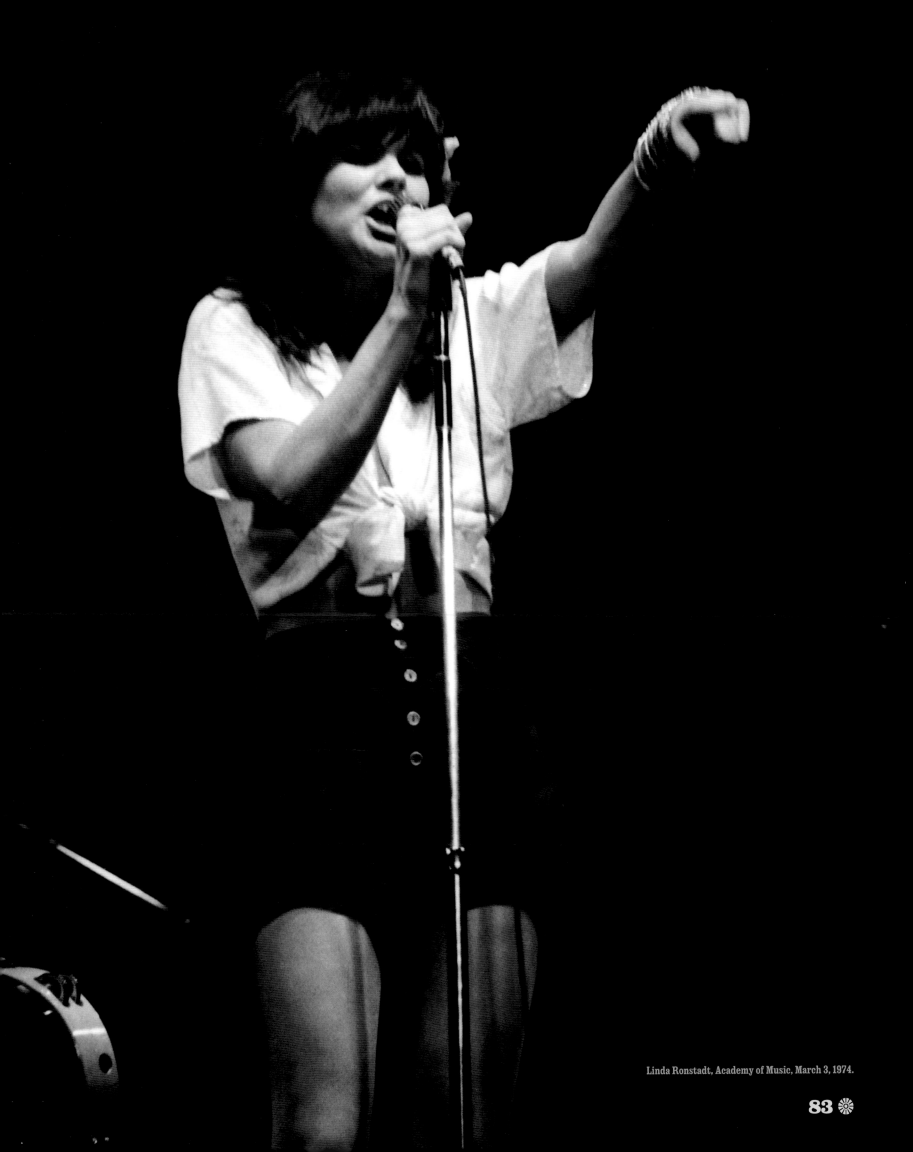

Linda Ronstadt, Academy of Music, March 3, 1974.

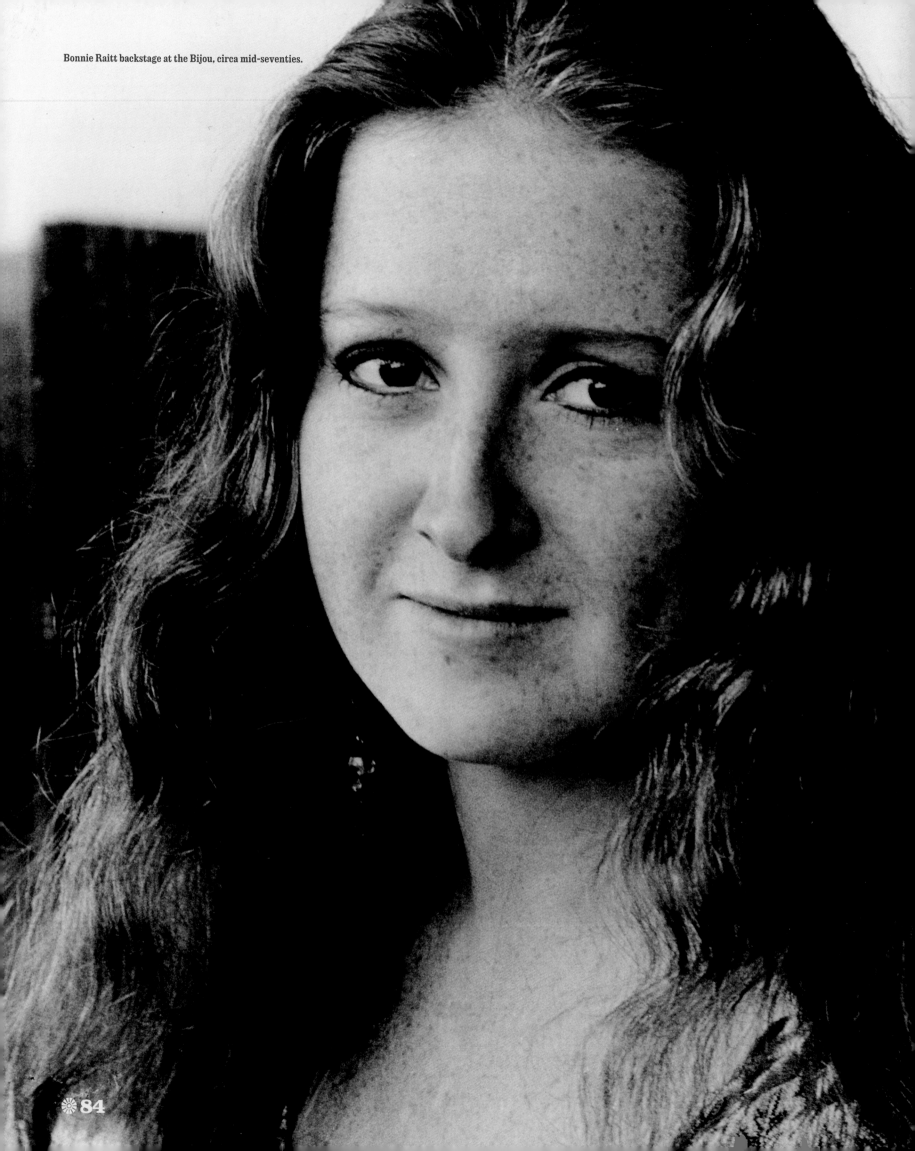

Bonnie Raitt backstage at the Bijou, circa mid-seventies.

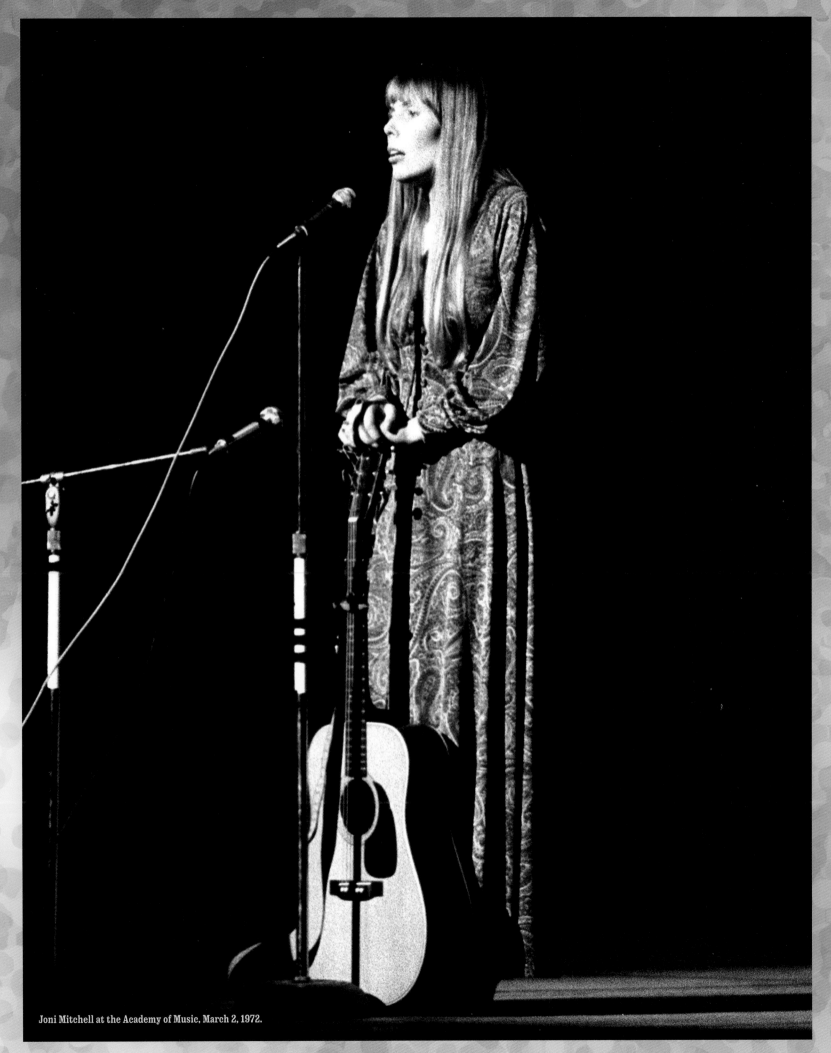

Joni Mitchell at the Academy of Music, March 2, 1972.

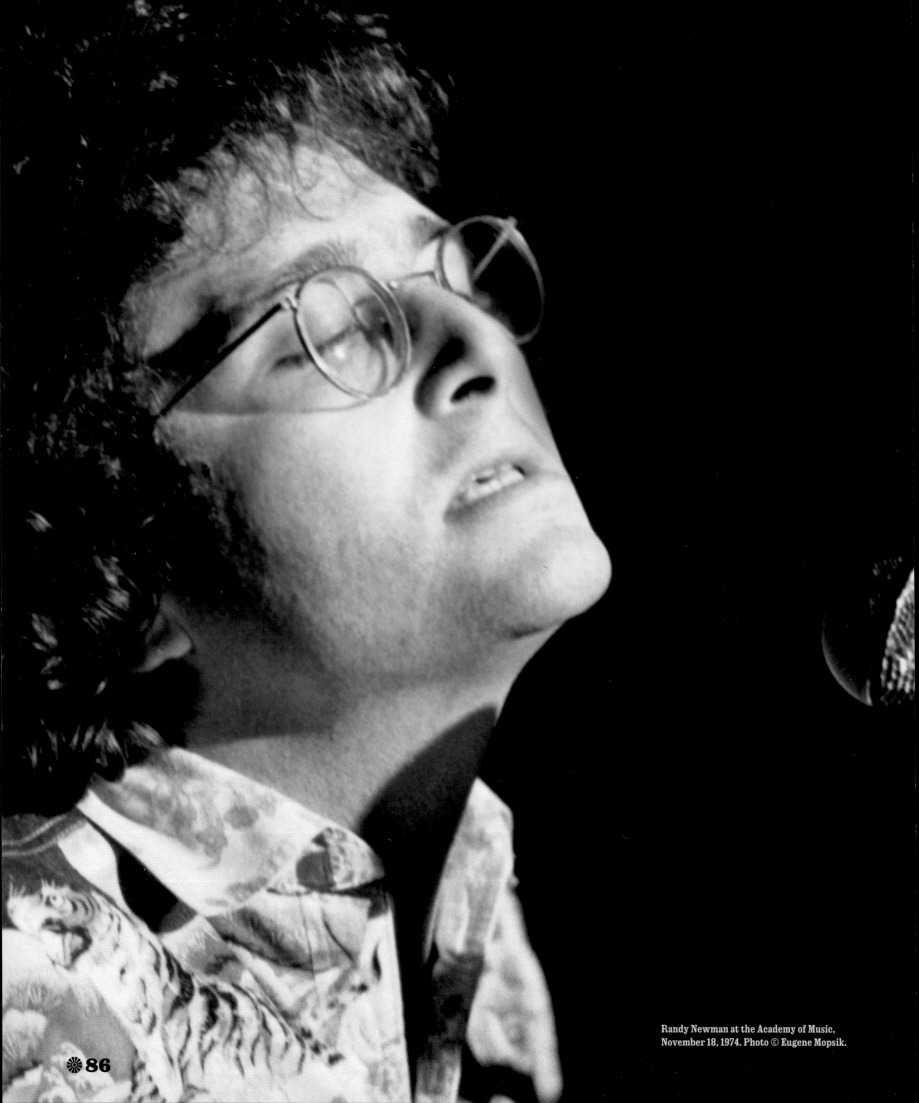

Randy Newman at the Academy of Music,
November 18, 1974. Photo © Eugene Mopsik.

THE BIJOU

The Bijou Cafe opened in 1972. By the early seventies, the underground had a downtown foothold in stores like Ward's Folly, replete with paisley shirts, and head shops like The Conspiracy. Small off-beat cafes were appearing. "When it opened, the Bijou seemed to legitimize the whole scene," says former DJ Steve Martorano, who lived just off Rittenhouse Square and immediately became a regular.

The Bijou helped introduce something else to Philadelphia: a place to go downtown on Sunday. Starting in the late seventies, the Spivaks and Larry Magid made it a point to keep the club open on Sundays to counter the general lifelessness of Center City on that day and help break down the blue laws prohibiting the sale of alcohol.

Whereas the Electric Factory was raw and rollicking, the Bijou felt informal and relaxed. Having a liquor license meant that it catered to a slightly older and more sophisticated clientele.

The club introduced a raft of musicians and comedians who would go on to claim Philly as their biggest market.

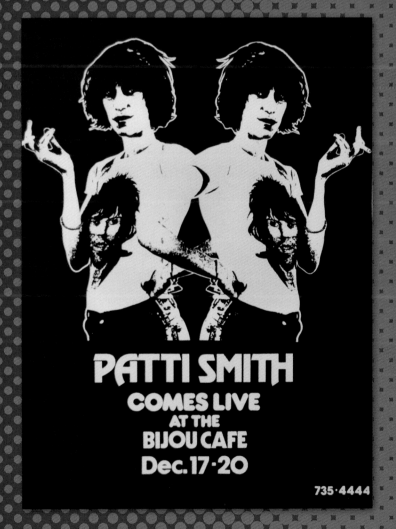

PATTI SMITH
COMES LIVE
AT THE
BIJOU CAFE
Dec. 17-20

735-4444

Above: Bijou neon sign, which hung over the stage, was designed by Anson McKenny, a local artist.
Right: Patti Smith played the Bijou in 1975, the year her classic album *Horses* was released.

Monday, September 22

JERRY WEINTRAUB
presents

The Concert

BASIE
FITZGERALD
AND
SINATRA

Tickets on sale Mon., Aug.18
$15.00, 12.50, 10.00
available at Spectrum box office,
all ⊗TICKETRON locations.

IIII Spectrum PHILADELPHIA 19148
(215) FL9-500E

MILLER HIGH LIFE
PRESENTS

MARVIN
GAYE

special guest

ASHFORD & SIMPSON

SATURDAY, JULY 9-8PM
$17.50 · 14 · 12.50
SEATING IN THE ROUND.

PRESENTED IN ASSOCIATION WITH

electric factory concerts

ANOTHER MILLER THRILLER

TICKETS: TICKETRON · EFC BOX OFFICE (1231 VINE ST.)
CHARGE BY PHONE (215) 627-0532 or (609) 344-1770 FOR INFO: (215) 569-9416

IIII Spectrum

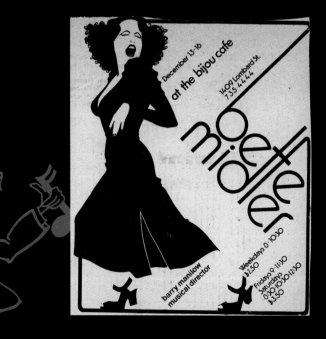

December 13-16
at the bijou cafe
1409 Lombard St.
735-4444

bette midler

barry manilow
musical director

Weekdays 6-10:30
$2.50

Fridays 9-11:30
Saturday
6:30-10:30-12:30
$3.50

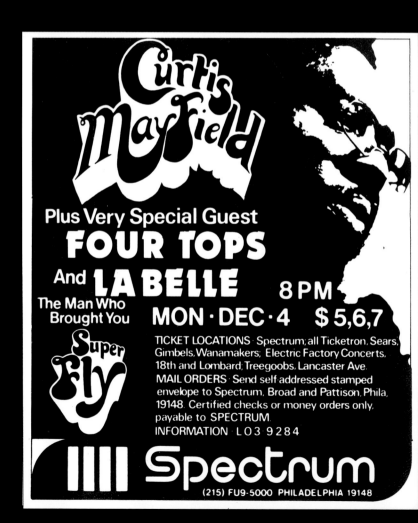

Curtis Mayfield

Plus Very Special Guest
FOUR TOPS
And LA BELLE
The Man Who
Brought You

8 PM
MON · DEC · 4 **$5,6,7**

Super Fly

TICKET LOCATIONS · Spectrum; all Ticketron, Sears,
Gimbels, Wanamakers; Electric Factory Concerts,
18th and Lombard; Treegoobs, Lancaster Ave.
MAIL ORDERS · Send self-addressed stamped
envelope to Spectrum, Broad and Pattison, Phila,
19148. Certified checks or money orders only,
payable to SPECTRUM.
INFORMATION · LO3-9284

IIII Spectrum

(215) FU9-5000 PHILADELPHIA 19148

MAGID-SPIVAK
present

LABELLE
...nightbirds

APRIL 8~13 ~ 8PM
ERLANGER THEATER 21ST. & MARKET
Wear something silver!

TICKETS: TUES.-THUR.- $7.50, 6.50, 5.50; FRI.-SUN.- $8.50, 7.50, 6.50;
at the Erlanger; TICKETRON; Wanamakers; & Electric Factory Concerts.
MAIL ORDERS- Send certified check or money order payable to
Electric Factory Concerts with stamped, self-addressed envelope
to Erlanger Theater, 21st & Market Sts., Phila., Pa. 19003.
For info.- (215) 561-5054 or (215) LO3-9284
Latecomers will be seated at the discretion of the management.

An *Electric Factory Concerts* Production

WDAS Presents

ISAAC HAYES

Mon, Nov 29.
Spectrum. at 8pm
tickets. $7.50, 6.50, 5.50, 4.50

TICKET LOCATION· The Spectrum, Paramount Records,
18th & Ridge Ave, 1518 South St; Wanamakers, Center City;
Empire Record Shop, 39 S. 52nd St; Treegoobs, 41st &
Lancaster Ave; Gimbels, Center City, Cheltenham; Herb
Johson's Record Store; Sunshine Records; Sly's Barber
Shop; Jam's Record Store; Broadway Records, Camden;
Lee's, Chester; Bag & Baggage, Wilmington

QUAKER CITY JAZZ

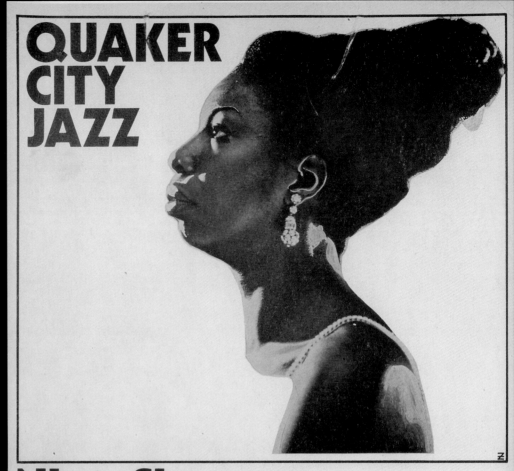

Nina Simone
Mandrill
Pharoh Sanders
Leon Thomas
Voices of East Harlem

special guest
The Undisputed Truth
"Smiling Faces, Sometime"

Mail Orders: Spectrum, Broad & Pattison Ave
Phila, Pa; Electric Factory Concerts,
338 So. 15th St; Empire Record Shop,
39 So. 52nd St; Treegoobs, 41st & Lancaster Ave
Paramount Record Shop, 18th & Ridge and
1518 South St; All Ticketron: All Sears,
Gimbels, Wanamakers;
Bag & Baggage, Wilmgton
Information: LOVE 222

SUNDAY·SEPT 19
Spectrum·7³⁰PM
TICKETS · $3,4,5,6
Produced by Spivak·Magid·Spectrum

89

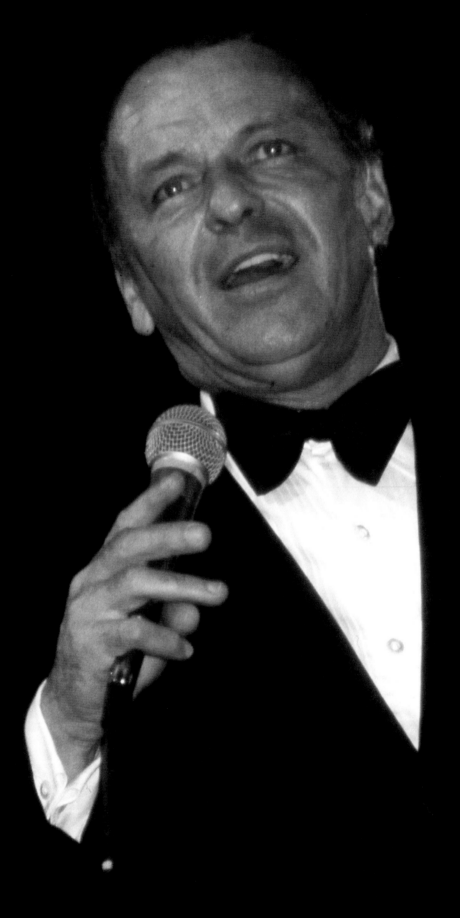

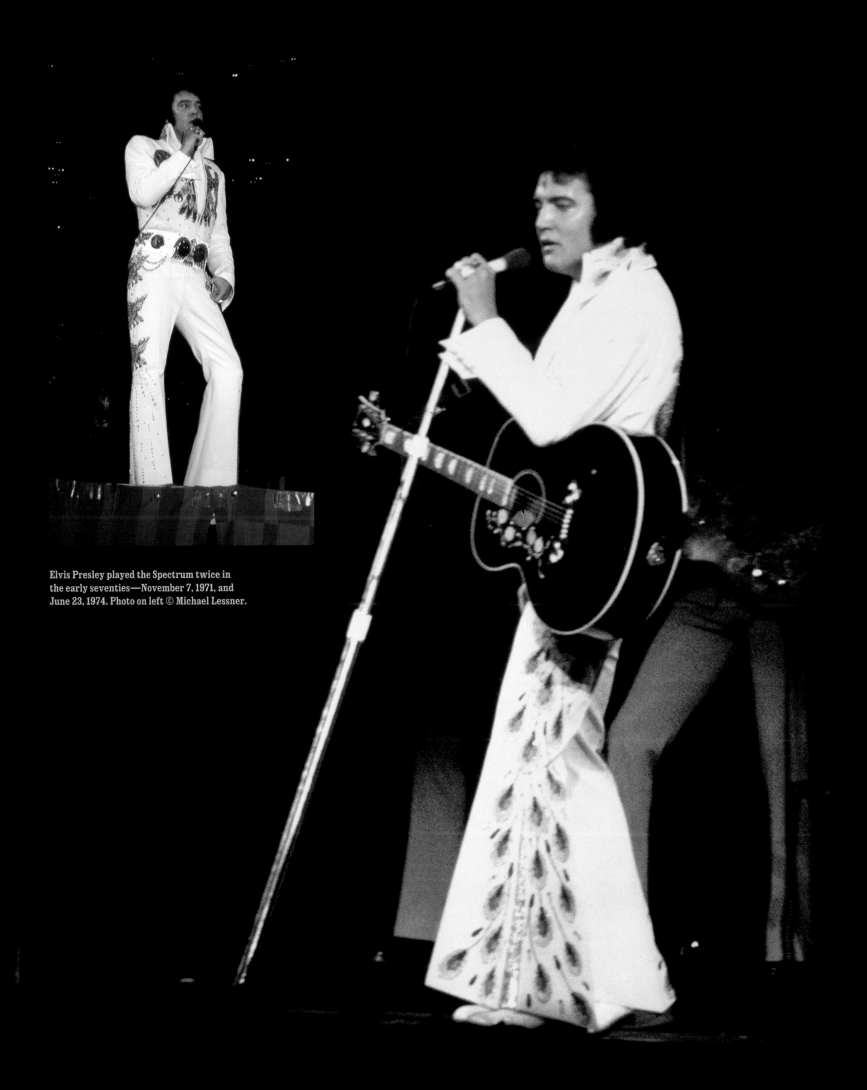

Elvis Presley played the Spectrum twice in the early seventies—November 7, 1971, and June 23, 1974. Photo on left © Michael Lessner.

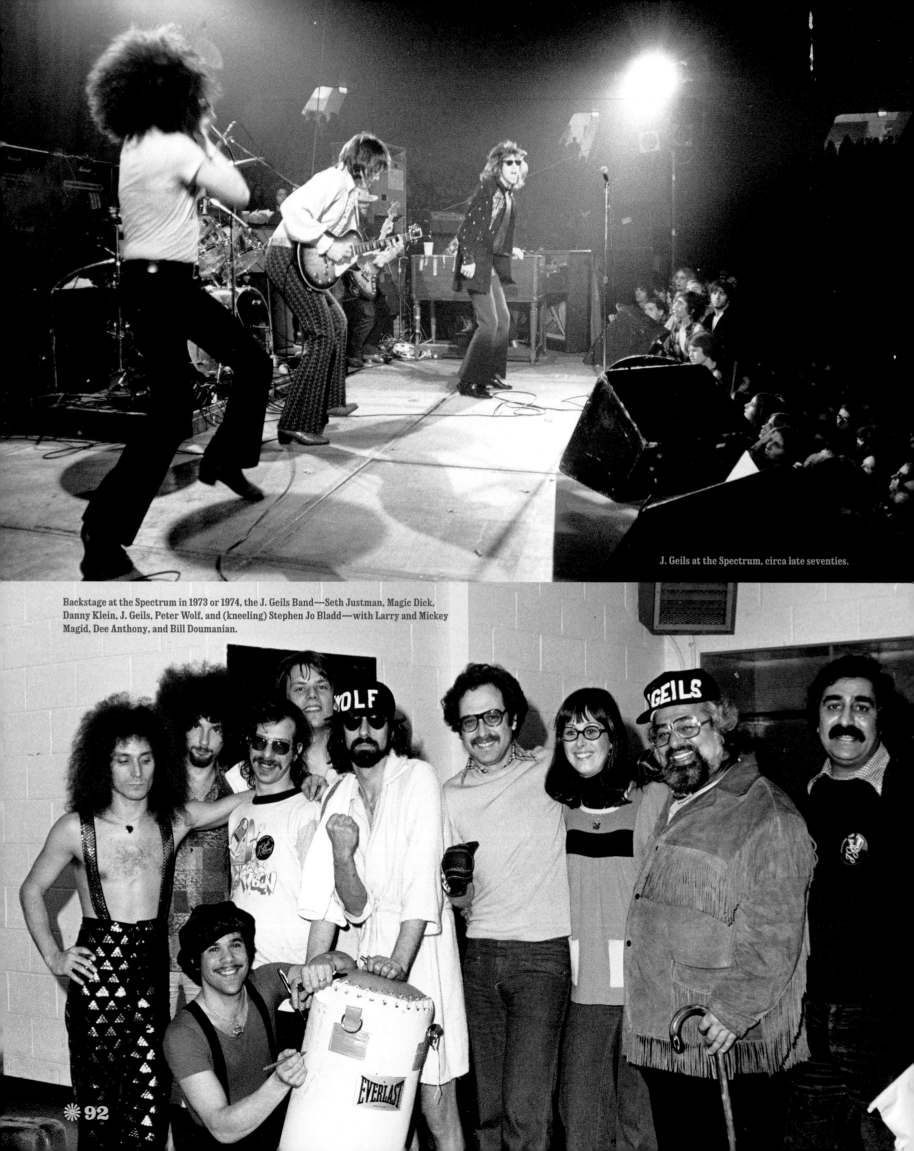

J. Geils at the Spectrum, circa late seventies.

Backstage at the Spectrum in 1973 or 1974, the J. Geils Band—Seth Justman, Magic Dick, Danny Klein, J. Geils, Peter Wolf, and (kneeling) Stephen Jo Bladd—with Larry and Mickey Magid, Dee Anthony, and Bill Doumanian.

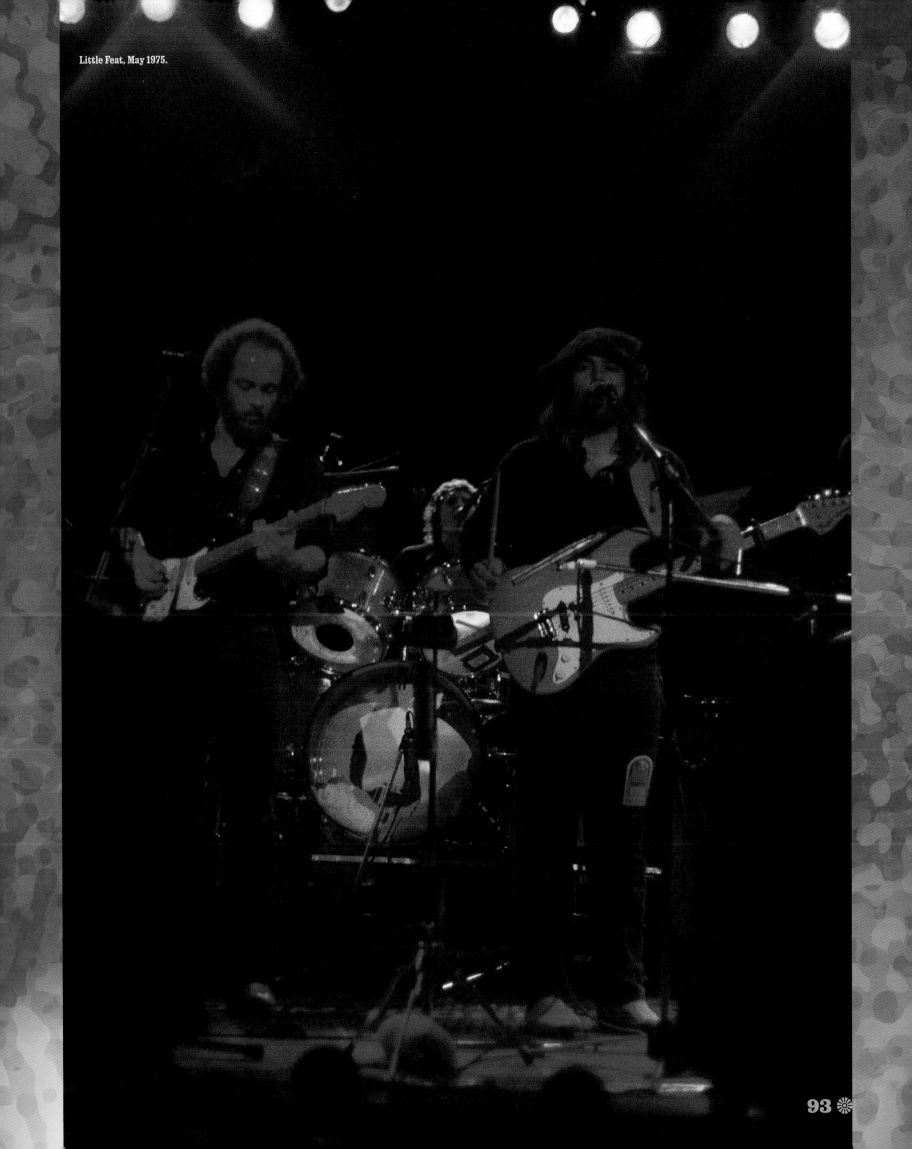

Little Feat, May 1975.

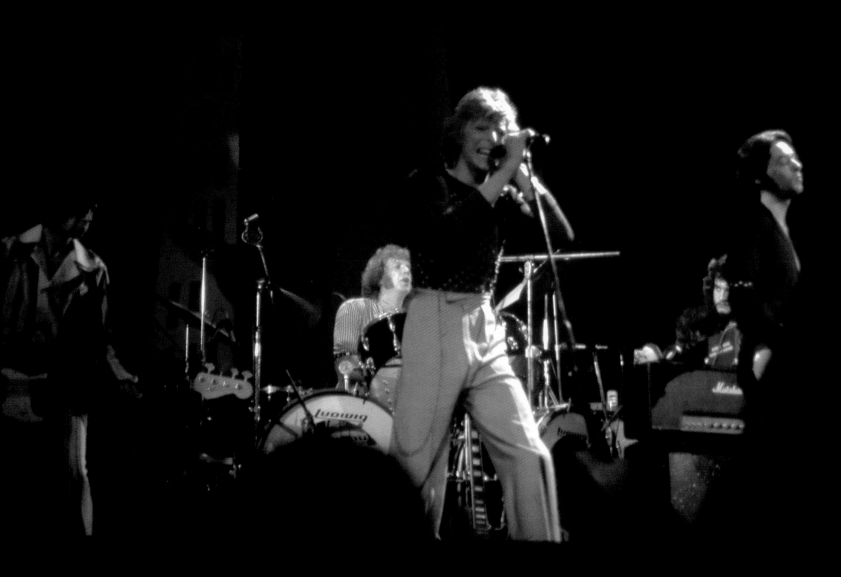

David Bowie. Top and bottom right photos:
Tower Theater, March 15–16, 1976. Photo ©
Michael Lessner. Inset photo: Spectrum, late
1970s. Photo © Zohrab Kazanjian.

Sara Dash of Labelle, Tower Theater, December 6–7, 1975.

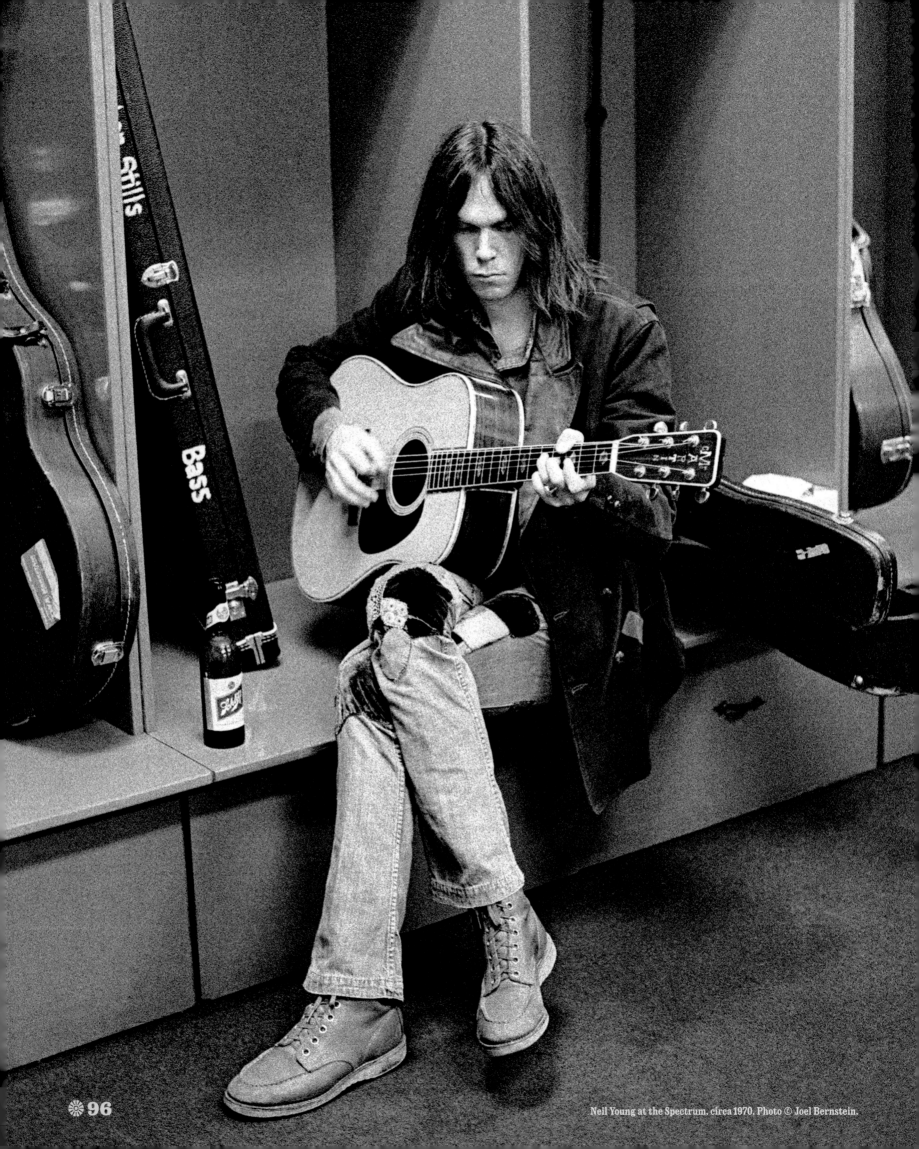

Neil Young at the Spectrum, circa 1970. Photo © Joel Bernstein.

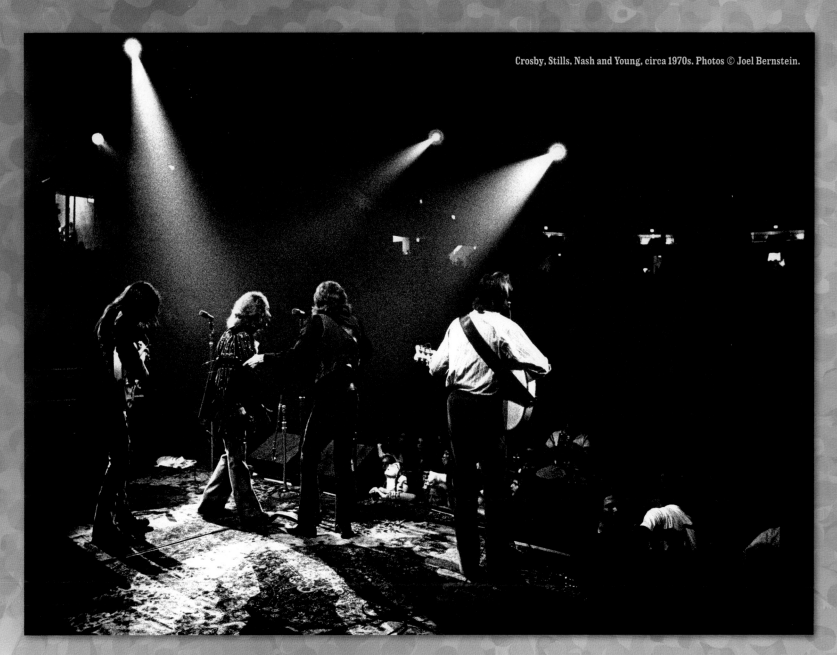
Crosby, Stills, Nash and Young, circa 1970s. Photos © Joel Bernstein.

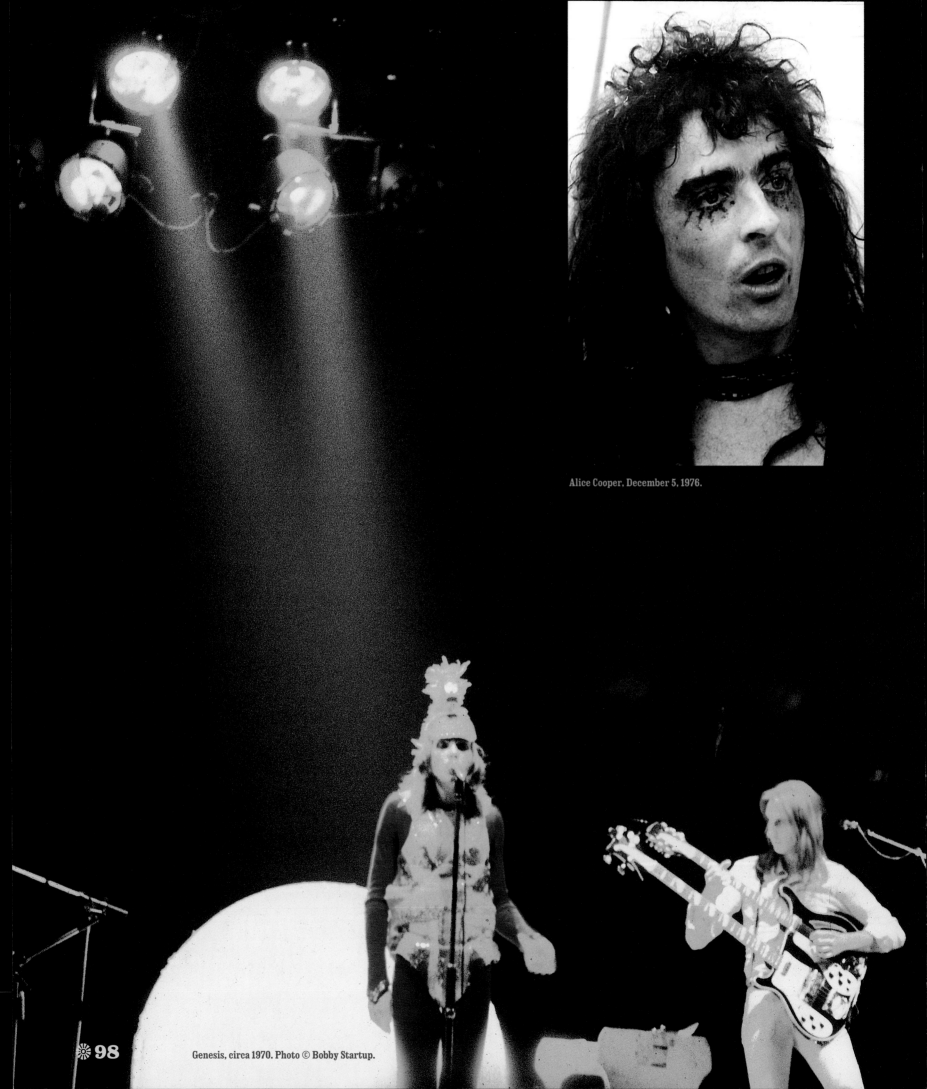

Alice Cooper, December 5, 1976.

Genesis, circa 1970. Photo © Bobby Startup.

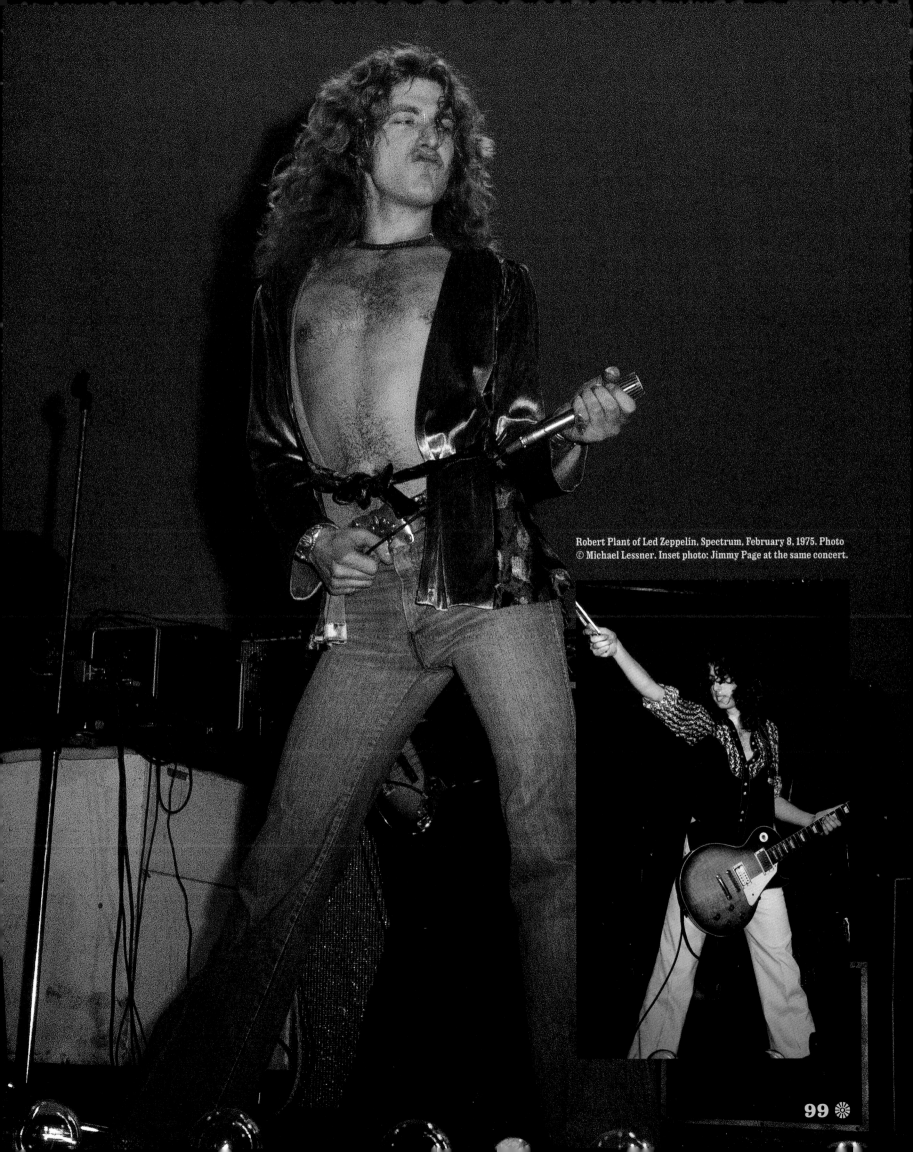

Robert Plant of Led Zeppelin, Spectrum, February 8, 1975. Photo © Michael Lessner. Inset photo: Jimmy Page at the same concert.

The Spectrum was a crucial launching pad both for big shows and for Electric Factory Concerts. Back in the fifties a local jazz promoter, Teddy Powell, gave Herb Spivak an important piece of advice: "I'll give you a hint for your business. The secret is in the bricks." Securing (or, better yet, owning) the building was the secret to making money on shows.

Putting on 50 or more shows a year at the 20,000-seat Spectrum introduced a new era for EFC. "We always made money at the Spectrum," Allen Spivak says. Acts performed on a revolving stage in the middle of the arena; the audience was closer to the band than in most other facilities, and applause ran down toward the stage rather than away.

"Concerts in big cavernous places were very controversial," remembers former DJ Steve Martorano. "It looked like, on one level, that business had overtaken every-

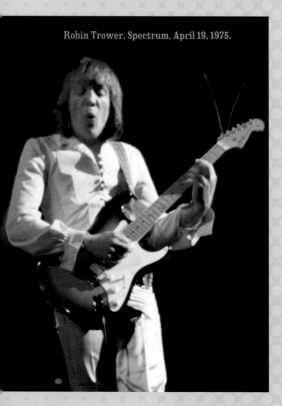

Robin Trower, Spectrum, April 19, 1975.

thing. On the other hand, it was thrilling seeing the Stones at the Spectrum in '69, or Cream on their farewell tour." The Stones played "Street Fighting Man" at the Spectrum, a politically charged song inspired by a massive antiwar rally at London's U.S. embassy. When Martorano heard it, he thought, "This whole thing transcends music. It was the sound of 40,000 charging feet. . . . The Spectrum represented the quantum leap rock music had made."

In 1976 the Spectrum was named Arena of the Year by *Billboard,* and the Spivaks and Magid put on 56 concerts there.

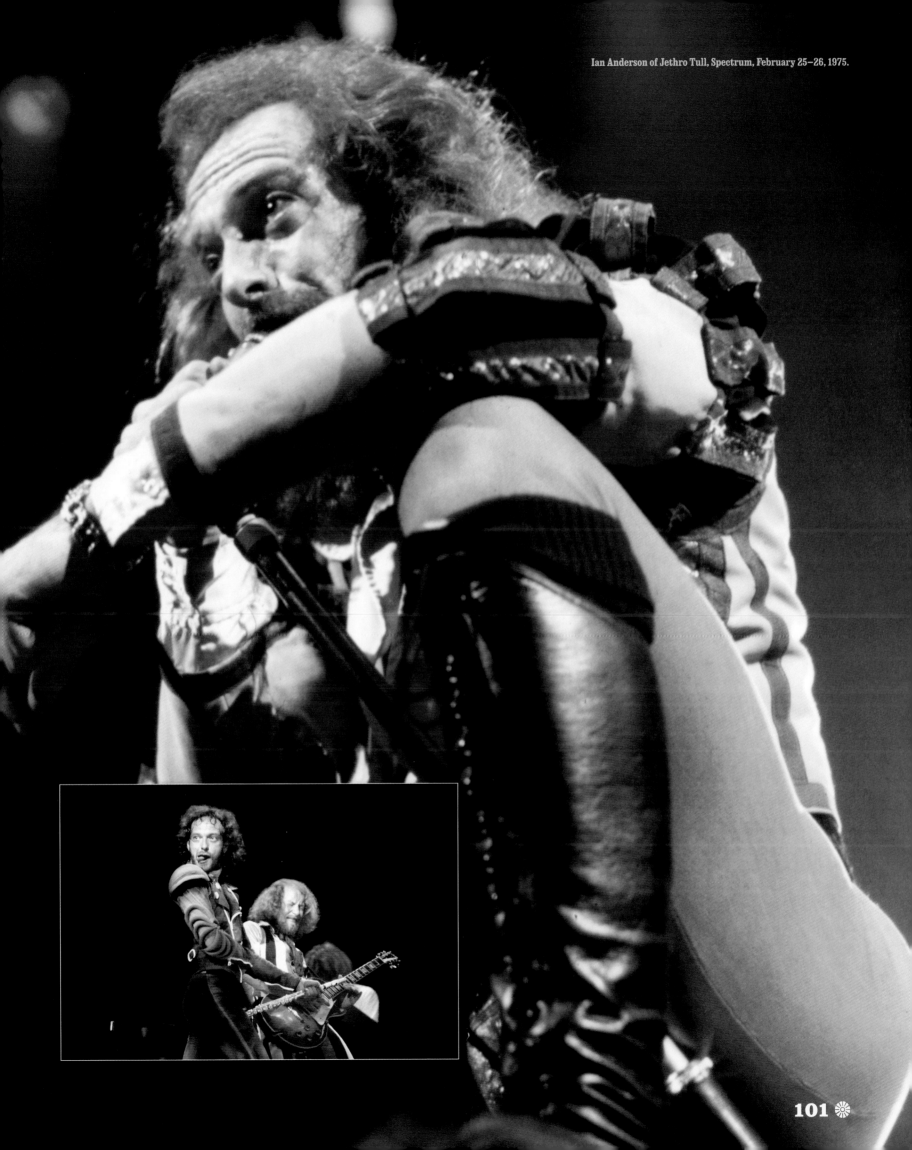

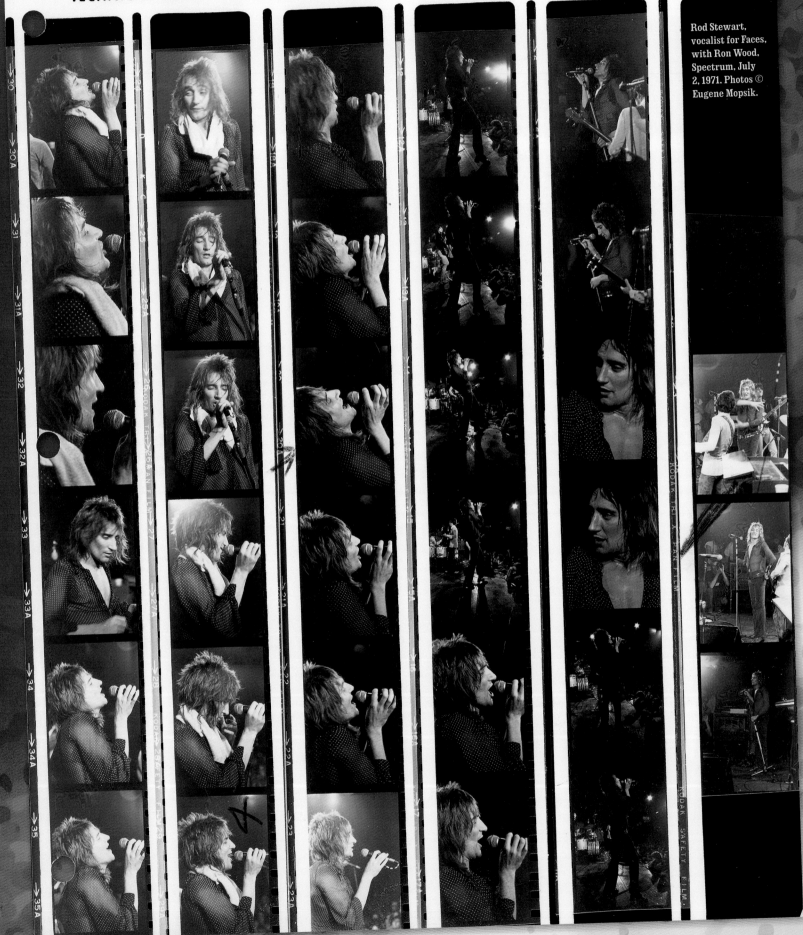

Rod Stewart, vocalist for Faces, with Ron Wood, Spectrum, July 2, 1971. Photos © Eugene Mopsik.

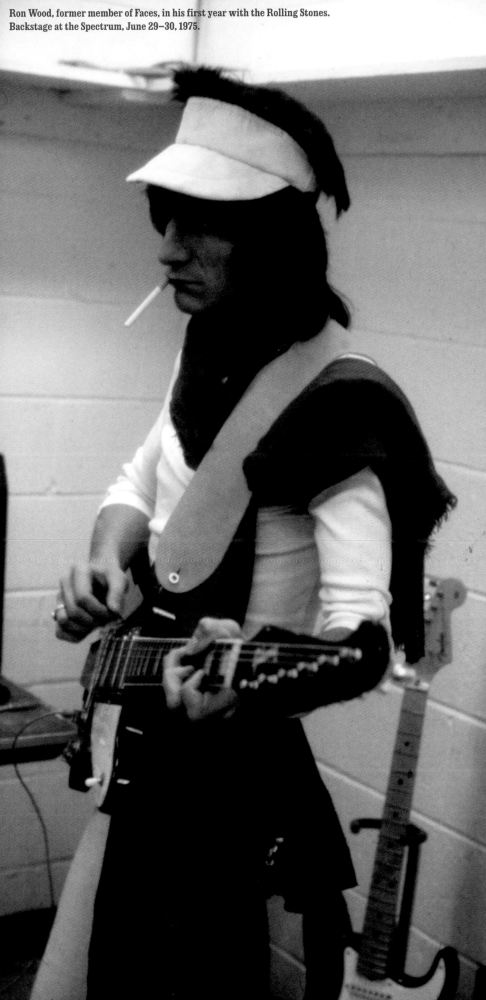

Ron Wood, former member of Faces, in his first year with the Rolling Stones. Backstage at the Spectrum, June 29–30, 1975.

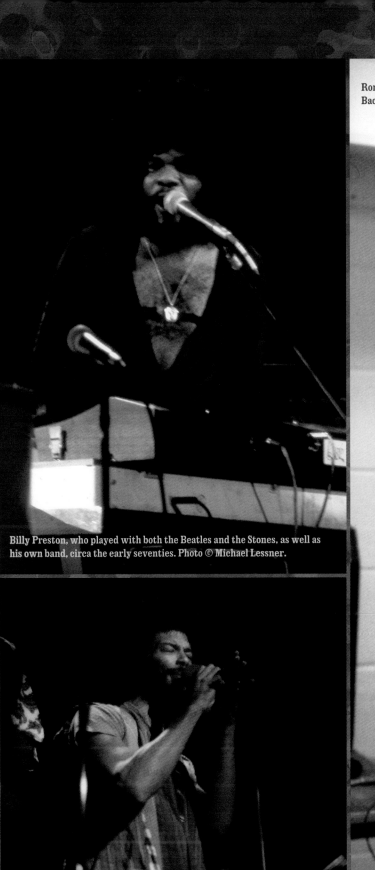

Billy Preston, who played with both the Beatles and the Stones, as well as his own band, circa the early seventies. Photo © Michael Lessner.

Gil Scott-Heron at the Bijou, circa mid-seventies.

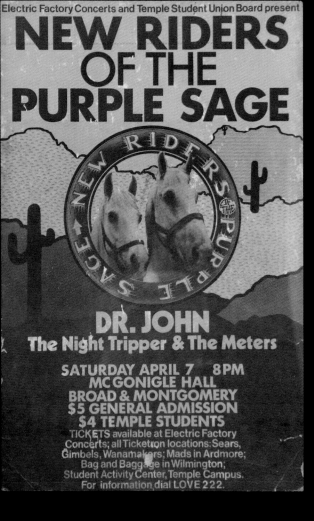

Electric Factory Concerts and Temple Student Union Board present

NEW RIDERS OF THE PURPLE SAGE

DR. JOHN
The Night Tripper & The Meters

SATURDAY APRIL 7 8PM
MCGONIGLE HALL
BROAD & MONTGOMERY
$5 GENERAL ADMISSION
$4 TEMPLE STUDENTS
TICKETS available at Electric Factory
Concerts; all Ticketron locations: Sears,
Gimbels, Wanamakers; Mads in Ardmore;
Bag and Baggage in Wilmington;
Student Activity Center, Temple Campus.
For information, dial LOVE 222.

GRATEFUL DEAD

& THE NEW RIDERS OF PURPLE SAGE
SATURDAY • APRIL 10 • 8 PM
MAYSER CENTER • F&M COLLEGE • LANCASTER, PA
$4.50 F&M students • $5.50 gen.adm.

Ticket Locations: CAMPUS HOUSE & SWITCHBOARD; STAN'S RECORD BAR, LANCASTER, PA; DISC-WORLD, YORK MALL;
CENTRAL TICKET AGENCY, COLONIAL HOTEL, YORK, PA; WEST SIDE SHOPPE, COLLEGE AVE. LANCASTER

Captain Beefheart
and his
Magic Band

Midnight
at the
Walnut Street Theater

Friday, Saturday, October 22 & 23
all tickets $5.
Ticket On Sale - Walnut Street Theater, 9th & Walnut Sts.
Electric Factory Concerts, 338 S 15th St. All Ticketron locations.
Produced by Electric Factory Concerts

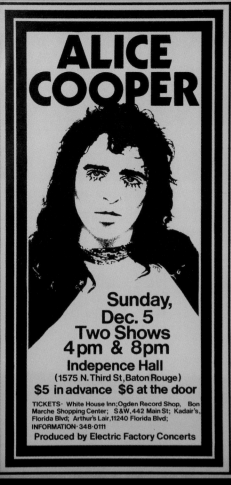

ALICE COOPER

Sunday, Dec. 5
Two Shows
4 pm & 8 pm
Indepence Hall
(1575 N. Third St, Baton Rouge)
$5 in advance $6 at the door

TICKETS: White House Inn; Ogden Record Shop, Bon Marche Shopping Center; S&W, 442 Main St; Kadair's, Florida Blvd; Arthur's Lair, 11240 Florida Blvd; INFORMATION: 348-0111
Produced by Electric Factory Concerts

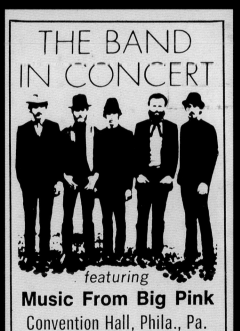

THE BAND IN CONCERT

featuring

Music From Big Pink

Convention Hall, Phila., Pa.
Wednesday, May 28 • 8 PM
$3 $4 $5

Tickets: Electric Factory, 2201 Arch St.; Mads, Ardmore; Wanamakers, 13th & Chestnut; We Three Record Store, Moorestown, N.J. & Plymouth Meeting Mall; Bag & Baggage, Wilmington, Del. **MAIL ORDERS:** Electric Factory, 2201 Arch St., Phila., Pa. Enclose self-addressed, stamped envelope.

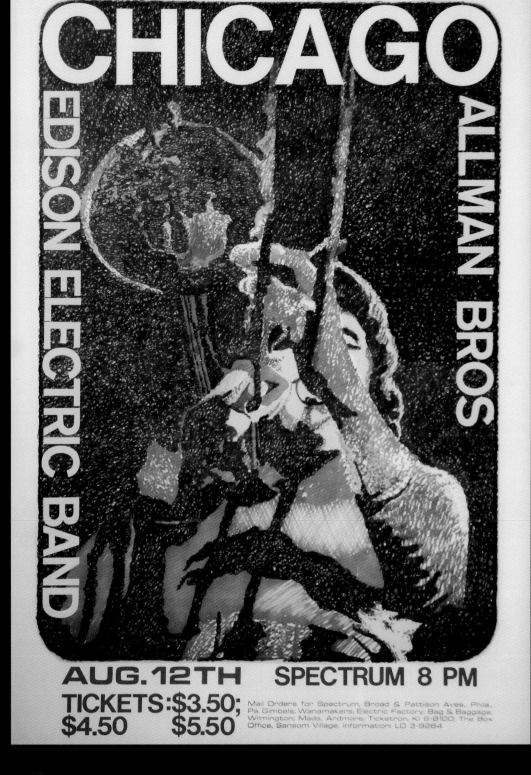

CHICAGO

EDISON ELECTRIC BAND

ALLMAN BROS

AUG. 12TH SPECTRUM 8 PM
TICKETS: $3.50;
$4.50 $5.50

Mail Orders for Spectrum, Broad & Pattison Aves., Phila., Pa. Gimbels; Wanamakers; Electric Factory; Bag & Baggage, Wilmington; Mads, Ardmore; Ticketron, KI 6-8100, The Box Office, Sansom Village. Information: LO 3-9284

105 ✻

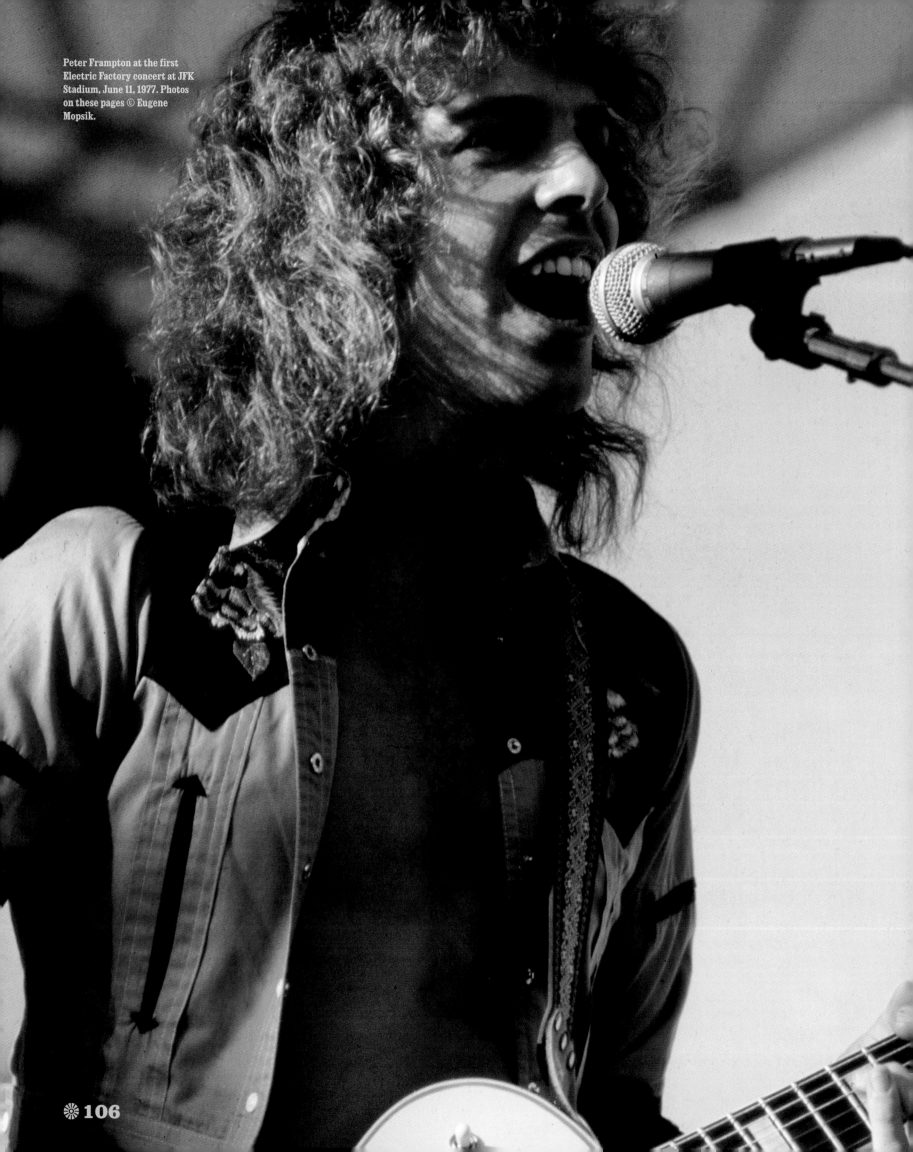

A Yes/Frampton concert at JFK Stadium in June 1976 grossed more than $1 million. It was hot in the daytime, cool at night. Fans started trash can fires in the stands to warm up. Allen Spivak would eventually offer the city $5 million to buy JFK Stadium, a creaky old place that needed work. Instead it would be torn down.

EFC's master plan of owning, or having primary access to, so many venues of different sizes and atmospheres let Magid and Spivak find and develop acts and take performers through all the stages of their careers, working toward bigger venues. Stadium concerts were the pinnacle of a specific kind of audience experience—young people gathered in huge numbers, the size of a small city, to listen to music and feed off of their own collective energy.

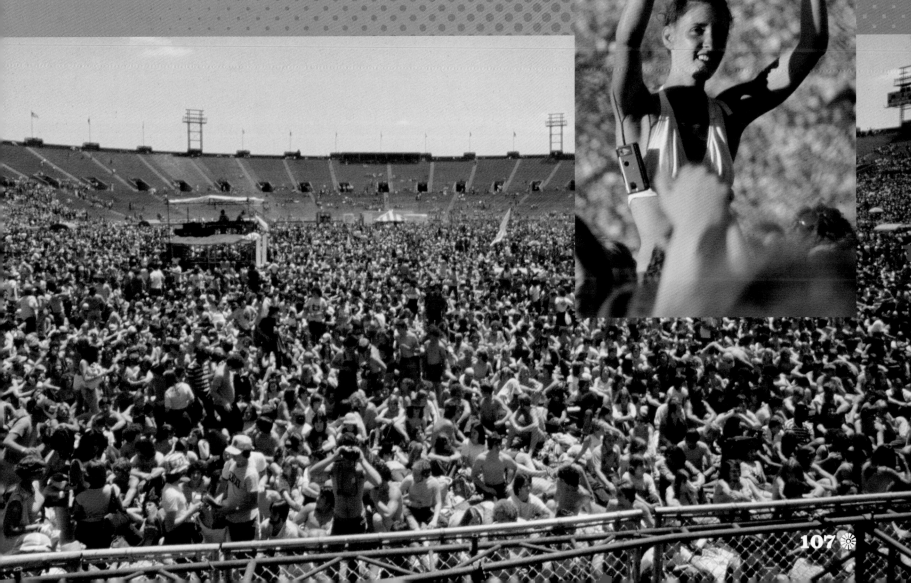

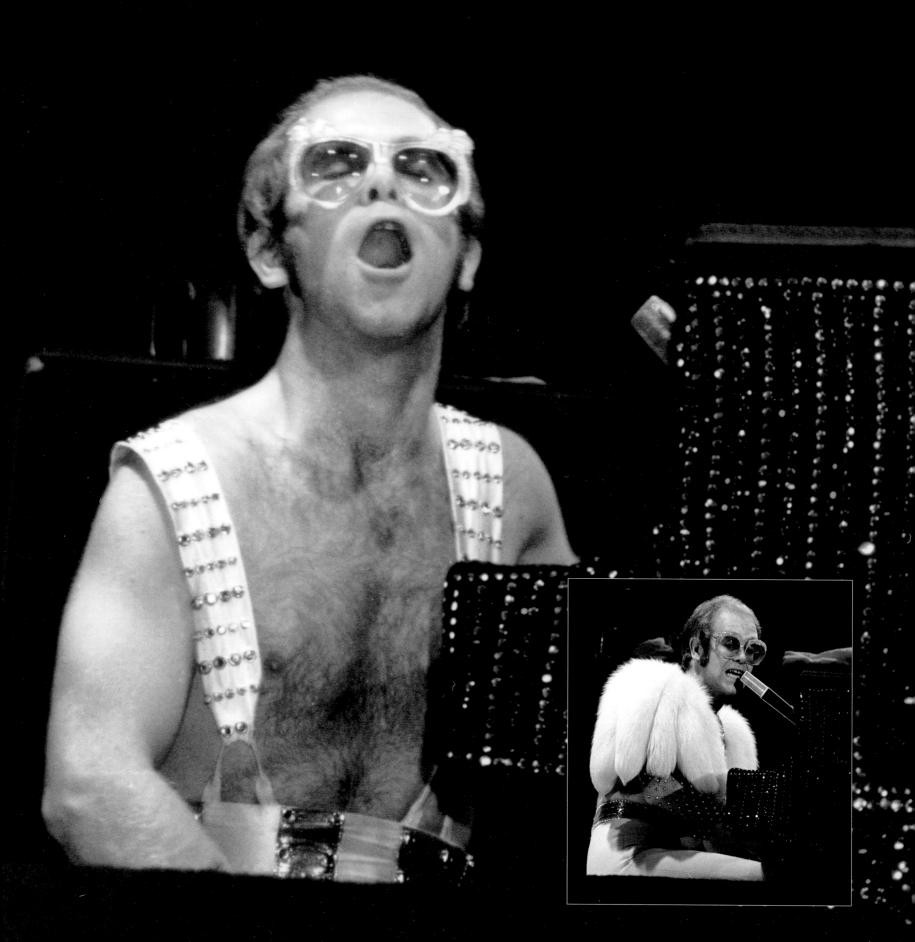

Elton John played the Spectrum numerous times in the seventies. Large photo © Michael Lessner. Inset photo © Zohrab Kazanjian.

Billy Joel, another Philly favorite, at the Bijou, September 25–28, 1974. Inset photo, at the Spectrum, circa late seventies. Photo © Zohrab Kazanjian.

109 ✳

Roger McGuinn, Spectrum, September 11, 1975.

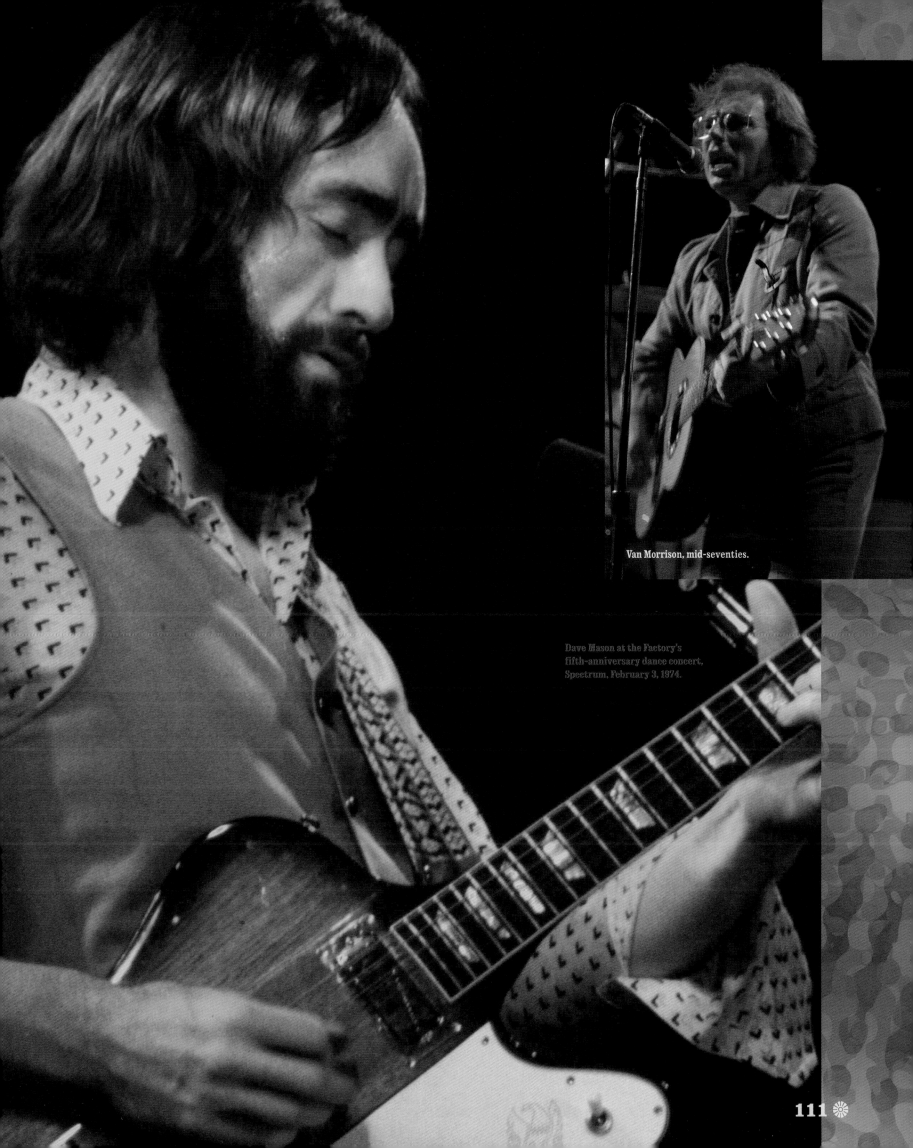

Van Morrison, mid-seventies.

Dave Mason at the Factory's
fifth-anniversary dance concert,
Spectrum, February 3, 1974.

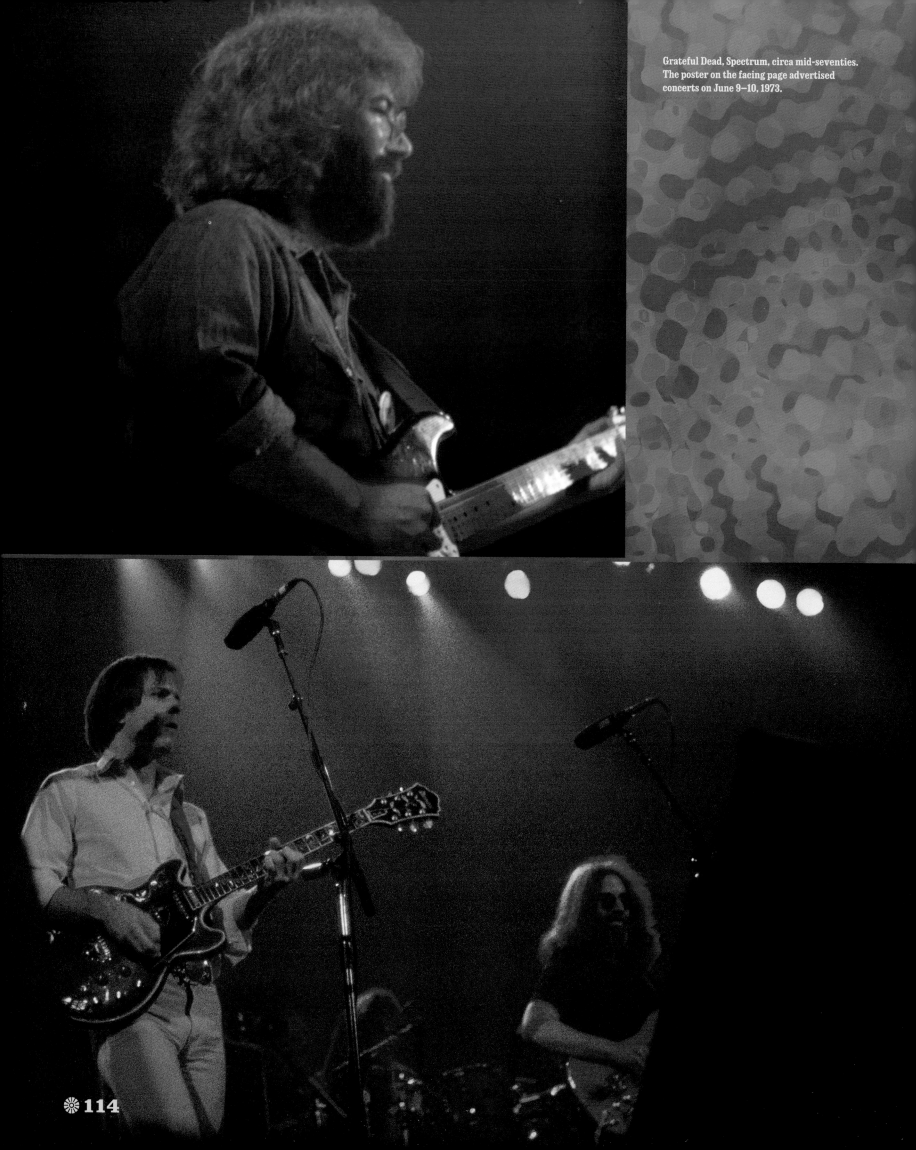

Grateful Dead, Spectrum, circa mid-seventies.
The poster on the facing page advertised
concerts on June 9–10, 1973.

Electric Factory Concerts Presents

Grateful Dead | Allman Brothers Band

Doug Sahm

Wet Willie

R.F.K. Memorial Stadium
Washington, D.C.
$7 General Admission Each Day

Tickets on sale now.
Tickets available at all 🎟 TICKETRON locations.
For information dial TICKETRON

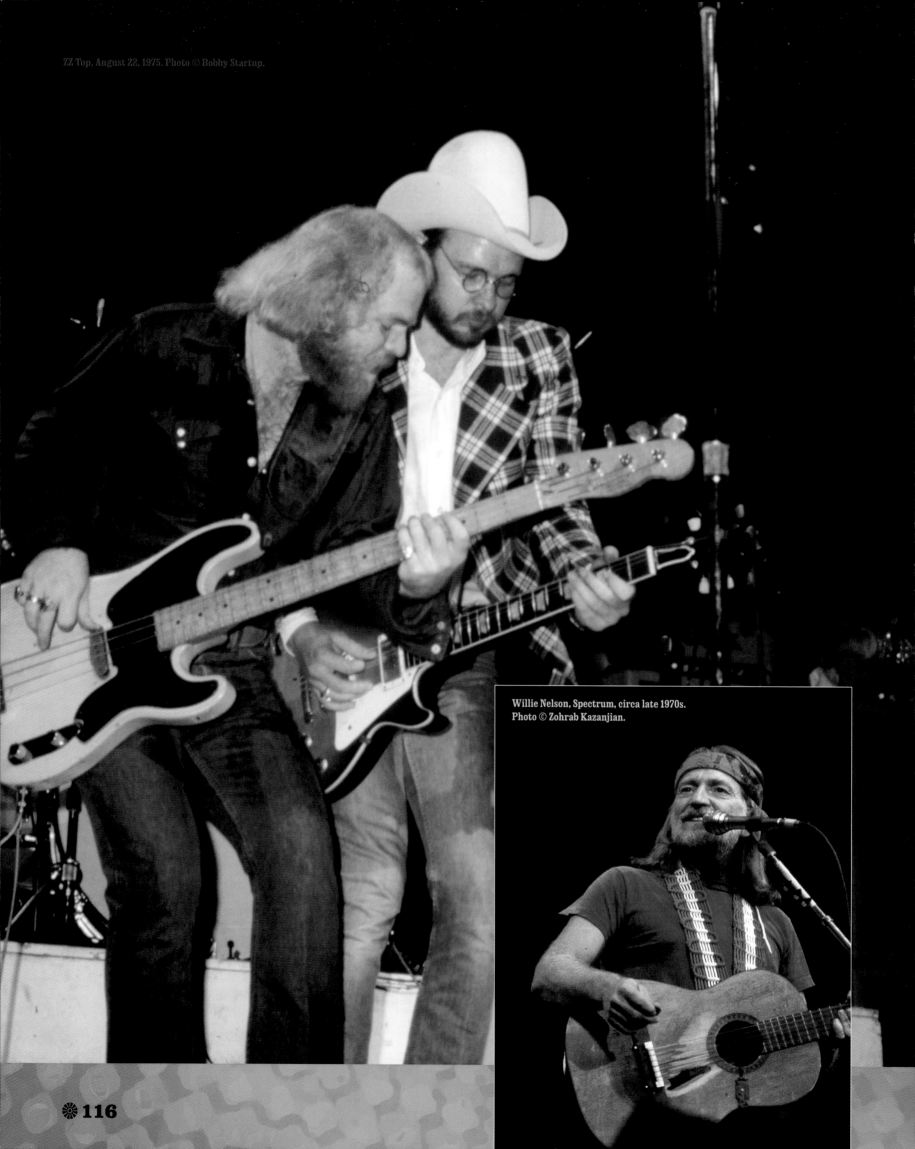

Willie Nelson, Spectrum, circa late 1970s.
Photo © Zohrab Kazanjian.

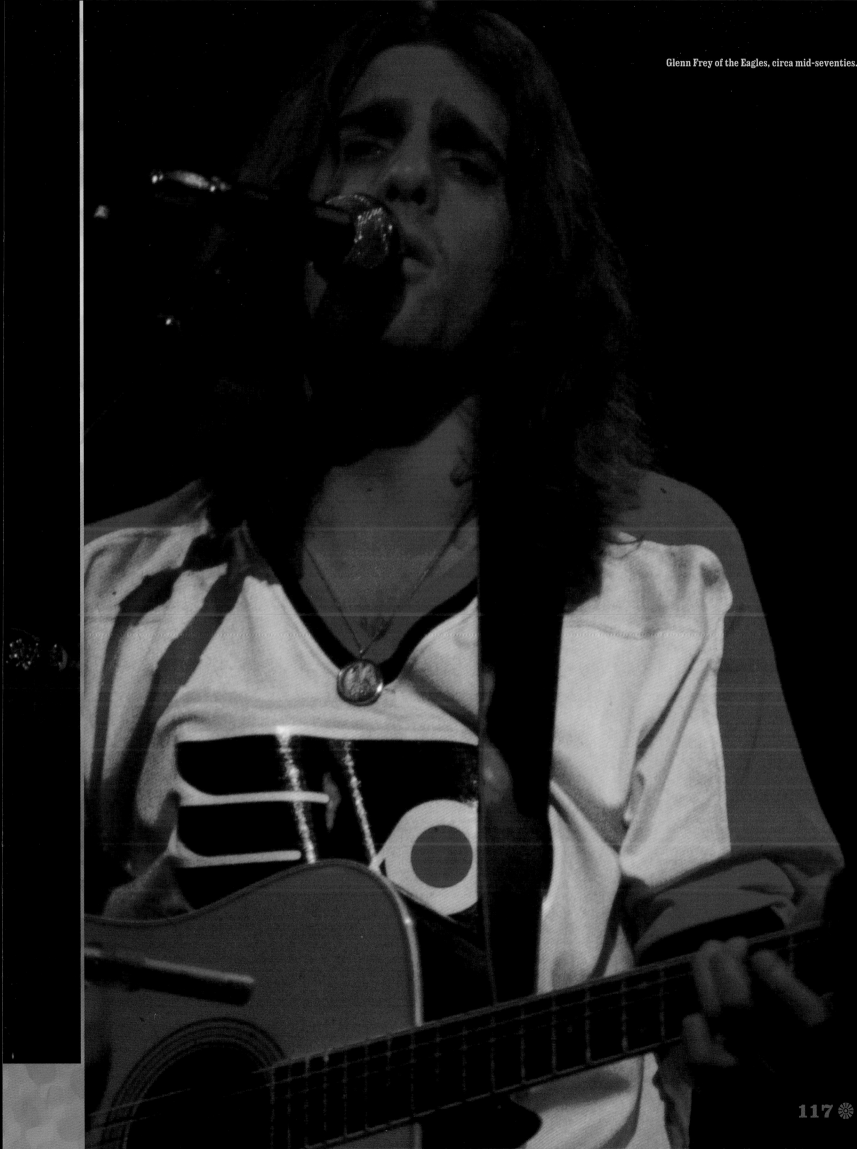

Glenn Frey of the Eagles, circa mid-seventies.

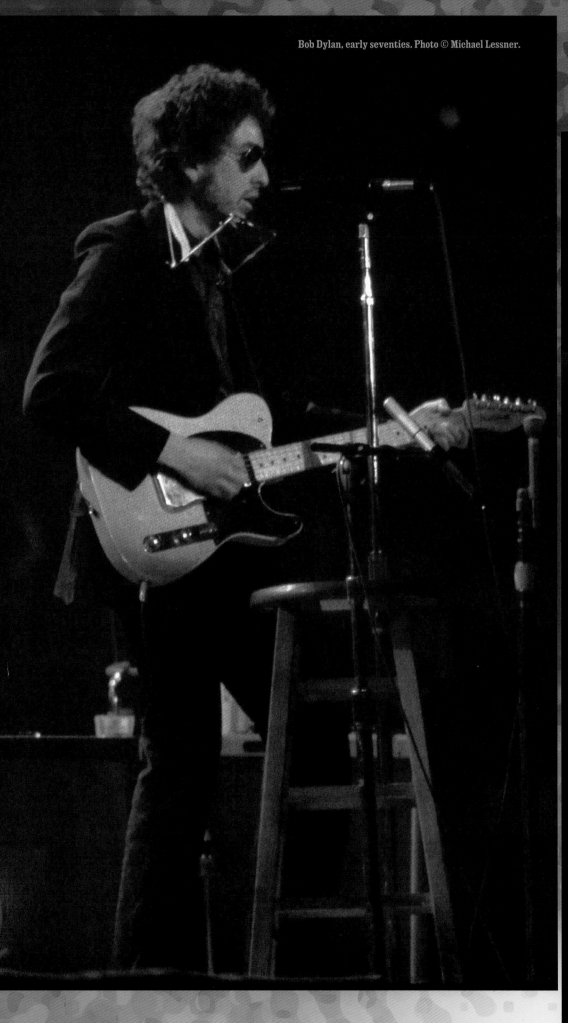

Bob Dylan, early seventies. Photo © Michael Lessner.

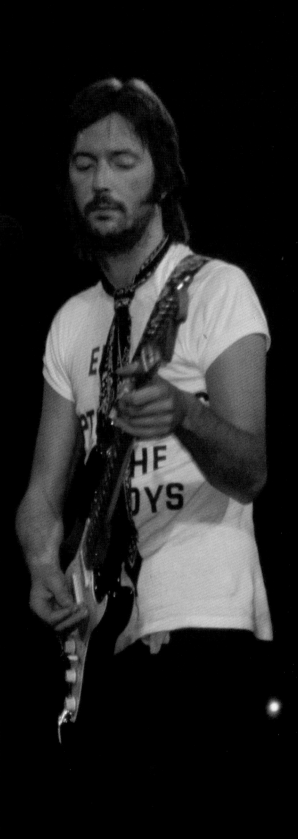

Eric Clapton, Spectrum, October 16, 1974.
Photo © Michael Lessner.

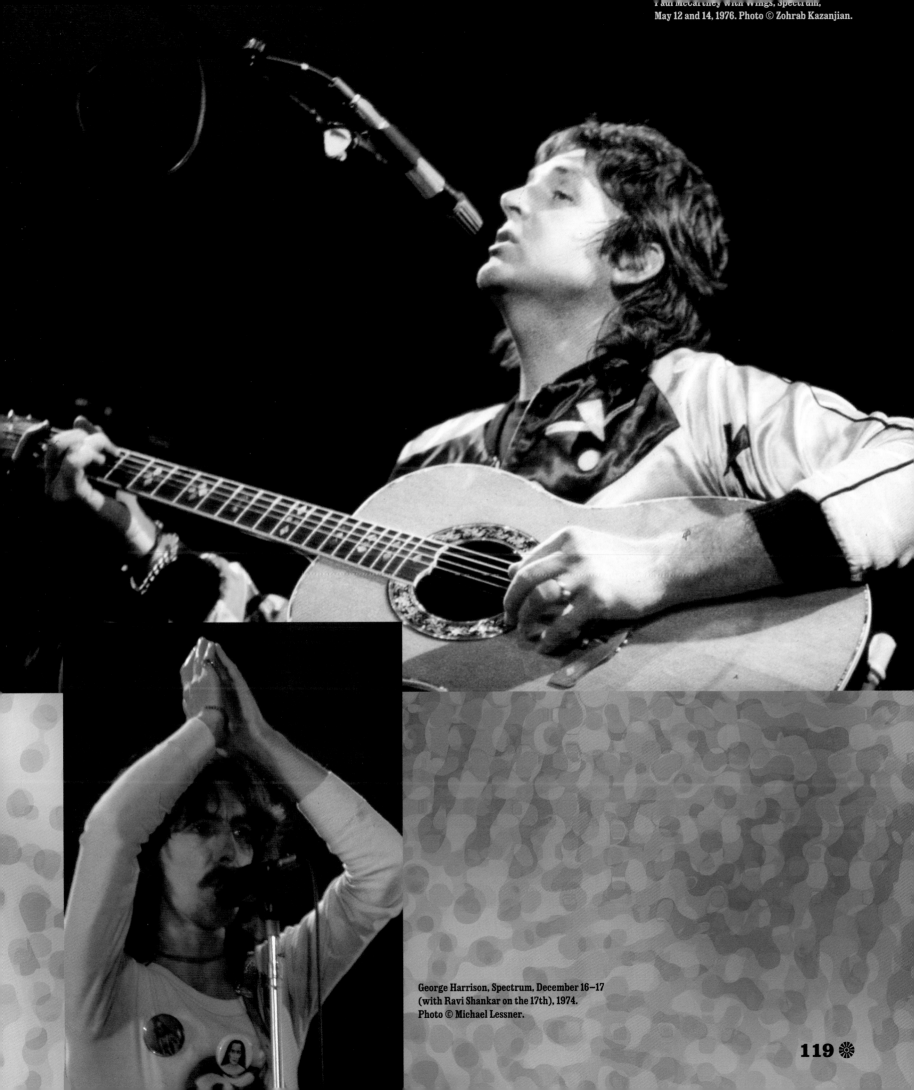

Paul McCartney with Wings, Spectrum,
May 12 and 14, 1976. Photo © Zohrab Kazanjian.

George Harrison, Spectrum, December 16–17
(with Ravi Shankar on the 17th), 1974.
Photo © Michael Lessner.

119 ✳

ELECTRIC FACTORY
1980s

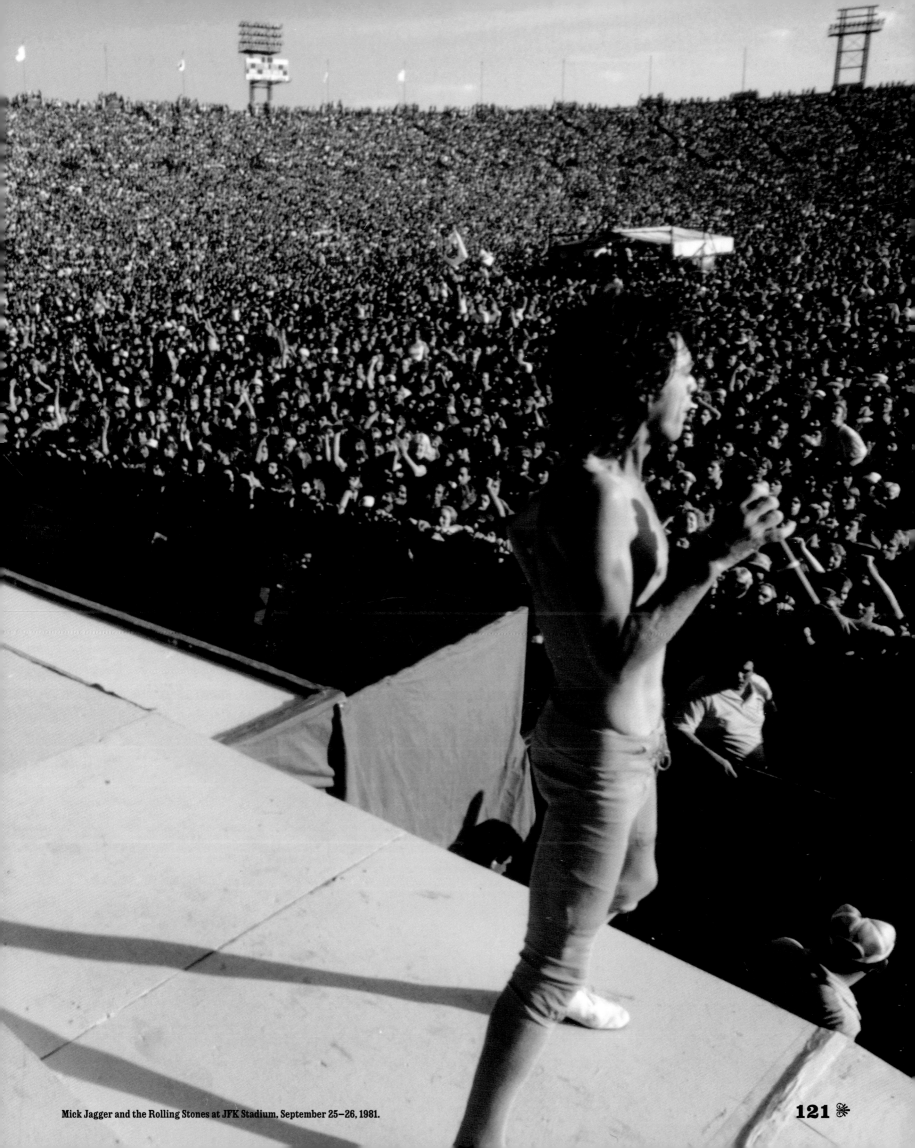

Mick Jagger and the Rolling Stones at JFK Stadium, September 25–26, 1981.

121 ✳

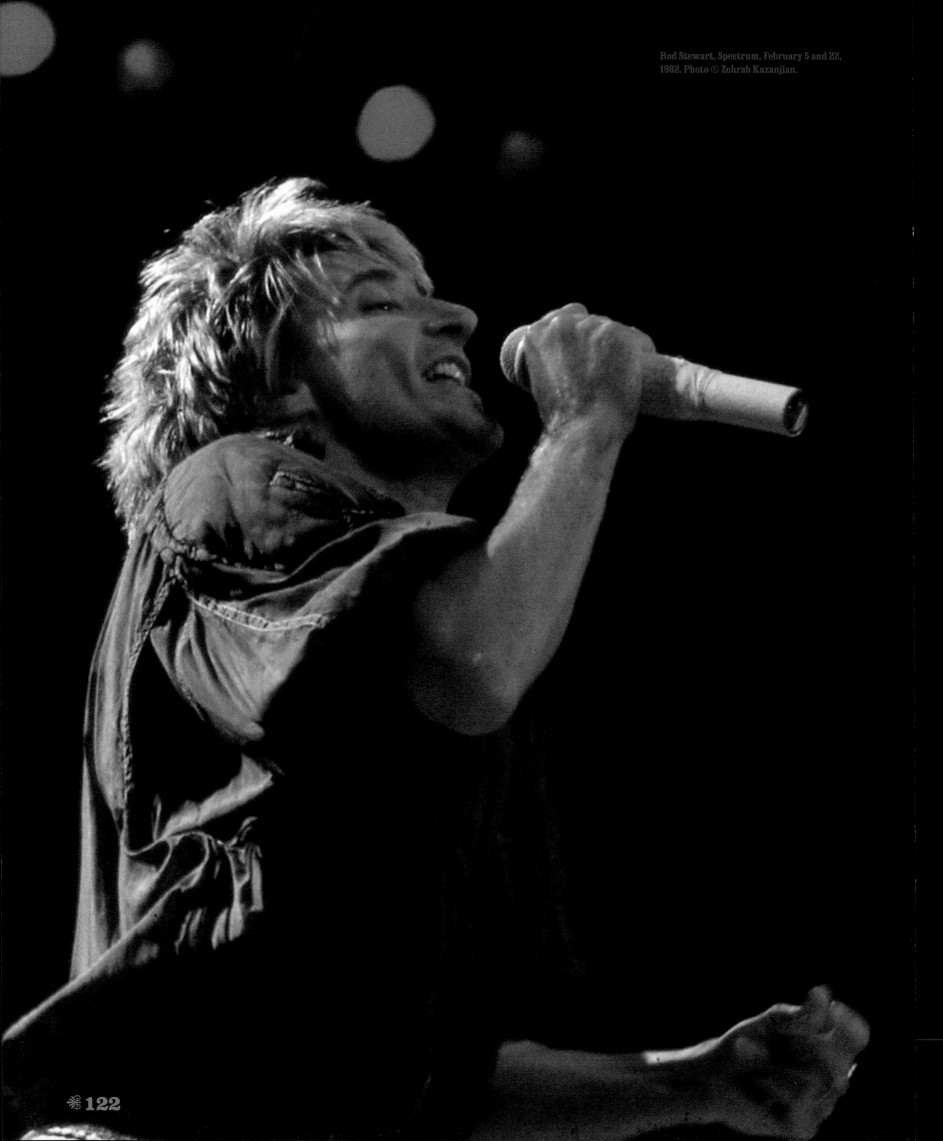

❋ 122

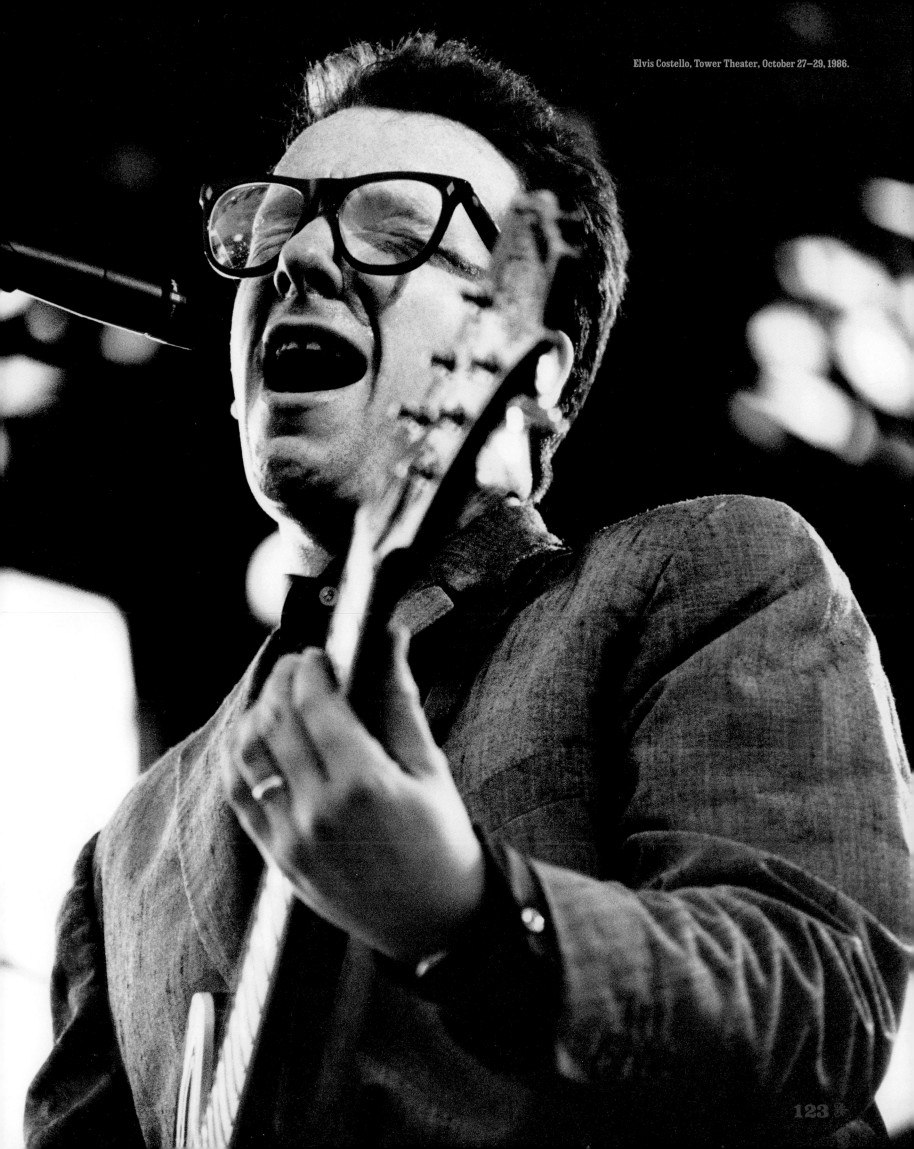

Elvis Costello, Tower Theater, October 27–29, 1986.

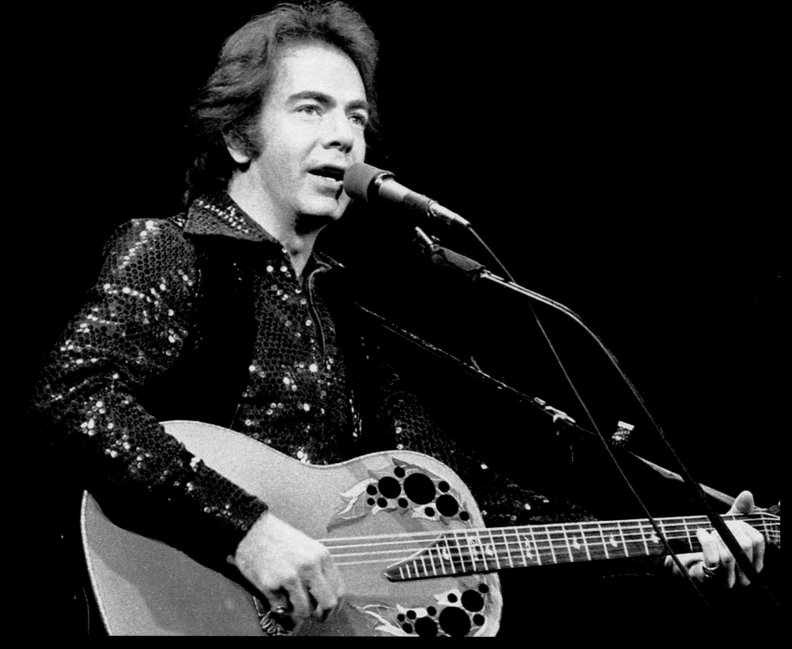

Neil Diamond at the Bijou, October 21–23, 1981.

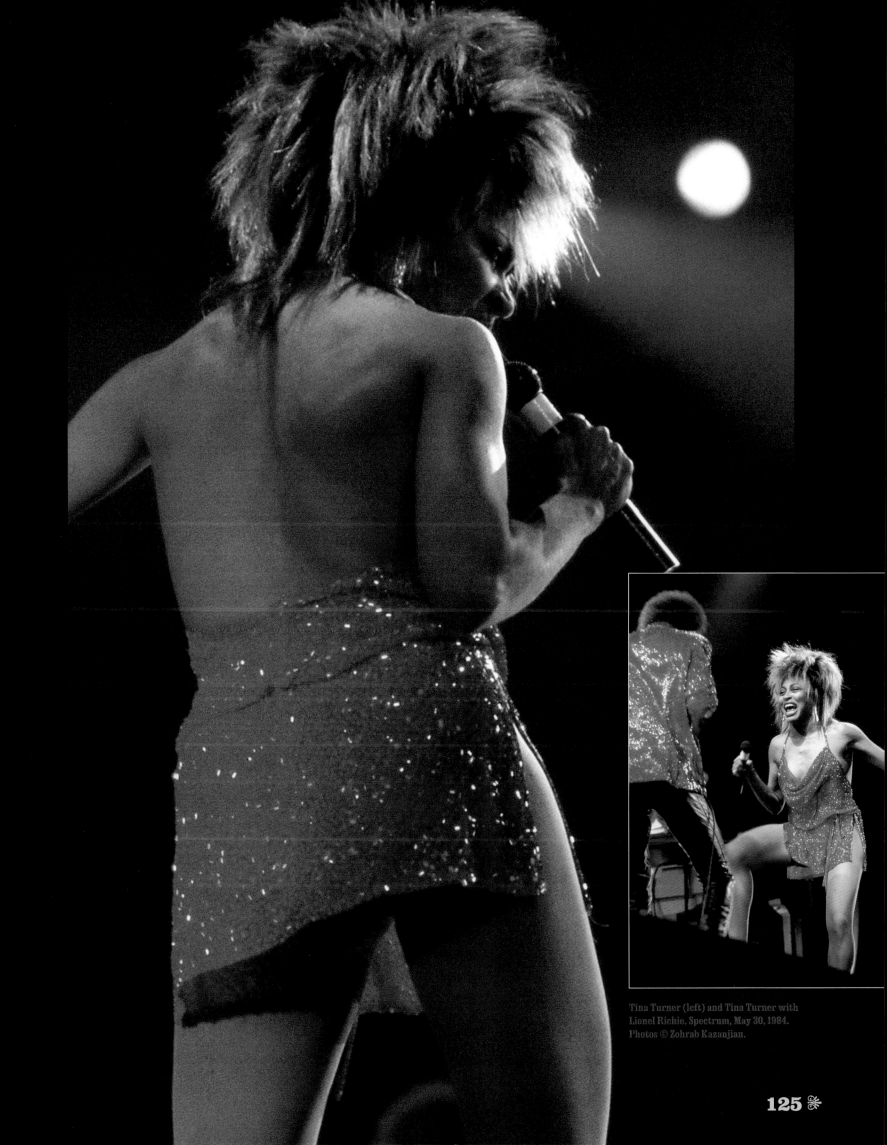

Tina Turner (left) and Tina Turner with
Lionel Richie, Spectrum, May 30, 1984.
Photos © Zohrab Kazanjian.

125

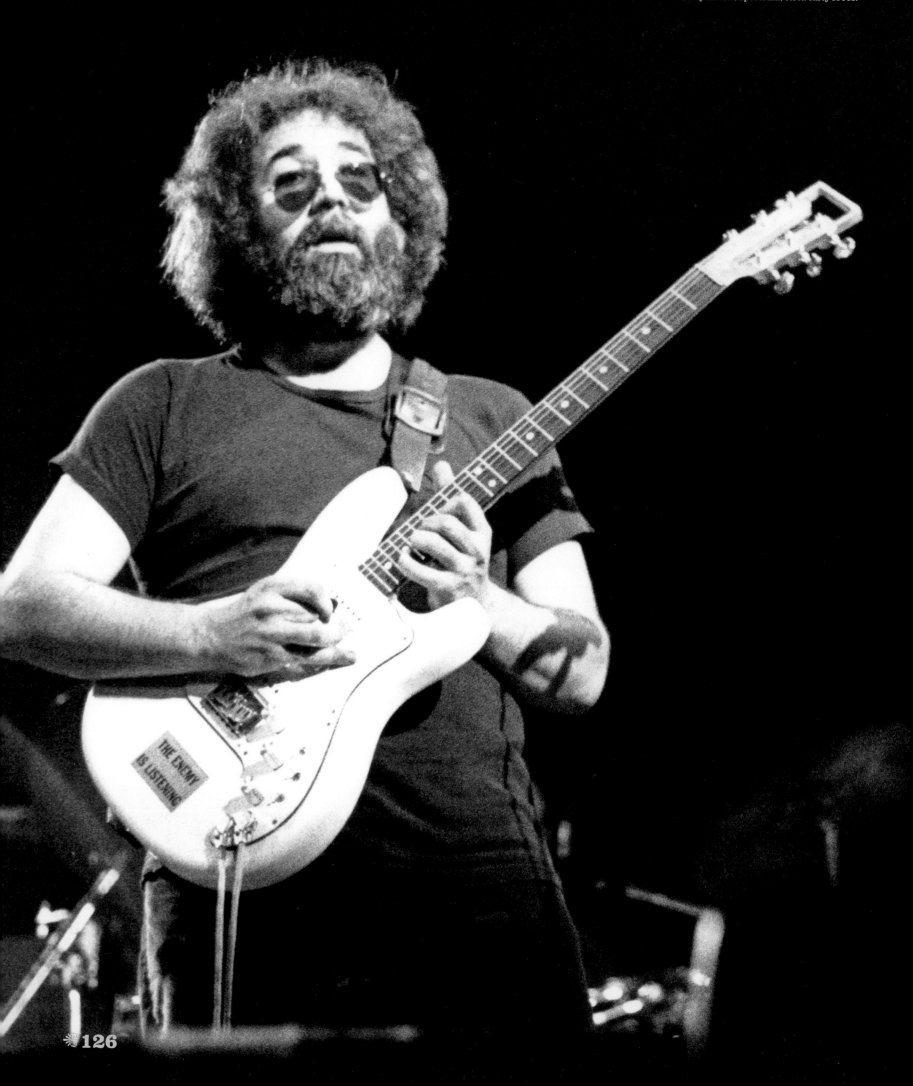

THE ENEMY IS LISTENING

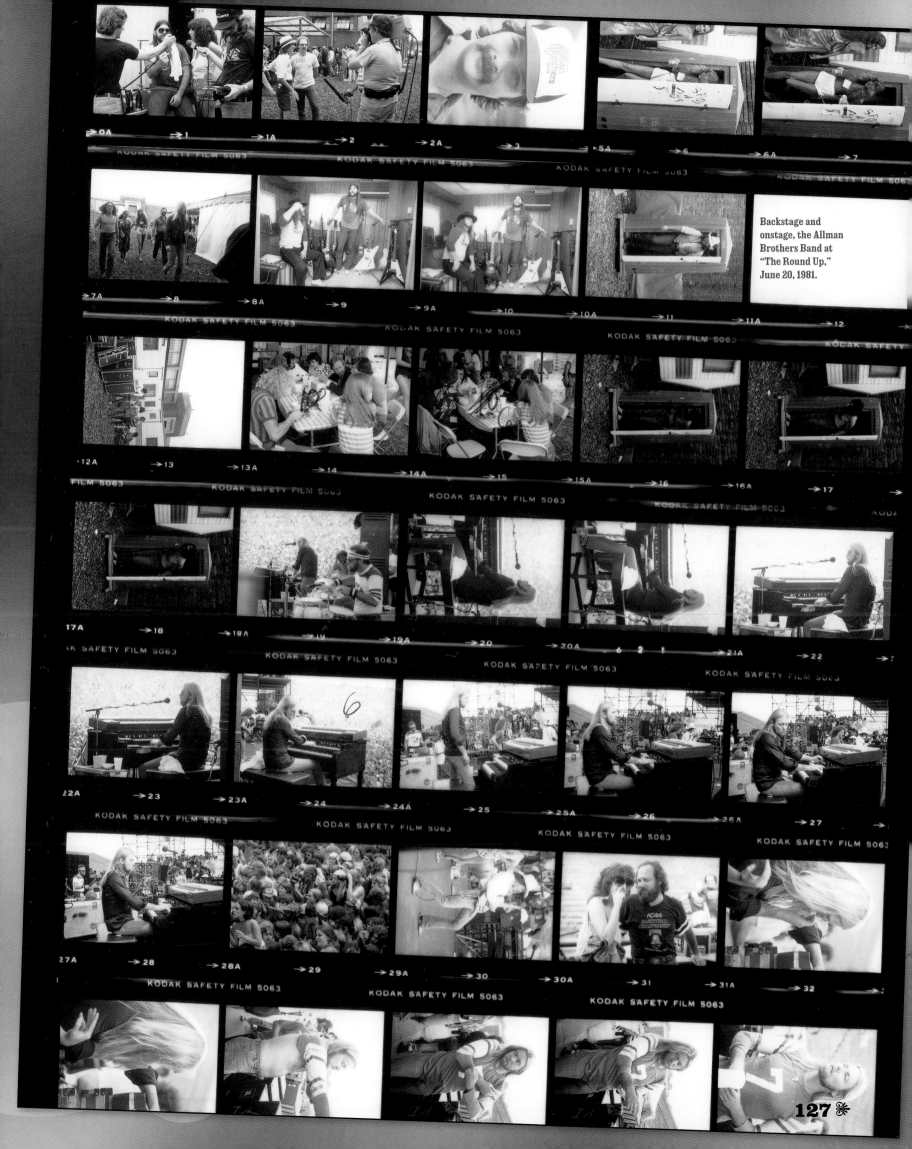

Backstage and onstage, the Allman Brothers Band at "The Round Up," June 20, 1981.

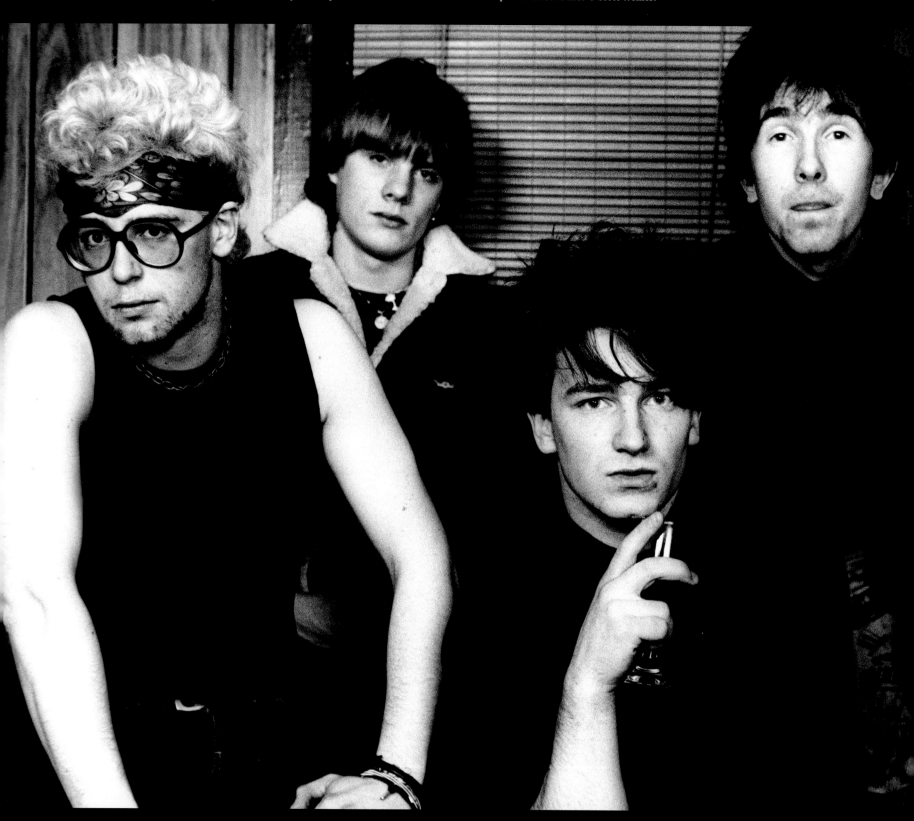

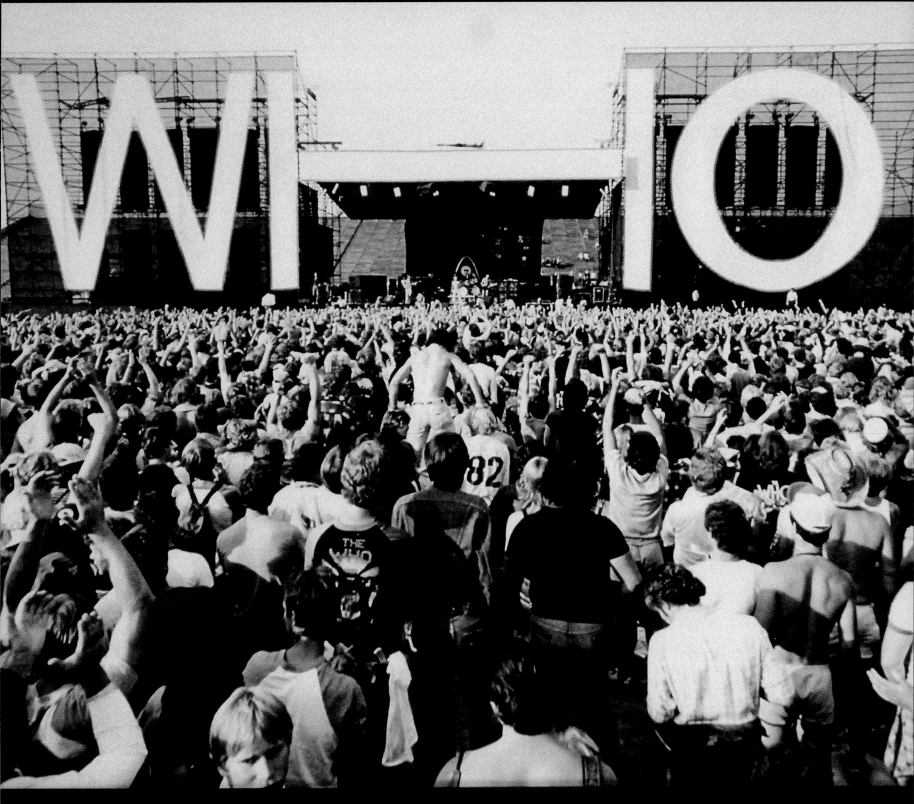

A capacity crowd saw the Who and the Clash at JFK Stadium on September 25, 1982.

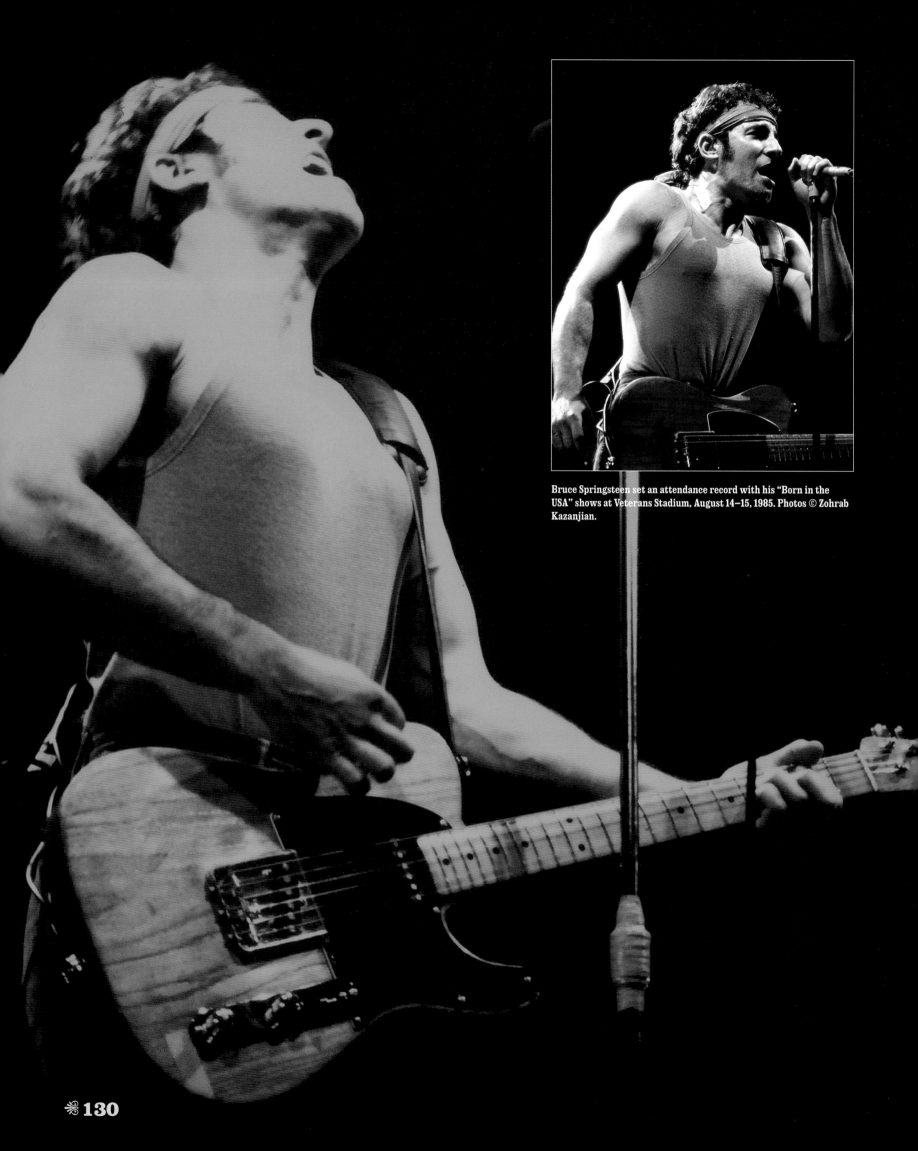

Bruce Springsteen set an attendance record with his "Born in the USA" shows at Veterans Stadium, August 14–15, 1985. Photos © Zohrab Kazanjian.

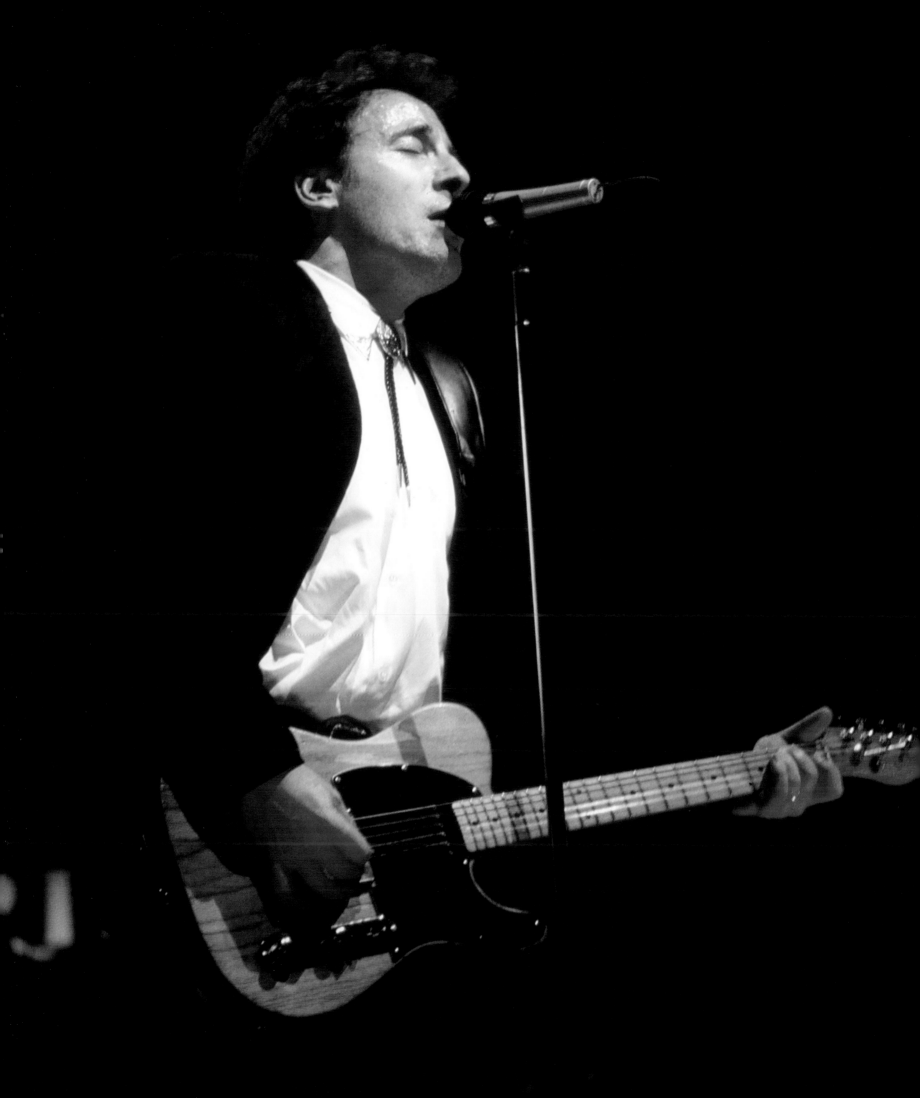

Springsteen during the "Tunnel of Love" tour, Spectrum, March 8–9, 1988.

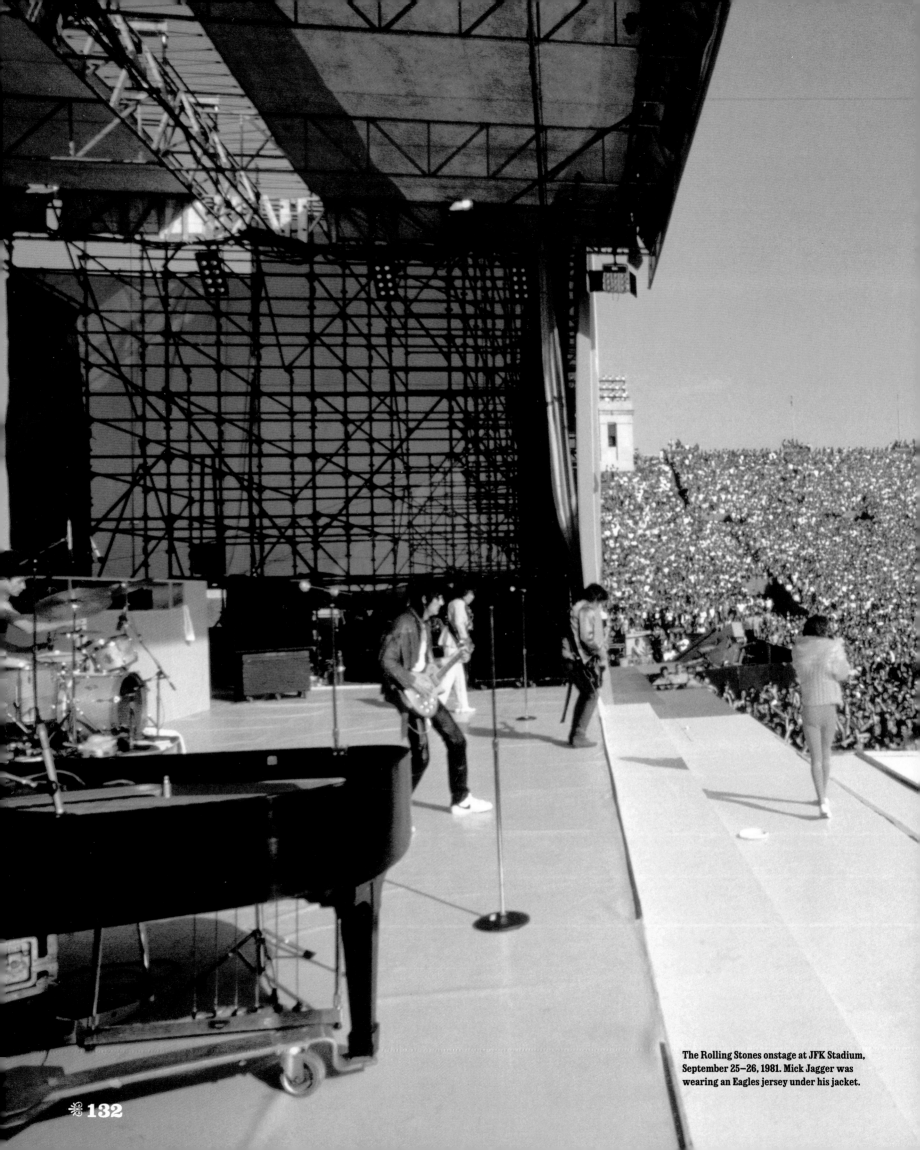

The Rolling Stones onstage at JFK Stadium, September 25–26, 1981. Mick Jagger was wearing an Eagles jersey under his jacket.

Top: Mick Jagger opening the "Tattoo You" tour at JFK Stadium with a press conference. Behind Jagger are (from far left) long-time Stones tour manager Alan Dunn; Allen Spivak; Larry Magid; Bill Graham, the tour's promoter (in warm-up jacket); and Richard Doran, commerce director in the Green administration. The Stones' 1981–82 tour of U.S. stadiums and arenas drew three million concertgoers and set several attendance records. Bottom: The Rolling Stones, with Mick Jagger in the Union Jack cape made famous during this tour. ❧

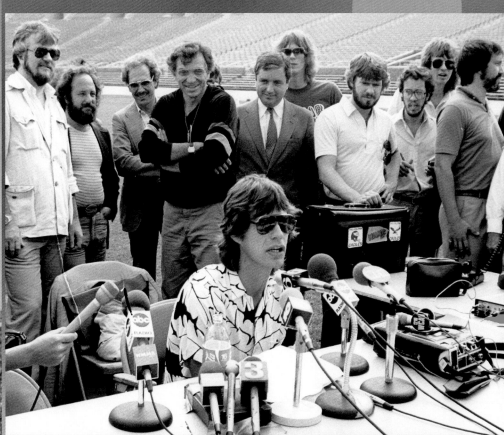

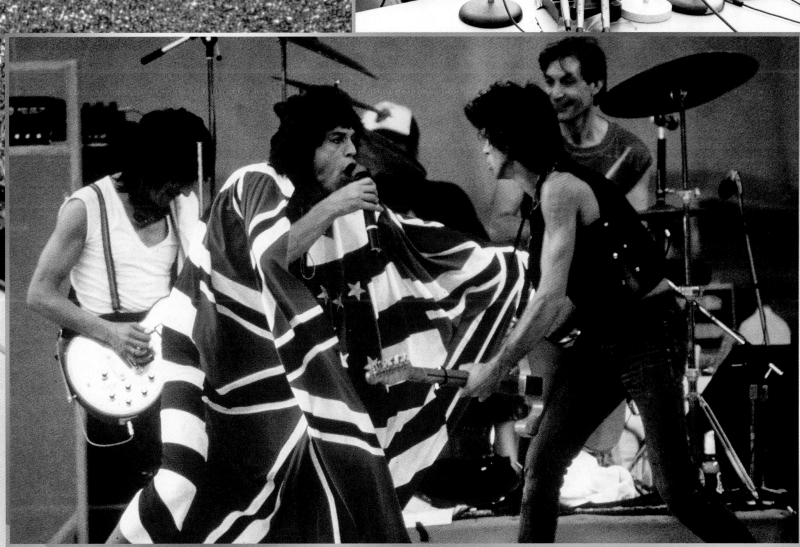

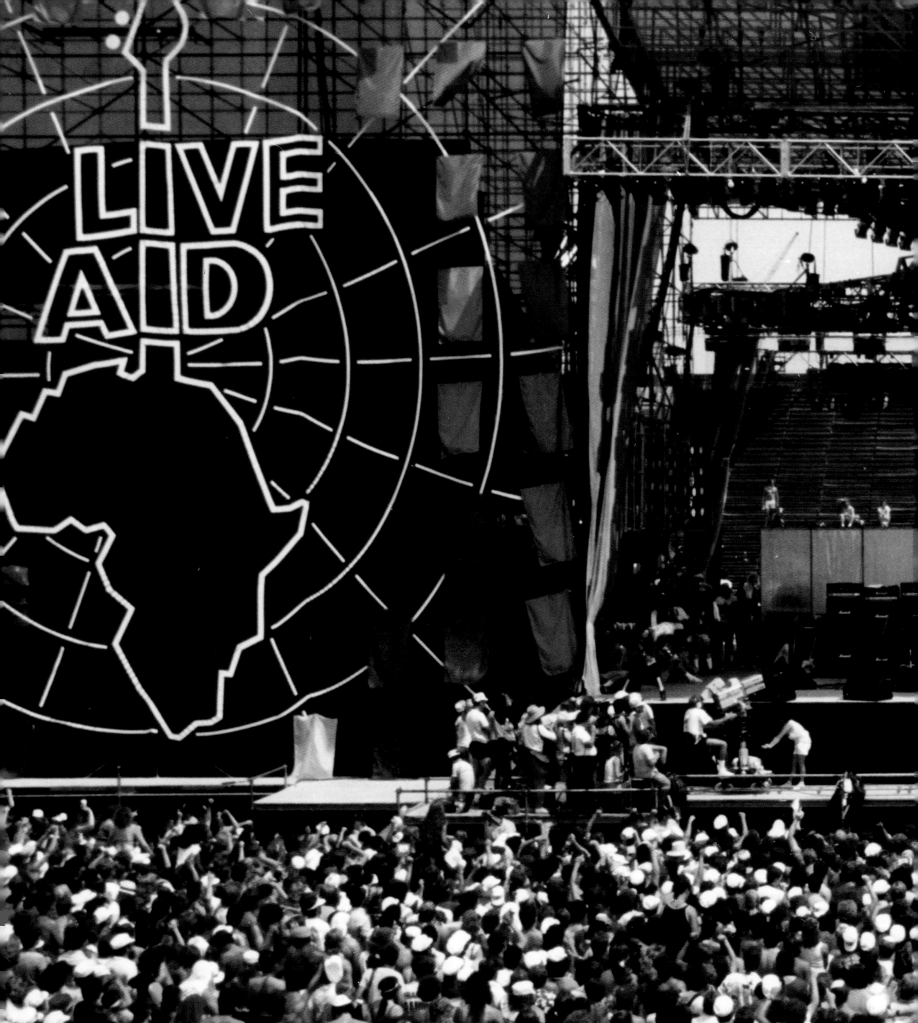

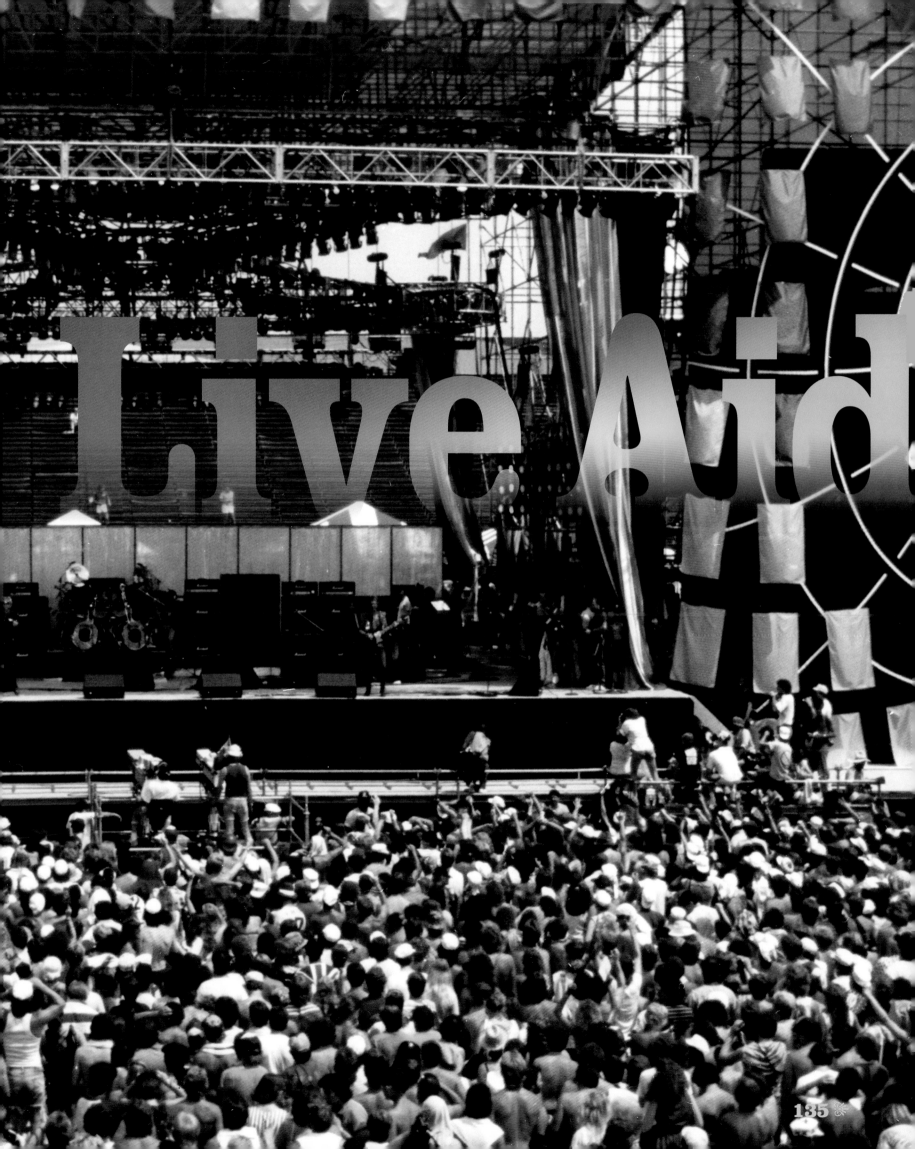

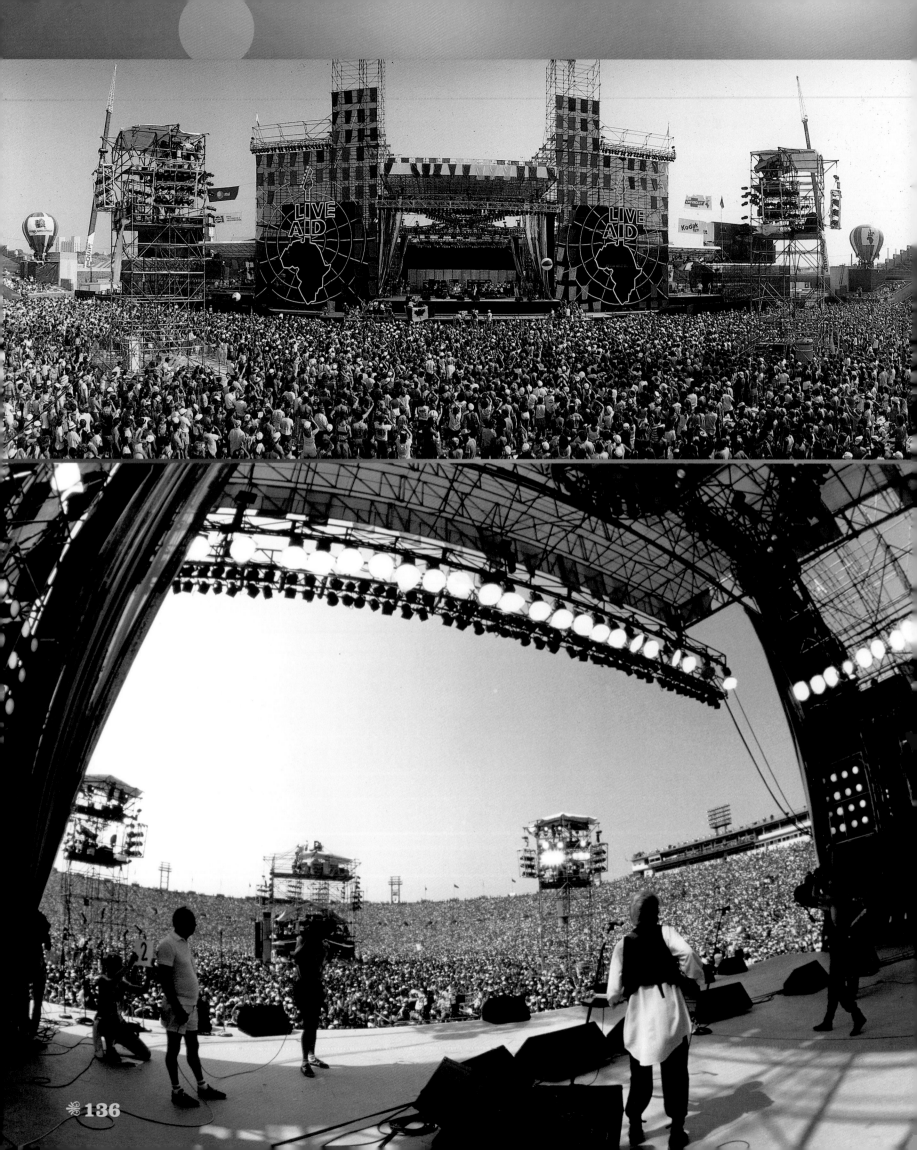

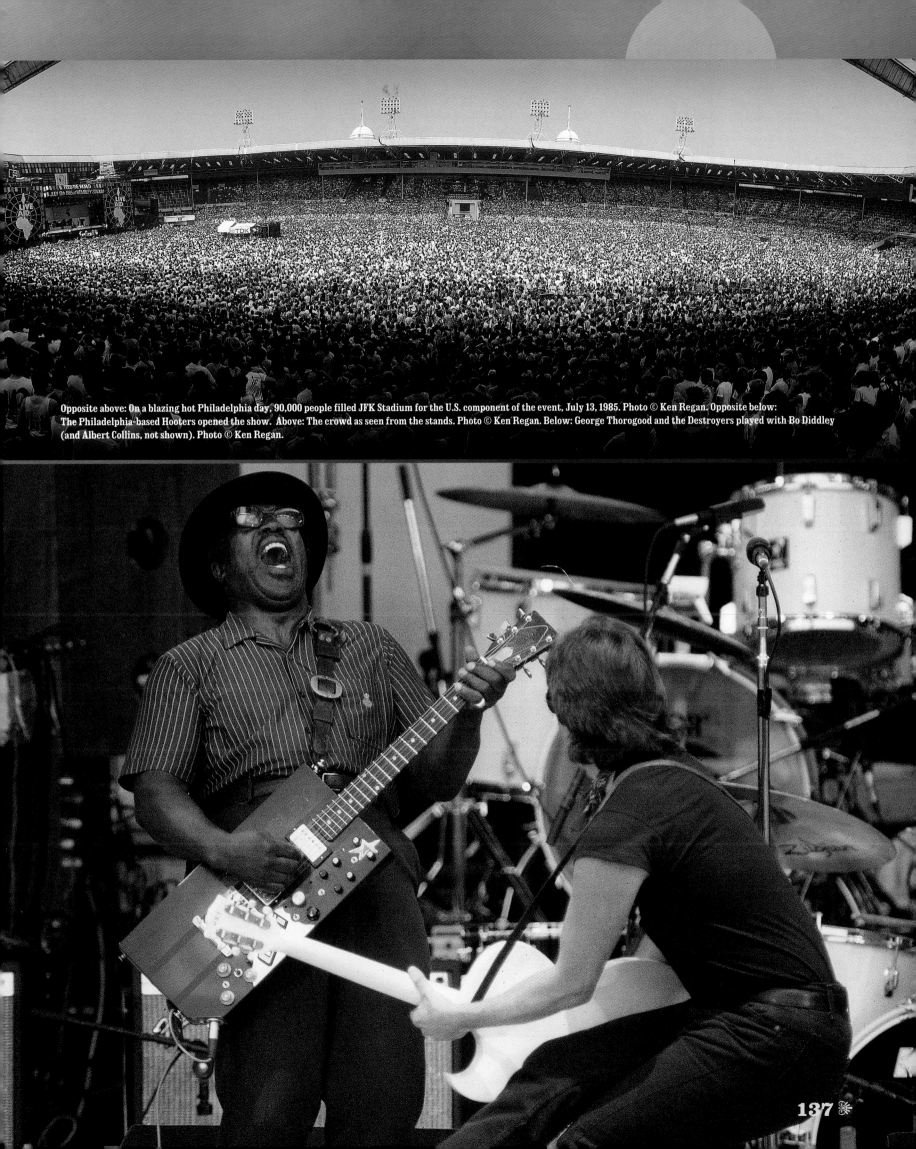

Opposite above: On a blazing hot Philadelphia day, 90,000 people filled JFK Stadium for the U.S. component of the event, July 13, 1985. Photo © Ken Regan. Opposite below: The Philadelphia-based Hooters opened the show. Above: The crowd as seen from the stands. Photo © Ken Regan. Below: George Thorogood and the Destroyers played with Bo Diddley (and Albert Collins, not shown). Photo © Ken Regan.

Once the City of Philadelphia had agreed to let Magid and Spivak stage Live Aid in JFK Stadium, they had five weeks to do it all and a $1.5 million budget. They got a revolving stage up and working at the stadium, handled catering and transportation, and set up a small medical facility to deal with drug overdoses and the heat. A myriad of passes were issued to manage the backstage confusion. The VIP tent was run by the original Hard Rock Cafe. Spivak hired all the stagehands, about 150 locals. Electricity had to be created by generators to power the stage and the TV trucks; the generators ended up burning through 10,000 gallons of diesel fuel. The Spivak brothers' own chain of eateries—H. A. Winston—provided the catering. Five expeditors coordinated the limos, vans, and trucks to move acts and support staff into and around town. The morning of the concert, Spivak had to contend with Philly cops who were coming into the backstage area on horseback and hanging out while the horses defecated all over the place. Allen chased them out. It was a huge undertaking.

For $35 the audience saw the world's top artists live at JFK and on video from Wembley Stadium in London. Later, Larry Magid and Allen Spivak would receive a congressional citation, several awards, and other kinds of recognition for their humanitarian work.

Jack Nicholson with Bette Midler. Photo © Ken Regan.

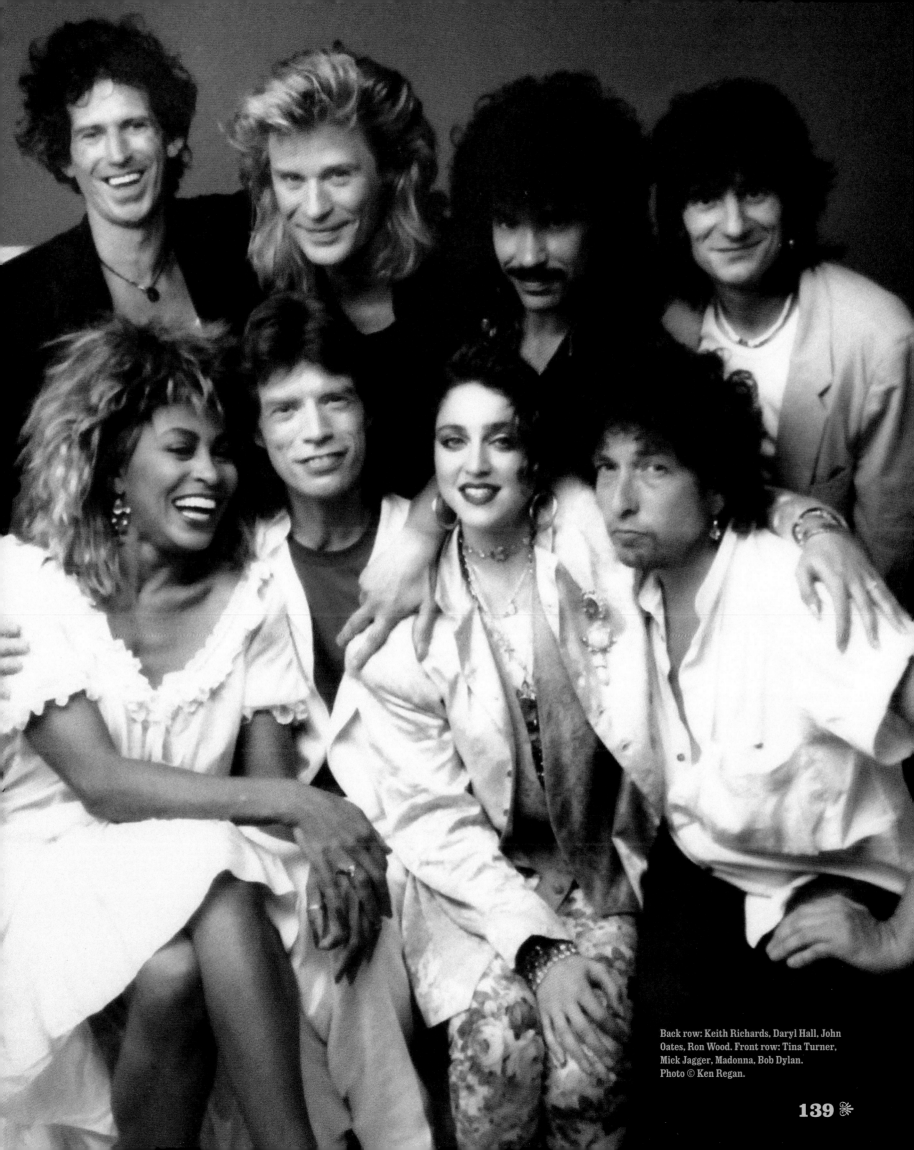

Back row: Keith Richards, Daryl Hall, John Oates, Ron Wood. Front row: Tina Turner, Mick Jagger, Madonna, Bob Dylan. Photo © Ken Regan.

139

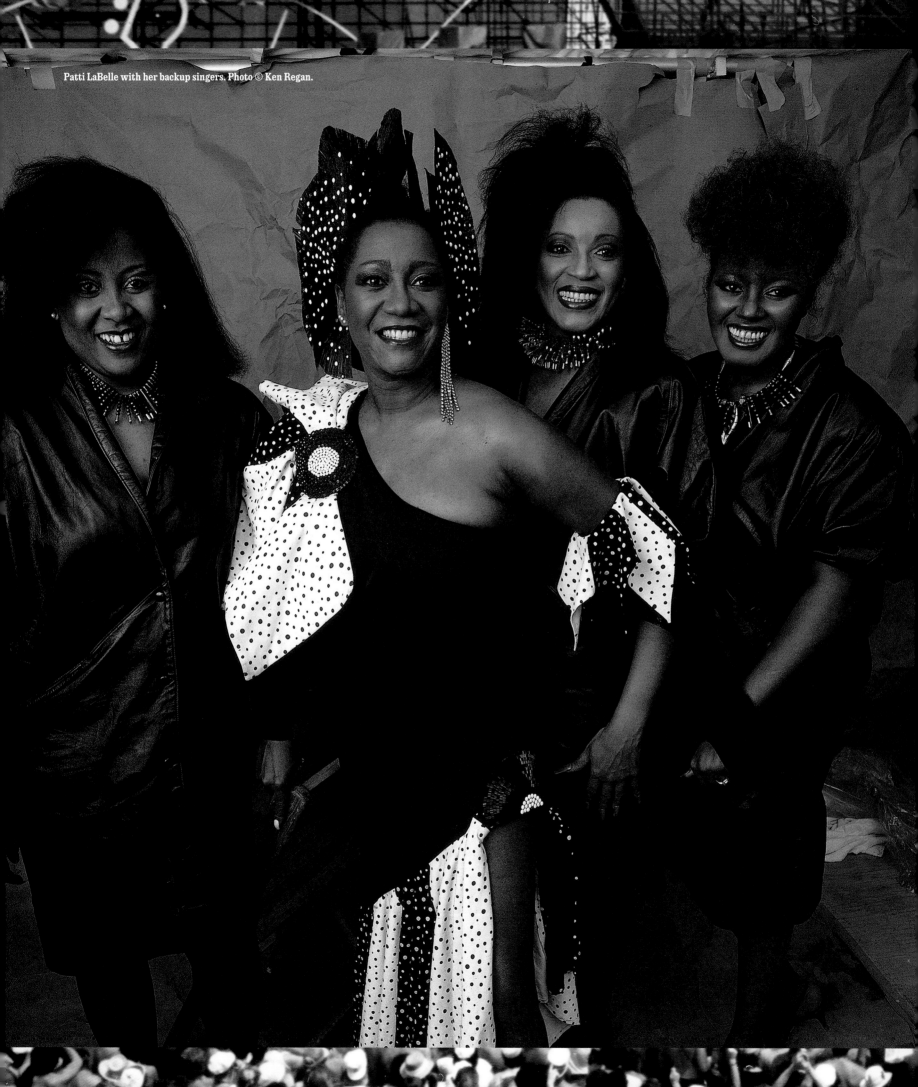

Patti LaBelle with her backup singers. Photo © Ken Regan.

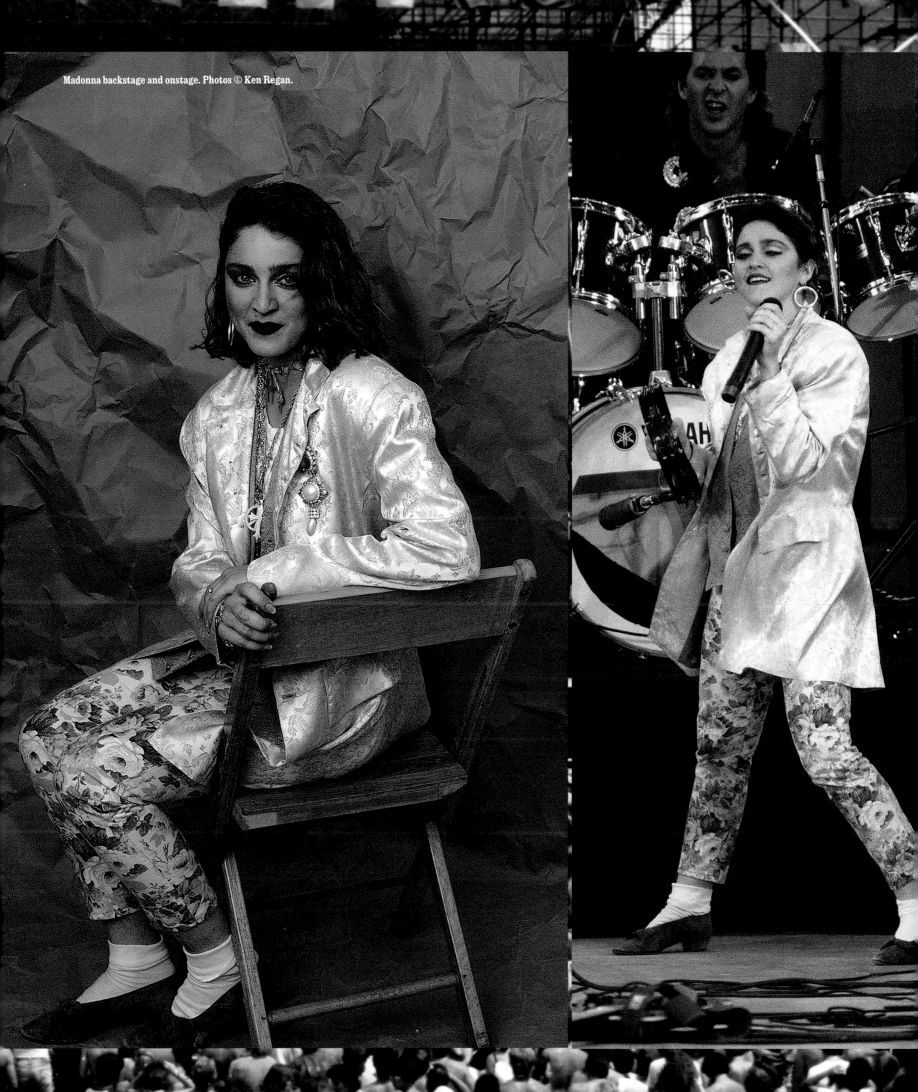

Madonna backstage and onstage. Photos © Ken Regan.

141

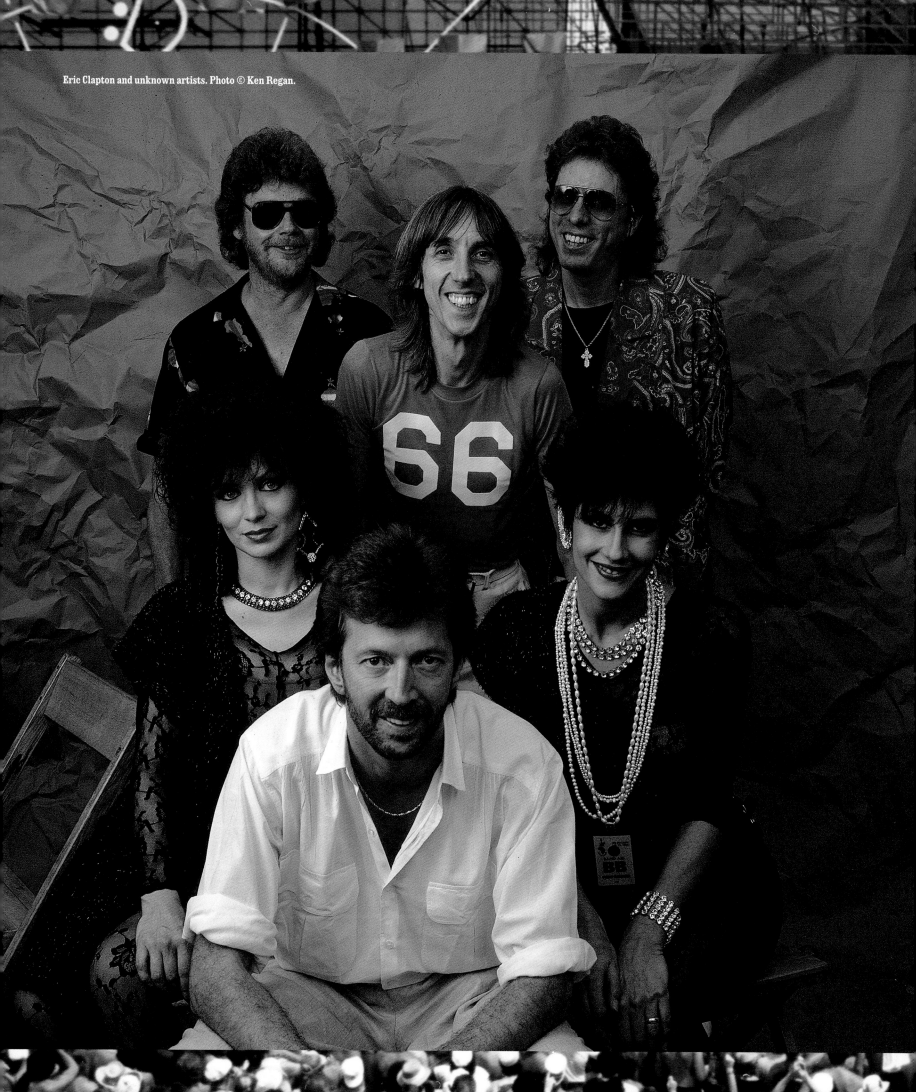

Eric Clapton and unknown artists. Photo © Ken Regan.

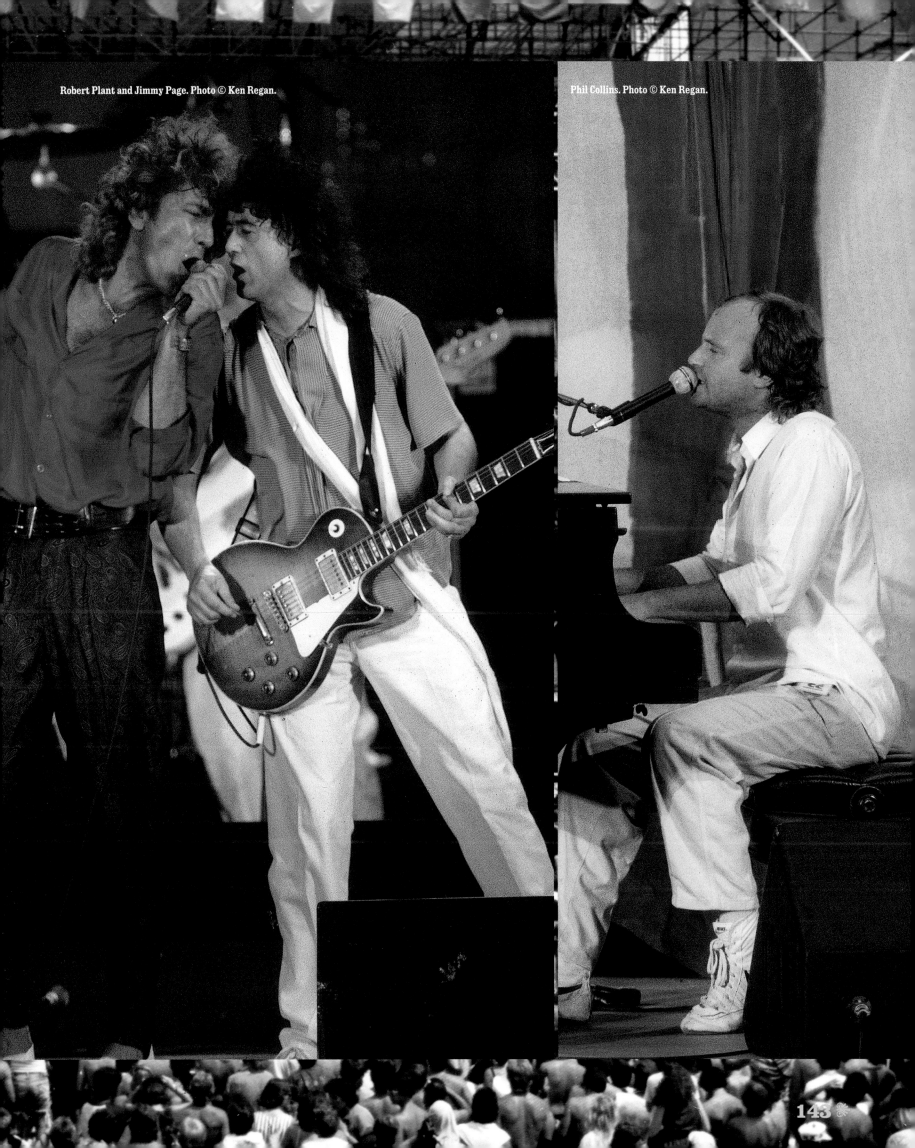

Robert Plant and Jimmy Page. Photo © Ken Regan.

Phil Collins. Photo © Ken Regan.

143

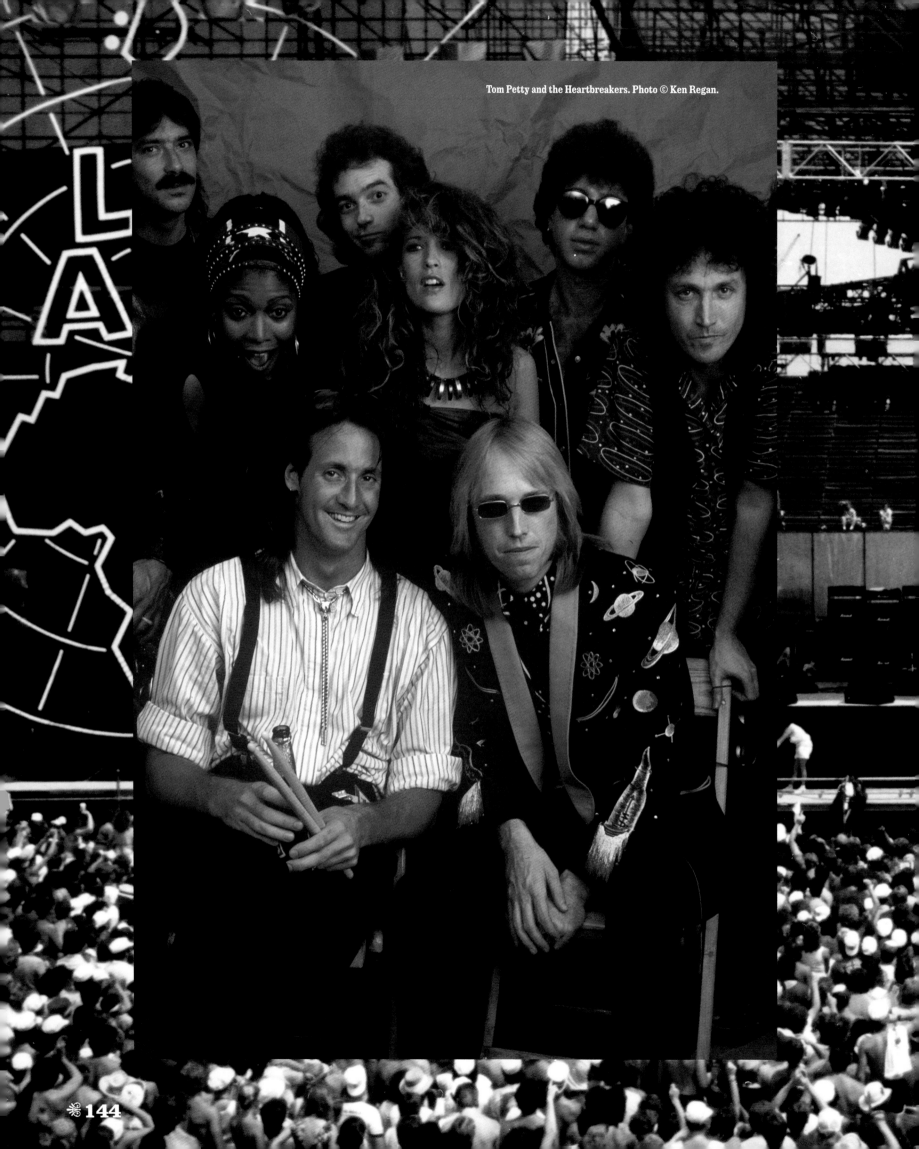

Tom Petty and the Heartbreakers. Photo © Ken Regan.

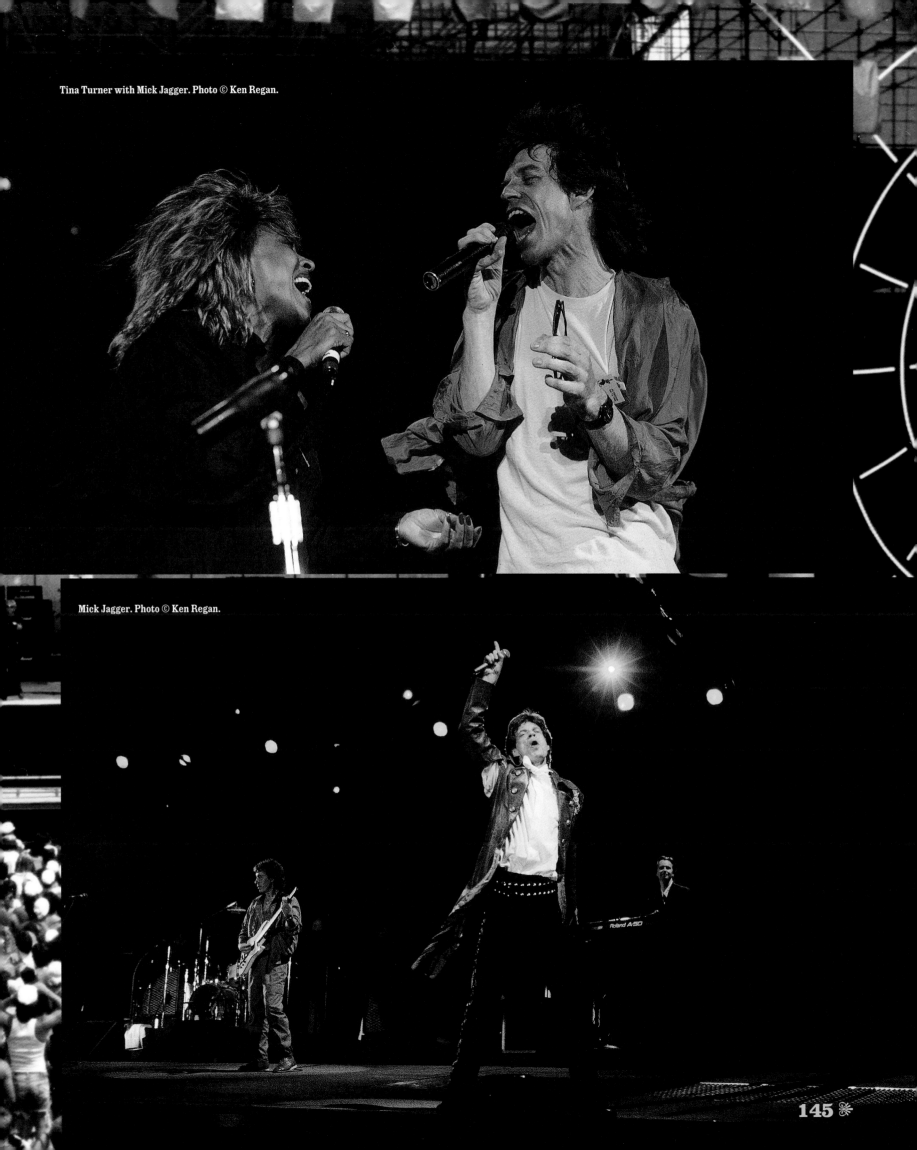

Tina Turner with Mick Jagger. Photo © Ken Regan.

Mick Jagger. Photo © Ken Regan.

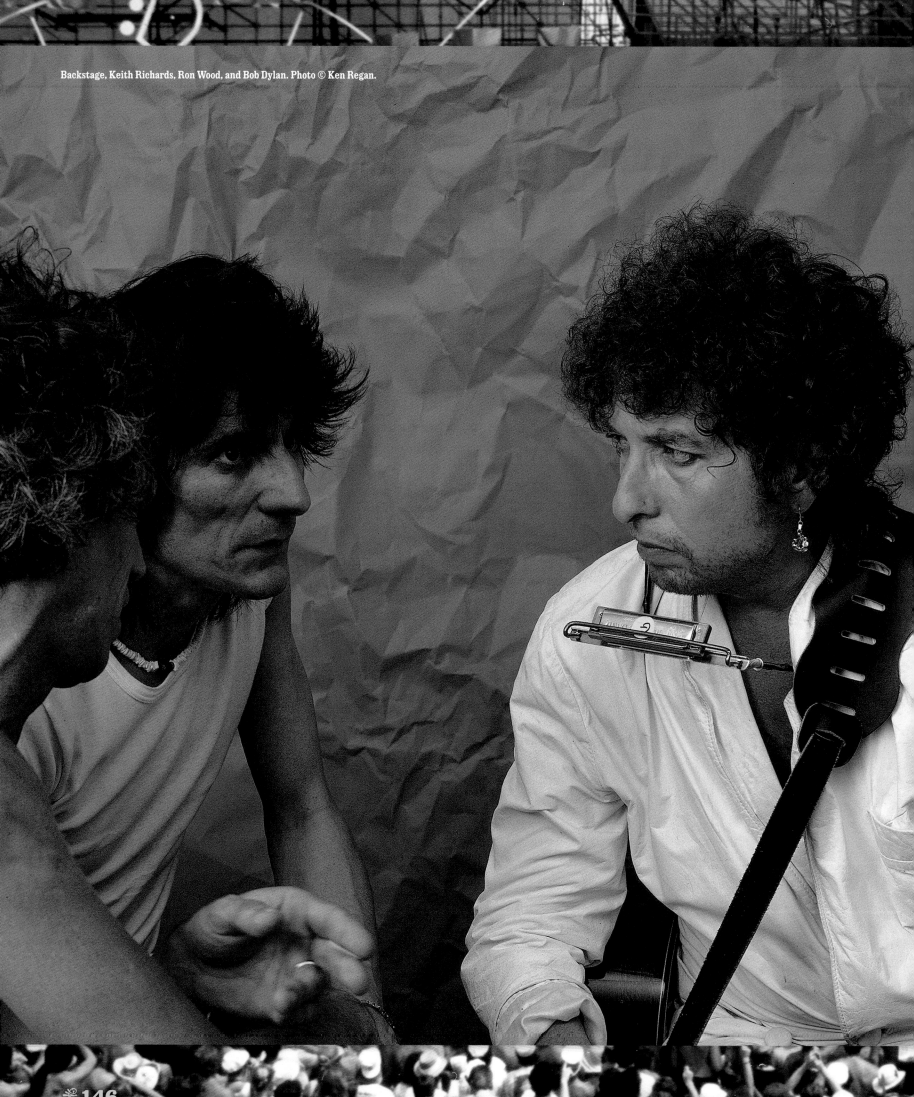

Backstage, Keith Richards, Ron Wood, and Bob Dylan. Photo © Ken Regan.

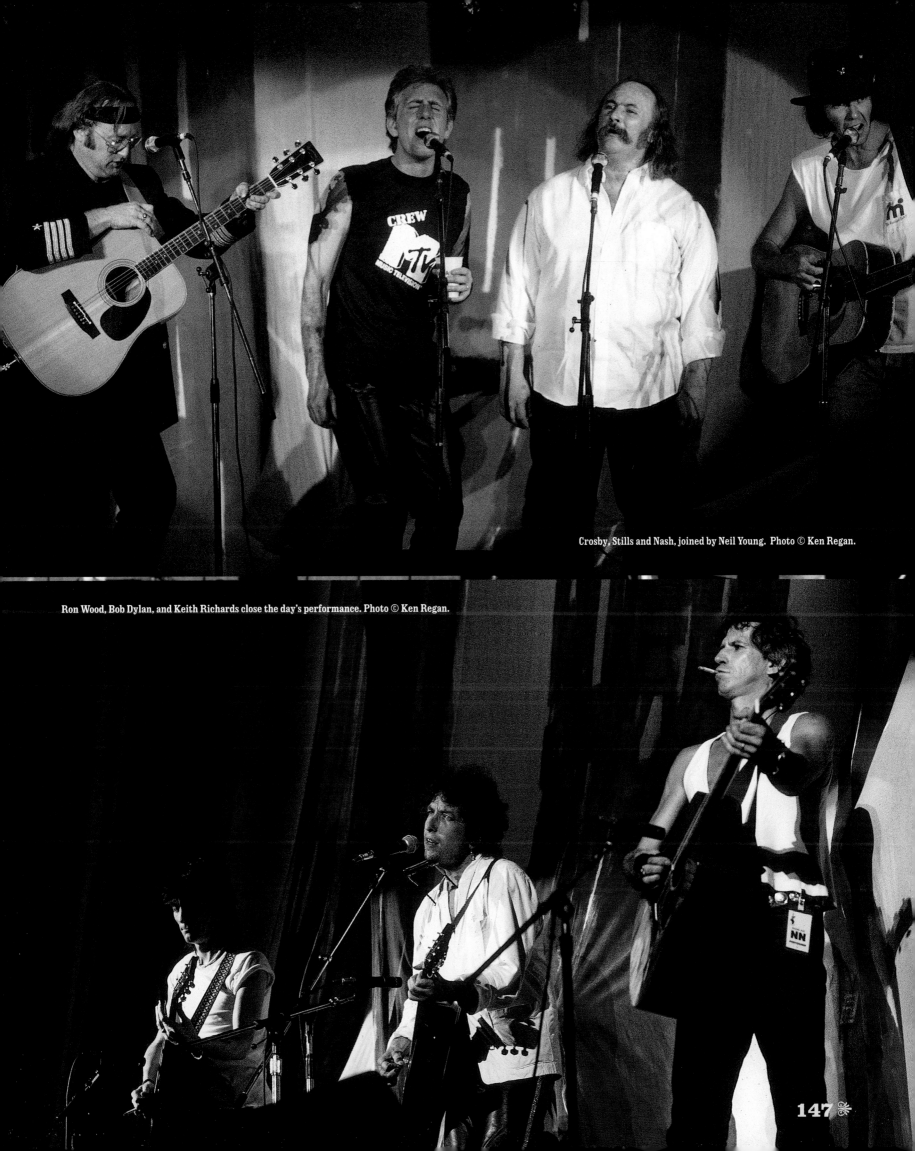

Crosby, Stills and Nash, joined by Neil Young. Photo © Ken Regan.

Ron Wood, Bob Dylan, and Keith Richards close the day's performance. Photo © Ken Regan.

147

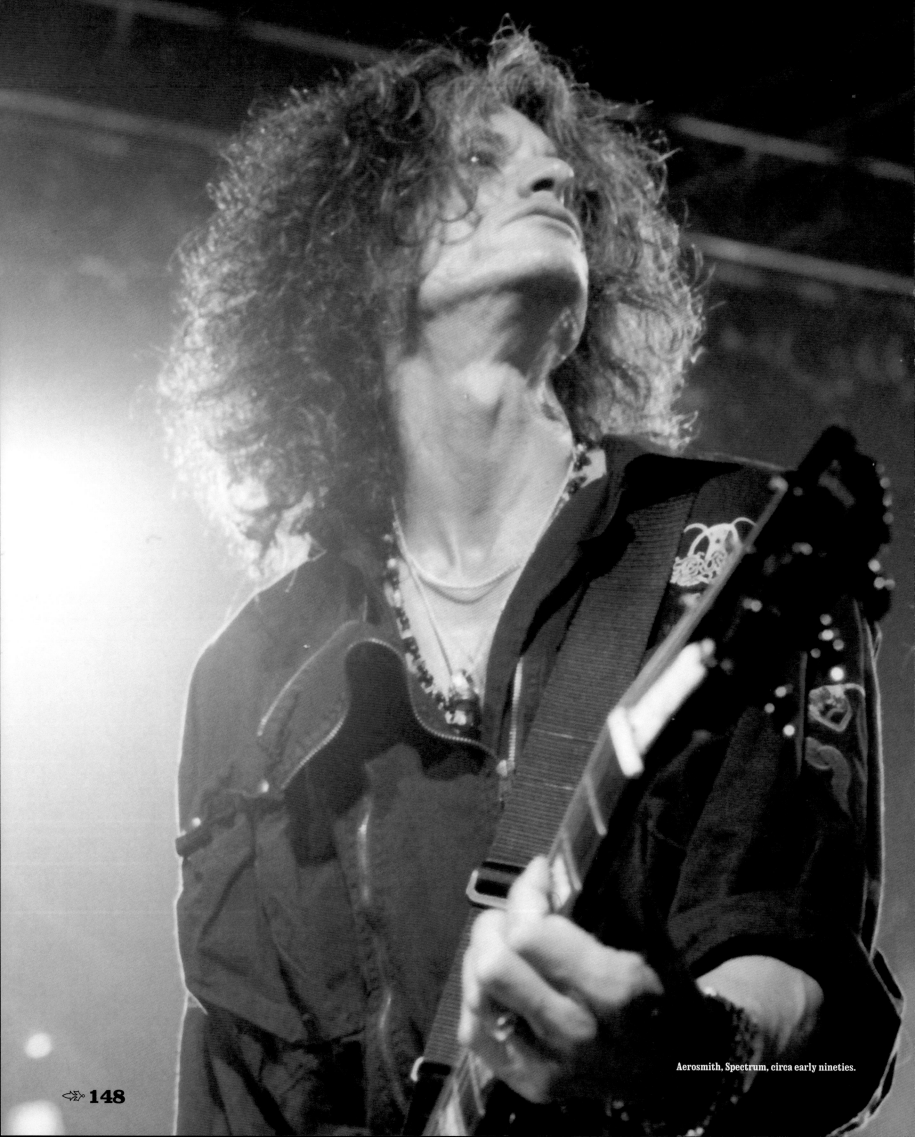

Aerosmith, Spectrum, circa early nineties.

ELECTRIC FACTORY

1990s

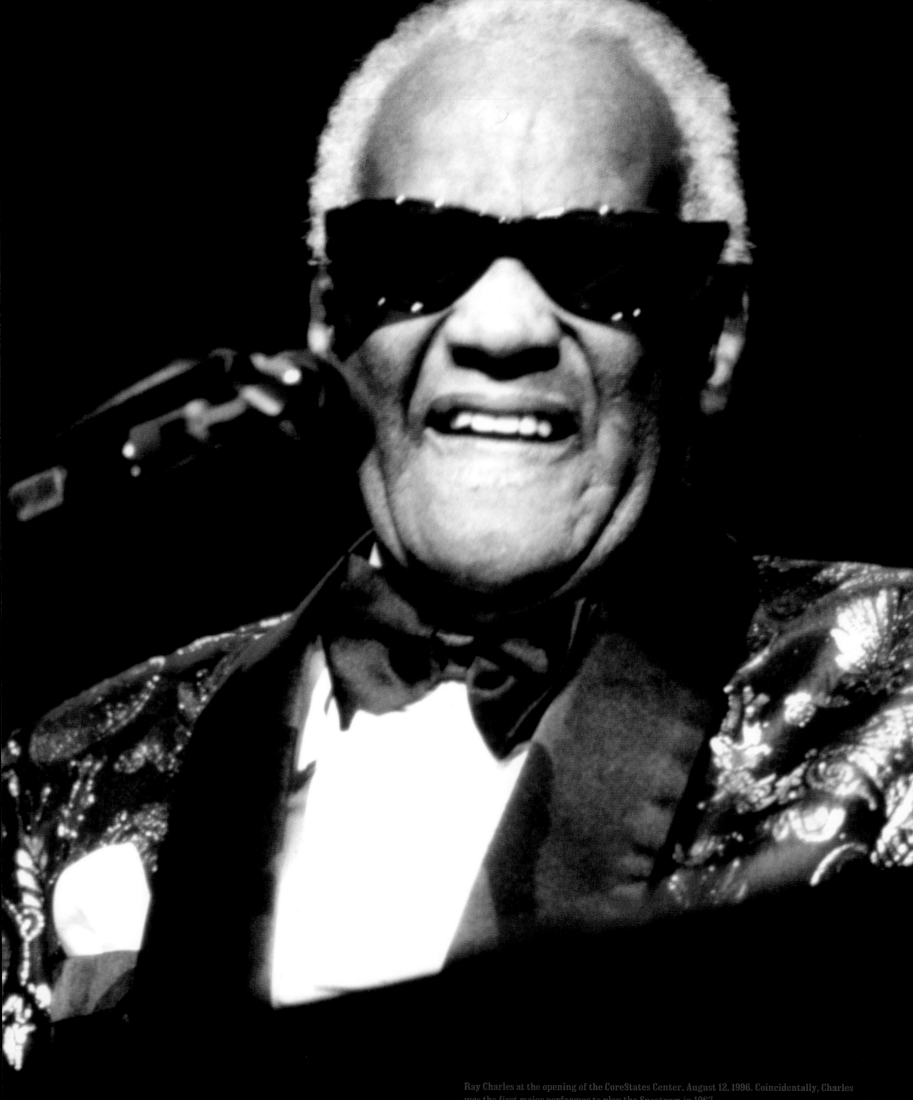

Ray Charles at the opening of the CoreStates Center, August 12, 1996. Coincidentally, Charles was the first major performer to play the Spectrum in 1967.

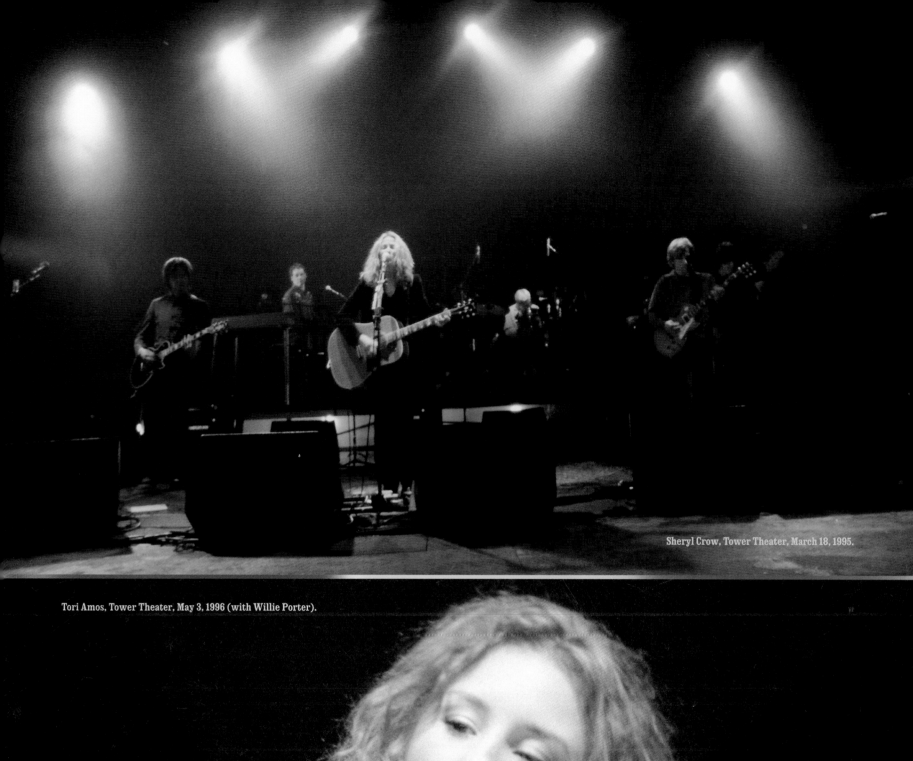

Sheryl Crow, Tower Theater, March 18, 1995.

Tori Amos, Tower Theater, May 3, 1996 (with Willie Porter).

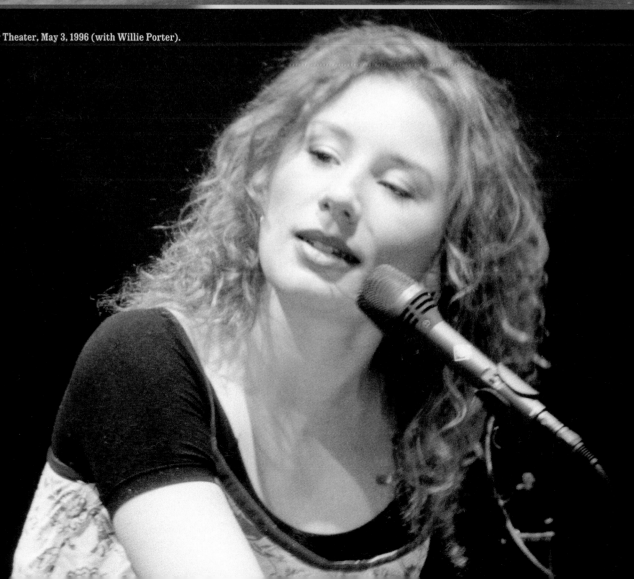

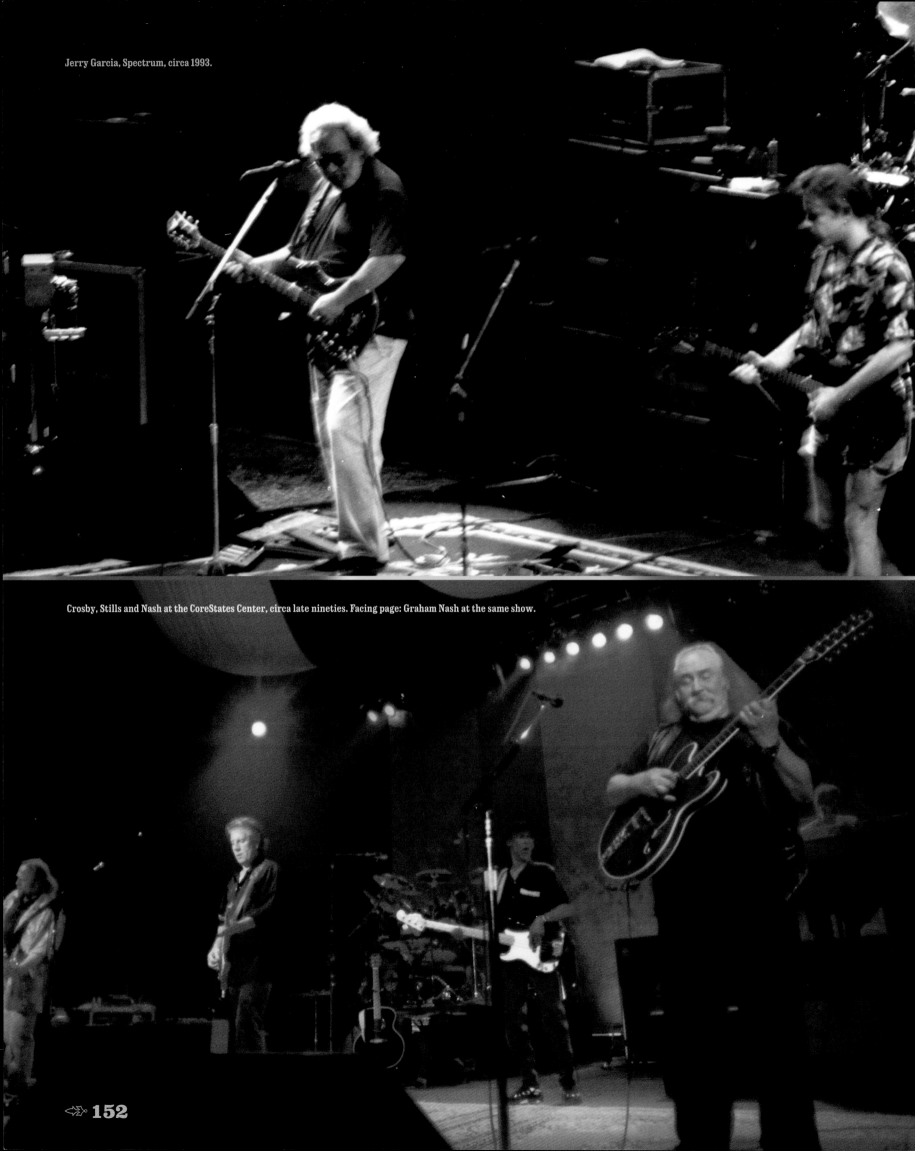

Jerry Garcia, Spectrum, circa 1993.

Crosby, Stills and Nash at the CoreStates Center, circa late nineties. Facing page: Graham Nash at the same show.

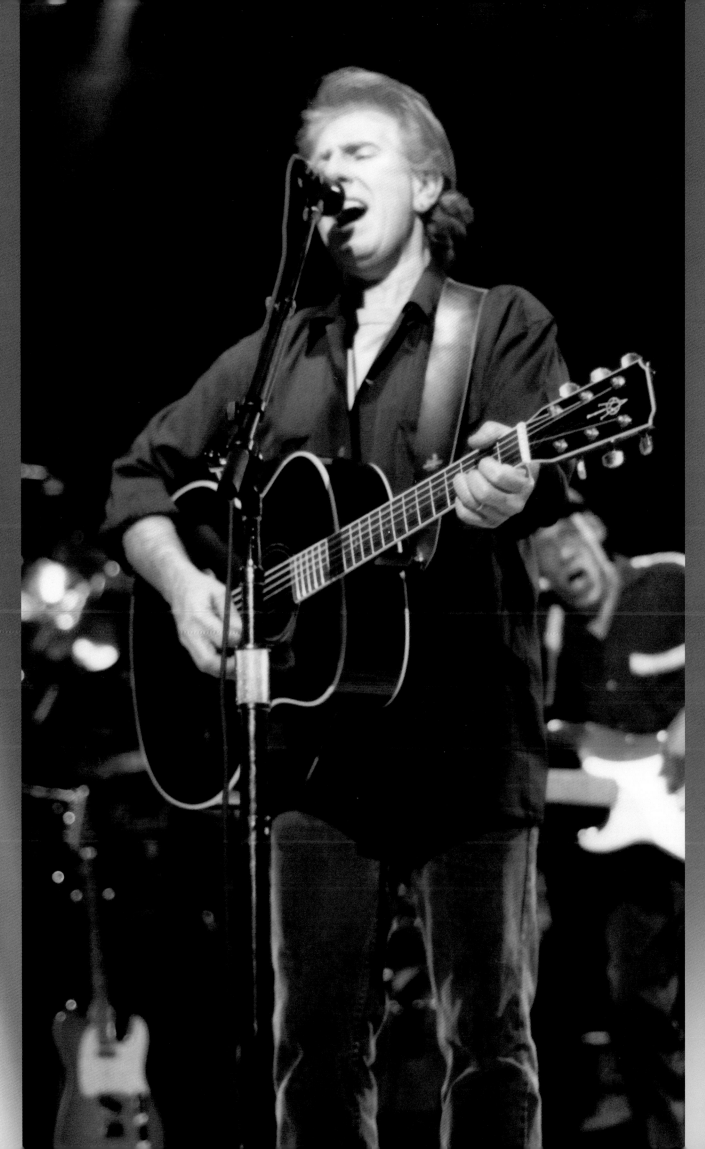

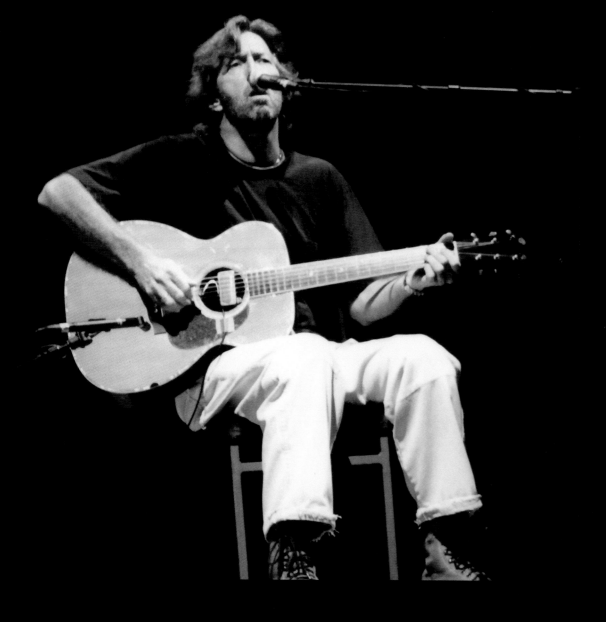

Eric Clapton, Spectrum, May 4–6, 1992.

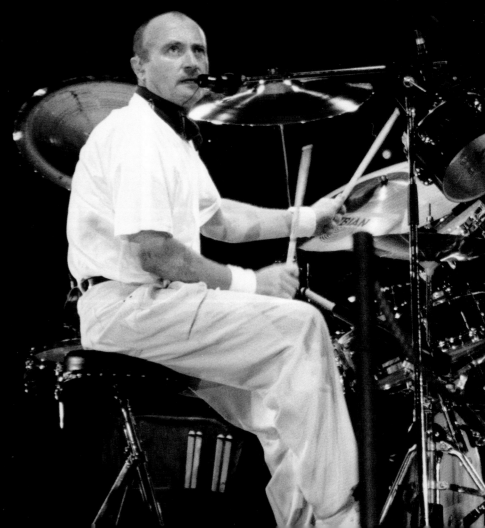

Phil Collins, Spectrum, June 10–20, 1994.

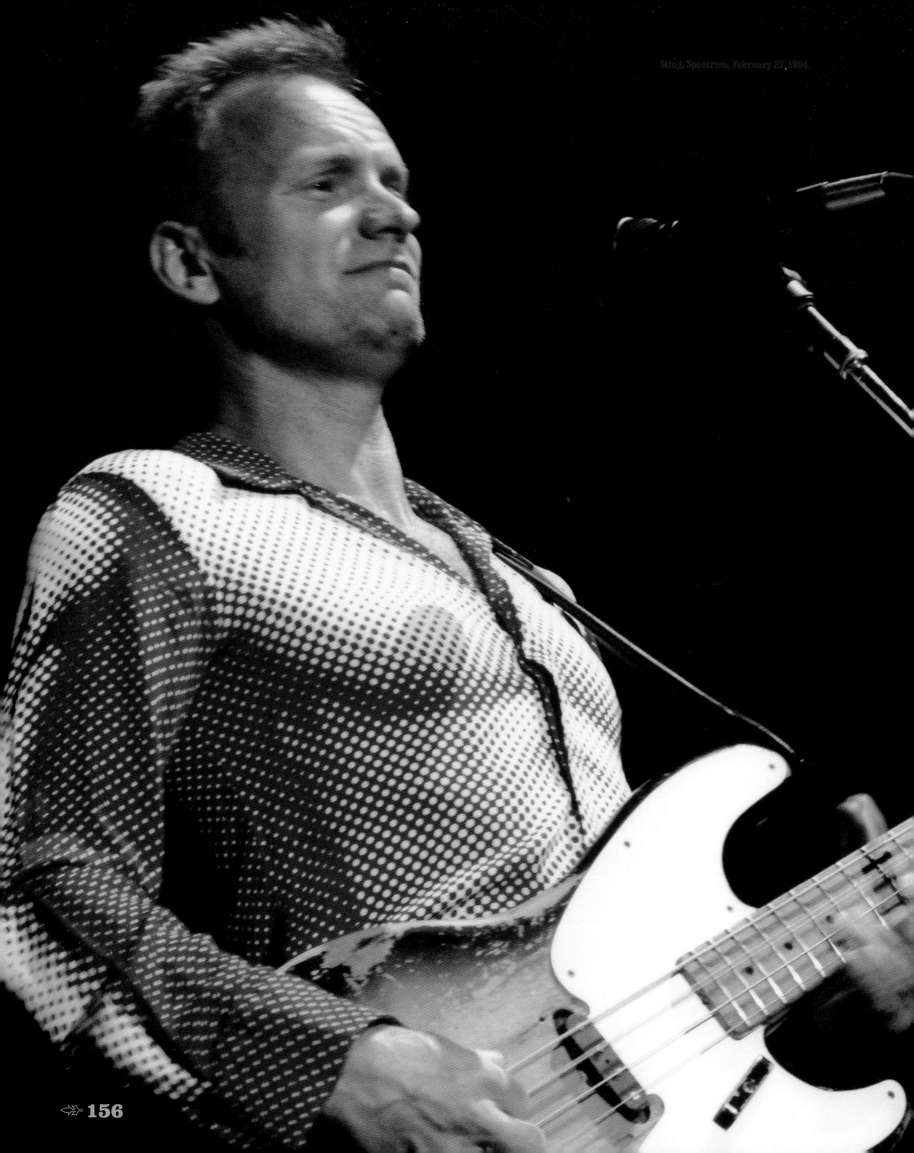

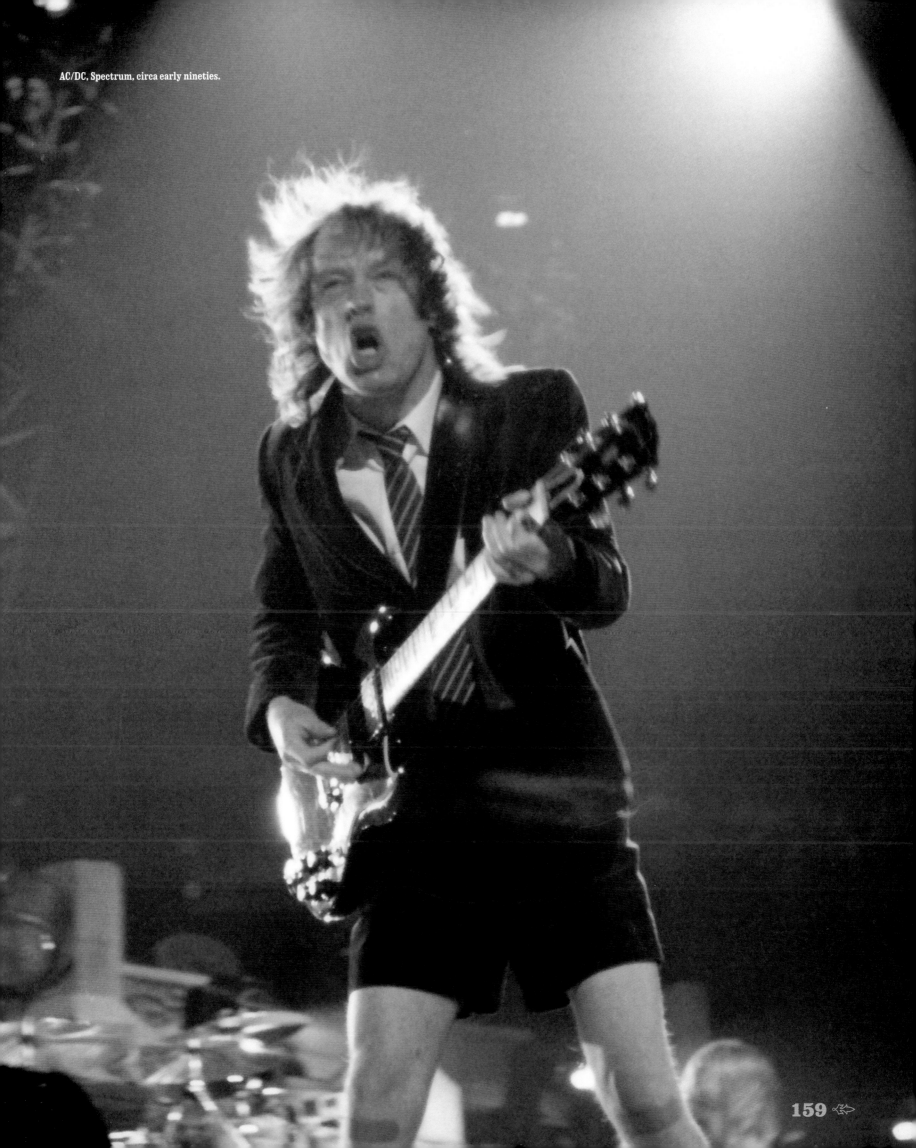

AC/DC, Spectrum, circa early nineties.

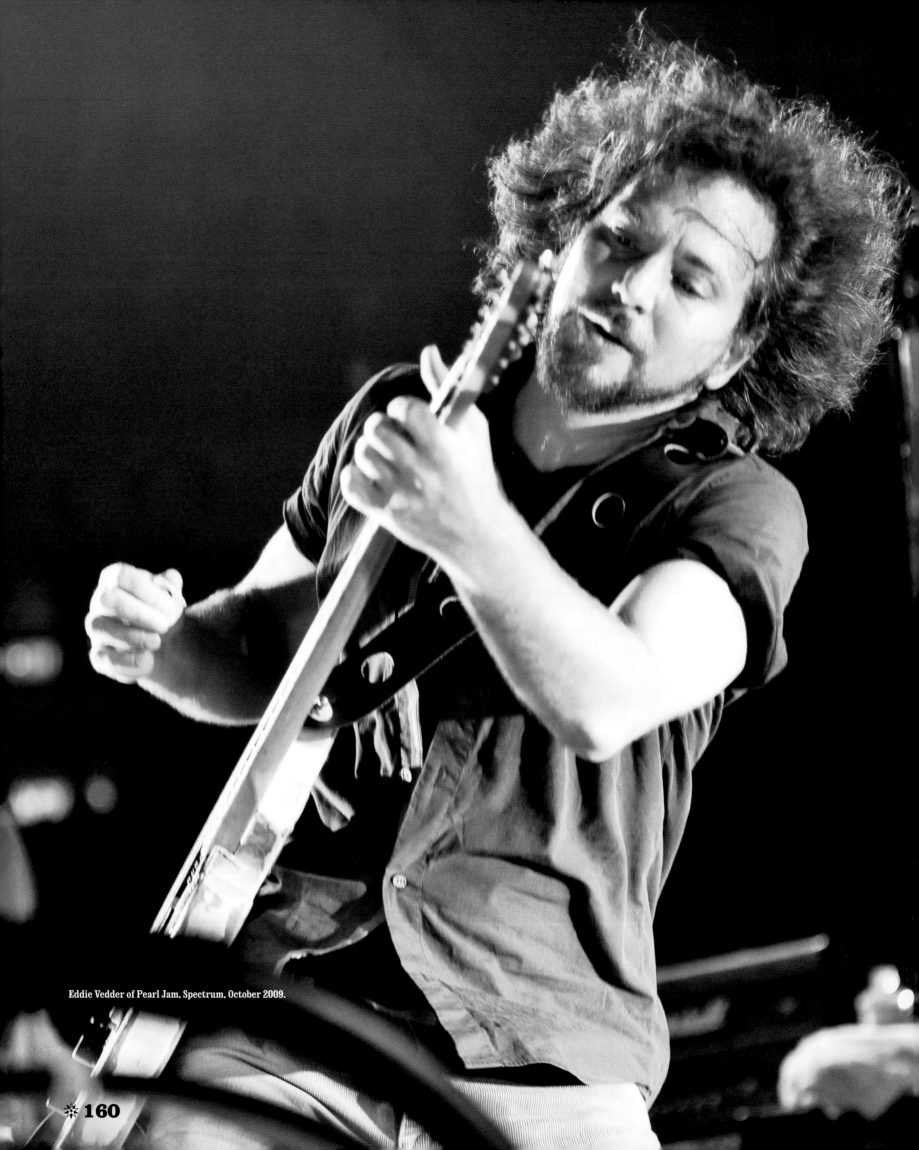

Eddie Vedder of Pearl Jam, Spectrum, October 2009.

ELECTRIC FACTORY
2000s

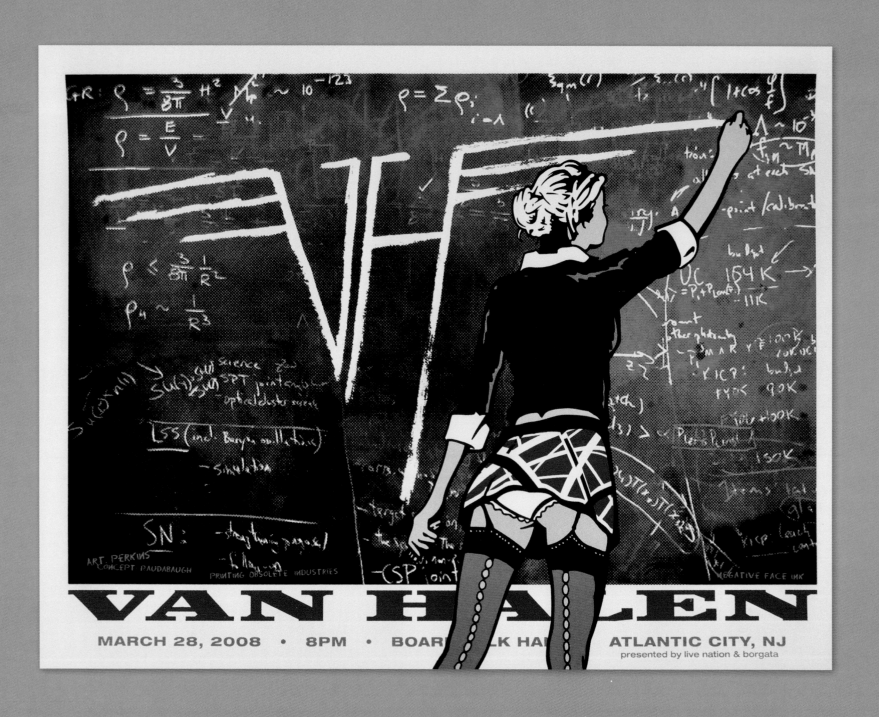

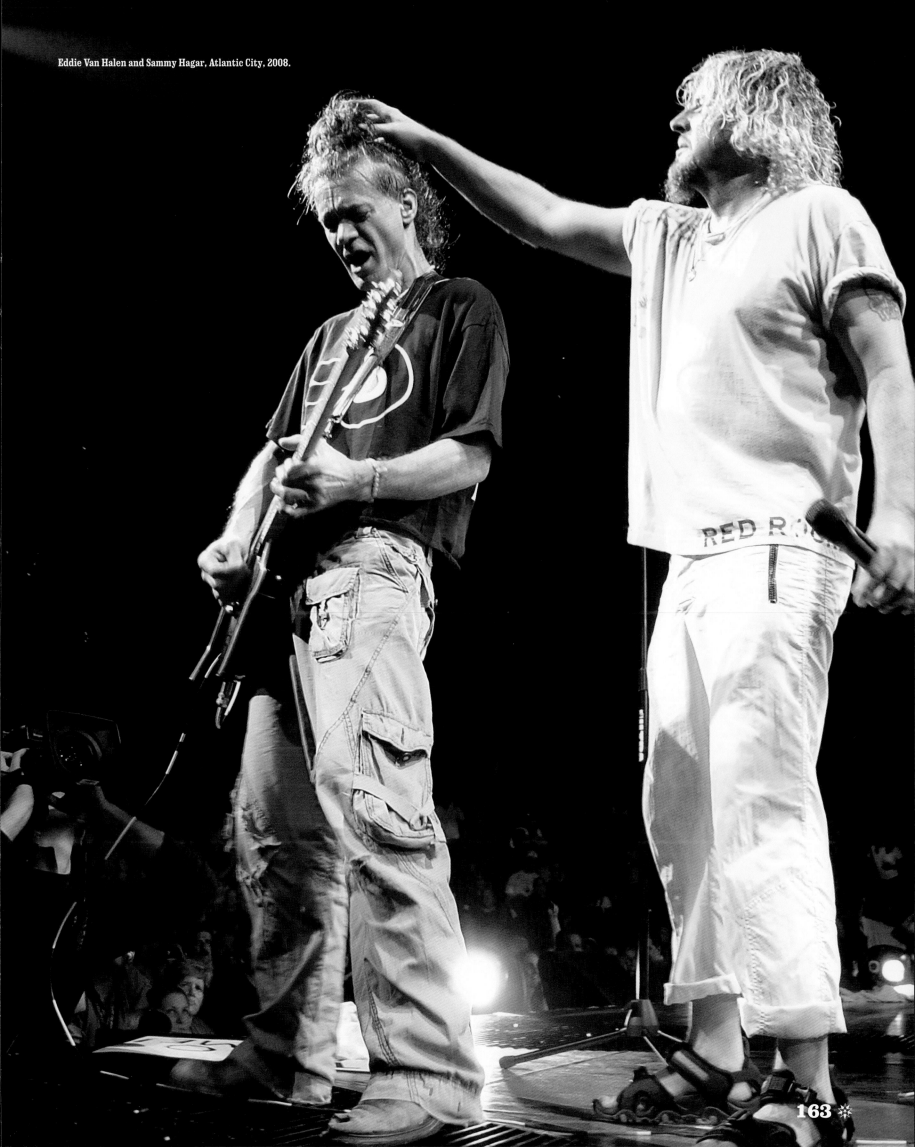

Eddie Van Halen and Sammy Hagar, Atlantic City, 2008.

163 ✺

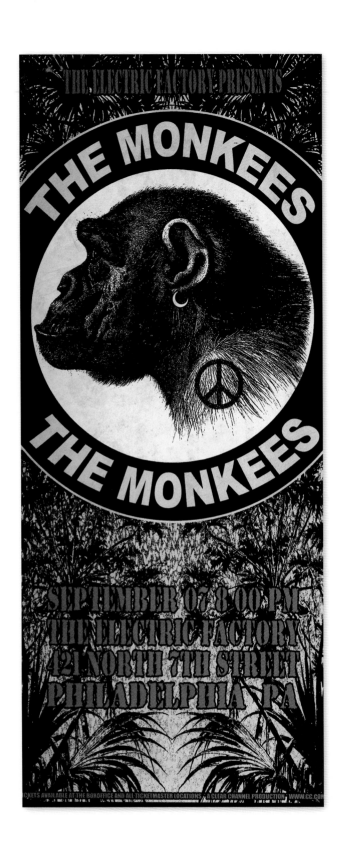

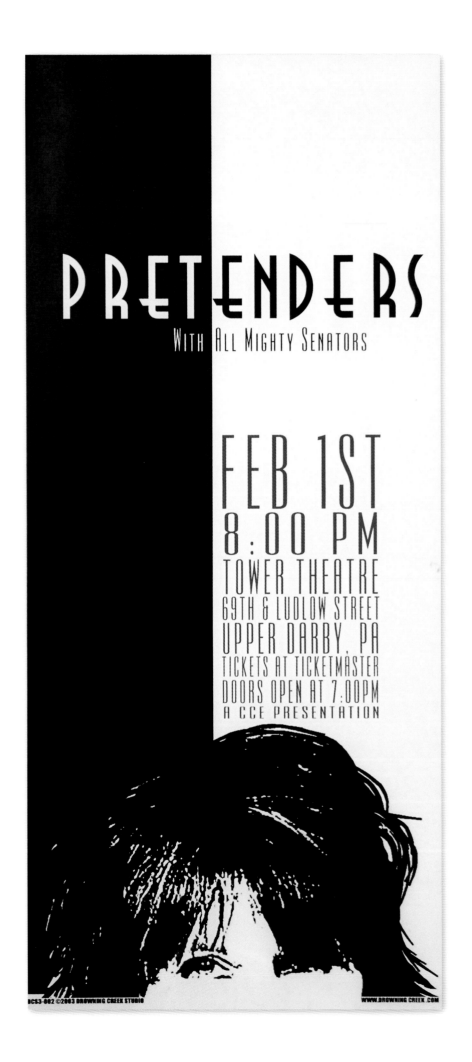

THE TEMPTATIONS

WDAS 105.3 FM

TOWER THEATER
PHILADELPHIA, PA
FEBRUARY 17, 2001 - 8:00PM

Tickets Available At All Ticketmaster Locations www.electricfactory.com / A SFX Music Presentation

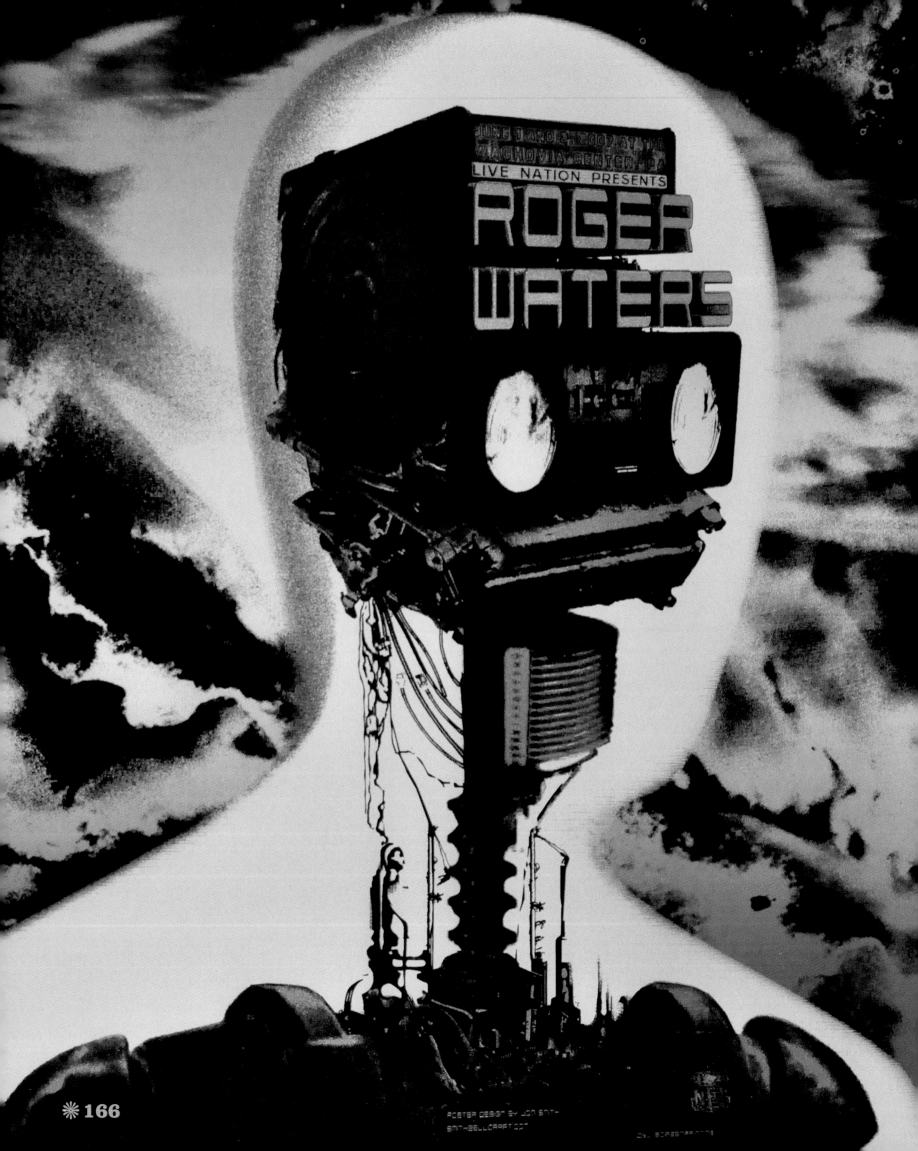

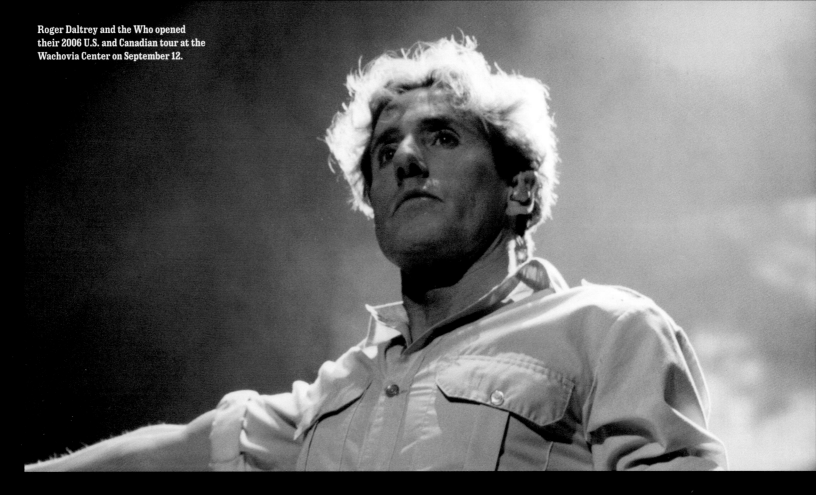

Roger Daltrey and the Who opened their 2006 U.S. and Canadian tour at the Wachovia Center on September 12.

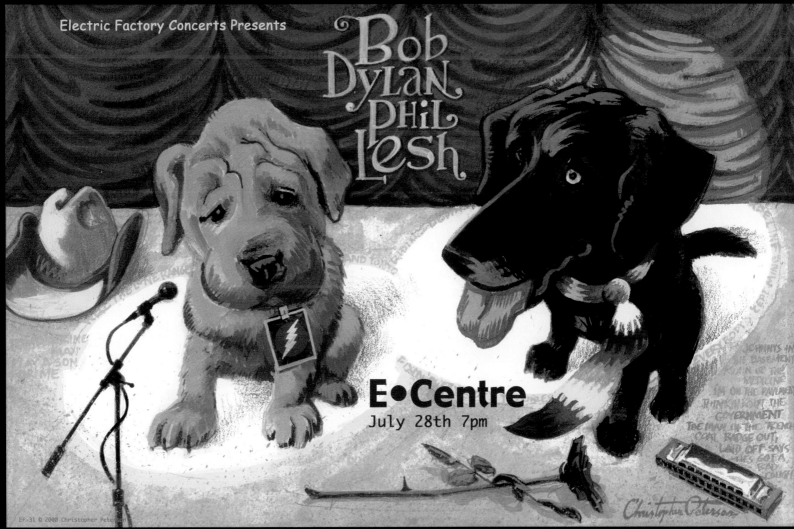

Electric Factory Concerts Presents

Bob Dylan Phil Lesh

E•Centre
July 28th 7pm

EF-31 © 2000 Christopher Peter

Christopher Peterson

www.live8live.com

PHILADELPHI

Amanda Farese Melod

Serena Sams Anne Keane John Keane

LIVE 8

CANADA FRANCE GERMANY ITALY RUSSIA

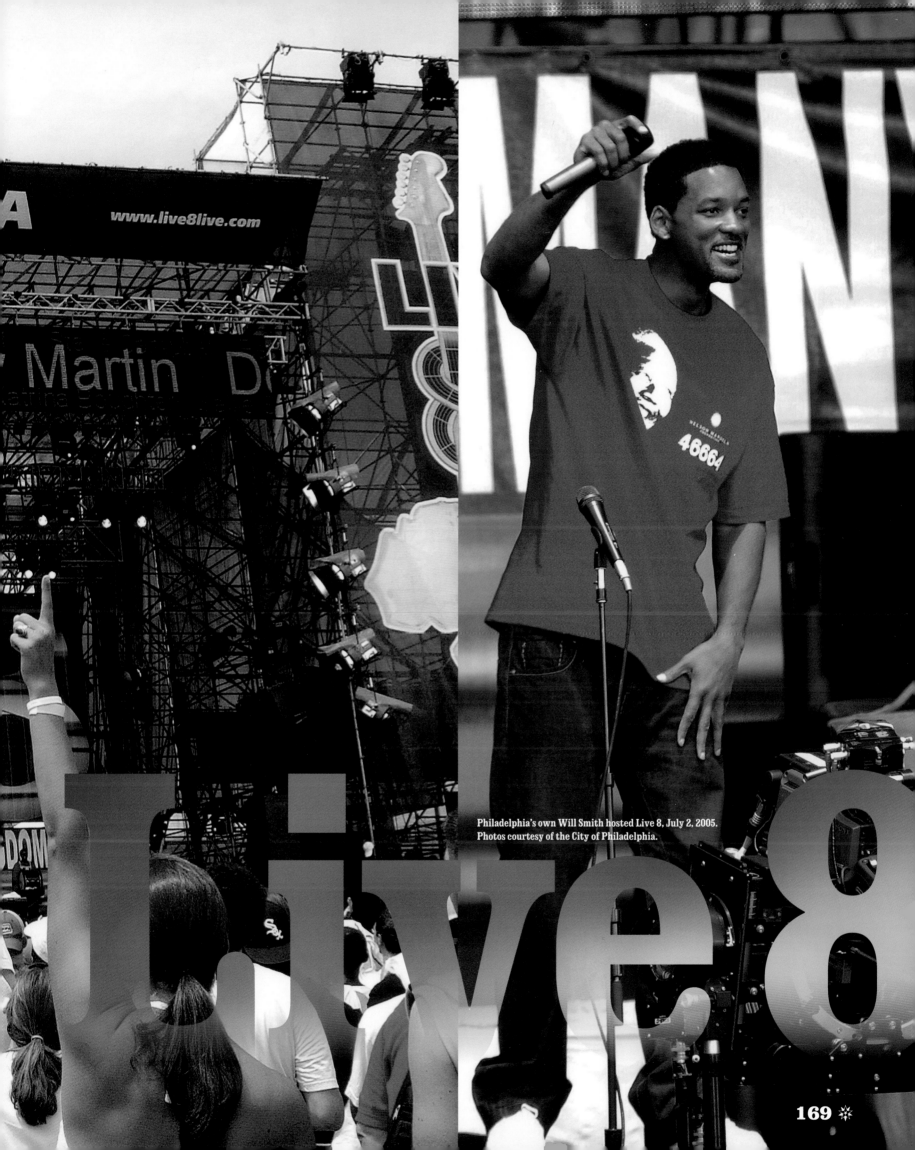

www.live8live.com

Martin De

Philadelphia's own Will Smith hosted Live 8, July 2, 2005.
Photos courtesy of the City of Philadelphia.

Live8

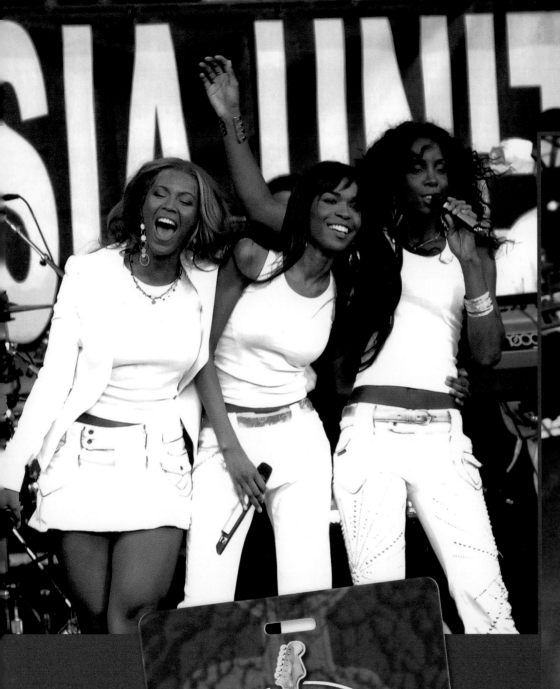

Destiny's Child. Photo courtesy of the City of Philadelphia.

LIVE 8
ARTIST GUEST
Philadelphia
July 2, 2005

Fergie, of the Black Eyed Peas, in a solo performance.

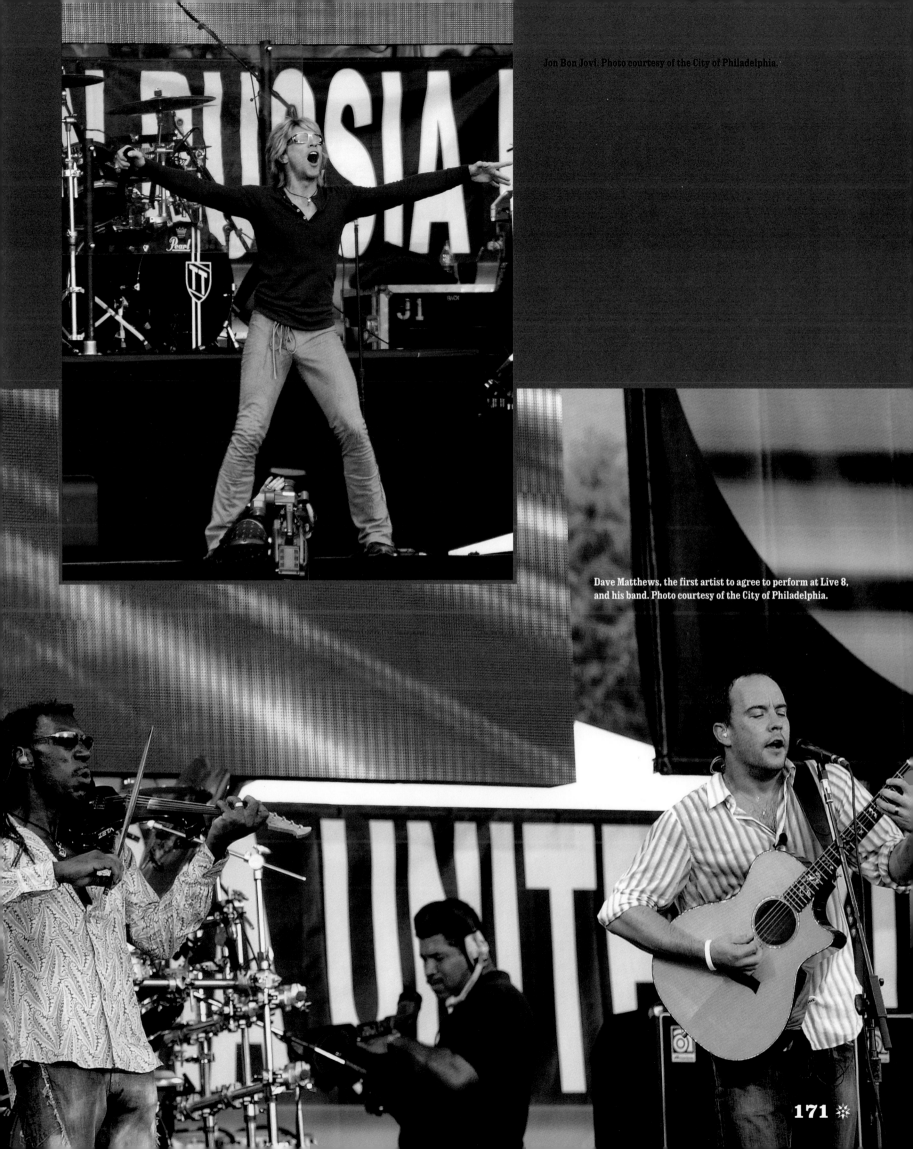

Jon Bon Jovi. Photo courtesy of the City of Philadelphia.

Dave Matthews, the first artist to agree to perform at Live 8, and his band. Photo courtesy of the City of Philadelphia.

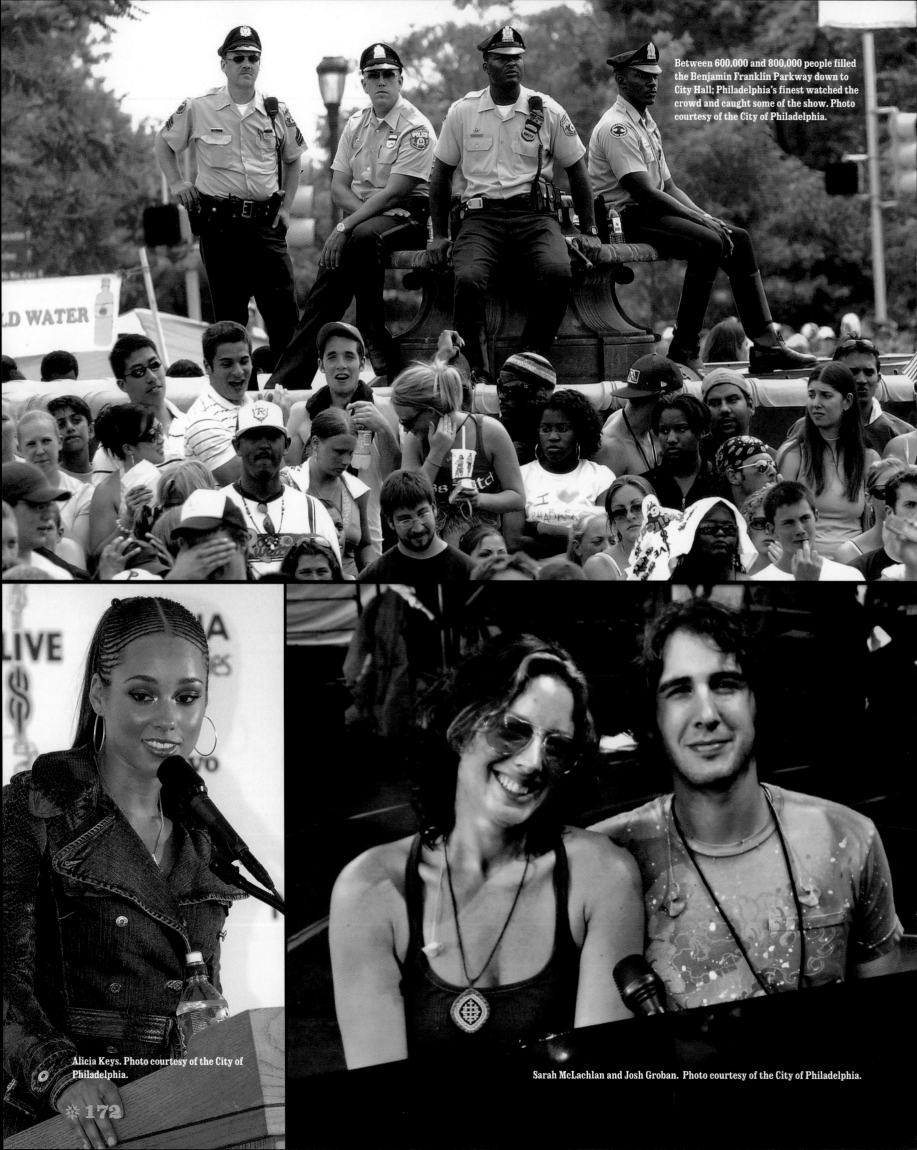

Between 600,000 and 800,000 people filled the Benjamin Franklin Parkway down to City Hall; Philadelphia's finest watched the crowd and caught some of the show. Photo courtesy of the City of Philadelphia.

Alicia Keys. Photo courtesy of the City of Philadelphia.

Sarah McLachlan and Josh Groban. Photo courtesy of the City of Philadelphia.

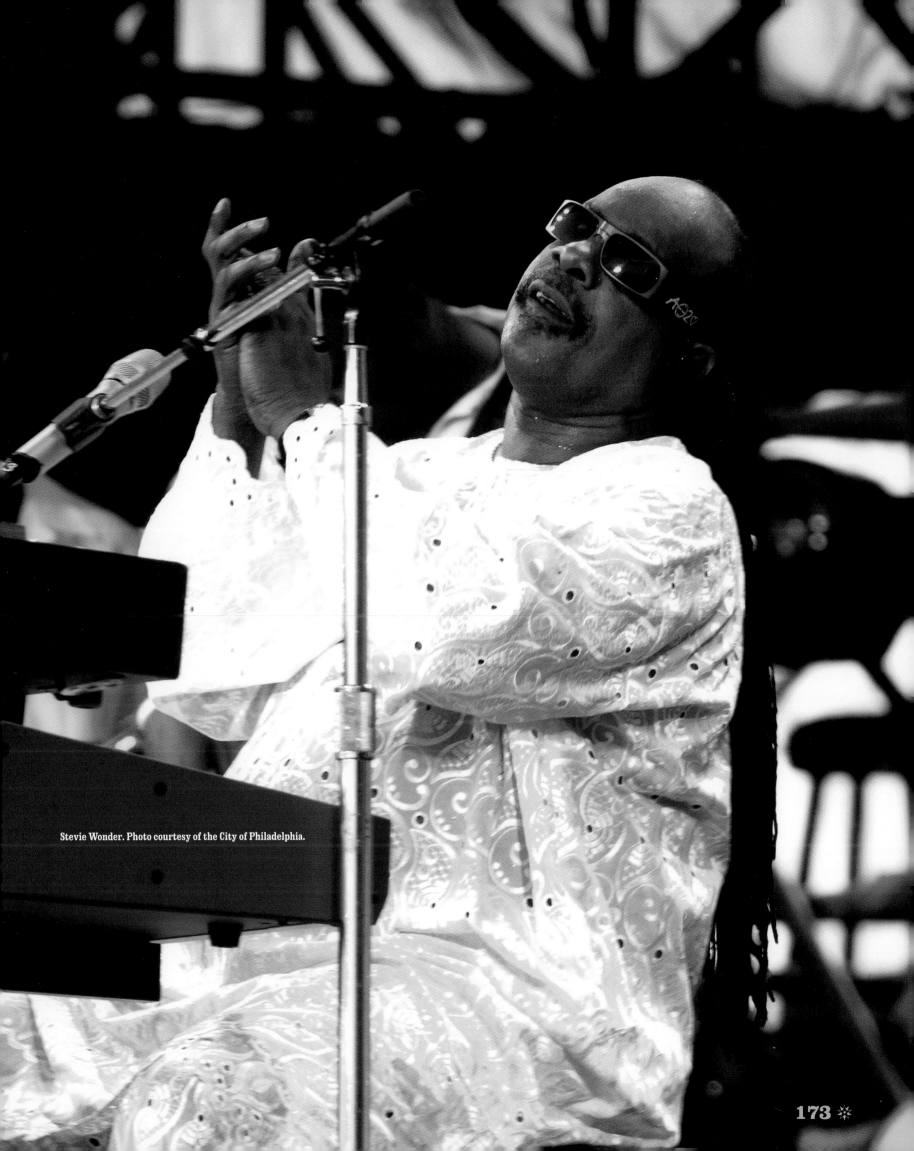

Stevie Wonder. Photo courtesy of the City of Philadelphia.

Kaiser Chiefs

SPECIAL GUESTS THE WALKMEN AND ANNUALS

ELECTRIC FACTORY · FRIDAY, APRIL 6, 2007 · 8:30 PM

❄ 174

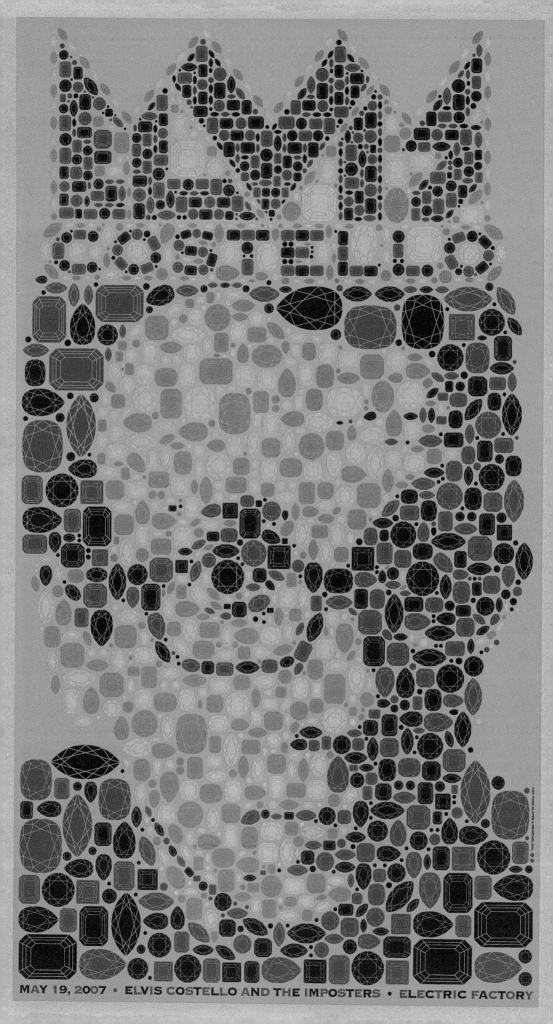

MAY 19, 2007 • ELVIS COSTELLO AND THE IMPOSTERS • ELECTRIC FACTORY

ON TOUR 2008

TOM PETTY and the HEARTBREAKERS

ACCESS
ALL
AREAS

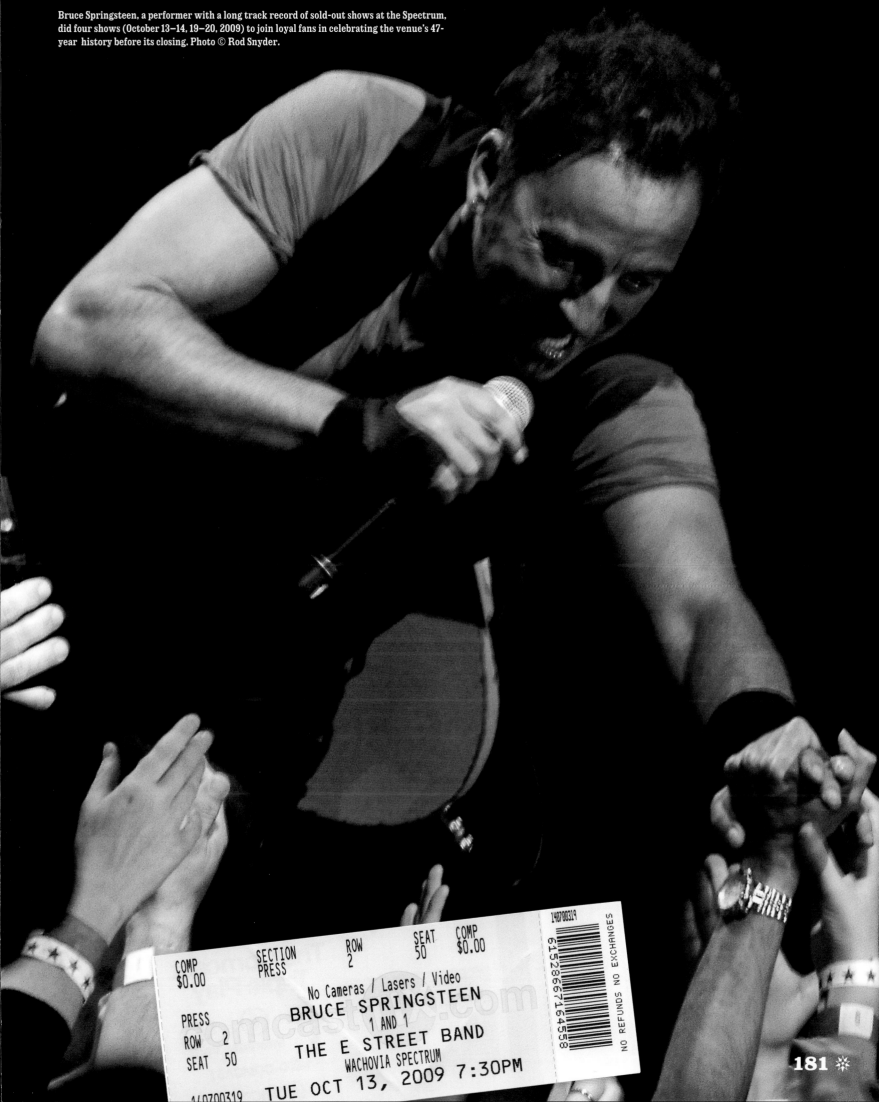

Bruce Springsteen, a performer with a long track record of sold-out shows at the Spectrum, did four shows (October 13–14, 19–20, 2009) to join loyal fans in celebrating the venue's 47-year history before its closing. Photo © Rod Snyder.

181 ✳

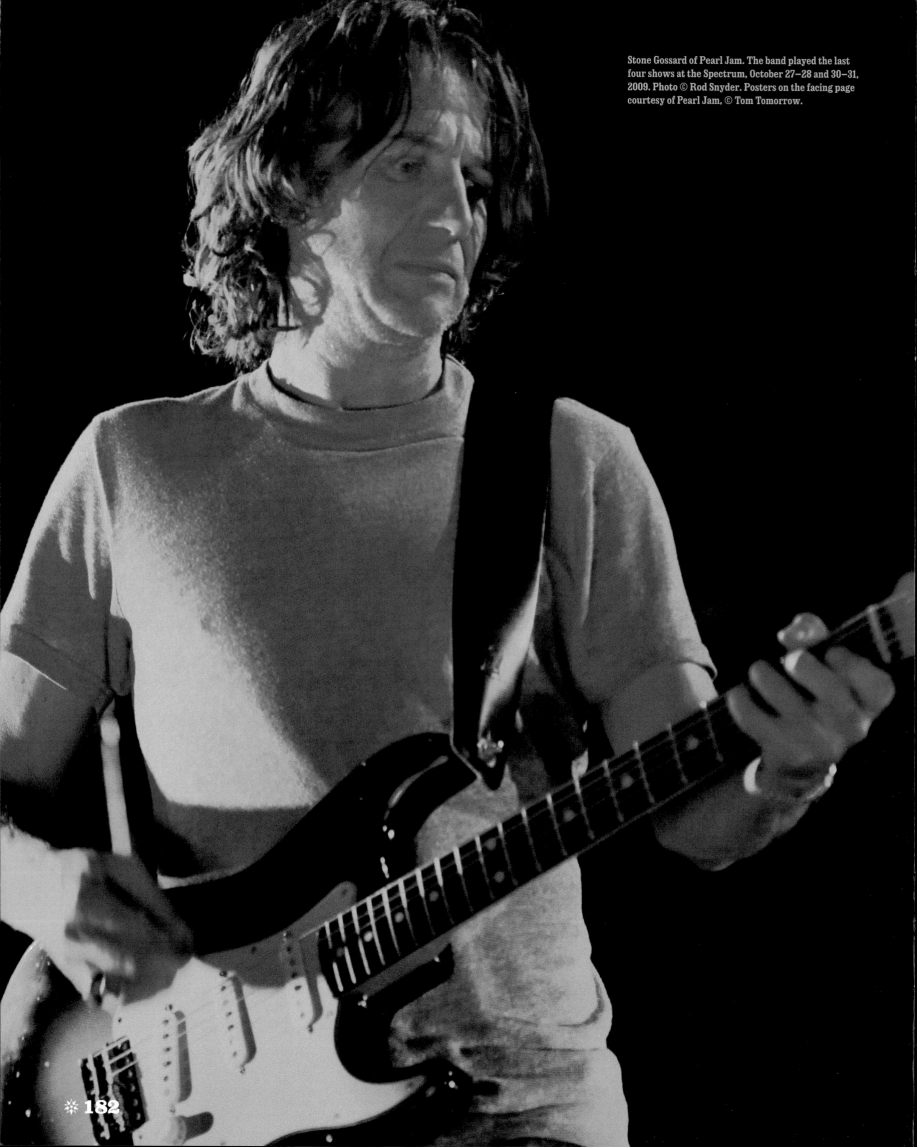

Stone Gossard of Pearl Jam. The band played the last four shows at the Spectrum, October 27–28 and 30–31, 2009. Photo © Rod Snyder. Posters on the facing page courtesy of Pearl Jam, © Tom Tomorrow.

✳ **182**

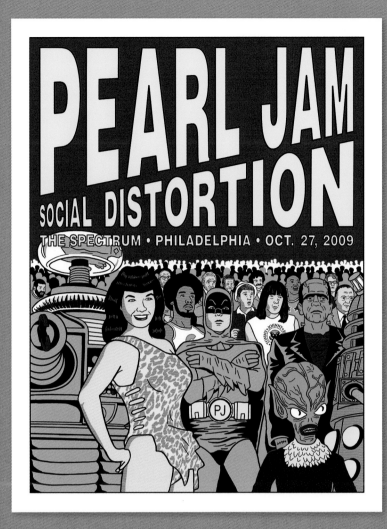

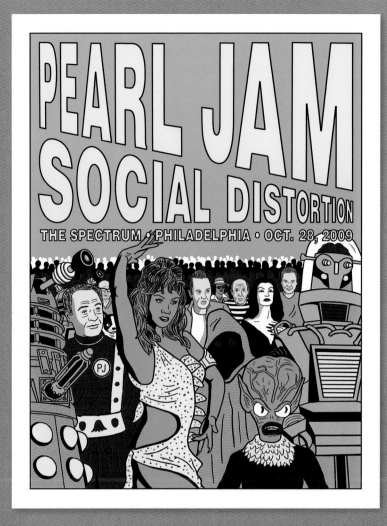

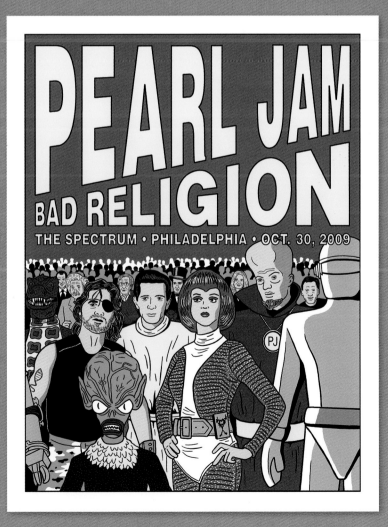

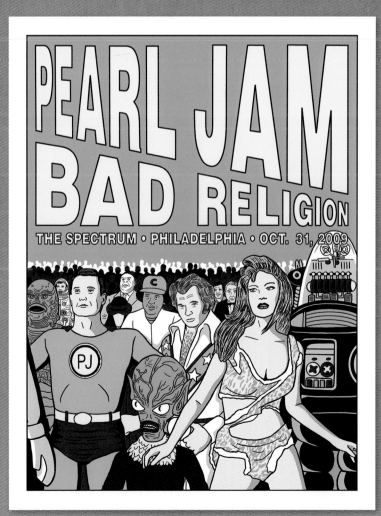

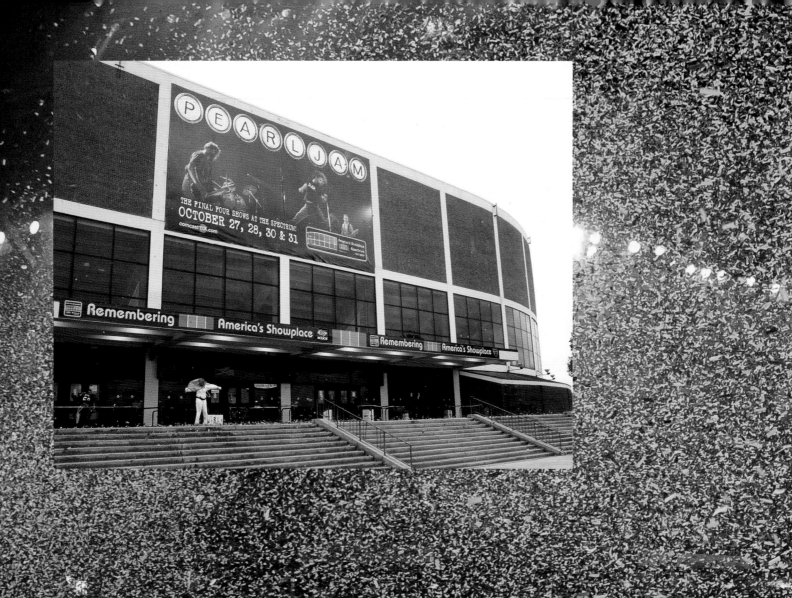

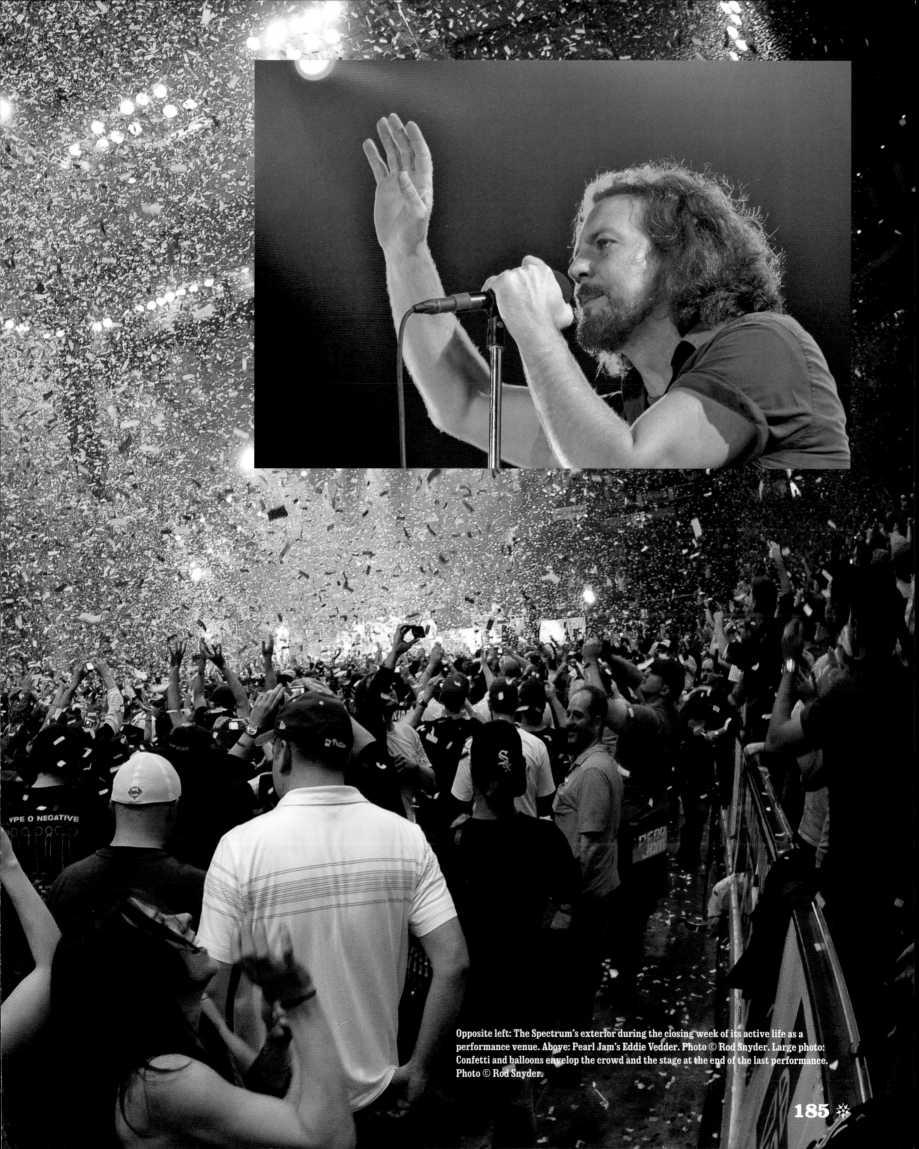

Opposite left: The Spectrum's exterior during the closing week of its active life as a performance venue. Above: Pearl Jam's Eddie Vedder. Photo © Rod Snyder. Large photo: Confetti and balloons envelop the crowd and the stage at the end of the last performance. Photo © Rod Snyder.

ACKNOWLEDGMENTS

To everyone who called or stopped me on the street and asked me to write a book. This is it. It isn't my life story, but a story of moments we shared together.

Thanks to Alex Holzman, Janet Francendese, Charles Ault, Jane Barry, Nanette Bendyna, Ann-Marie Anderson, Gary Kramer, Irene Imperio, Amanda Steele, and everyone at Temple University Press for the heavy lifting; to Bob Huber; and to Phil Unetic for his great design that captures our history.

How do you start a project like this without acknowledging some of the people who have made these pages possible? Special thanks to my wife, Mickey, for trying to understand me. To all of the people who have worked for and with us for all these years. How do you acknowledge everyone? But here's to Paul Fishkin, "Chico" Palermo, Mary Roach, Suzanne and Margo, John Kalodner, Margie, Bob Kelley, David Kasanow, Adam Spivak, Janet Trambo, Ellen Weiss, Dave Ruess, Spencer Zahn, Flossie Jacobs, Julie Vitello, Carole Goldman Kinzel, Bill Rogers, Skip Johnson, Bryan Dilworth, Carrie Cunningham, Mary Smotrys, Rene McDonald, Kathy Kuhl, Dave Chesler, Sid Payne, TJ Smith, Curt Voss, Andy McFadden, Ellen Weiss, and Mole for making the day brighter.

Many thanks to the folks who helped create the original Electric Factory: Bobby Startup, Jims Nelson, John Musall, John Roth, Doug Aldefer, Ichabod, Snake, Lisa, Bruce Howze, Dave Hadler, and the PCA kids.

Thanks to all the photographers who have contributed to this book. Your documentations capture the essence of musical and entertainment history for all time. Eric Bazilian, Joel Bernstein, Lewis Bernstein, George Bilyk, Jeff Hurwitz, Zohrab "Zorro" Kazanjian, Michael Lessner, Eugene Mopsik, Ken Regan, Bobby Startup, and Scott Weiner.

And to some major influences: Leon Fisher aka Julian Graham aka "The Cannonball" for giving me a huge push. Stan Schmucker and Richard Atkins for helping us fight City Hall and winning. To Frank Barsalona, Herb Spar, Dan Weiner, Tom Ross, Albert Grossman, Bert Bloch, Frank Modica, Jack Whitemore, Phil Walden, Dee Anthony, Jon Landau, Bill Graham, Don Law, Steve Wolf, Jay Jacobs, Joe Smith, Steve Barnett, Jerry Wexler, Jerry Greenberg, Jerry Weintraub, Tom Willen, Larry Mullin, and Bob Regehr for lighting the way.

Illustration Sources

Publisher's Note

Most of the items shown on the preceding pages come from Larry Magid's extensive collection of posters, photographs, and memorabilia. Few posters include the full date of the performance, and still fewer can be attributed. The majority of the photographs in the collection lack attribution and dates. Photographers frequently gave Larry copies of the photos they made at a particular performance; few of them put their names or dates on the prints or slides. In several instances, when we contacted photographers for permission to use their work, they offered us some additional images that were not in Larry's collection. Thus, over time, the book has grown in unexpected but welcome ways. For unattributed photos and the ones that photographers could not date, we used a combination of EFC records, Internet searches, and Larry's memory to provide the date and venue information that is in the captions. In the process, we have gained new appreciation for the work that professional historians and archivists do.

Readers will note that the photos from the earlier decades are more numerous. This is largely the result of increasing restrictions on photographing live performances. Some venues authorized only a few photographers to shoot during a show. Readers will also note that EFC's use of posters to advertise upcoming shows varied over its long history. In some periods, EFC didn't use posters at all. Throughout, we have attempted to capture the range of artists who have performed at the Electric Factory and its associated venues as well as the sweep of the company's history.

Photographs

Eric Bazilian
Pete Townshend, frontispiece
Jimi Hendrix negative strip, p. 12
Jimi Hendrix, p. 52
David Gilmour, p. 57
The Who negative strip, p. 60
Pete Townshend, p. 61
Jack Bruce, p. 62
Eric Clapton, p. 63
Mick Jagger, p. 72
Pete Townshend sequence, pp. 78–79

Joel Bernstein
Janis Joplin, p. 14
Rose at Neil Young Concert, p. 47
The Chambers Brothers, p. 51
Frank Zappa, p. 55
Neil Young, pp. 74–75, 96
Crosby, Stills, Nash and Young, p. 97

Lewis Bernstein
Electric Factory Cadillac, p. 13

George Bilyk
Phil Ochs, p. 77

City of Philadelphia
View of Benjamin Franklin Parkway, p. 41
Live 8 Stage, pp. 168–169
Will Smith, p. 169
Destiny's Child, p. 170
Jon Bon Jovi, p. 171
Dave Matthews Band, p. 171
Police officers on fountain, p. 172
Alicia Keys, p. 172
Sarah McLachlan, and Josh Groban, p. 172
Stevie Wonder, p. 173

Jeff Hurwitz
Grace Slick, pp. viii, 49
Grace Slick and Jorma Kaukonen, pp. 70–71
Steve Winwood and Traffic, p. 76

Zohrab Kazanjian
Tina Turner, p. viii
Bruce Springsteen, p. 28
David Bowie, p. 94 (inset)
Elton John, p. 108 (inset)
Billy Joel, p. 109
Willie Nelson, p. 116
Paul McCartney, p. 119
Rod Stewart, p. 122
Tina Turner, p. 125
Tina Turner and Lionel Richie, p. 125
Bruce Springsteen, p. 130

Michael Lessner
Jeff Beck, p. 44
The Who, p. 60
Ron Wood and Mick Jagger, pp. 80–81
Elvis Presley, p. 91
Frank Sinatra, p. 90
David Bowie, p. 94
Robert Plant, p. 99
Billy Preston, p. 103
Elton John, p. 108
Elton John, p. 108 (inset)
Bob Dylan, p. 118
Eric Clapton, p. 118
George Harrison, p. 119

Eugene Mopsik
Randy Newman, p. 86
Rod Stewart contact sheet, p. 102
Peter Frampton, p. 106
Crowd at Peter Frampton show, p. 107

Charles Myers/*Philadelphia Daily News*
Elton John and Frank Rizzo, p. 36

Ken Regan
Keith Richards, Bob Dylan, and Jack Nicholson, p. 40
Stage at Live Aid, p. 136
Crowd at Live Aid, p. 137
Bo Diddley and George Thorogood, p. 137
Jack Nicholson and Bette Midler, p. 138
Keith Richards, Hall and Oates, Ron Wood, Tina Turner, Mick Jagger, Madonna, and Bob Dylan, p. 139
Patti LaBelle and her backup singers, p. 140
Madonna seated, p. 141
Madonna standing, p. 141
Eric Clapton Group, p. 142
Robert Plant and Jimmy Page, p. 143
Phil Collins, p. 143
Tom Petty and the Heartbreakers, p. 144
Tina Turner and Mick Jagger, p. 145
Mick Jagger, p. 145
Keith Richards, Ron Wood, and Bob Dylan, p. 146
Ron Wood, Bob Dylan, and Keith Richards, p. 147
Crosby, Stills, Nash and Young, p. 147

Rod Snyder
Bruce Springsteen, p. 181
Stone Gossard, p. 182
Eddie Vedder, Spectrum closing, pp. 184–85

Bobby Startup
Roger Waters, pp. viii, 58
Nick Mason, p. 58
Pink Floyd, p. 59
John Mayall, p. 72
Genesis, p. 98
ZZ Top, p. 116

Scott Weiner
U2, p. 128

Posters

Tom Tomorrow
Pearl Jam Series, p. 183

Index

Note: *Italicized* page numbers indicate photographs.